Plastic

COLLINS | DESIGN

An Imprint of HarperCollins*Publishers*

Plastic

Edited by Cristian Campos

COLLINS | DESIGN

An Imprint of HarperCollins*Publishers*

First Edition:
Published by **maomao publications** in 2007
Talles, 22 bis, 3º 1ª
08001 Barcelona, Spain
Tel.: (34) 93 481 57 22
Fax: (34) 93 317 42 08
mao@maomaopublications.com
www.maomaopublications.com

English language edition first published in 2007 by:
Collins Design
An Imprint of HarperCollins*Publishers*
10 East 53rd Street
New York, NY 10022
Tel.: (212) 207 7000
Fax: (212) 207 7654
collinsdesign@harpercollins.com
www.harpercollins.com

Distributed throughout the world by:
HarperCollins*Publishers*
10 East 53rd Street
New York, NY 10022
Fax: (212) 207-7654

Publisher:
Paco Asensio

Editorial Coordination:
Anja Llorella Oriol

Editor:
Cristian Campos

Translation:
Antonio Moreno

Art Direction:
Emma Termes Parera

Layout:
Zahira Rodríguez Mediavilla

Library of Congress Cataloging-in-Publication Data

Plastic design now / edited by Cristian Campos.
 p. cm.
 ISBN-13: 978-0-06-124200-7 (hard cover)
 ISBN-10: 0-06-124200-4 (hard cover)
 1. Design, Industrial. 2. Plastics. I. Campos, Cristian. II. Title.

 TS171.4.P56 2007
 745.2--dc22

2007025263

Printed in Spain

First Printing, 2007

Contents

Of all the possible bad beginnings you could imagine, Parkesine probably had one of the worst. Nonetheless, the story does have a rosy ending.

Parkesine was an innovative cellulosic material that won the bronze medal at the 1862 London International Exhibition. Obtained by treating cotton with nitric acid, sulfuric acid, and castor oil, it was a hard material that could also be molded when hot. However, it cracked and broke easily after repeated use. Its inventor, Alexander Parkes (England, 1831–1890), also failed at producing Parkesine on an industrial level, as it was extremely cost-prohibitive for its time. Yet in 1868 John W. Hyatt improved Parkes's material by adding camphor to the mix. Thus celluloid, a viable plastic material that was capable of being produced industrially, was born.

The first plastic products could hardly wait. By some estimates, billiard balls were the first product made entirely of plastic (back then ivory was just as rare as it is today) although the best bet is that dentures beat them to it. These, by the way, had a problem: Heat softened them, making something as trivial as sipping tea a major problem. Not to mention that camphor aftertaste ...

But let's jump forward in time. We're in 2007, smack in the prime of plastic's golden age, a golden age that actually began with Bakelite in the early twentieth century. Nowadays, plastic is present in almost each and every industrial field. It would be almost impossible to step outside without seeing at least one plastic product within 50 feet.

Without plastic it would be virtually impossible to enjoy a Formula 1 race, decorate our homes with reasonably priced furniture, listen to music, enjoy our PlayStation 3, perform surgery, or even play ball on the beach. In fact, huge publishing and cinematic empires were built thanks to the plastics industry. Just ask Hugh Hefner.

Plastic has countless advantages over other materials: It is inexpensive, flexible, impermeable, insulating, resistant, and easily shaped. Other materials might have one

or two of these characteristics, but no other material has all of these qualities. Nevertheless, plastic also has what we can call a "snob" disadvantage. Since it is inexpensive, it cannot compete with glamorous heavyweights such as marble, stone, steel, and glass. Plastic is condemned to being commonly perceived as a working-class material—or, in the best case, a middle-class material (as a kitsch item). Yet, in fact, the price of plastic hasn't stopped going up in recent years thanks to the rising price of petroleum, the material that is chemically altered to make commercial plastics.

Plastic gathers dozens of international designers that have made plastic one of their favorite materials. In most cases, plastic has enabled them to undertake projects that couldn't have been realized with any other material. Experimentation and a sense of humor predominate, but let's not let the trees keep us from seeing the forest: The products in this book are undoubtedly the predecessors of others that, in the future, will continue to revolutionize the way we experience our surroundings.

For easy use, this book has been divided into thematic chapters, according to each type of product. Although plastic is an "accommodating" material that, as we've said before, can be seen in all fields of industrial design, it tends to be used for chairs, lamps, and small items that are destined for use in the kitchen or bathroom. It is also widely used in architecture, although to date the only home that has largely been built using plastic is Kengo Kuma's Plastic House in Tokyo.

This wide range of uses is reflected in the projects selected for this book, which cover practically all fields in which plastic has been used as an industrial material. We've tried to offer a wide variety of products that, beyond their mere aesthetic beauty, give an idea of the practical uses of polymeric, synthetic, and semi-synthetic materials and their possible uses in the future. Science fiction may be fiction, but plastic will make it less so than we might be inclined to imagine.

Lamps and lighting systems

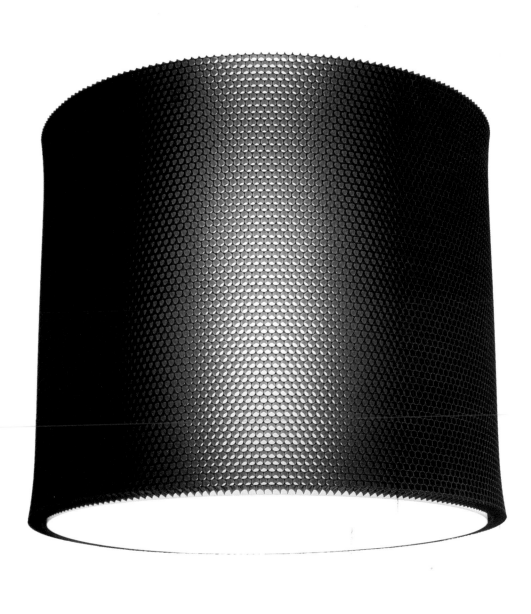

Black Honey | J.P. Meulendijks for N-U | 2006 | www.n-u.nl

Black Honeycomb is an acrylic plastic used primarily as separating panels in interior design and is very similar to, as the name suggests, the hexagonal honeycombs made by bees. When designer J. P. Meulendijks discovered this material, he decided to begin experimenting with it, with no particular objective. Nevertheless, the material very quickly demonstrated one of its principal characteristics: the ease with which it provokes spectacular lighting effects that change depending on the observer's position. From that to designing the Black Honey hanging lamp was just one small step. For its production, J. P. Meulendijks had only to bend the half-inch-thick Black Honeycomb. "Molded" in this fashion, the material softens the light from the bulb inside it in a unique way. When one looks at the lamp from the front, the light is filtered directly, in a straight line, through the spaces in the material. On the other hand, if one looks up at the lamp from beneath it, the light filtering through is greatly diminished. The resulting effect is perfect for creating a relaxed atmosphere, similar to that created by dozens of LED lights. In J. P. Meulendijks' own words, "Occasionally, and depending upon the point of view and intensity of the light, the lamp creates optical illusions." The white interior clashes with the black exterior, provoking an interesting set of contrasts.

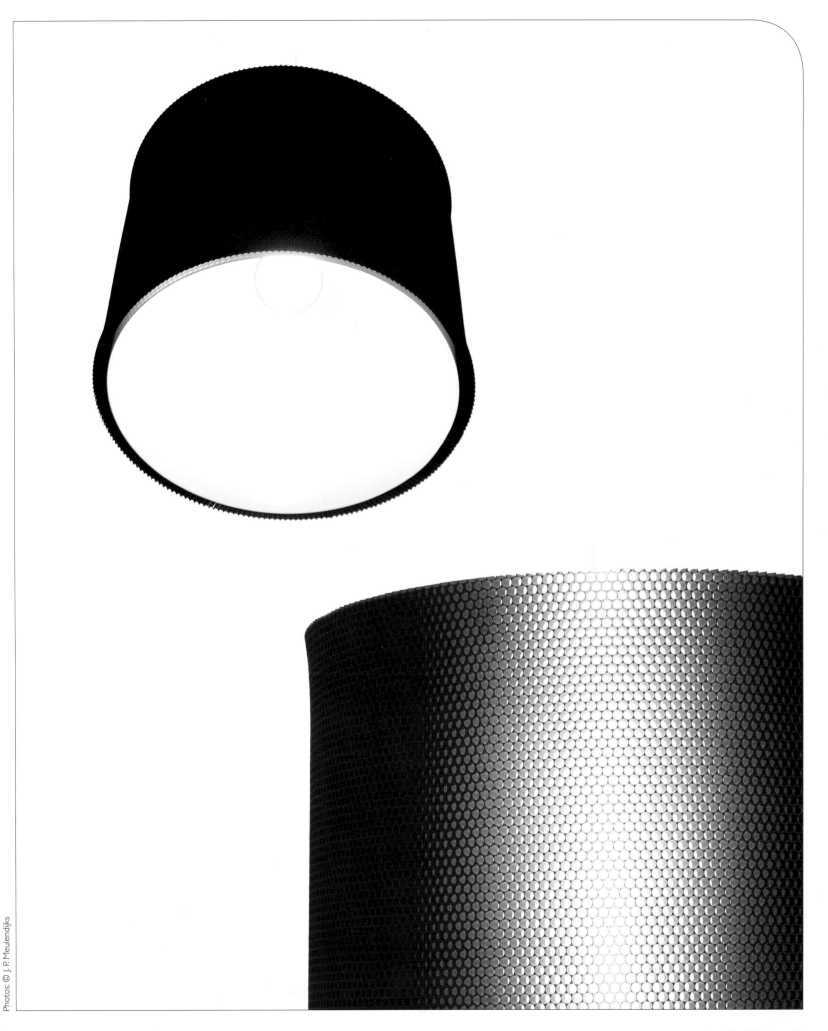

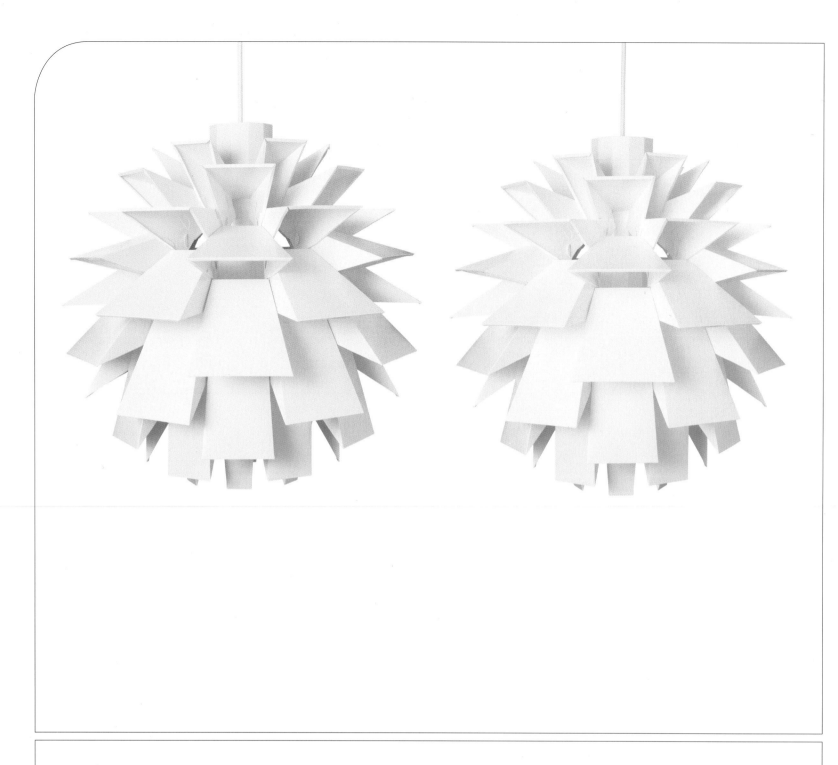

Norm 69, Norm 06 | Normann Copenhagen by Simon Karkov | 2002, 2006 | www.normann-copenhagen.com

In 1969 Simon Karkov designed the Norm 69 (which wasn't named as such at that time). After not finding the financing necessary for the project, he tucked it away in a drawer until 2002, when the Dutch company Normann Copenhagen rescued it. Attaining the rights to the design, the firm injected it with the visionary, radically modern character that others had left behind at the tail end of the '60s. The Norm 69 (this page) is composed of 69 pieces that are fitted together without glue or hardware of any kind. After an initial failed attempt with another material that didn't live up to expectations because it couldn't handle the constant manipulation needed for a lamp that would be assembled and reassembled at will, the designers opted

for rubber because of its flexibility and resistance under conditions of extreme temperature. (In the words of Normann Copenhagen directors, the lamp had to be as good for "Hawaii as for Iceland".) The 69 pieces of the Norm 69, which measures 1.67 feet in diameter, have been arranged in such a way that it is impossible to see the bulb from the outside.
The Norm 06 (opposite page) has been in the works for the past four years by Simon Karkov and has as its inspiration the water lily. Much like the Norm 69, the lamp is easily assembled and made of rubber. It consists of some 20 or so pieces.

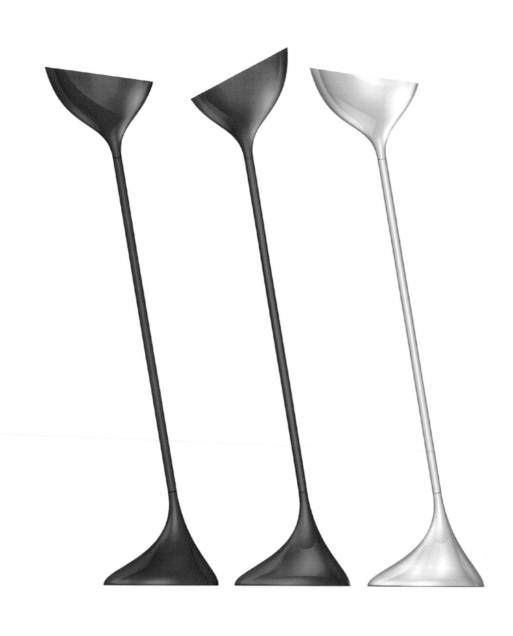

Floob | Karim Rashid for Kundalini | 2005 | www.karimrashid.com

Finding the "average American," that individual who theoretically encompasses the many characteristics that define the citizens of the United States, is a difficult task (though Kevin O'Keefe believed he'd found him, and wrote of him in his book *The Average American*). It may be easier to spot the one design that unites all the distinctive characteristics of a particular designer's work. In Karim Rashid's case, it's very probable that the piece that most reflects the varied essences of his work may be the Floob lamp: pure and original lines, bright colors (pink, orange), and see-through Plexiglas with distinctive forms. The result is one of the most attention-grabbing floor lamps found on the market today. The Floob measures almost 6 feet high,

and its form recalls that of a slightly leaning Tulip. The Floob has its own dimmer mechanism, designed with IGBT technology, which ensures the lamp's completely silent operation and helps control its indirect, ambient lighting. The tone of this light will be influenced by the color of the model the customer has chosen. Having been formed in a hot aluminum mold, the Plexiglas reacts by forming miniscule bubbles and small pockets of air. These bubbles and pockets of air, an aesthetic characteristic of the Floob lamp, may be best seen in the translucent version of the lamp.

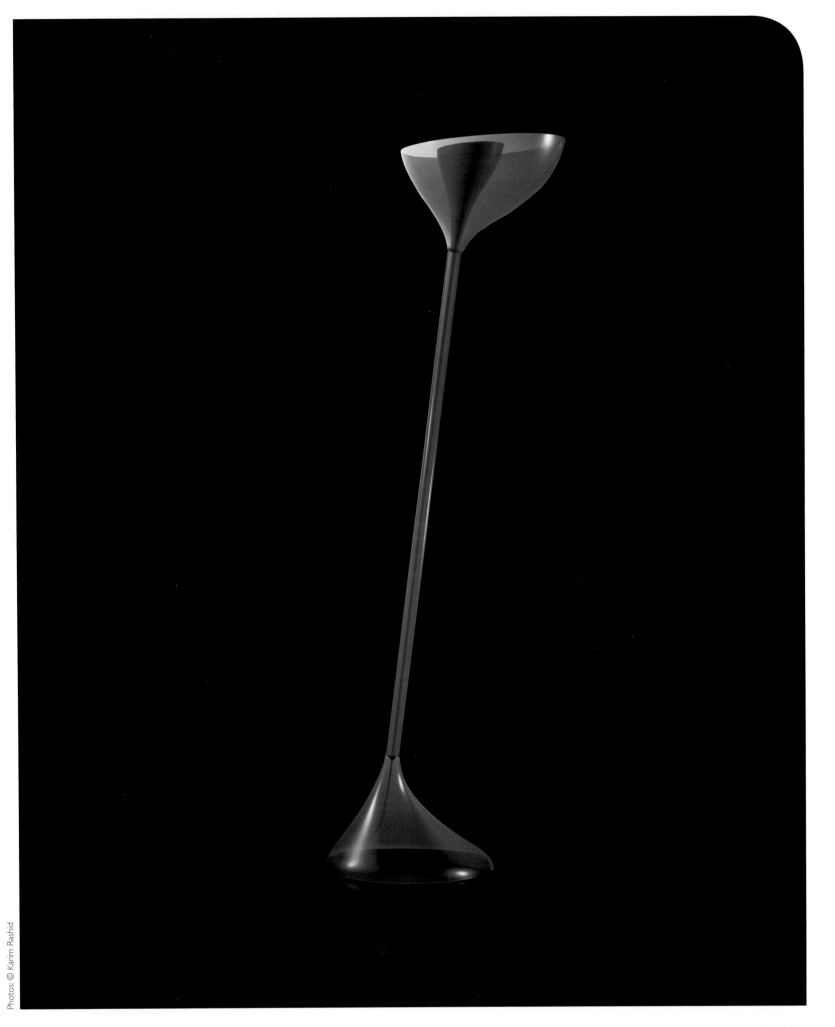

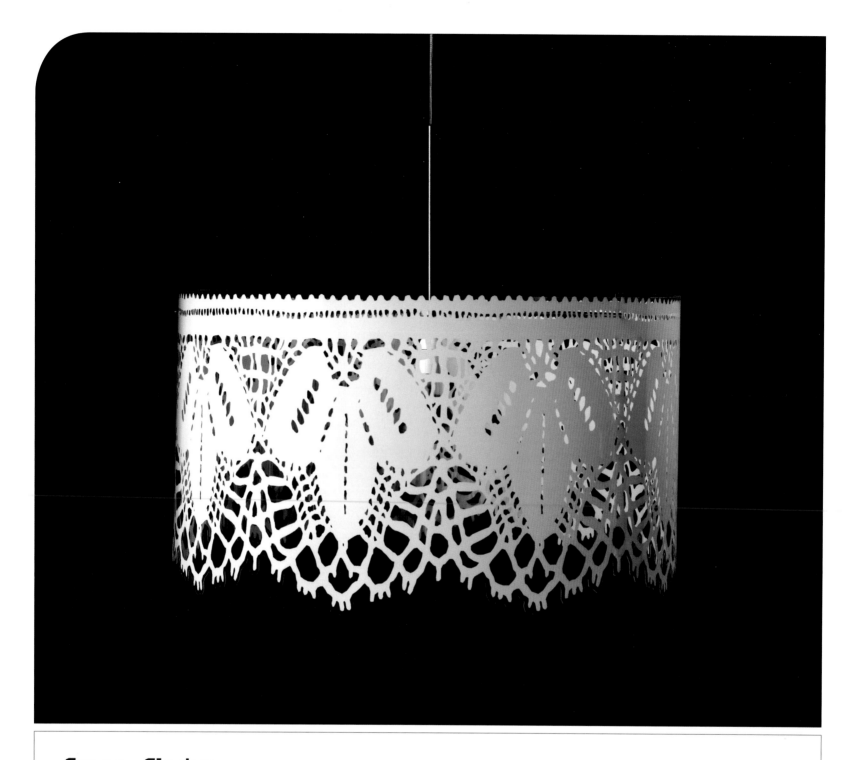

Grace, Gladys | Charming Unit Design Studio for Bsweden Belysningsbolaget | 2005, 2004 | www.charmingunit.com

Each of the Grace and Gladys family of products boasts a varied selection of different lamps (table lamps, floor lamps, ceiling lamps, and candelabras), endowed with a certain decorative element that is repeated in each and every model. In the Grace collection, all the lamps are characterized by a transparent plastic border perforated with a pattern aesthetically similar to the narrow lace fringes and embroideries of artisanal tablecloths. The result is a piece halfway between the traditional and the fashionable, a fusion of antique look with daring design brought forth by the latest technology in the realm of plastic work.

The Gladys collection uses the following distinctive flourishes: a perforated, transparent plastic border similar to that of the Grace lamp, although in this case, some of the models have been made with chrome. The customer may choose not only the color of the lamp but the color of the retractable-cord housing that actually fixes the lamp to the ceiling (available in white or black plastic). The floor-lamp model features a steel base lacquered with the color gray.

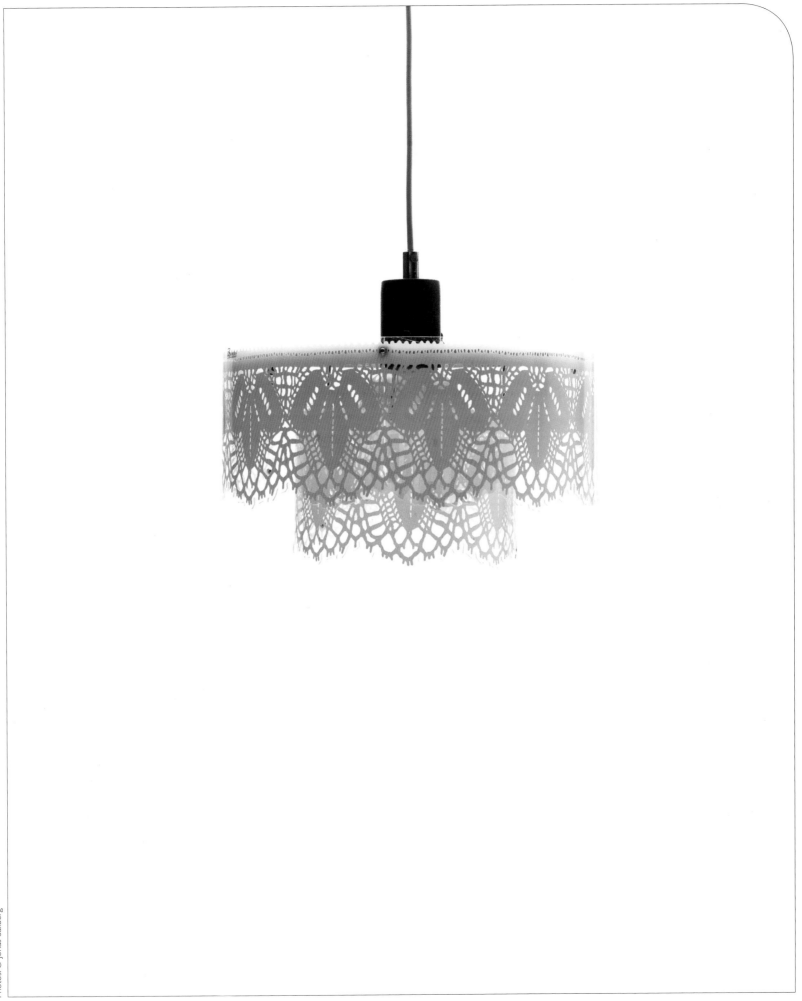

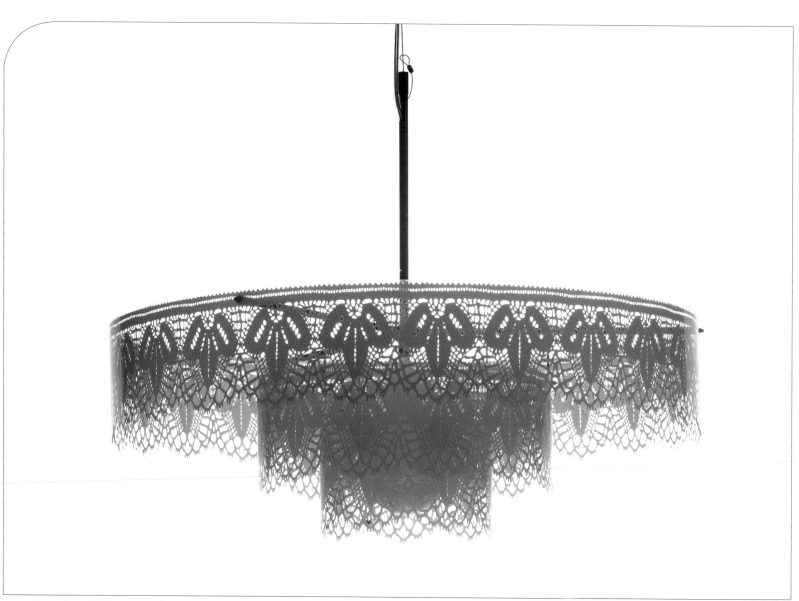

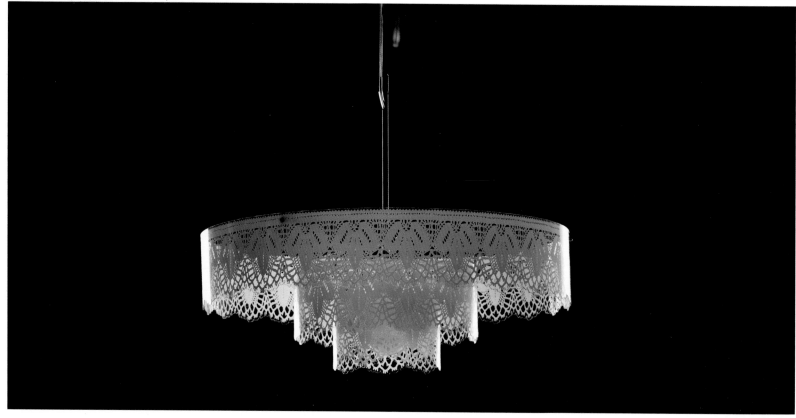

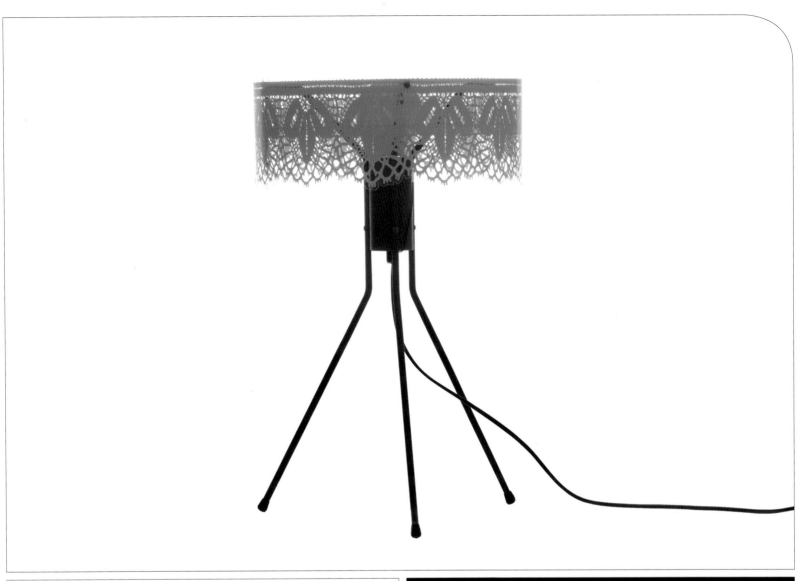

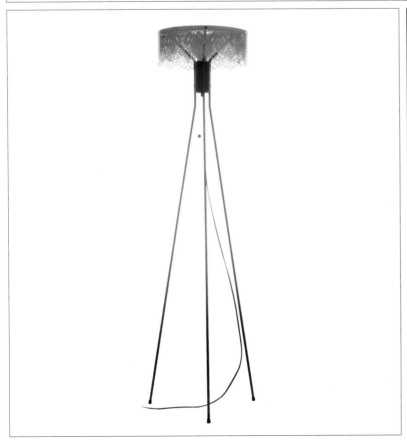

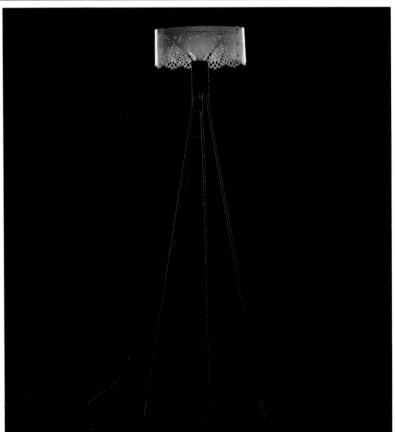

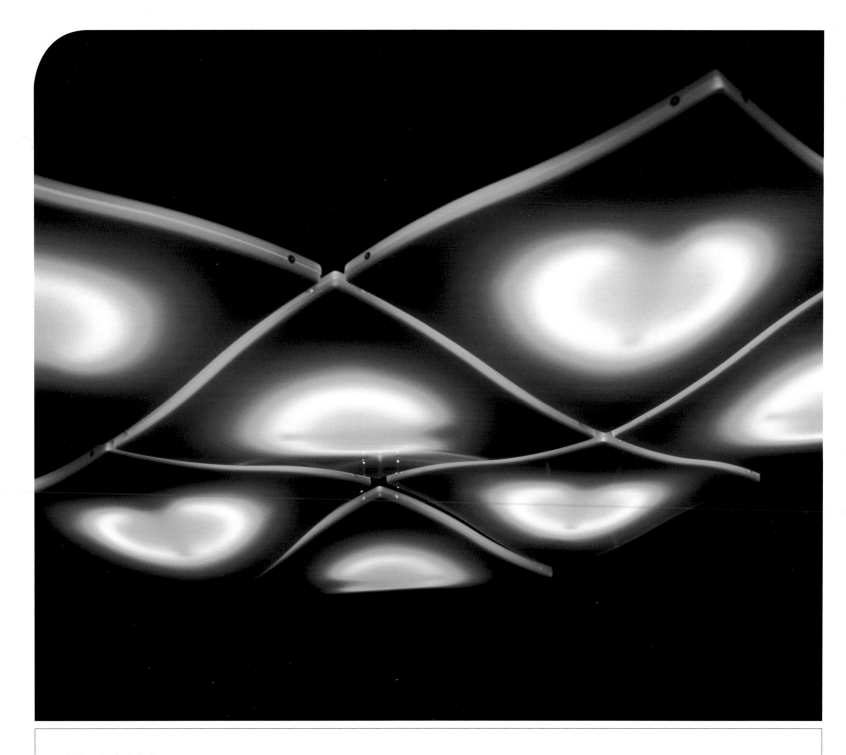

Light Wave | Studio Aisslinger for Bombay Saphire | 2006 | www.aisslinger.de

Light Wave is a spectacular lighting system composed of various independent units, each measuring 1.64 by 1.64 feet, that may be combined in dozens of different ways, much like the way a computer screen uses pixels to form a large image. The units have been designed and manufactured in such a way that the convex and concave spaces within their wavy shape allow additions to be made to the system without jarring breaks in the design, conserving instead i's continuity no matter how many units are used. The visual effect is that of a wave "floating" above the spectator, provoking subtle plays of light that give the piece the sensation of movement.

Light Wave is manufactured with a vacuum-sealed acrylic plastic and uses other plastics and metals in a purely "accessorial" capacity. The quality of light projected is perfect for illuminating a "meeting" place or a restful, contemplative area that is visually separated from adjacent areas (these ideas reflect Light Wave's ability to create smaller boundaries within larger spaces). In this way, the borders are created by light and not a screen, partition, or rug. This eliminates the need for floor or visual obstacles and helps "clean up" certain areas of clutter.

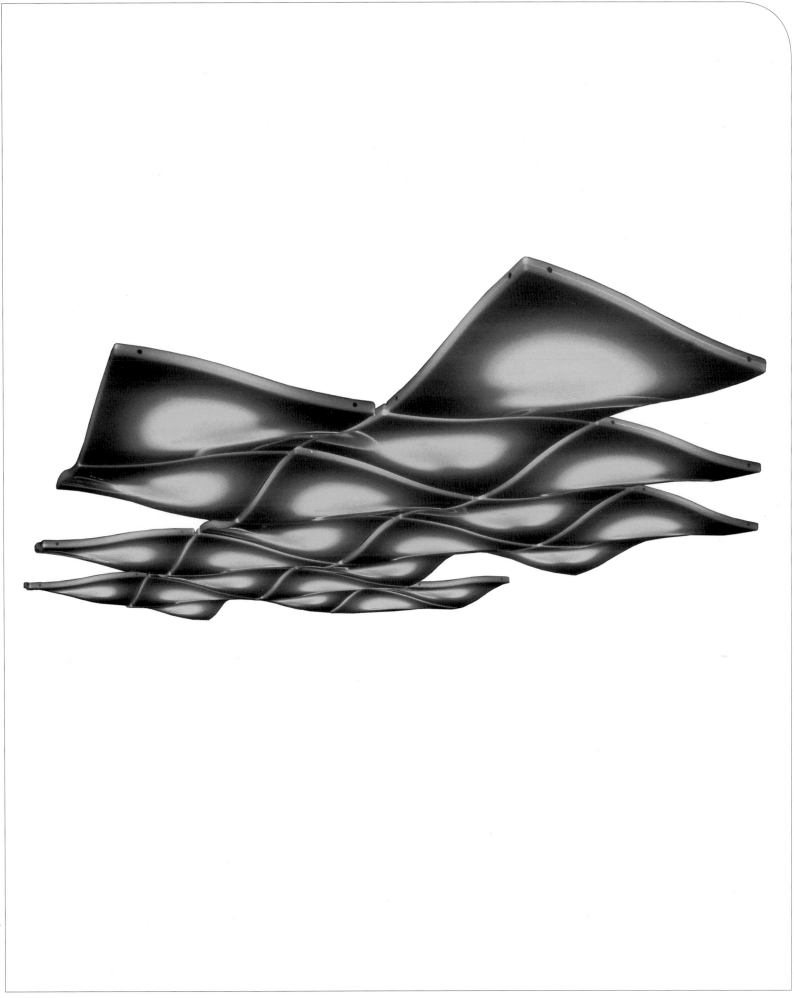

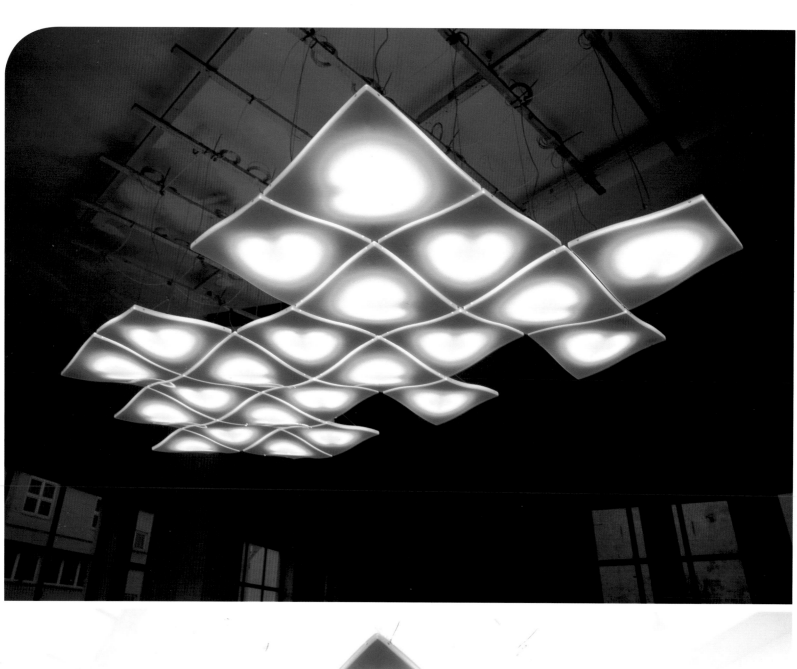

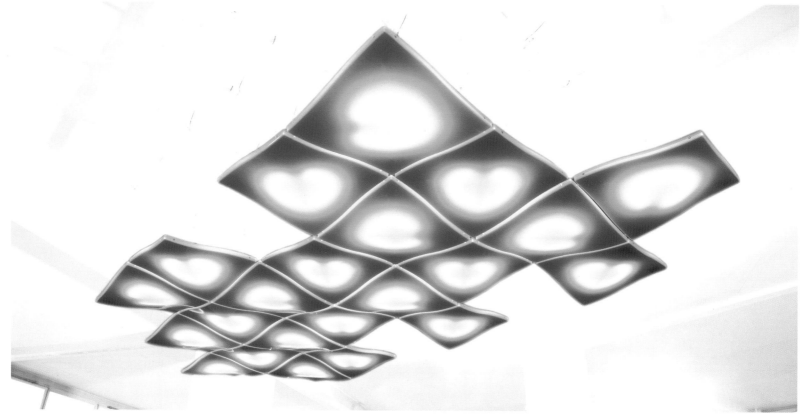

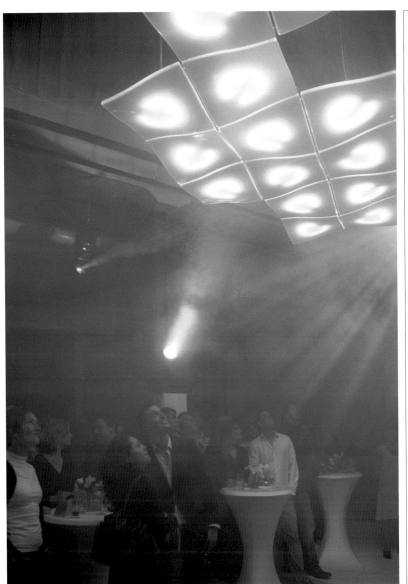

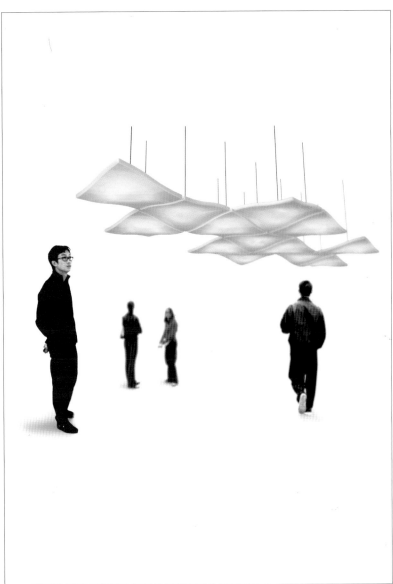

The Light Wave may hang from a living room ceiling by way of metallic cables, which permits it to be hung at any desired height (closer or farther away from the floor). Each unit has its own connecting cable; this prevents the final installation from leaning the wrong way once all the different pieces have been combined.

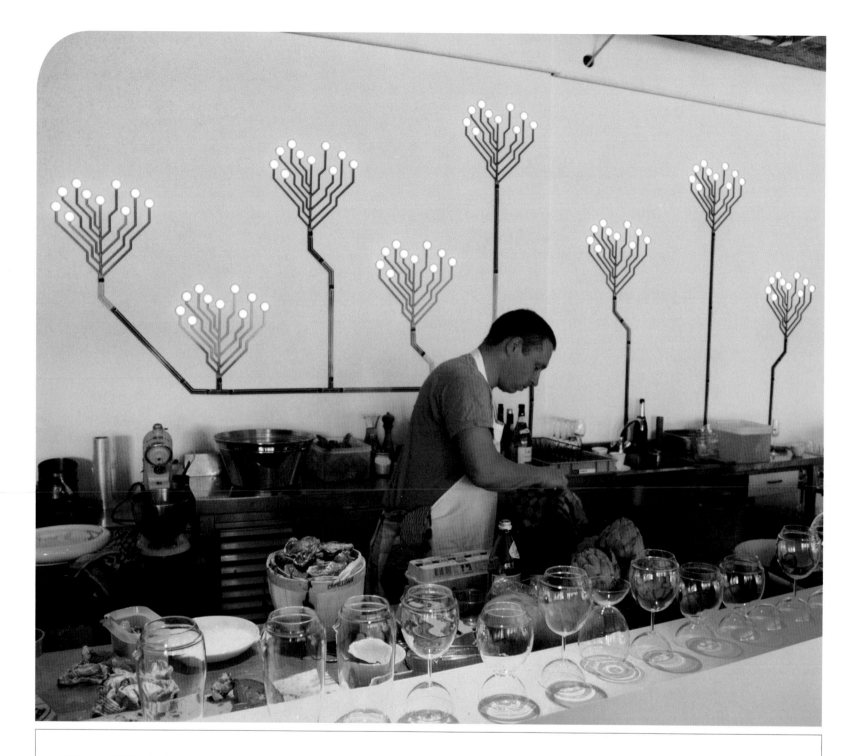

Flexilight | Jos Kranen for Metatronics | 2004 | www.joskranen.nl

How would one go about hiding the unsightly electrical cord of a ceiling lamp in living quarters where one could not install a drop ceiling? What sense would it make to buy a beautiful lamp only to have the electric cord hang unattractively from the ceiling or collect dust as it snakes across the floor? Why is it that practically every element of our living space except those related to electrical installation can be modified? Designer Jos Kranen, who became frustrated with electrical installation plans completed in his name by an architect with whom he wasn't acquainted, asked himself these very questions. The answer was the Flexilight, a light installation similar in appearance and idea to the subway maps of New York and London, that runs along the wall with almost no need for an electrical cable, adapting to the shape the customer wants and culminating in dozens of LED lights. The Flexilight, made with epoxy and fiberglass doesn't have a predetermined shape. The customer chooses the pieces and combines them to conform to the shape and the lighting he or she desires. The homeowners themselves create the design. Free to indulge their tastes, they may elaborate on their most whimsical design ideas, chosing a straight-line motif or losing themselves in the most baroque of arrangements. The use of LED lights guarantees the Flexilight a long-lasting life and low-energy consumption.

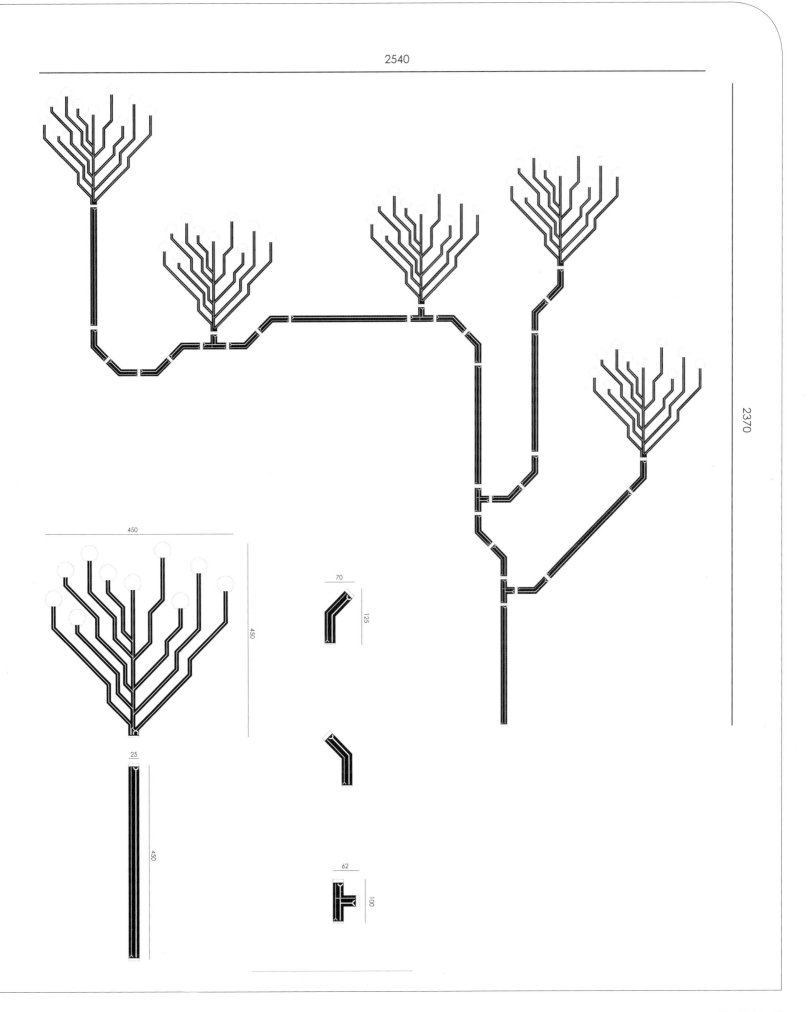

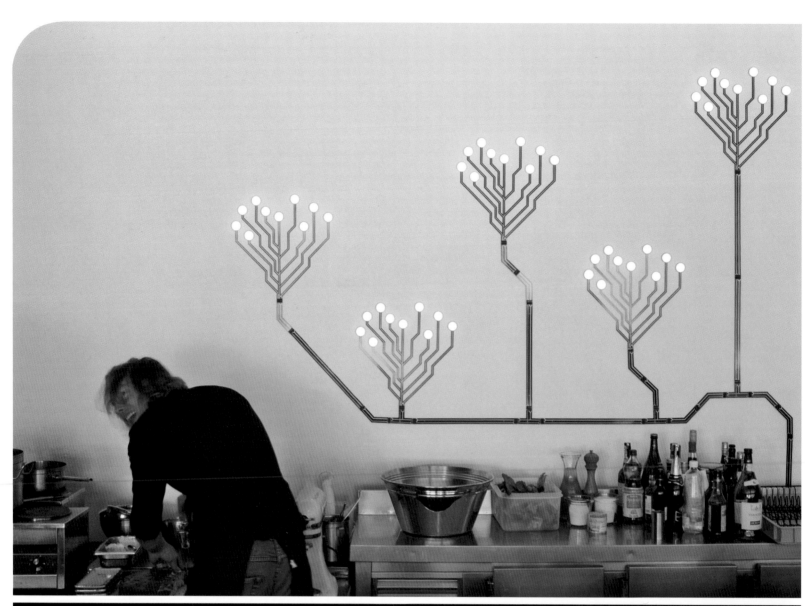

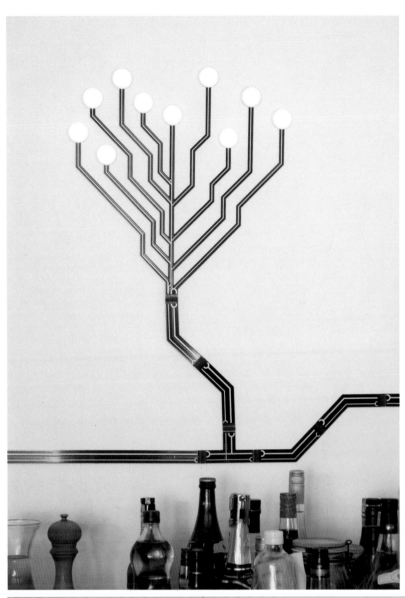

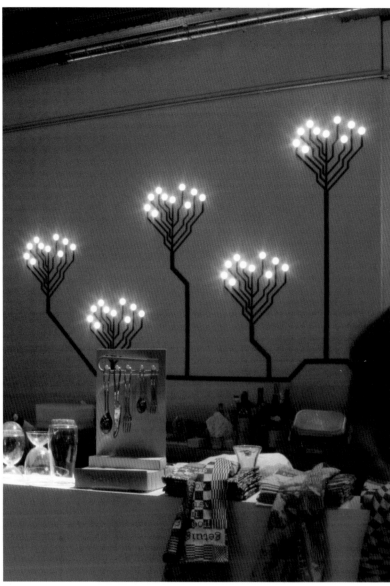

Flexilight is not only a conventional lamp but an authentically decorative object, almost a piece of art on the level of a painting or a large-format photograph that is destined to become a focal point in the home, office, or club, thanks to its trendy design. In this manner, Flexilight has achieved the perfect balance between the aesthetic and the functional.

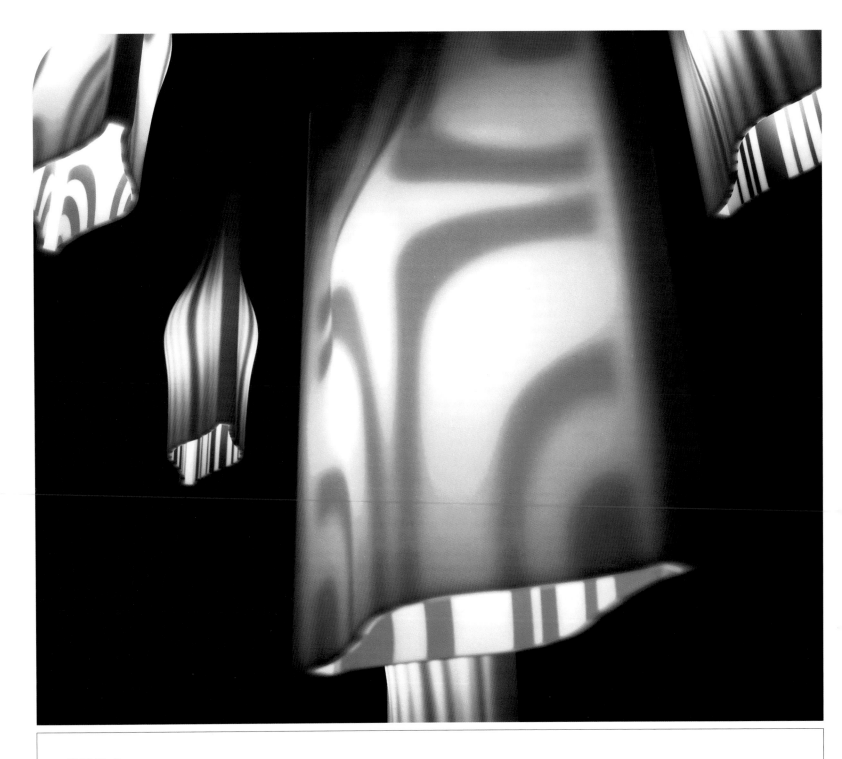

OPS Lamp | Studio I.T.O. Design for DuPont | 2006 | www.studioito.com

Studio I.T.O. Design's OPS ceiling lamps are manufactured with Corian, a plastic material that, in this case, has been made translucent enough to let light through but prevents one from seeing through it. The almost subliminal decorative motifs are similar to those of the OPS sofa (in fact, various unit pieces form part of the same family) and are carved into the lamp's interior, not the exterior, which is more typical. The subtle transparency of this decorative motif visually reinforces the Corian's carved curvatures, giving movement and volume to the piece, and endowing it with a completely different personality than it would have if constructed of some other material (like glass). An installation of various OPS lamps in the same space is almost ghostly, considering that their sinuous irregularity provokes the aforementioned visual illusion of movement. This effect is enhanced by the fact that the Corian retains part of the light from the bulb itself, enabling it to illuminate with a potency substantially different from that of a conventional lampshade. In this sense, the OPS lamp is better suited to endow a warm, modern ambience to a space or a corner of a home. In other words, it's more a decorative light element than it is a general light source.

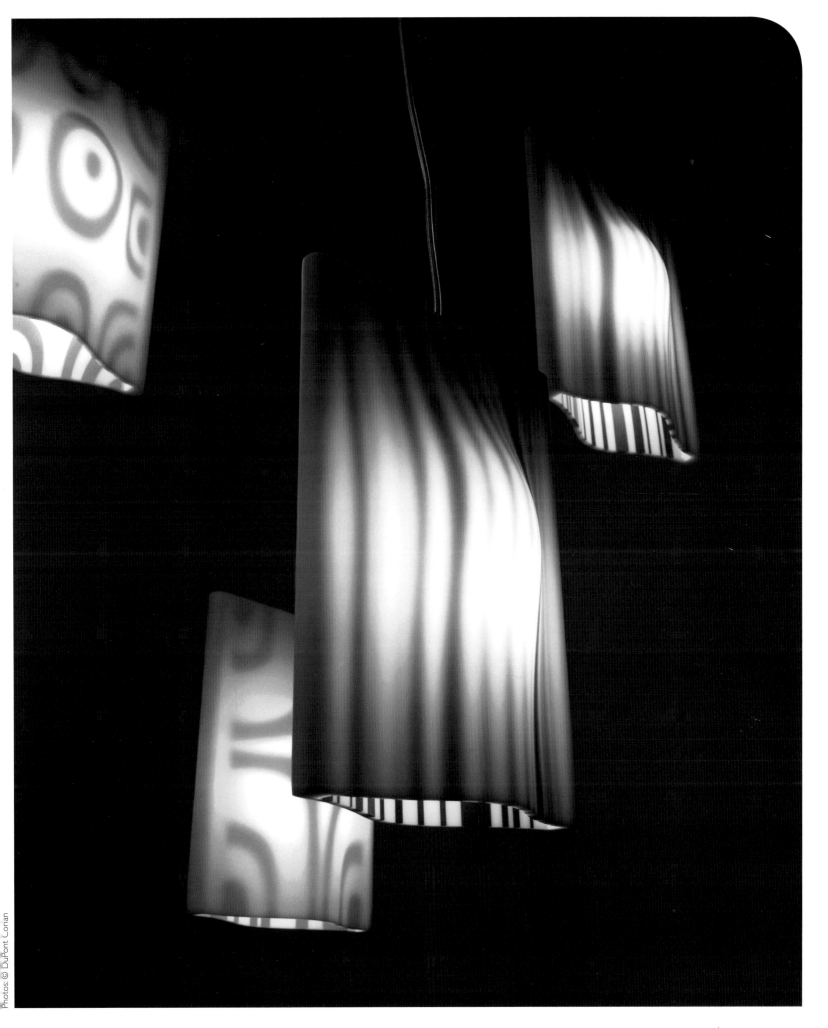

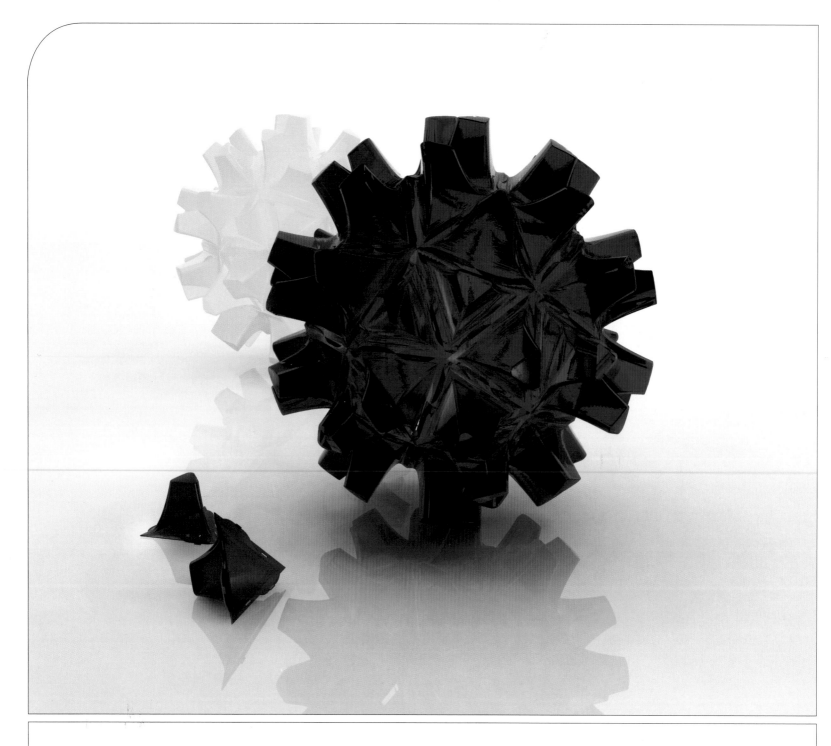

Snap | Tom Dixon | 2005 | www.tomdixon.net

On a daily basis, the world produces thousands of products that no one will ever buy, a veritable army of manufactured garbage destined, in a best-case scenario, to languish, covered in dust, on the shelves of a discount store. A complete waste, not only from the viewpoint of environmental sustainability but also from that of simple industrial logic. Snap, a lamp manufactured unit for unit according to the customer's specifications, demonstrates the path to a more rational consumer logic. For its manufacture, the 35-ton Arburg Allrounder 270U350-100, a molding machine that isn't exactly within the reach of every industrial designer, is needed. The objective? To integrate the client into the manufacturing process, which entails connecting 60 identical pieces of plastic to form the finished product. Available in three colors, Snap is the result of a collaboration between designer Tom Dixon and Gabriel Chemie, a company that specializes in the coloring of thermoplastics and the next wave in the furniture and interior-design marketplace. If companies like Ikea have brought the customer to the warehouse, the next step consists of bringing the customer directly to the factory, where a completely personalized lamp will be manufactured for him or her. This system not only saves on transportation costs, storage, and personnel, it also contributes to a sustainable work flow while limiting production to only those pieces that are guaranteed to be sold.

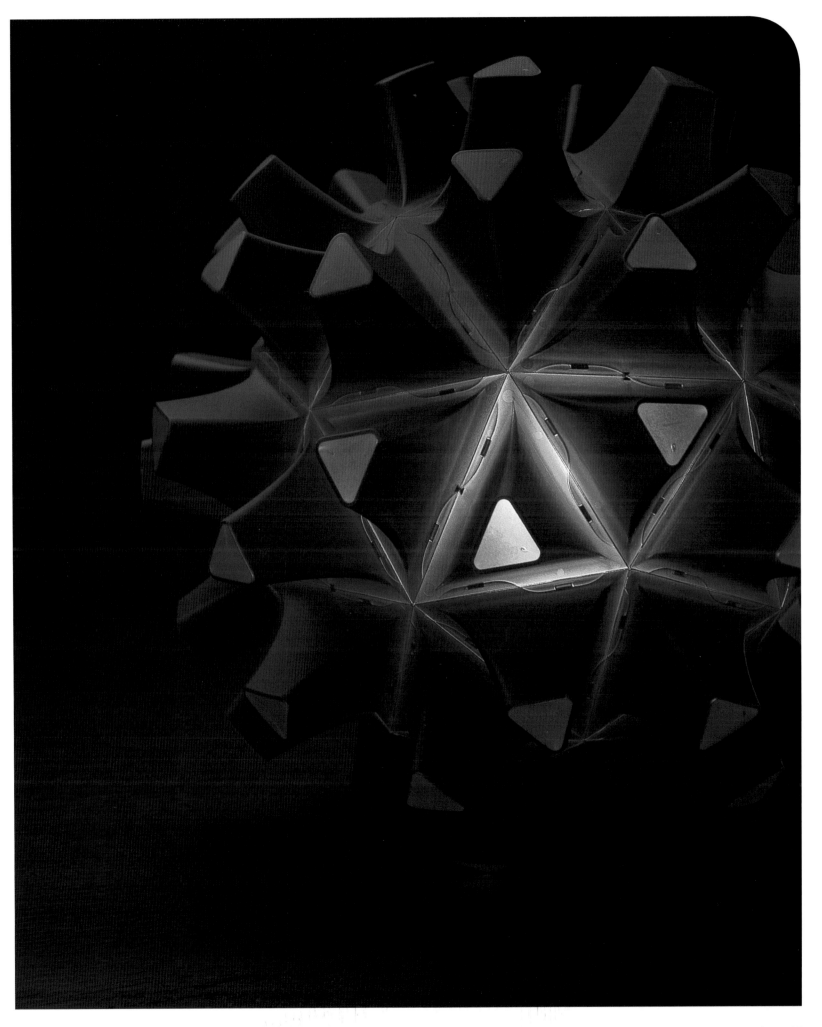

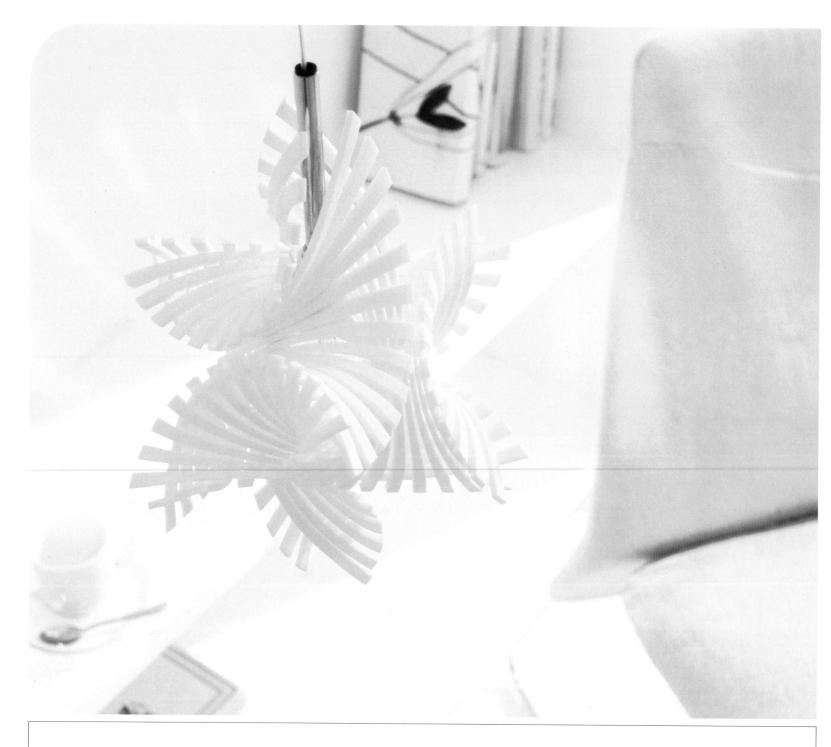

Flame | Bathsheba Grossman for MGX by Materialise | 2005 | www.bathsheba.com

Although it may not be evident to the eye, the origins of the Flame lamp can be found in a fistful of clay. That clay was first formed into the shape of a cube. Then, the top four corners of the clay were twisted clockwise and the bottom four corners were twisted in the opposite direction. The resulting piece became the point of departure for the Flame prototype. The density we instinctively associate with a block of clay has been done away with, to better construct a light and translucent design.

The Flame is manufactured in polyamide (nylon) and its mounting cup, in stainless steel with a chrome finish. The lampshade measures 8 inches tall and weighs just over 7 ounces. However, two other characteristics make the Flame a truly unique piece: The first one is that it is made through the use of rapid prototyping (RP) technology, which allows an unlimited amount of freedom when it comes to designing the piece. The second is that the title MGX takes its name from the software included with every lamp sold, and this MGX file is totally unique. If the owner of the piece and, in turn, the file, wants a new copy of the product, all he or she has to do is send the file to Materialise.MGX.

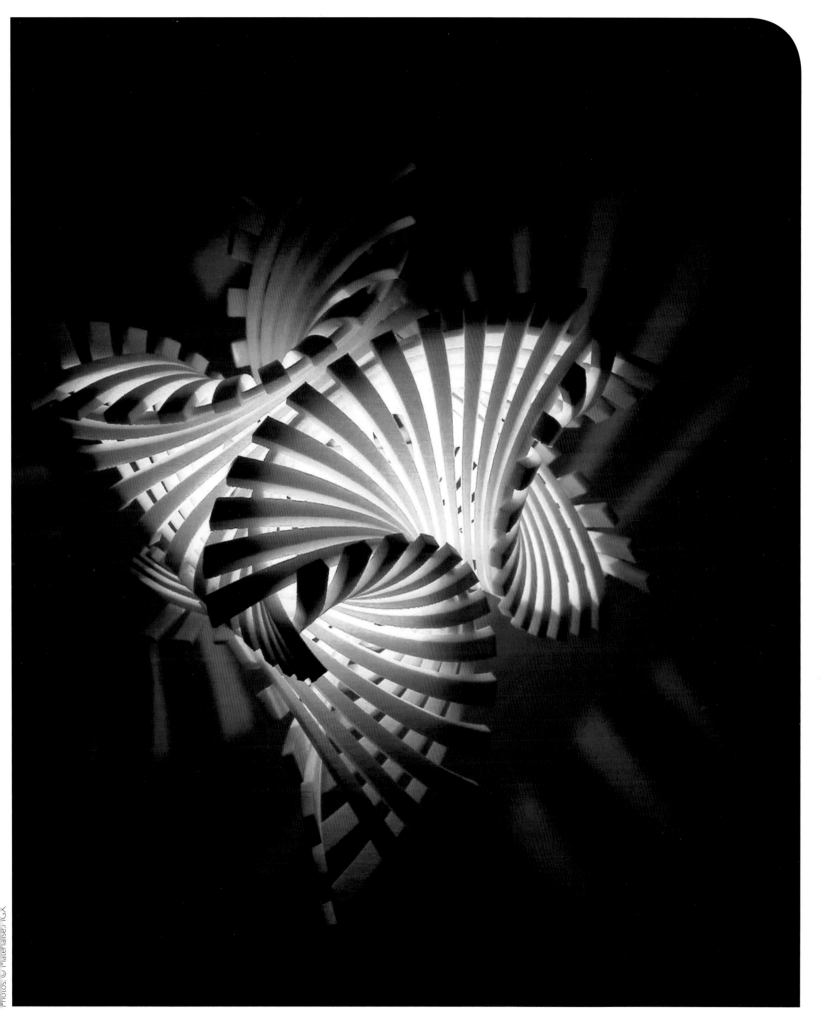

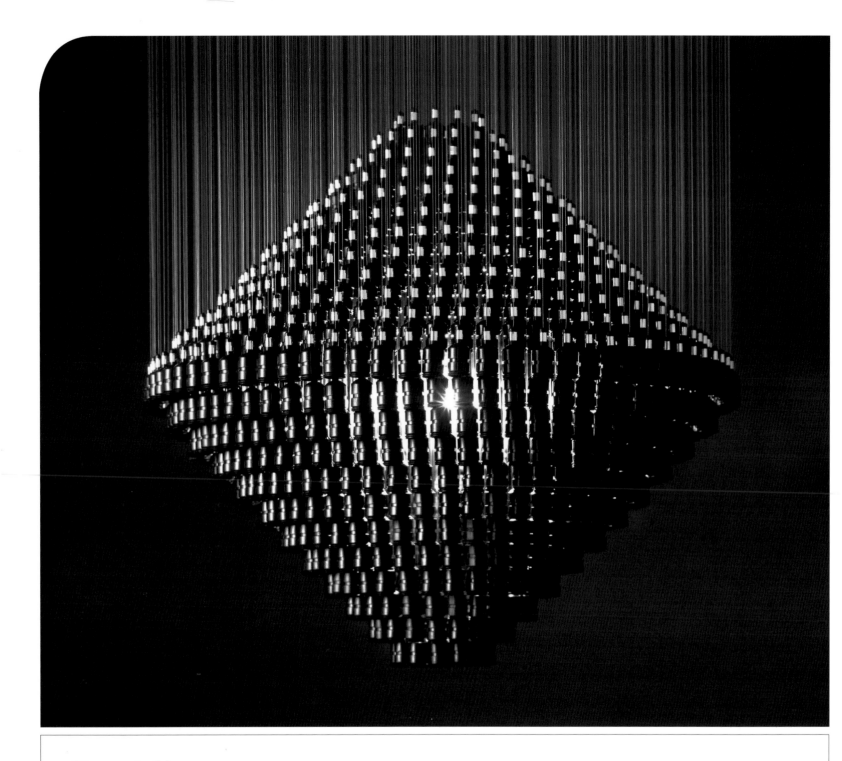

Chandeliers | Stuart Haygarth | 2004, 2005, 2005, 2006 | www.stuarthaygarth.com

The work of artist and designer Stuart Haygarth revolves around ordinary found objects that he collects in great quantity and uses in a variety of designs. Some examples are the four chandeliers shown in these pages. Millennium is made with 1,000 party poppers collected after the new-millennium celebrations of January 1, 2000. The lamp moves and balances itself with the smallest breeze as if it were some kind of organic form. There is a special edition of the lamp consisting solely of black party poppers. The Tide lamp (opposite page) is composed of dozens of objects washed up on the Kent shore-line with the tide. Material found in this way is classified according to type, though some pieces were made specifically for the lamp. The objects themselves are of different shapes and colors, but once put together they form a sphere that represents the moon itself. The process is as follows: The moon affects the tides, which results in objects' being washed ashore, where Stuart Haygarth collects them and uses them to make his lamp in the shape of the moon. The objects hang on monofilament line held by "split shot" from a 16.4-square-foot MDF platform above. The light source is a 100-watt incandescent bulb.

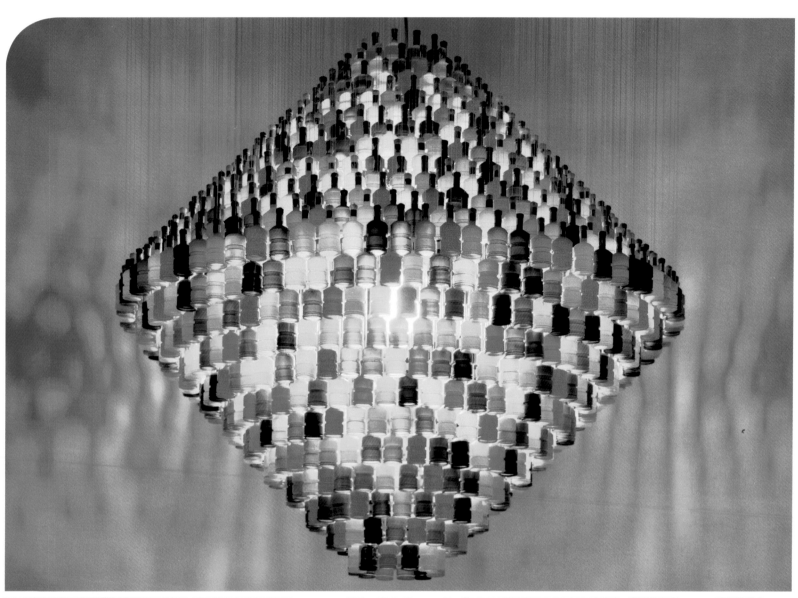

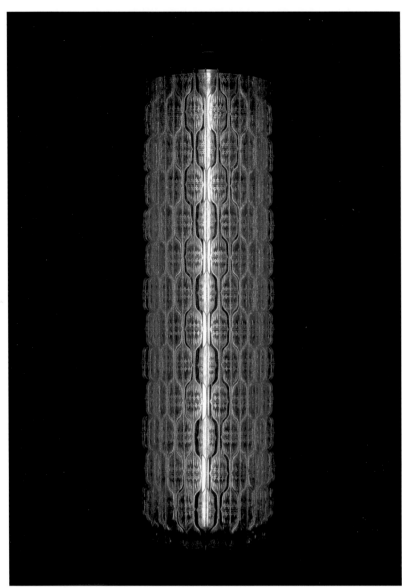

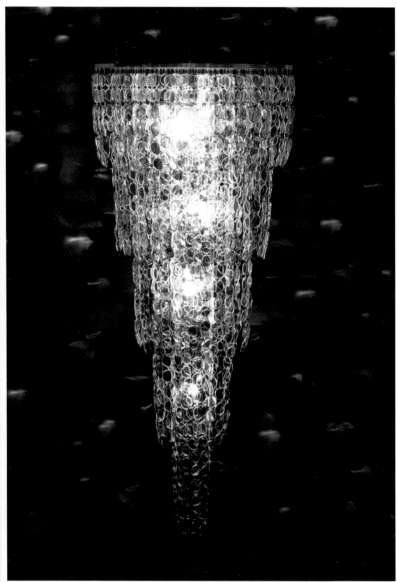

Disposable comprises 416 plastic wineglasses and one fluorescent pink light source. It measures 6 feet high by 1.64 feet in diameter. Spectacle, on the other hand, is composed of 1,020 pairs of eyeglasses linked together in such a way as to recall the traditional tear-drop lamp.

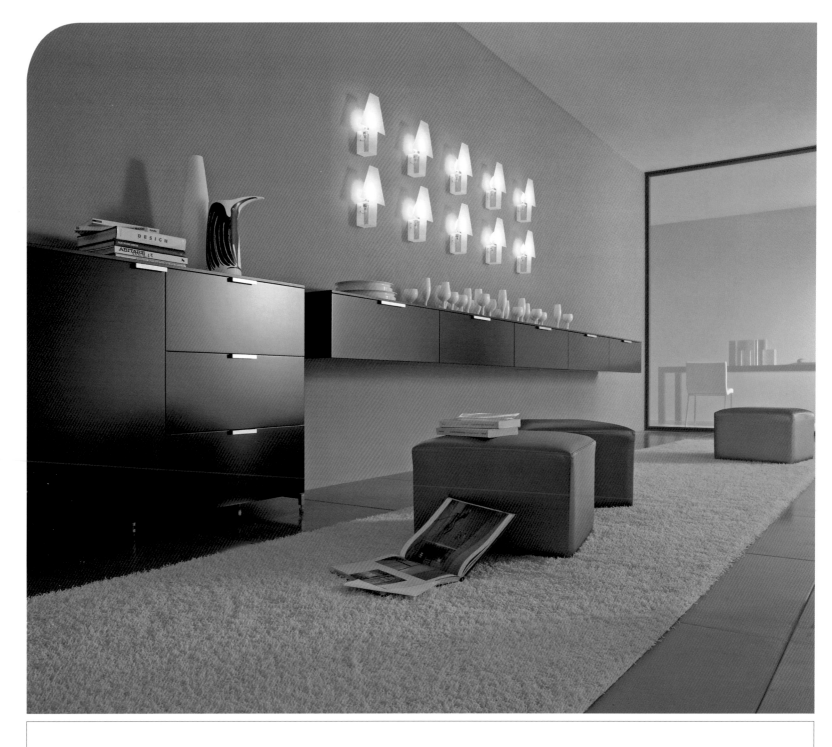

Alum | Ligne Roset by Arno | 2005 | www.ligne-roset.com

Table lamp or wall lamp? The correct answer to the question is … both, because Alum is exactly that: a table lamp that can be converted into a wall lamp simply by removing its base. Alum is made with Plexiglas and is available in gray or white. The base is manufactured in matte chromed steel. The lamp's power switch has a dimmer integrated into it. From a design point of view, the Alum's chief characteristic is its similarity to those antique candle holders that contained one candle protected from the breeze by a thin metal or other inflammable plate. In the Alum's case, that thin plate is a sheet of translucent Plexiglas which has been cut to resemble a table lamp and hints at the form of a candle, which is actually nothing more than a bulb in reality behind it. The total effect seems to be a mirror game in which nothing (or everything) is as it appears: the lamp with a fake lamp shape hiding a candle that is actually a bulb in the shape of a candle. A masterful design for such a simple item as the wall light.

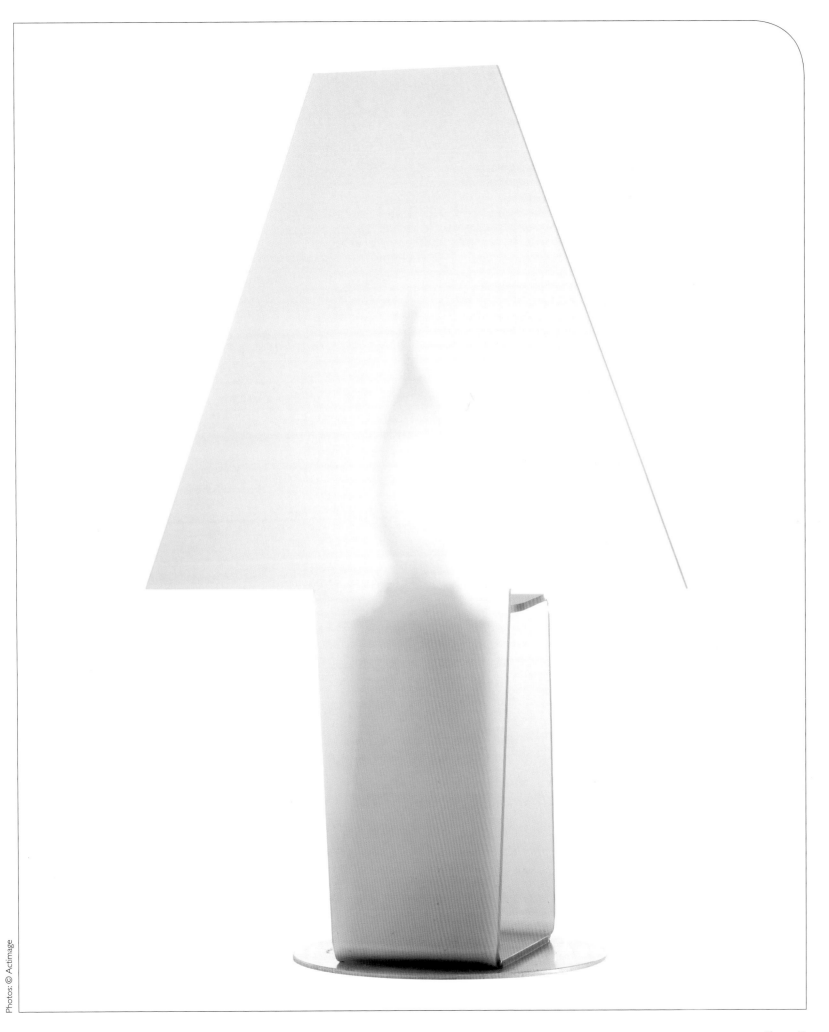

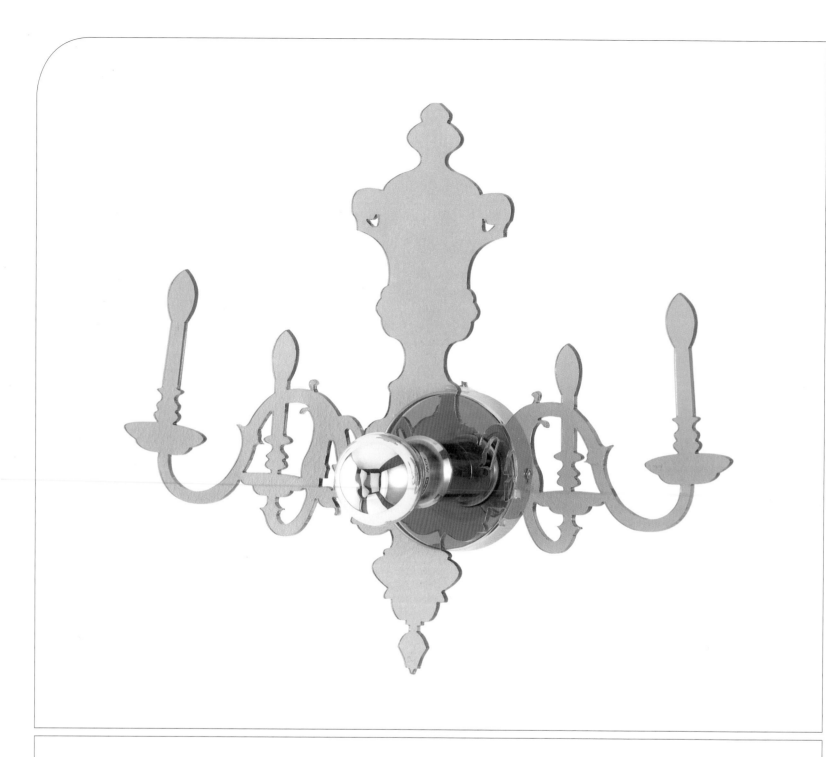

Louis 5D | Ligne Roset by Blandine Dubos | 2004 | www.ligne-roset.com

The Louis 5D is without a doubt one of the most commercially successful wall lights on the market today. Made in either transparent red Plexiglas, orange flux, or a smoked hue, the Louis 5D is shaped to imitate the chandeliers of the seventeenth century. The lamp is hung slightly away from the wall so that the metallic-tipped lightbulb may project an enlarged shadow of the lamp's own silhouette onto the wall behind it, creating a particular lighting effect that is very possibly the key to the lamp's great popularity. The Louis 5D measures 2 feet wide by 1.6 feet tall. Nevertheless, the Louis 5D's size is best measured by the size of the shadow it casts upon the wall: 3.2 feet wide by 2.8 tall, of which, in this last case, 1.9 feet are visible above the lamp's axis and almost one foot beneath it. The measurements are always taken from the lamp's central axis. A mini-version of the Louis 5D has been made with installation on both sides of a bed in mind and measures 1 feet wide by nearly one foot tall. The Louis 5D lamp received a special VIA mention for its innovation and creativity in the 2004 Furniture Show at Paris.

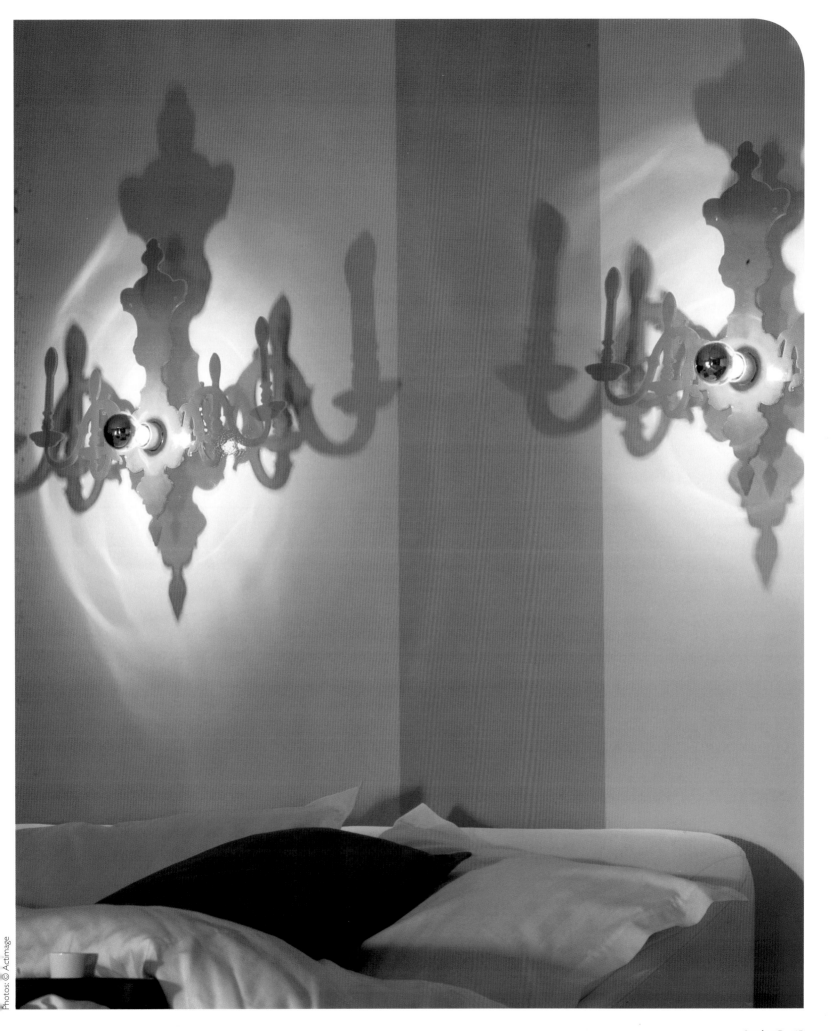

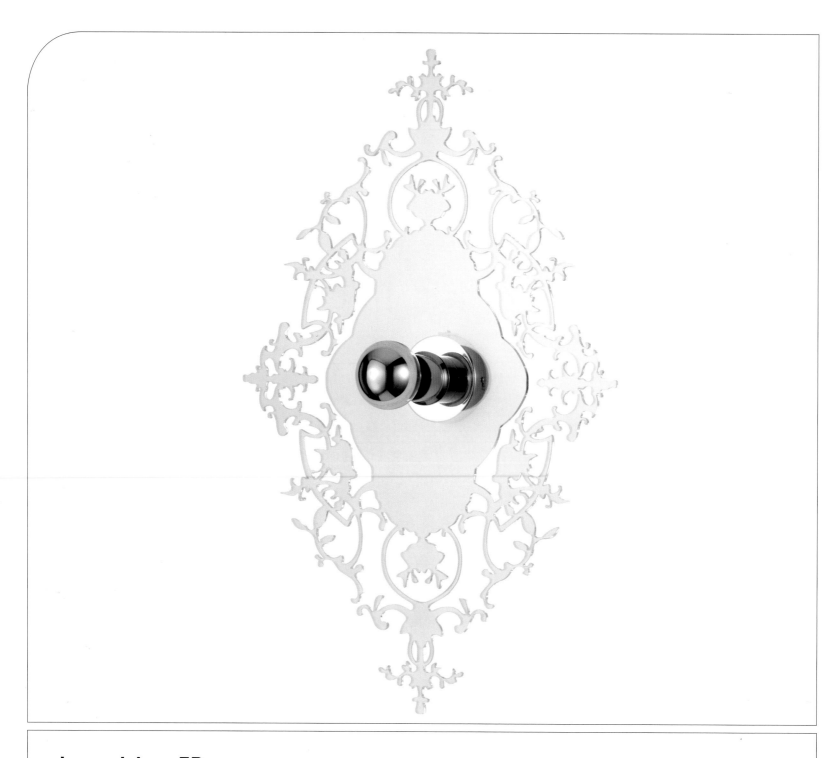

Josephine 5D | Ligne Roset by Blandine Dubos & Richard Fard | 2006 | www.ligne-roset.com

If it ain't broke, don't fix it. No sooner said than done, the Josephine 5D lamp is the offspring of the enormously popular Louis 5D. The new lamp, which is slightly more baroque than its predecessor, functions as a wall light as well as a ceiling light. In fact, it's been designed to adapt perfectly to both of these uses. In addition, its unique design allows it to be hung either horizontally or vertically. In each case, the lamp is connected to the electrical current by a connection box, though another option is to plug the Josephine 5D directly into a wall outlet. Josephine is made with clear Plexiglas (acrylic glass). The power cord is transparent, allowing it to go completely unnoticed. The bulb that is included with the Josephine 5D has a unique characteristic that lends the lamp its special aesthetic: The crown has been painted with a metallic tint. The light escapes only from the sides, illuminating the Josephine 5D itself and preventing any light from escaping from the top or the bottom (depending on how the lamp has been installed).

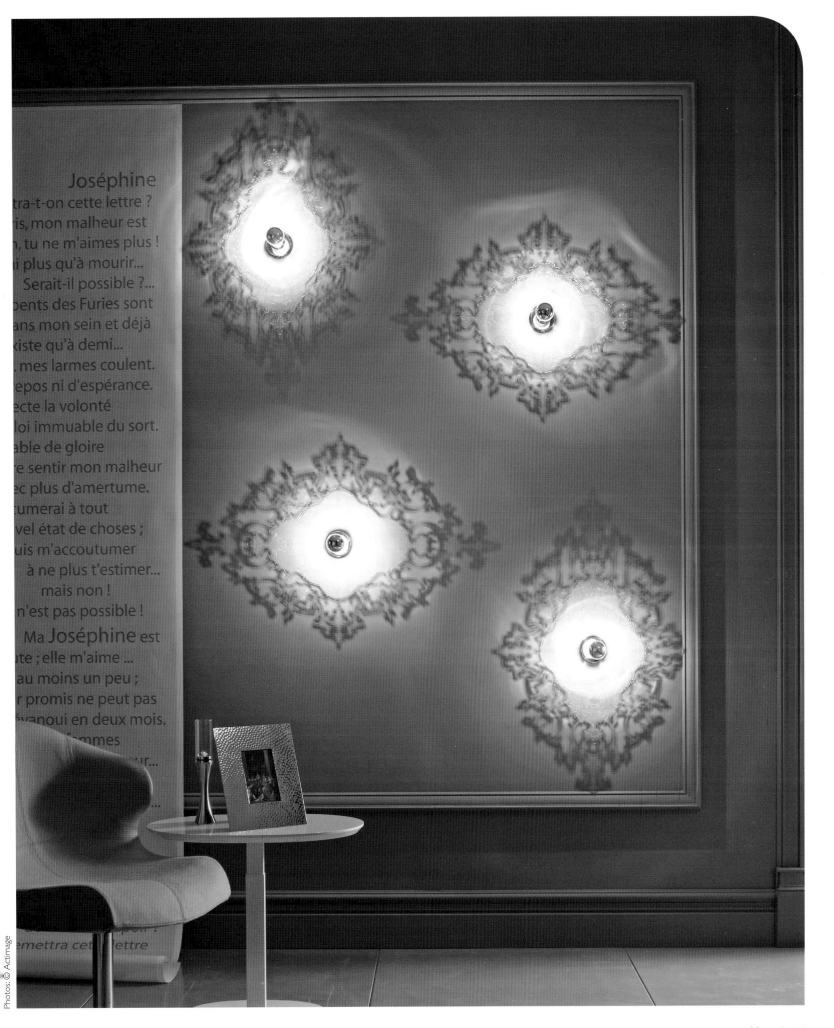

Joséphine

...tra-t-on cette lettre ?
...ris, mon malheur est
...n, tu ne m'aimes plus !
...ai plus qu'à mourir...
... Serait-il possible ?...
...ents des Furies sont
...ans mon sein et déjà
...xiste qu'à demi...
... mes larmes coulent.
...epos ni d'espérance.
...ecte la volonté
...loi immuable du sort.
...able de gloire
...re sentir mon malheur
...ec plus d'amertume.
...umerai à tout
...vel état de choses ;
...uis m'accoutumer
... à ne plus t'estimer...
... mais non !
...n'est pas possible !
... Ma Joséphine est
...te ; elle m'aime ...
...au moins un peu ;
...r promis ne peut pas
...évanoui en deux mois.
... mmes
... ur...

...emettra cette lettre

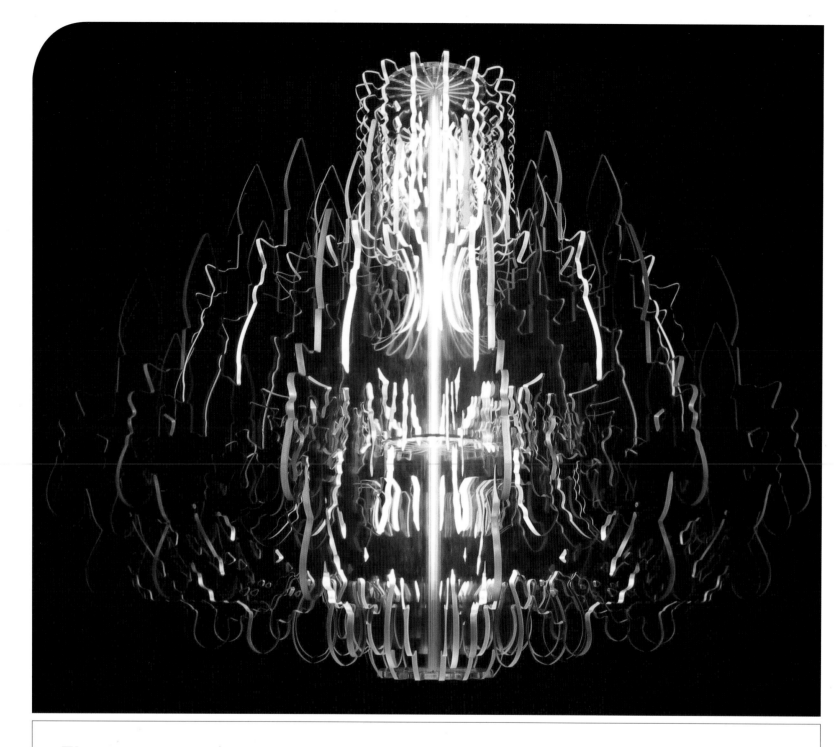

Therese | Buro Vormkrijgers for Cultivate | 2006 | www.burovormkrijgers.nl

Right now, irreverence itself is experiencing its most popular moment in the world of industrial design. However, this irreverence is different from that found in the realm of pop music, film, or theater. In the world of industrial design, this irreverence consists of reinterpreting classic pieces and furniture in such a way as to become openly heterodoxical. Such is the case with Therese, a lamp made from 16 transparent sheets of PMMA, all illuminated by a special fluorescent bulb. Belonging, along with the Josephine and Marie-Louise models, to the Overdose series, Therese gives a turn of the screw to the orthodox concept of the "chandelier," enough so to have

practically become a collector's item. The lamp emits a diffusely hued light of an almost surreal quality. The 16 PMMA sheets are virtually invisible when the Therese light is turned off, each seeming to blend with the next, and making it hard to discern the lamp's actual shape in the dark. Therese is easy to assemble and clean, thanks to a simple connecting system that allows the 16 sheets of plastic to hold together. There is an extra-large Therese model, although the conventional version weighs 33 pounds and measures 31 by 37 inches.

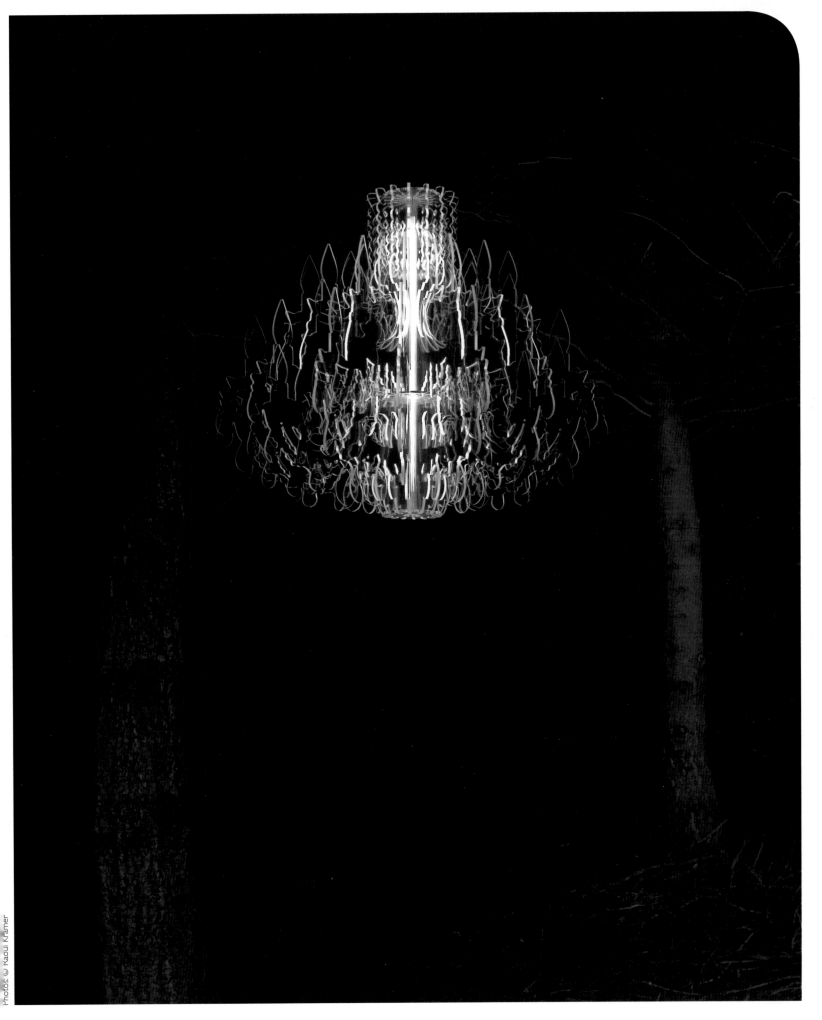

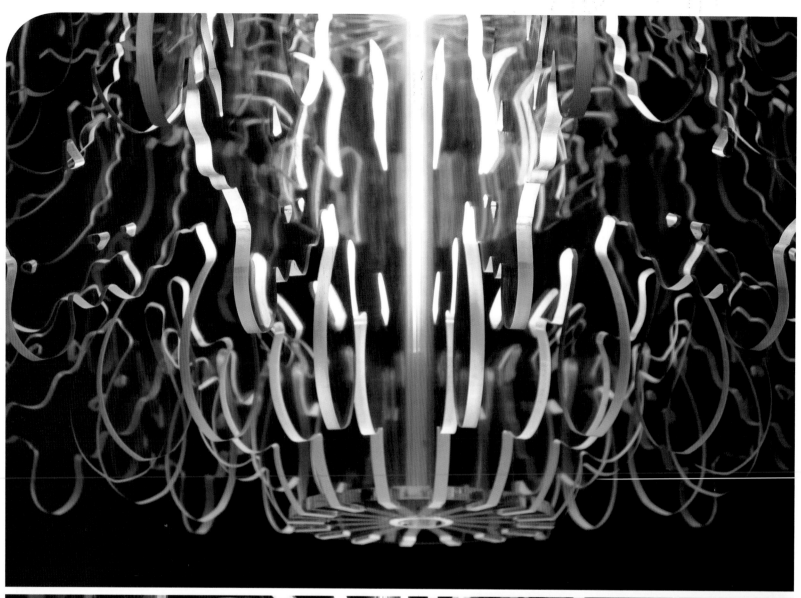
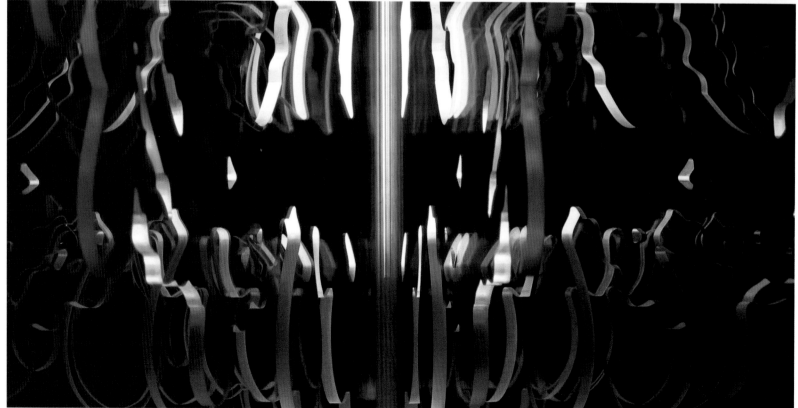

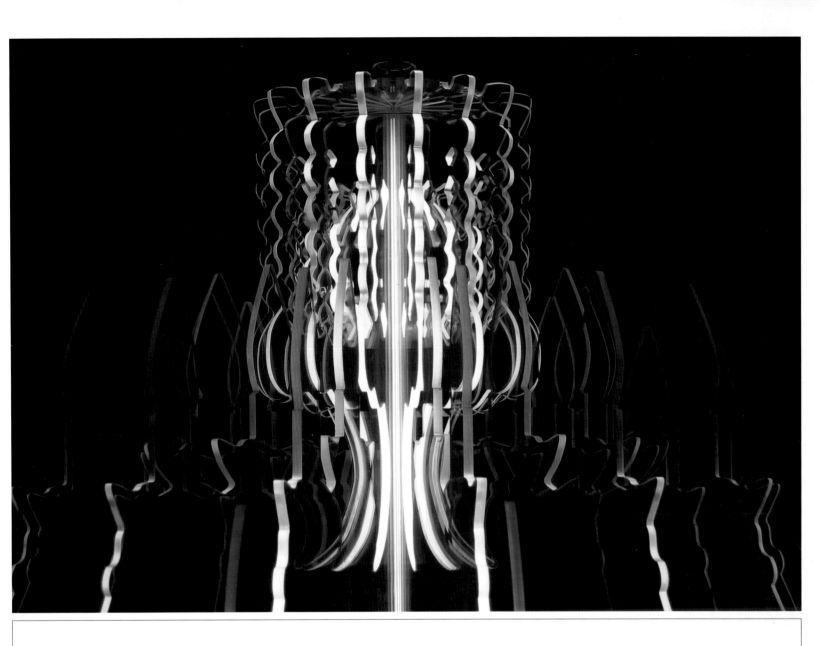

Each one of the 16 plastic sheets that make up the Therese lamp imitate the silhouette of a conventional chandelier, including the candles and the traditional crystal teardrops (in this case, they're PMMA). The result is a lamp that becomes another decorative element in the home, not just a functional one.

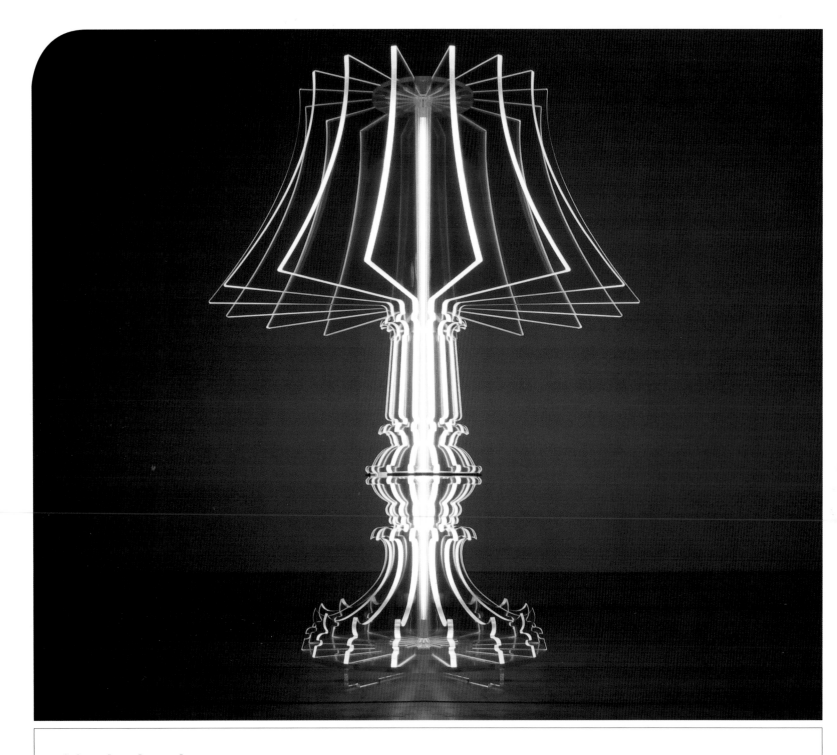

Marie-Louise | Buro Vormkrijgers for Cultivate | 2006 | www.burovormkrijgers.nl

As part of the Overdose series, the Marie-Louise attempts the revitalization and updating of the traditional ambient light. Made by linking together sheets of PMMA with a fluorescent 14-watt, polycarbonate tube, the Marie-Louise weighs 11 pounds and measures 23 inches tall by 15 inches wide. Each one of the PMMA sheets that compose the Marie-Louise have been shaped to imitate the silhouette of the traditional ambient, or table, light, including its lamp shade. Together, these sheets make a spectacular ambient lamp capable of casting an ethereal glow. But the Marie-Louise's main attraction is not its groundbreaking design, as one might think at first glance, but its unique lighting system. For example, the light emitted by the Marie-Louise is clearly not enough to read a book, but it is sufficiently powerful to illuminate the borders of the PMMA's silhouette. The light emitted by the fluorescent tube inside the Marie-Louise gives the lamp a "corporeal" quality, lending it greater presence—a presence that, since we're obviously dealing here with transparent plastic sheets, goes completely unnoticed when the lamp is turned off. The fluorescent light can be customized as well, thanks to eight different colored filters.

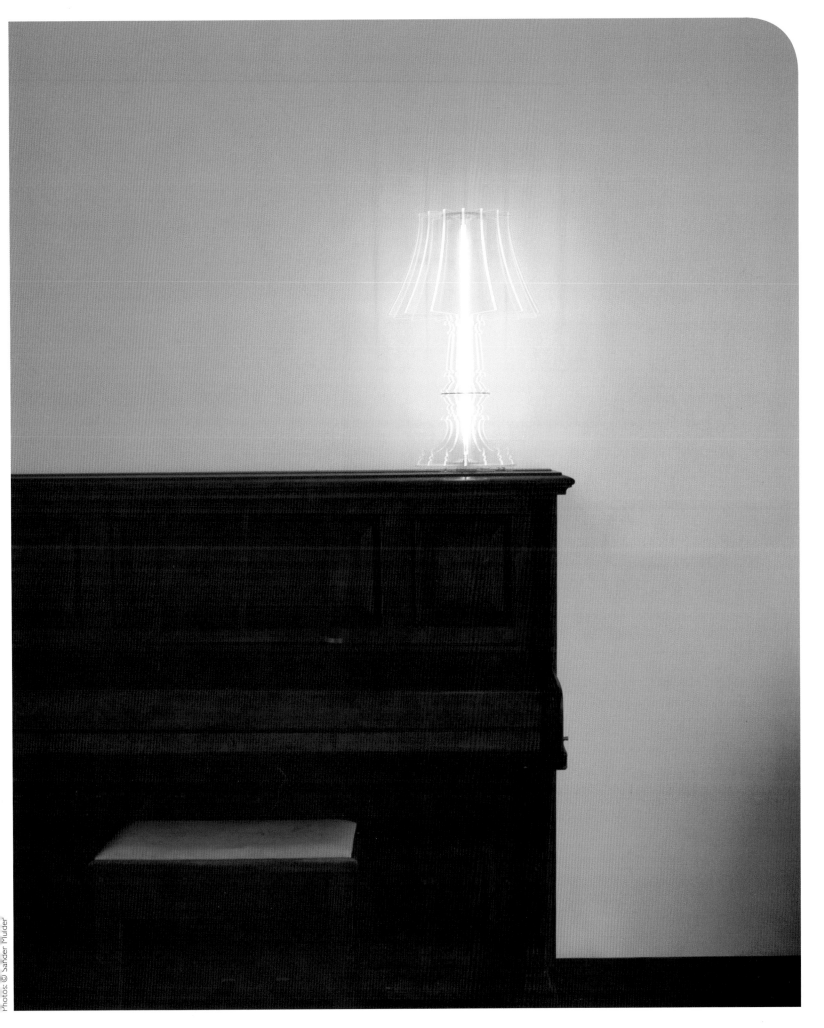

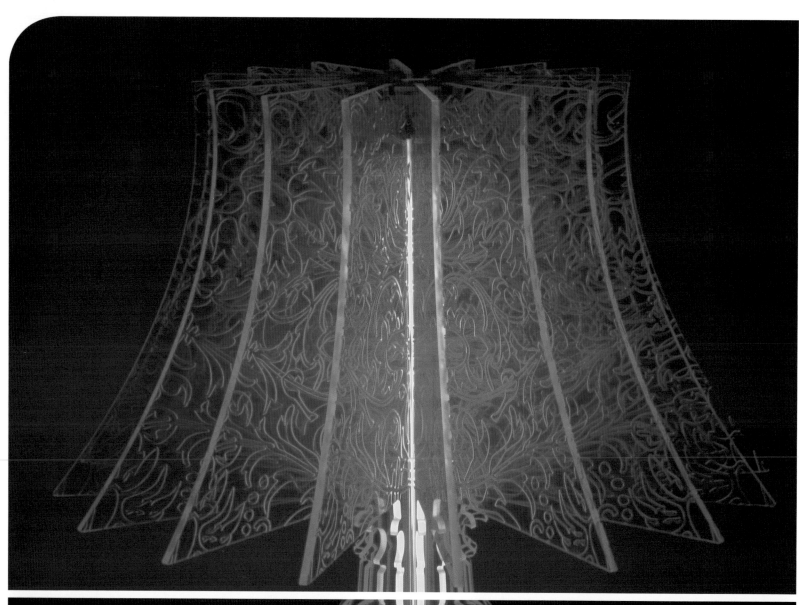
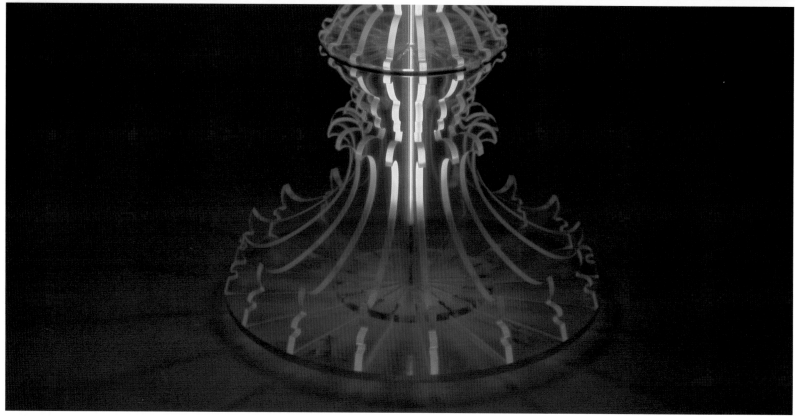

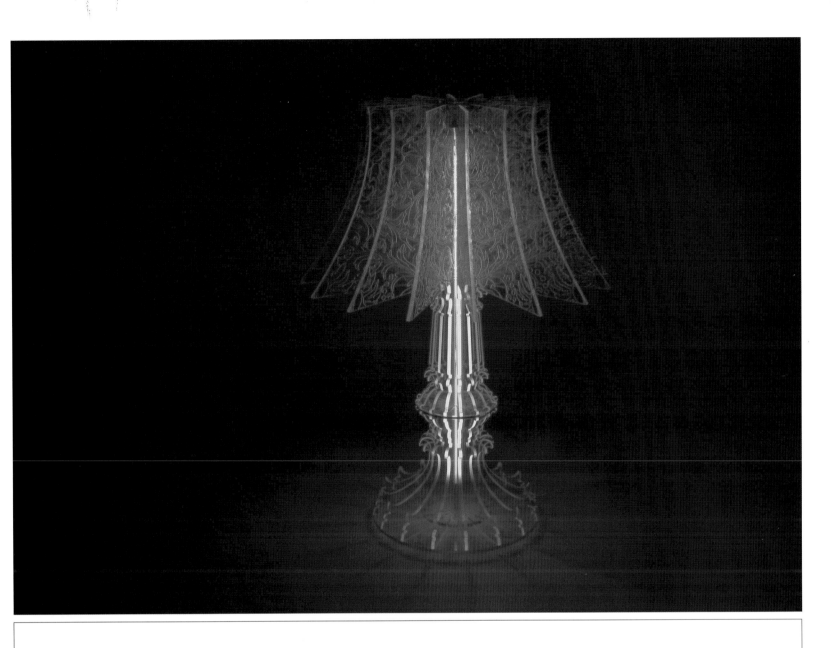

The Marie-Louise is available in two different models. The first is composed of the afore-mentioned PMMA sheets, with no ornamentation. In the second model, the sheets have been engraved with arabesque designs on the hood, the part that imitates the silhouette of the lamp shade of a traditional table lamp.

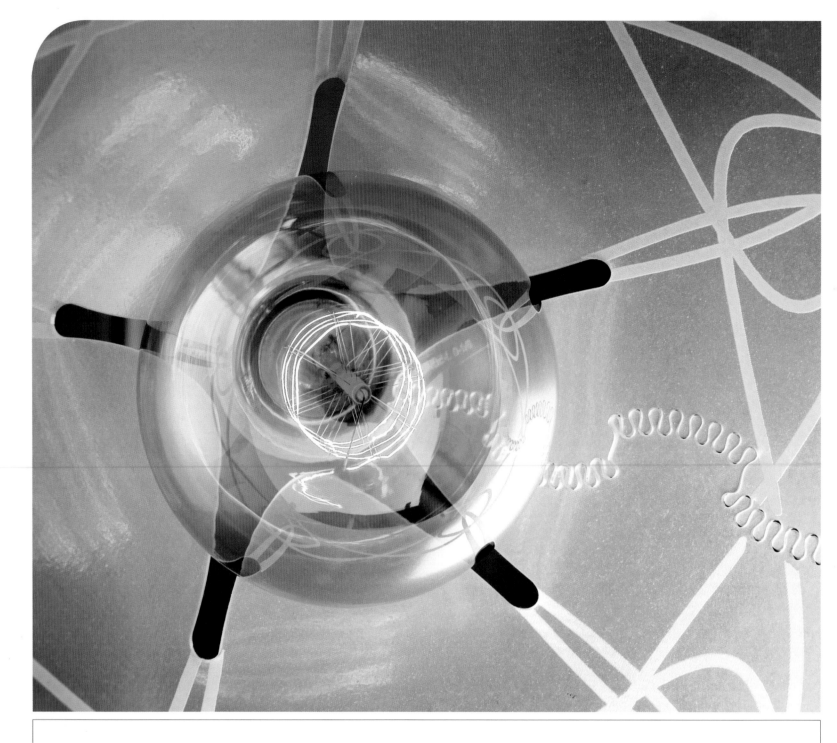

Unue-L | Studio Bizq | 2006 | www.bizq.nl

Unue-L is the second product developed by Studio Bizq for Newdeqo, and it was designed to be produced on a small scale thanks to its creative use of the latest technologies. It's a lamp with a silicone lamp shade that hangs directly from the bulb itself instead of being affixed to the piece in the traditional way. The lamp shade, which has a conical shape, is in reality a smooth plastic sheet that has been zipped-up at its edges to form this conical shape perfectly, fully surrounding the bulb. The silicone sheet is placed on the bulb, making direct contact. The high-temperature resistance of this material prevents the shade from burning. The lamp shade may be unzipped and removed at any moment, then be put back just as easily. This allows it to be cleaned with no fuss and in a very short time.

The Unue-L lamp is fitted with a woven white wire and a porcelain socket with a smooth-shaped solid-nylon connecting part, while the lamp shade comes in a decorated version inspired by the wavelike properties of light. In fact, those waves seem to emanate directly from the bulb, thanks to the transparent quality of the silicone sheet. The Unue-L has a diameter of 8.6 inches and is available in three different versions: NE (no engraving), OE (outline engraving), and FE (full engraving).

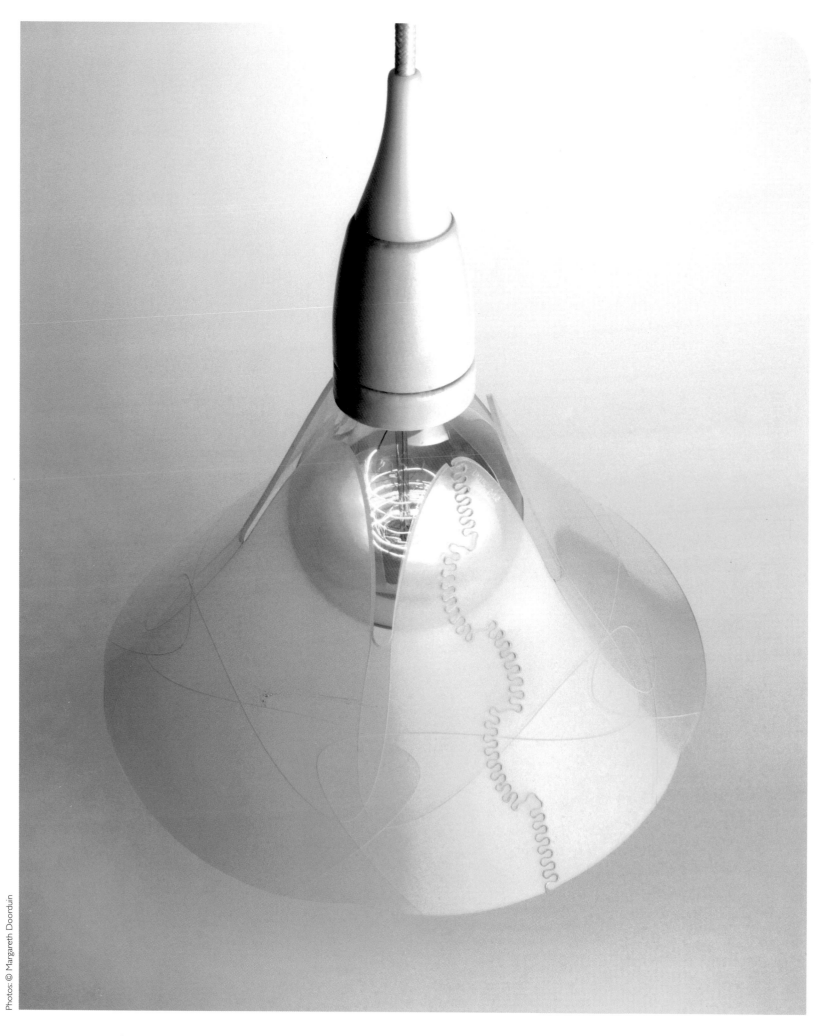

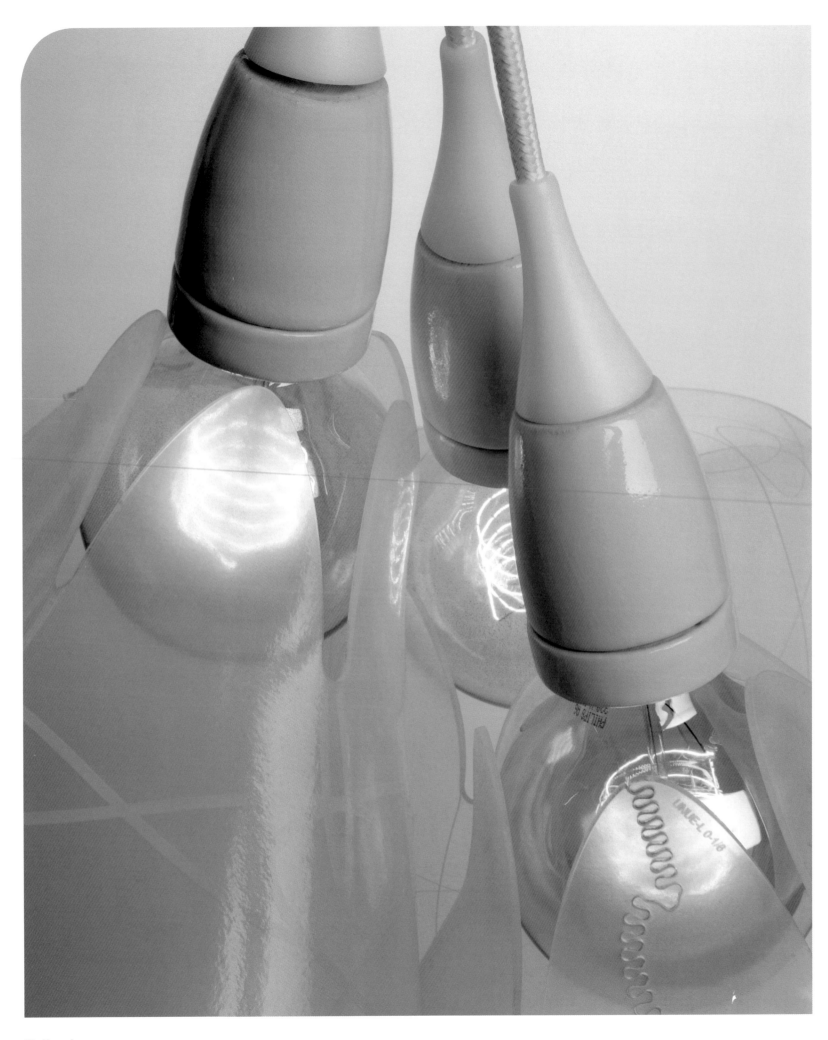

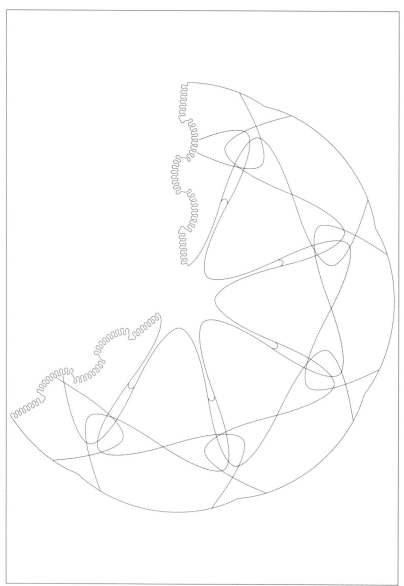

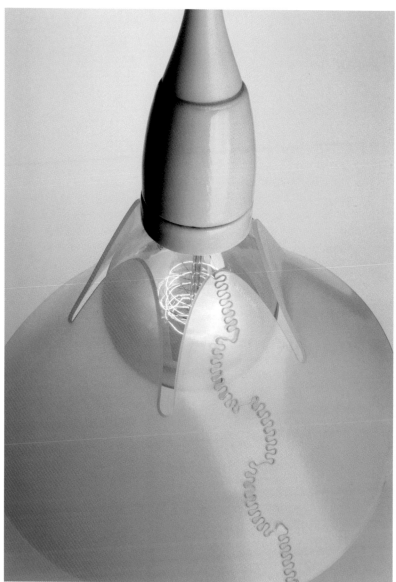

The silicone sheet has been laser-cut, a technique that allows detailed and subtle finishes like the ones we see engraved in the Unue-L. The lamp's elegant appearance is rounded off by the use of an oversize, decorative carbon-filament bulb measuring 3.15 inches in diameter.

Chairs

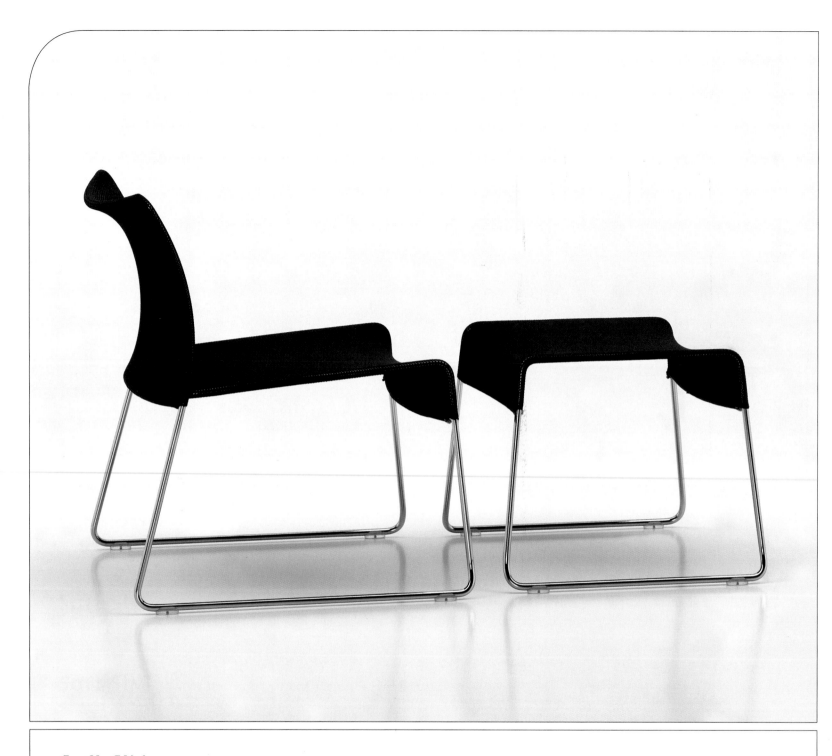

Soft SIM | Jasper Morrison for Vitra | 2004 | www.jaspermorrison.com, www.vitra.com

Soft SIM and its alternate version, Soft SIM Low, are kin to the famous SIM chair designed by Jasper Morrison in 1999 and the result of the further development of this landmark design. The original SIM combined simple designs with excellent quality and maximum comfort and were available in two different models: an outdoor version (with a powdery, weather-resistant surface) and an indoor version (in chromed steel). Soft SIM and Soft SIM Low retain some of these characteristics while presenting some interesting innovations. Soft SIM's backrest and seat are made of a highly resistant, knitted polyester. This novel aesthetic, created with the latest technology in textiles treatments, maintains the symbolic charge of the original SIM while providing improved comfort. Soft SIM Low, while practically identical, stands slightly lower than its companion. Its principal difference is that it can be accompanied by a separately purchased stool made of the same material. SIM is easily stackable in groups of 12 chairs.

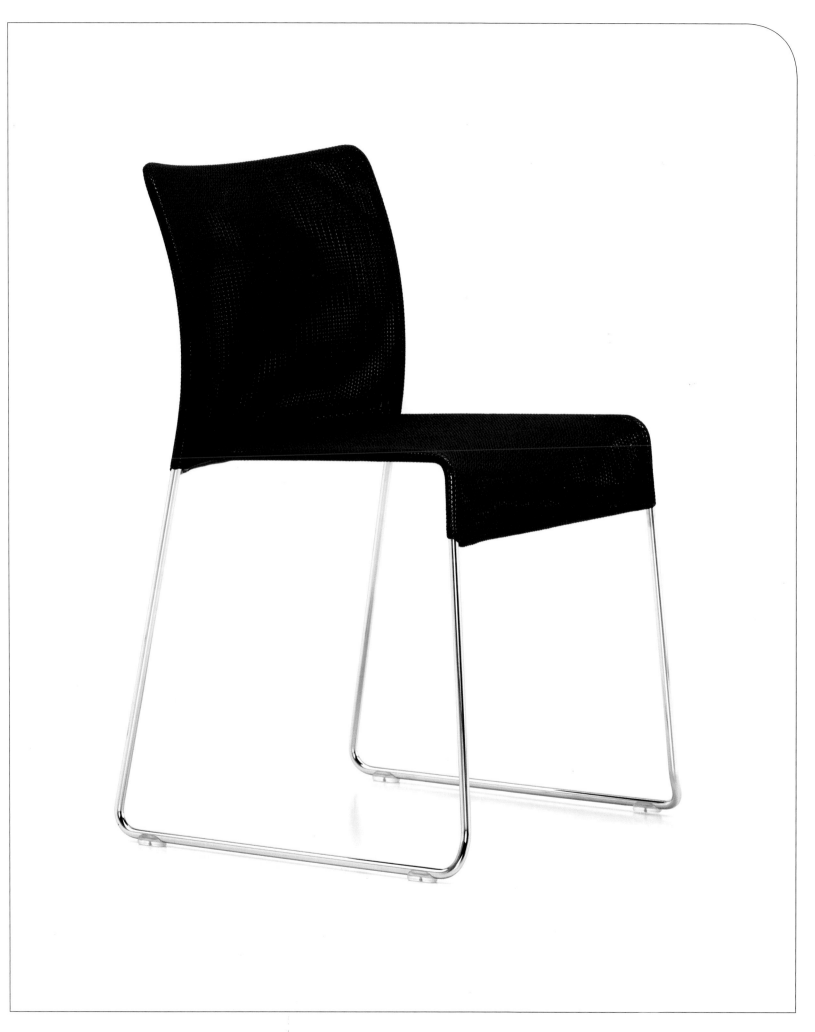

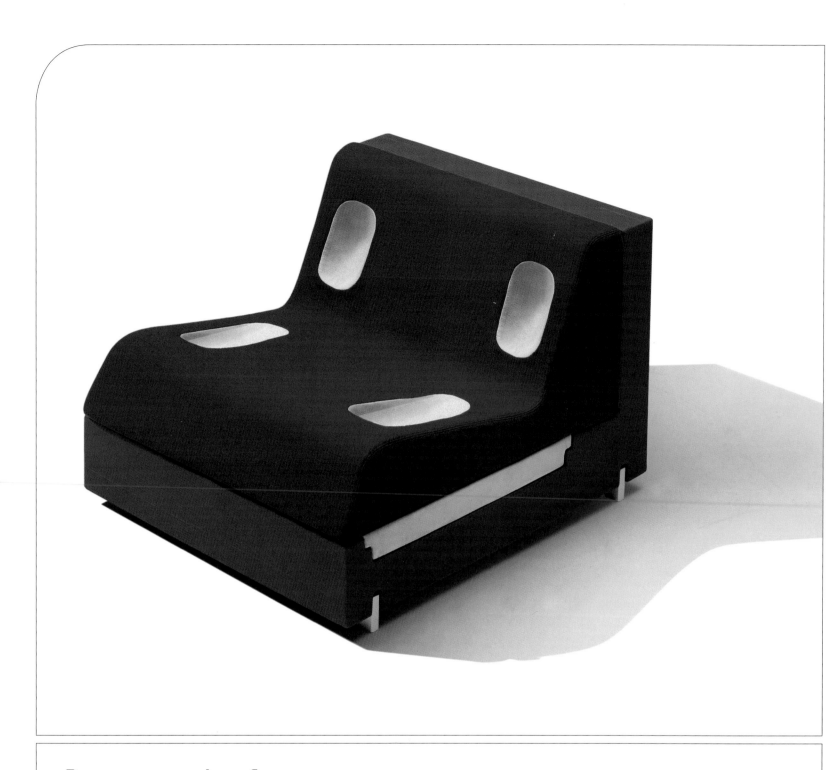

Decompression Space | Matali Crasset for Felice Rossi | 2004 | www.matalicrasset.com

Matali Crasset is not a conventional designer, she is an artist, or, as writer Bruce Benderson mentioned in his introduction for the volume of *Designers & Design* dedicated to her, "more a philosopher, a semiotician, a physicist and an aesthetician than a servant of production." On judging Matali Crasset's creations it might be wise to keep in mind that her motivations and objectives are not exactly the same as those of other industrial designers. Nevertheless, some of Crasset's creations may rub up against what might be called "conventional" terrain. This is the case with Decompression Space, a sectional chair made of polyethylene, using the rotomolding sys-

tem along with elastic bands over its metallic structure, and upholstery fashioned with polyurethane foam. One of the principal characteristics of Matali Crasset's armchair are the playful hollows in the upholstery that appear similar to eyes on a face. In reality, these allow the user to slip arms and elbows comfortably inside thanks to their ergonomic design. In the interactive music installation which was shown at the Centre Georges Pompidou in Paris in 2005, Salon D'Interface Musical, a Decompression Space chair held within those hollows the command controls with which the user could operate the installation.

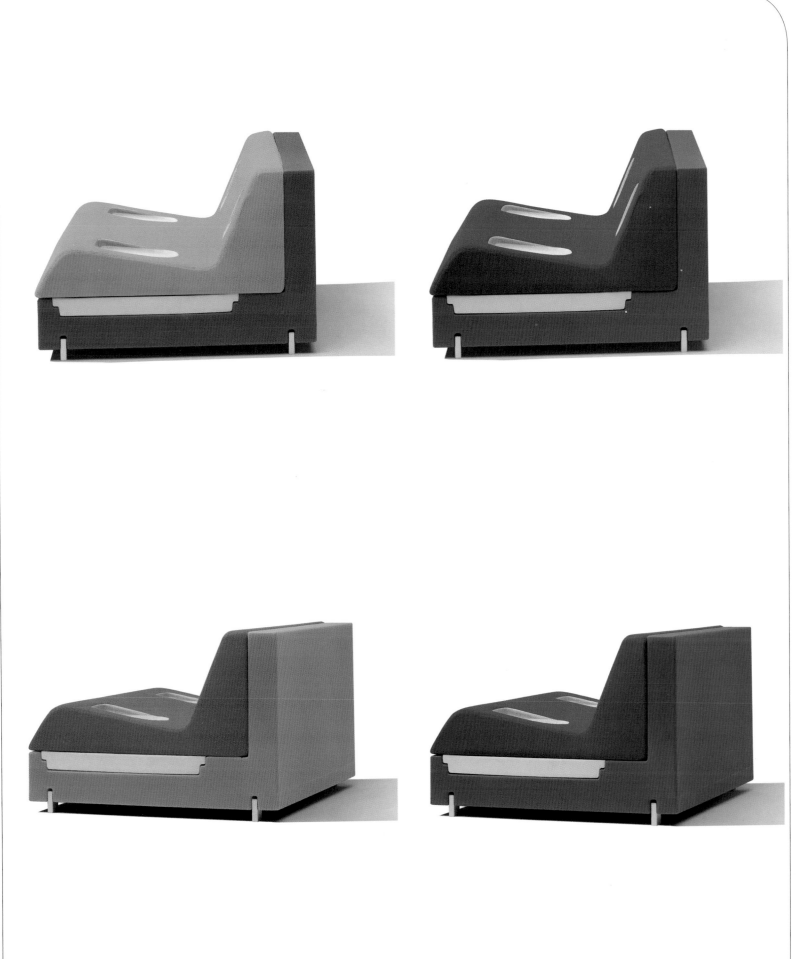

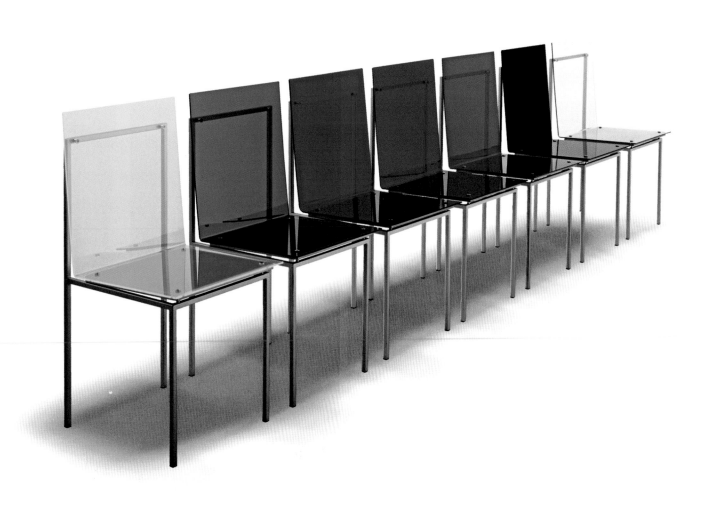

Adelphi Chair | Denton Corker Marshall for Edra | 1998 | www.dentoncorkermarshall.com

This Adelphi is the descendant of the famous Adelphi chair designed for the Adelphi Hotel, in Melbourne, Australia. A principal characteristic is the purity of its line, a reflection of the minimalism commonly associated with the style of Denton, Corker, Marshall, the studio responsible for this design. Beyond the minimalism, the Adelphi features a unique seat made of acrylic plastic mounted on a metal frame with a slight inclination. The effect breaks the chair's geometric purity and gives it personality. The very thin seat recalls a sheet of paper folded in half. The Adelphi is available in different colors and finishes, some of them transparent, this transparency helps reinforce the paper effect. The Adelphi is one of the more popular products made by Edra, a company that is "oriented toward creativity" and well-known for the modernity of its products but also for having been one of the first to so extensively introduce color into its collections. Edra has experimented, very successfully, with the most advanced technology and materials: polypropylene, high-tech fabrics like Hi Speed, and classics like velvet and leather.

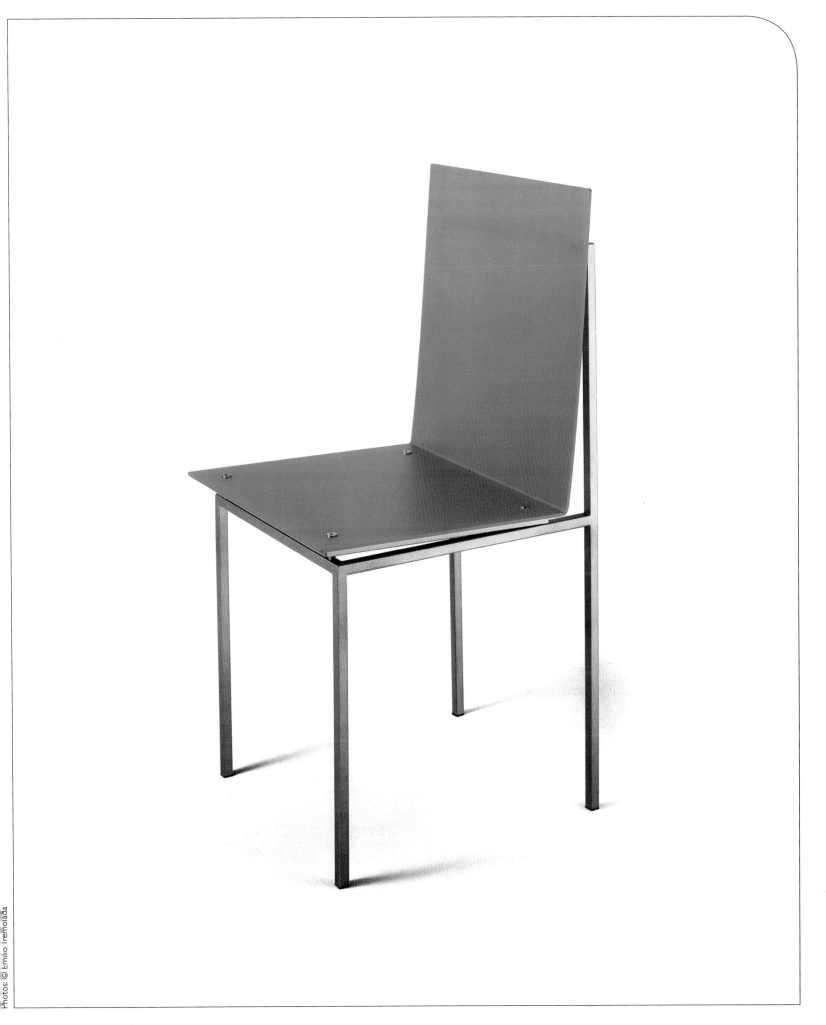

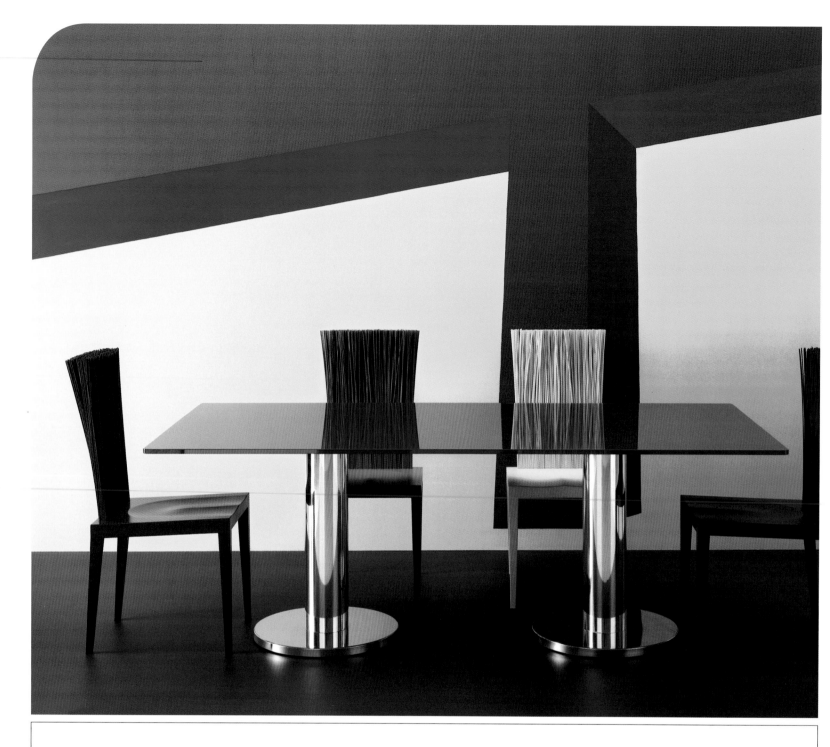

Jenette | Fernando and Humberto Campana for Edra | 2005 | www.campanas.com.br

The design for the Jenette chair has passed through many stages to reach this, its definitive form. At first, the Campana brothers of Brazil thought that the Jenette chair should be hand-made in wood. Afterward, they redesigned it; the result is seen in these pages. This Jenette chair is made with injection-molded polyurethane, although it has a steel interior structure. Nevertheless, the Jenette's main attraction is its unique backrest, a stainless-steel slab hidden behind a curtain of approximately 900 flexible stalks of PVC that shoot upward much like a rush of fountain water. The effect is spectacularly attractive and, according to the designers, "suggests analogy with nature," although others have found it ironically fun, describing it as a cross between a typical dining room chair and a broom. The chair is painted with polyurethanic opaque paints and is available in six different colors. It is ergonomically designed, with concave spaces that adapt perfectly to the user's legs. The seat's sharp corners and the spare design of the legs form a powerful aesthetic contrast with the chair's backrest.

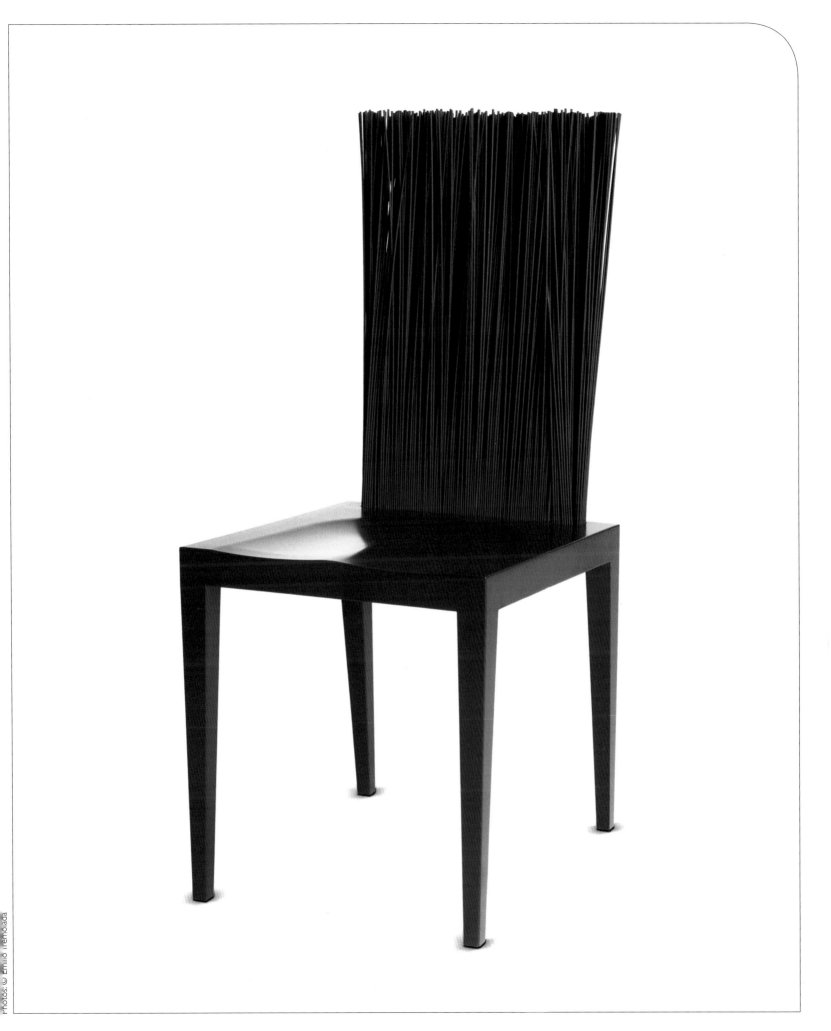

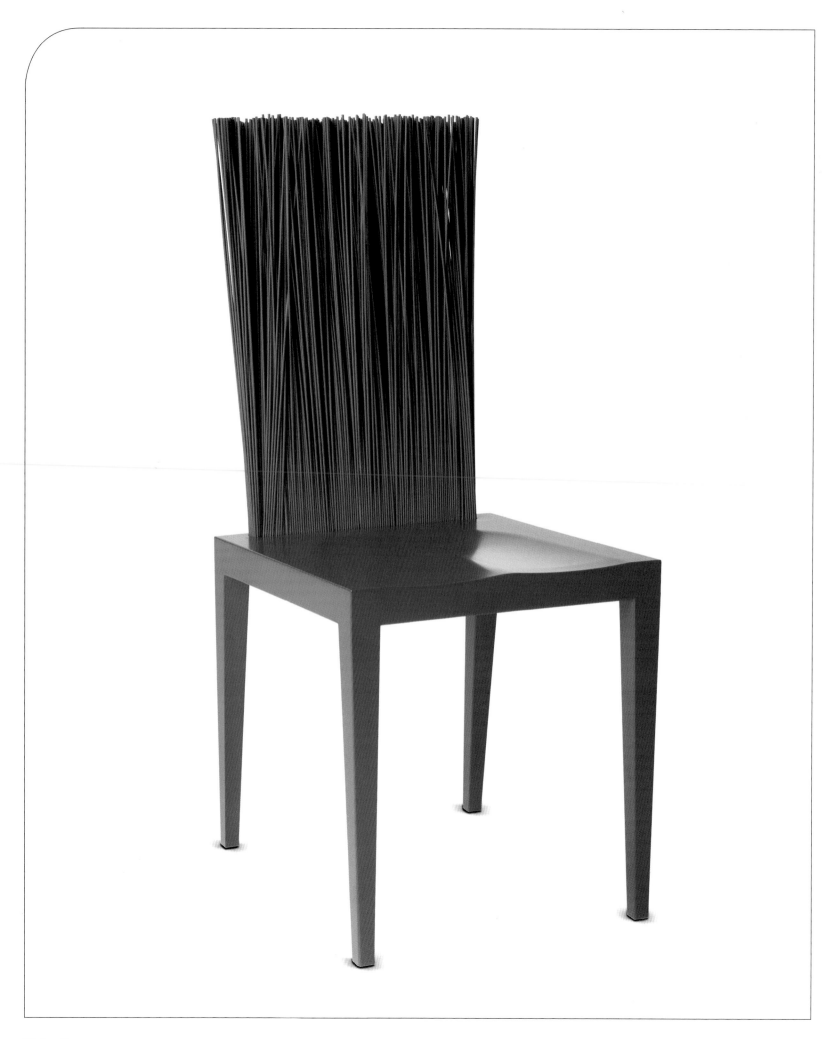

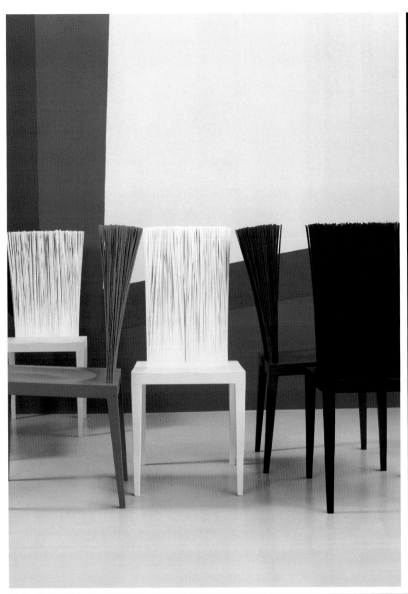

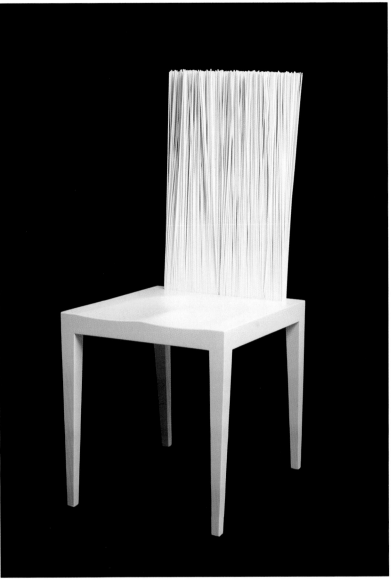

Part of the Jenette chair's attraction is its irony. At first glance, it seems the back-rest is comprised solely of those 900 PVC filaments and that, in turn, it should not be able to support the weight of a person's back. Only after sitting in it does the user realize that the back-rest is actually solid steel.

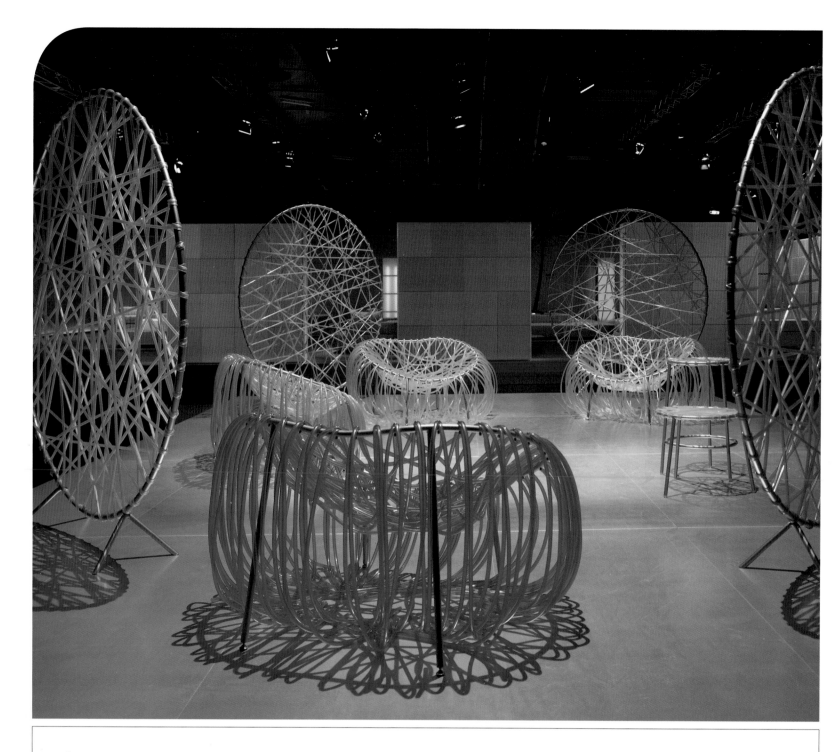

Anemone | Fernando and Humberto Campana for Edra | 2001 | www.campanas.com.br

The Campana brothers are known for playing with versatile materials and, even better, with materials left over from industrial manufacturing processes. These are given new life, occasionally directly inspired by nature. Whole books have been written about the influences of the shapes and colors of animal life and vegetation in art and contemporary design. In many cases, this influence is more anecdote than anything truly significant, though in some cases a deeper meaning beyond some simple and superficial aesthetic inspiration can be sensed. This is the case with the Campana brothers' Anemone chair (or, better said, lounge chair). It draws its inspiration from the spectacular sea anemone. Anemone is made up of dozens of long, thin PVC hoses wrapped around a stainless-steel frame. While the hoses appear to follow some chaotic formula, they have been arranged in such a manner as to simulate the form of a conventional lounge chair. This allusion is aided by the Anemone's front legs, which are shorter than those in the back. The Anemone family also includes stools, windshields, and even a small round stool similar to a child's trampoline.

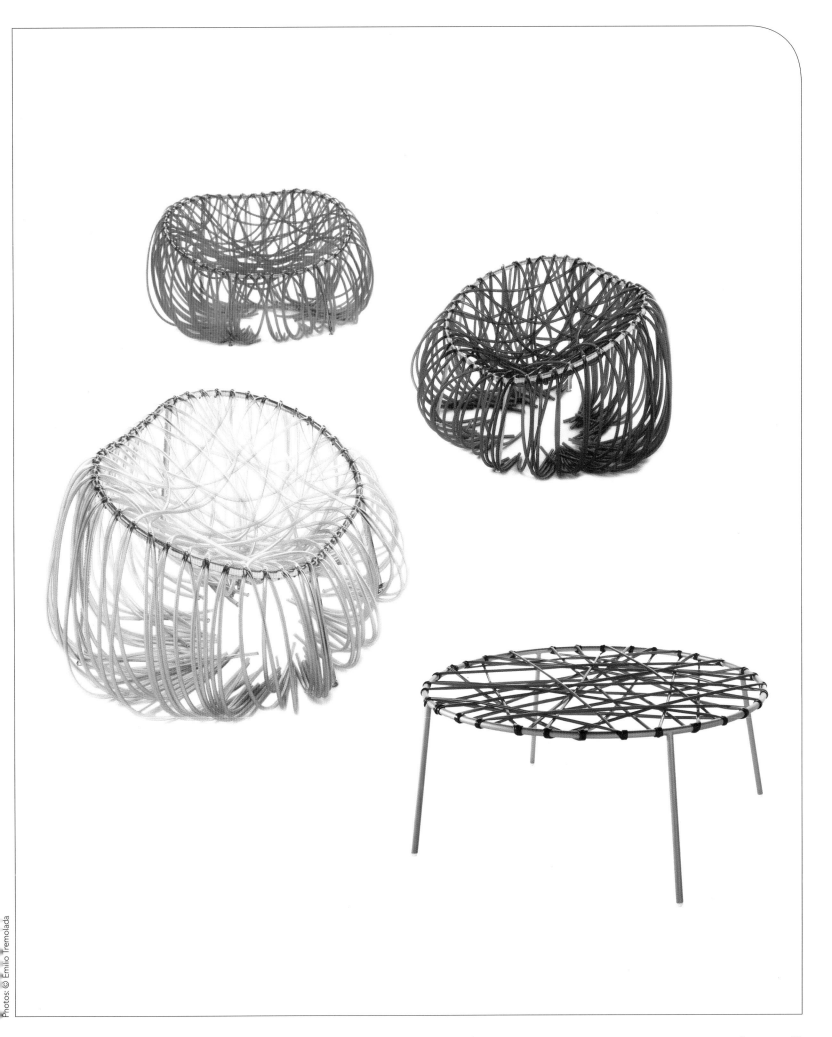

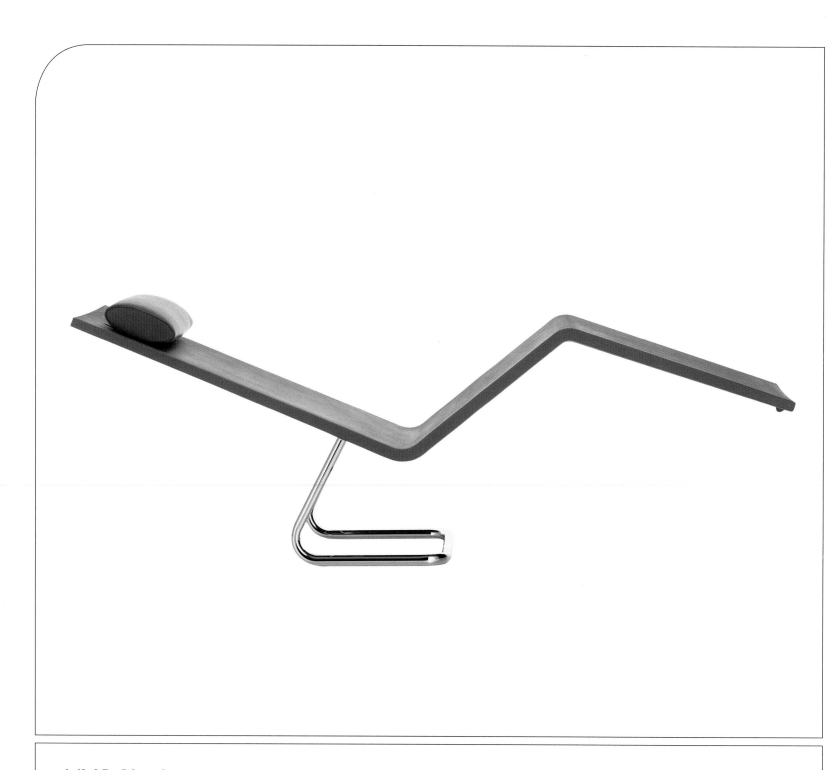

MVS Chaise | Vitra by Maarten Van Severen | 2000 | www.vitra.com

At first glance, the MVS Chaise may seem more like a sculpture or a purely decorative and apparently unstable object than what it actually is: one of the most unique lounge chairs currently on the market. The MVS Chaise is a piece by Maarten Van Severen, possibly the most internationally well-known Belgian designe, thanks primarily to all his work for Vitra and his collaborations with architect Rem Koolhaas. The chair is made of polyurethane integral foam. The MVS Chaise also features a leather cushion to rest your head and a shiny chrome base that permits, via an ingenious calculation of balance, moving from a sitting position to a reclining position with ease. The MVS Chaise has been designed for outdoor use as well (using the base made of stainless steel and a cushion made of polyurethane integral foam). Uniting all the most emblematic characteristics of Maarten Van Severen designs: a clean and simple shape with elegant finish and, above all, an attention-grabbing effect without unnerving the customer.

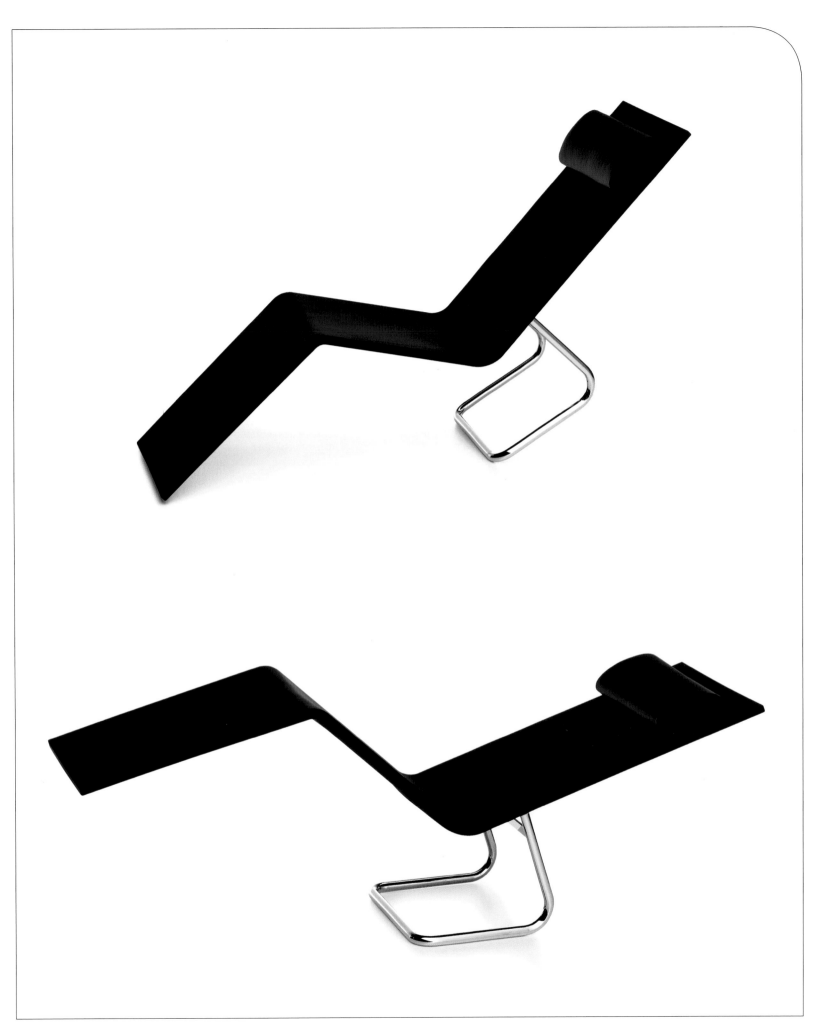

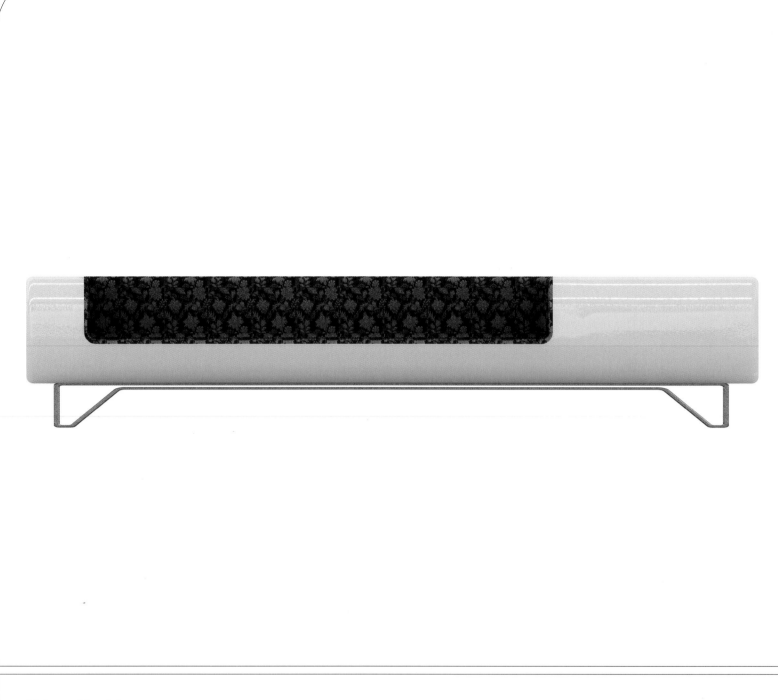

DivaNetto | Dot Kite | 2006 | www.dotkitedesign.com

When an industrial-design studio announces that what differentiates it from its competitors is the "extra psychological advantage" its work bestows upon its customers, that's when you know you're witnessing something truly serious. The proof? The DivaNetto sofa, a design that drinks from the cups of comfort, style, sensibility, and function. It is not difficult to imagine the DivaNetto in the reception area of a hotel accommodating the hero of one of Steven Spielberg's utopian fantasies or in the luxuriously retro-futuristic VIP waiting room of an airport in some capital city of Asiatic stripe.

This is owing to the marked contrast between the piece's curved structure, made with white FRP (fiber-reinforced plastic), and the design of the seat itself, available in stamped fabric or laser-etched leather. The DivaNetto's legs are constructed of stainless steel. The sofa, offered in both single- and double-seat versions, also has various ports so that users may navigate the Internet with the portable electronic device of their choice. These devices may be comfortably positioned on the sofa's level armrests, which were designed specifically by Dot Kite with this objective in mind.

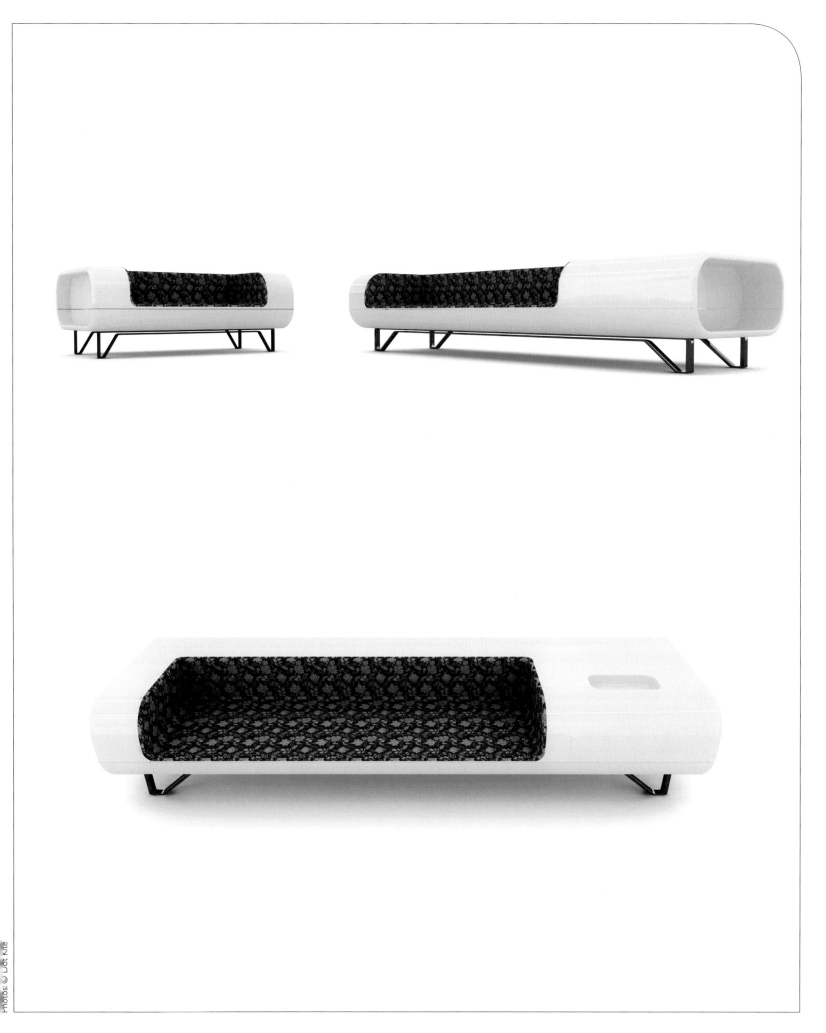

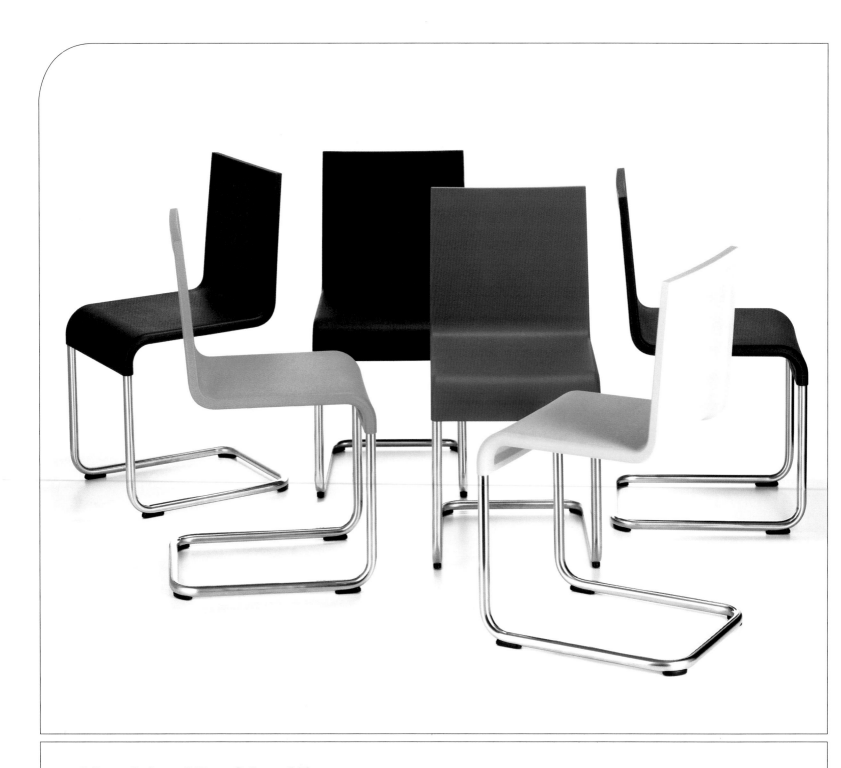

.03, .04, .05, .06, .07 | Vitra by Maarten Van Severen | 1999-2005 | www.vitra.com

The .03, .04, .05, .06 and .07 chairs are part of a collection that Belgian designer Maarten Van Severen designed for Vitra. All of them have something in common: their simple form. The chairs do not have a single capricious detail belying their initial concept of "less is more".

The .05 chair (on this page), manufactured with a polyurethane integral foam, has a stainless-steel, tubular frame and a backrest with integrated springboards. The .03 (opposite) firmly supports the user's back with a backrest made from a polyurethane integral foam shell that is also rein-

forced with integrated springboards. The rear legs are made of tubular steel, while the front legs are constructed of aluminum. The mechanical balance of the .04 allows to move smoothly in each direction without difficulty, thanks to a ball of gum located under the seat. The .06, very similar to the .05, is lower and slightly reclined to the rear, and it has been designed for both interior and exterior use. The fluid line is a recurring theme in this collection, whose pieces are devoid of intersecting angles or any other "aggressive" element that might lessen the initial minimalist idea.

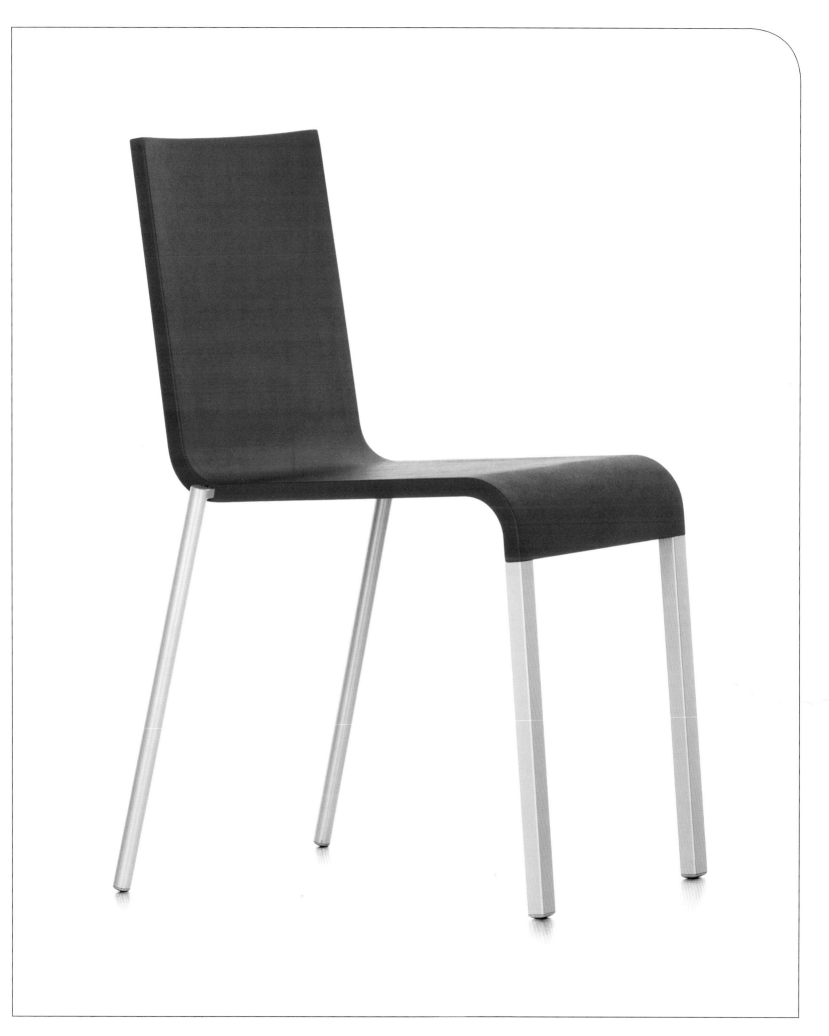

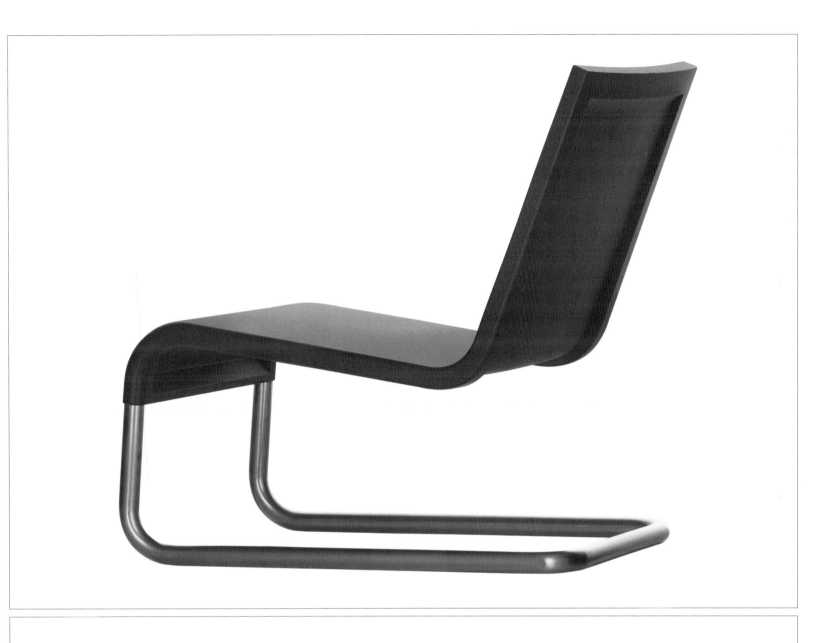

The fluid purity of their lines is one of the central characteristics of this collection designed by Maarten Van Severen. The pieces shown on these pages seem to have been constructed "of a piece"; only the diversity of materials and their different colors prove otherwise.

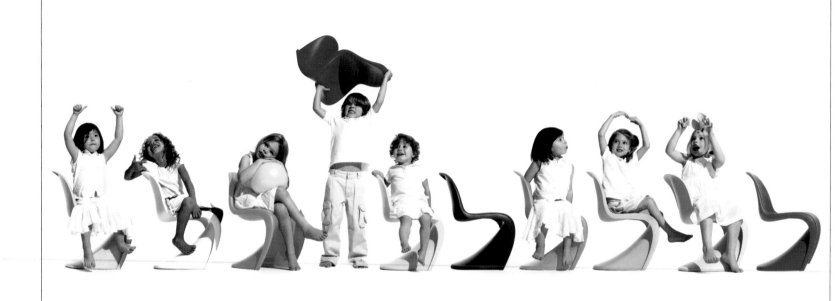

Panton Junior | Vitra by Verner Panton | 1959-60, 2006 | www.vitra.com

The classic Panton chair, designed by Verner Panton just prior to the dawn of the sixties, has always been known for being a furniture favorite in the eyes of children. The reason for this may lie in the chair's curves, in its cheerful colors, and its flexibility come playtime. Nevertheless, Verner Panton never had the opportunity to produce a Panton chair for children because of the exorbitant amount it would have cost to manufacture and the era's scarce demand for children's furniture. The project was abandoned and the children of the '60s had to make do with the "adult" Panton chair of their parents. In any case, with the arrival of the twenty-first century, Vitra has revived Verner Panton's old idea by manufacturing, with the approval of Panton's wife, Marianne Panton, and based on the designer's original sketches, a children's version of the Panton chair with a matte finish on colored poly-propylene. The Panton Junior is approximately a fourth the size of the original, making it ideal for kindergarten and grade-school children. Aside from the four original colors (orange, red, black, and white), the Panton Junior is available in the newer light pink, light blue, and lime colors as well.

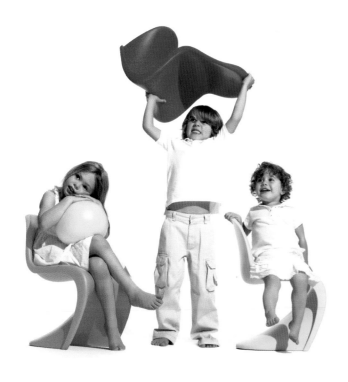
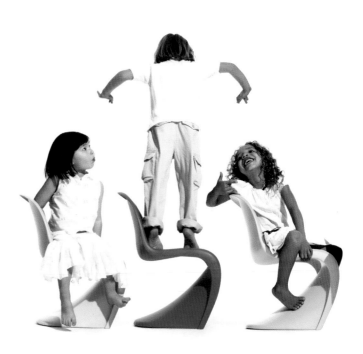
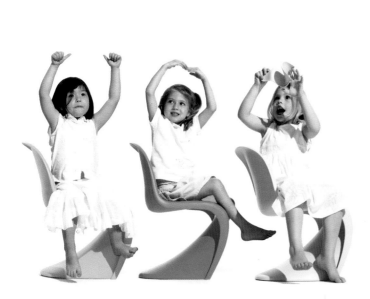

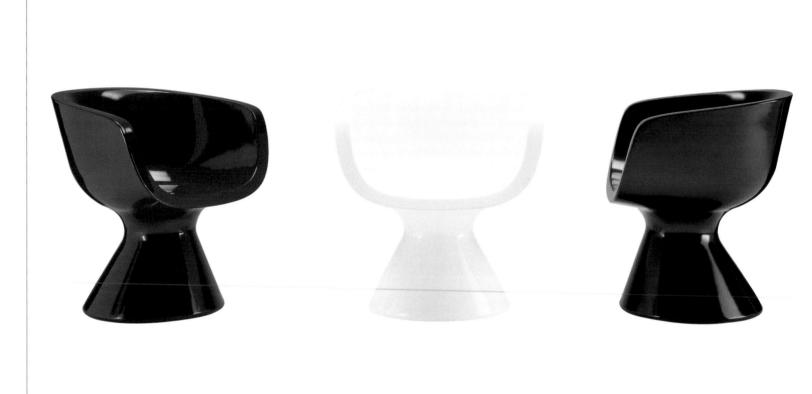

Dora, Tod, Brasilia | Zanotta by L. & R. Palombo, T. Bracher, R. Lovegrove | 2005, 2005, 2003 | www.zanotta.it

It's difficult to avoid the automatic mental association between plastic furniture and the 1960s esthetic. The pieces by Dora, Tod, and Brasilia are not the exception that proves the rule. Any one of these pieces could be accidentally placed on display in some exhibition of '60s or '70s furniture, and only a few small details, like the colors chosen or the designs that adorn them, could raise the viewer's suspicion. The small Dora armchair, made in one complete piece, seems more like a sculpture than a conventional piece of furniture. The customer can choose between two different models: the first one, made of polyethylene, is decorated with a floral motif on white, beige, black, and aluminum. The second, made from polypropylene, features a brightly lacquered surface in white, red, brown, and black. Both models are versatile enough to be used indoors or outdoors.

The small Tod coffee table is also made with polypropylene, to which has been added a brightly lacquered finish designed to make the table the center of attention in contrast to the straight lines typical of tables, sofas and other types of furniture. In fact, the Tod table was designed with the understanding that it would never stand alone, but always in the company of other pieces of furniture. Its unique shape allows it to "fit" laterally with other furniture (a sofa, for example) so that it may function as a side table as well.

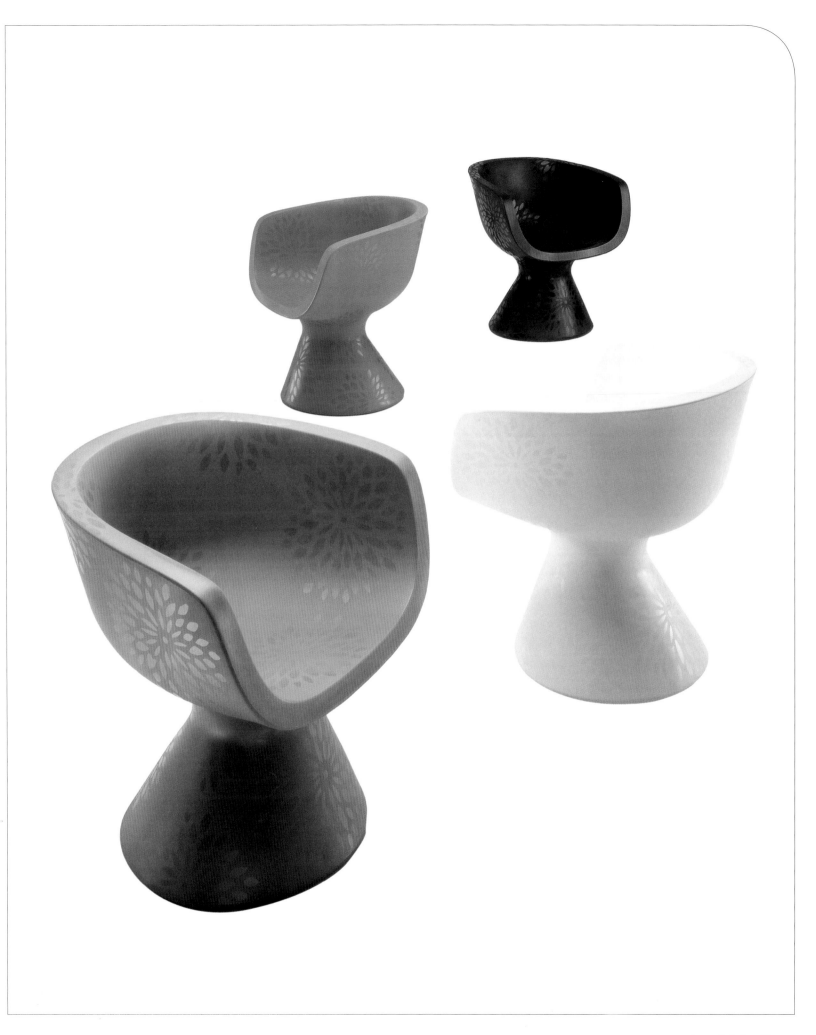

The Brasilia chair, with its rigid polyurethane structure, has been varnished with an embossed anti-scratch finish (an embossment is a type of raised stamp design consisting of repeated patterns, some the negative of the other) available in many colors. A leather-clad model is also offered. The Brasilia boasts a footrest with a wavy shape that seems a smaller version of its predecessor's.

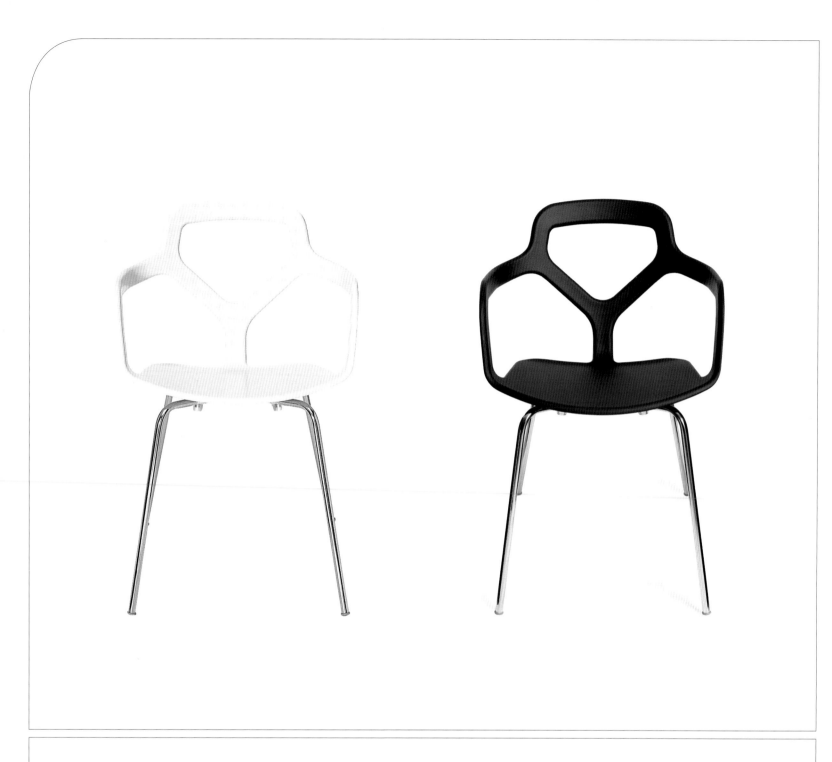

Trace | Shin Azumi for Desalto | 2005 | www.shinazumi.com

Similar to the way in which elemental physics speaks of antimatter (formed by the antiparticles of "normal" matter's particles), contemporary design contemplates the possibility of producing anti-furniture constructed from the negative space of a conventional piece of furniture. An example of this is the Trace, an indoor/outdoor stackable chair, 2.5 feet high and 1.7 feet wide, made from a Hirek polymer body and a chromed frame. The origin of its unique shape, particularly its body, lays in the familiar profile of a conventional armchair. The Trace's silhouette is, in effect, the same as that traced by the retina after looking for a few seconds at your average armchair; hence, the piece's name. By reducing the chair to its most basic contours and revealing those elements behind the chair, its visual effect is accentuated. Maximum decorative potential is achieved when the Trace is placed in front of a non-white, colored wall. Trace is sold alone or with a leather cushion that fits snugly into the chair's seat and is available in two distinct versions: the conventional model with four chrome legs or with the four-leg swivel base.

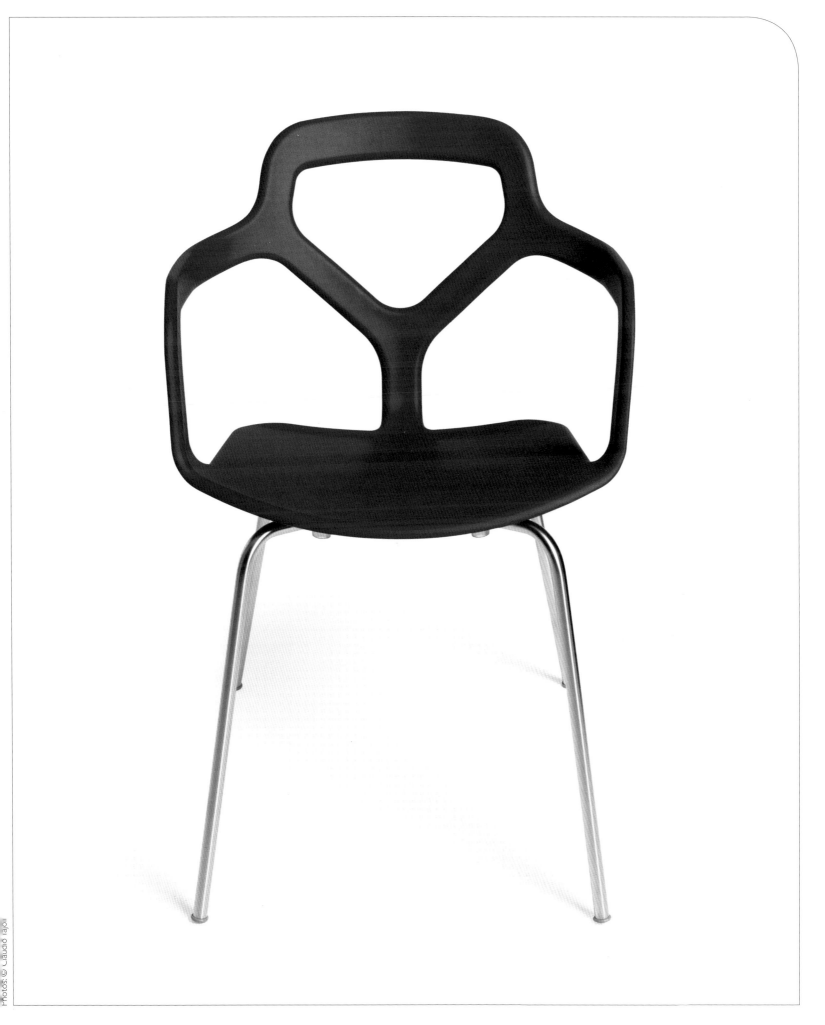

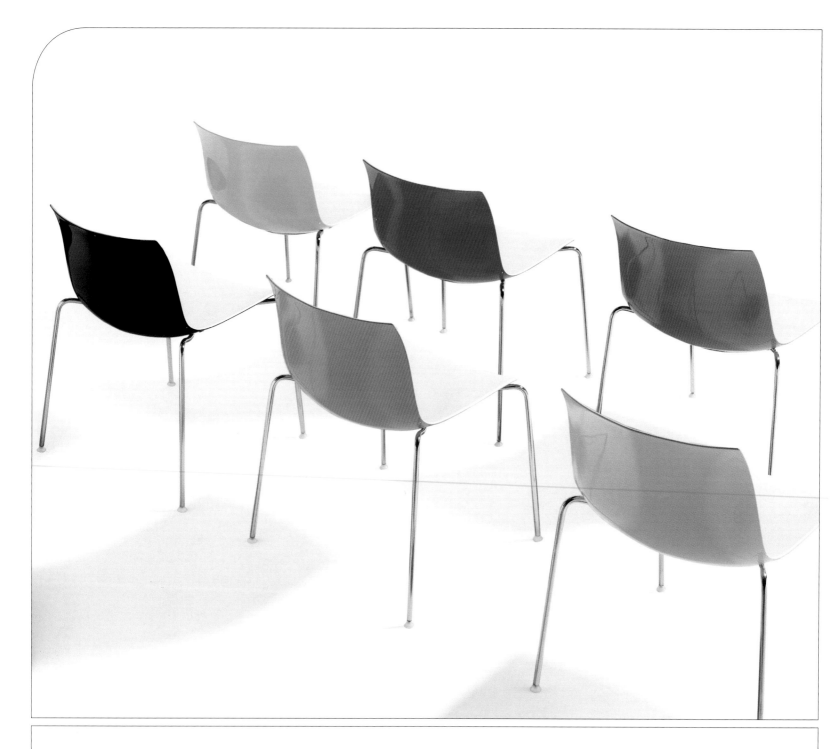

Catifa 53 | Lievore, Altherr, Molina for Arper | 2001 | www.lievorealtherrmolina.com

Rarely does a piece attain "classic" status as soon as it hits the streets, but that is exactly what happened with Catifa 53, a chair that acquired its name from the width, in centimeters, of its seat (exactly 53 cm/ 1.73 feet). Catifa 53's success is the result of the innovative technology with which it has been made and its aesthetic, which combines elegant comfort and break-through design. All this at a price within reach of the large consumer base that tends to think twice before investing its hardearned money on a "designer chair." Catifa 53 is also an architect's and designer's favorite.

Catifa 53 is available in leather and in one- or two-color polypropylene, fabric, wood, or with the fabric provided by the customer. This applies to all the models: the conventional four-legged chair; its star-shaped uni-base version, and its sled base. The range has recently been expanded to include a star-shaped uni-base with castors at the end of each of its five legs and a new chrome-finish option for the conventional four-legged version. The choice of using polypropylene wasn't an accident. It is one of the few materials capable of adapting itself to the varied, sensual design aesthetic of Catifa family, a design based primarily in the realm of the straight line and all its possibilities.

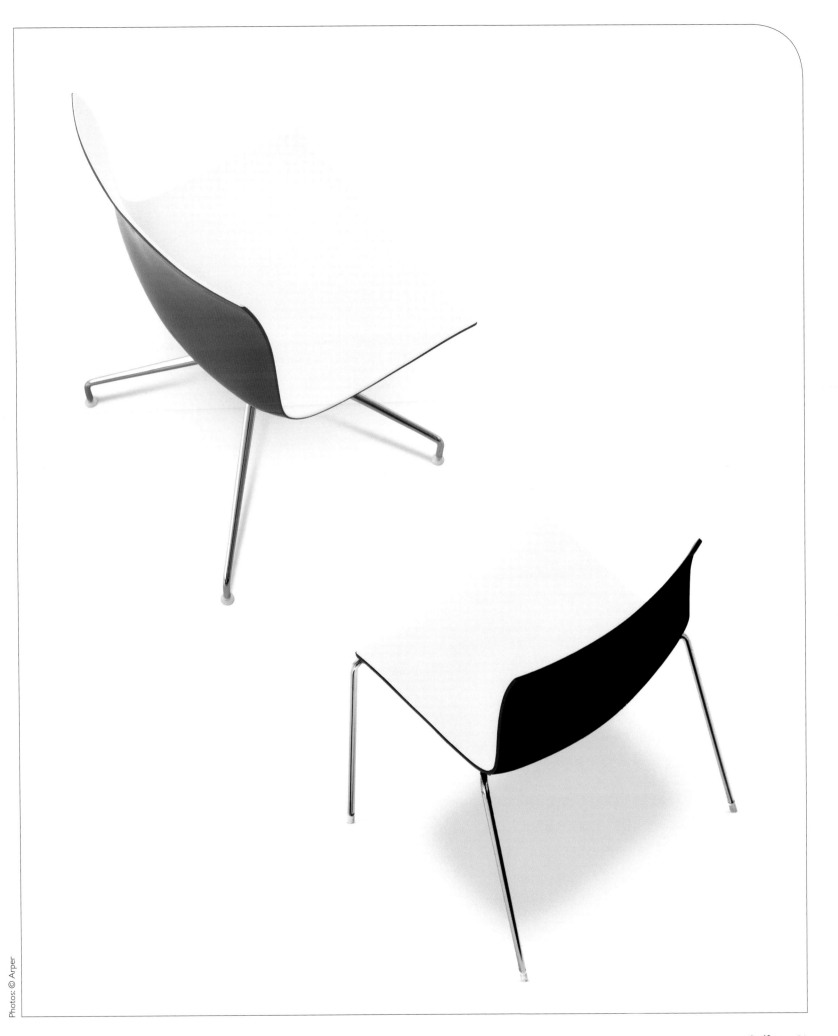

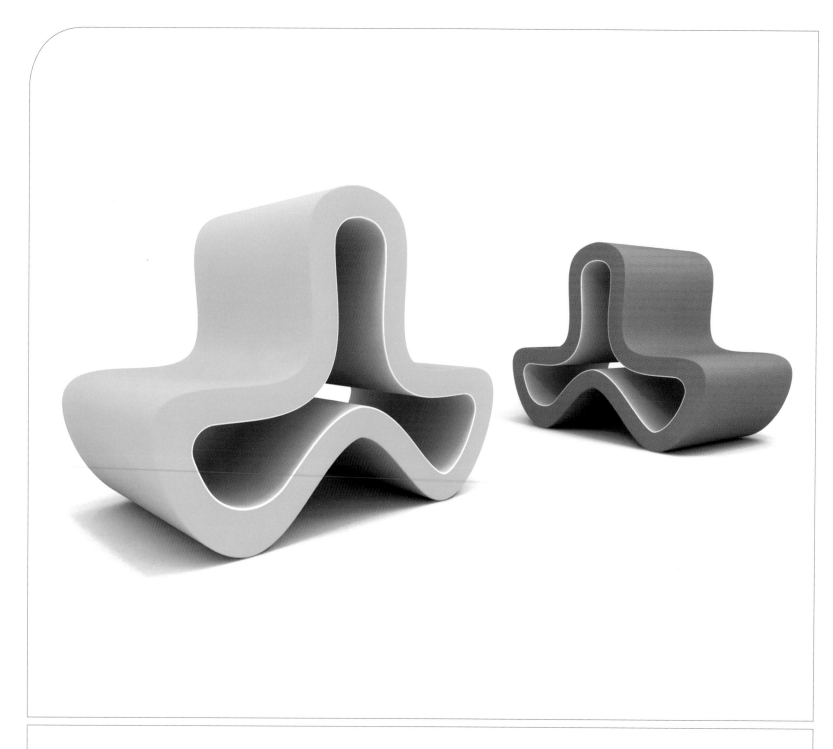

Trio | Ersah Mobilya by Secil Ugur | 2007 | www.ersah.com

Trio is one of the most popular designs by the 24-year-old Turkish comic-artist and designer Secil Ugur. *Wallpaper* magazine has called Ugur one of the "most desired" international designers of 2005. Trio is a hybrid piece of furniture halfway between the chair and the sofa that eludes categorization and that recalls, without much effort, the three-leaf clover. The piece, on which two users sit back-to-back with each other, is made with polyurethane and given shape and volume by the metallic skeleton hidden in its interior. This interior boasts a hollow recess in the shape of a three-pointed star, accessible on both sides, where one can store any number of objects (magazines, for example). Together, two or more Trio units can become a sofa of various lengths. These may be chosen all in one color or in different colors. The Trio manufacturing process itself is quite interesting: The mold is not composed of the piece's entire shape, only half. Consequently, each Trio unit is made by joining two asymetrical pieces; after the two pieces are combined, all trace of joining is eliminated. The result is a flowing vision as jarring as it is effective.

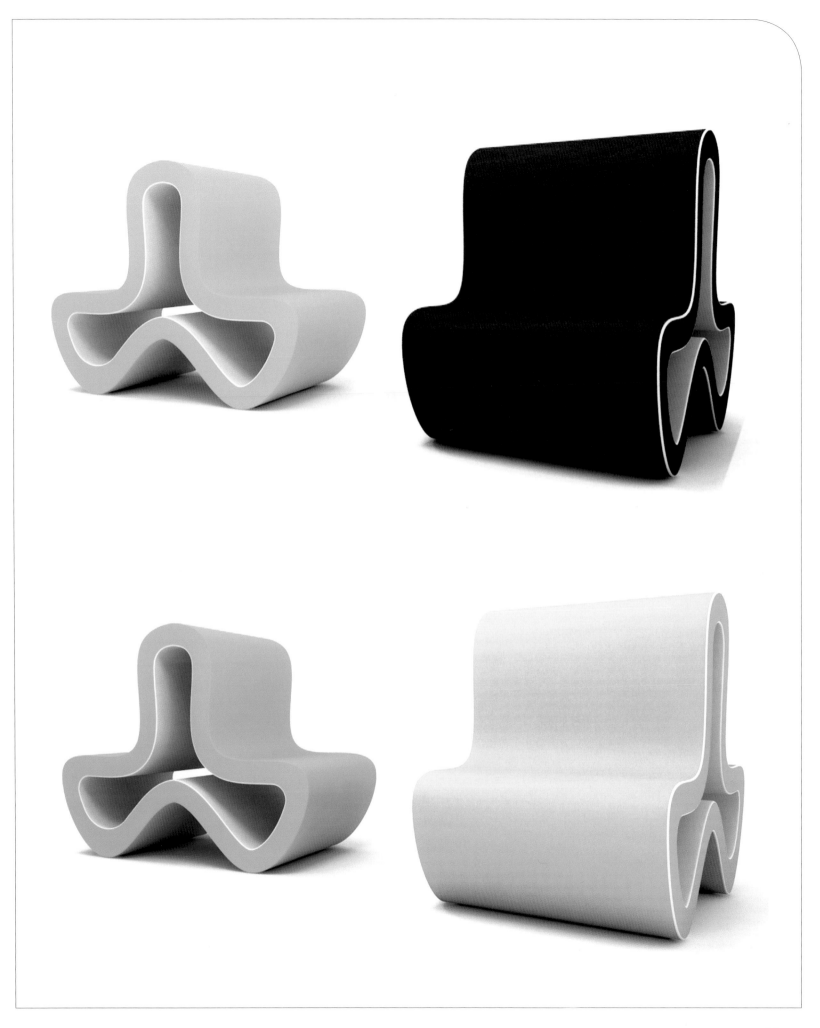

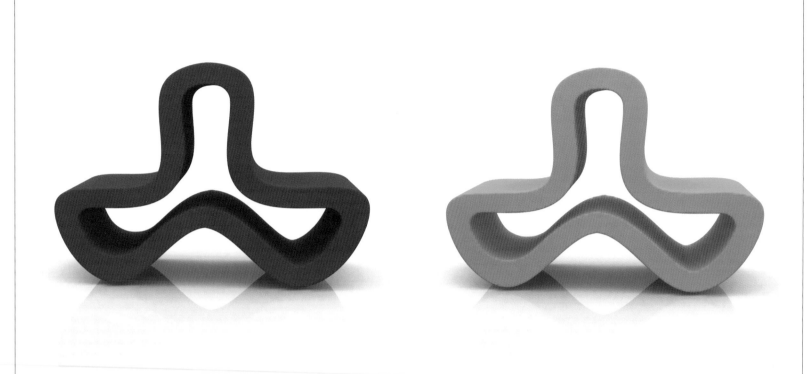

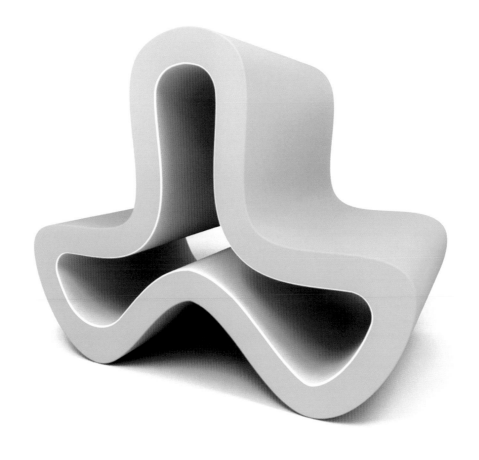

The Trio's pop aesthetic and attractive colors call to mind an even greater psychedelic version of Stanley Kubrick's film *2001: A Space Odyssey*, making it perfect for children's interiors or wherever one may wish to create an informal or unorthodox atmosphere. The Trio's bright colors have been chosen with this purpose in mind.

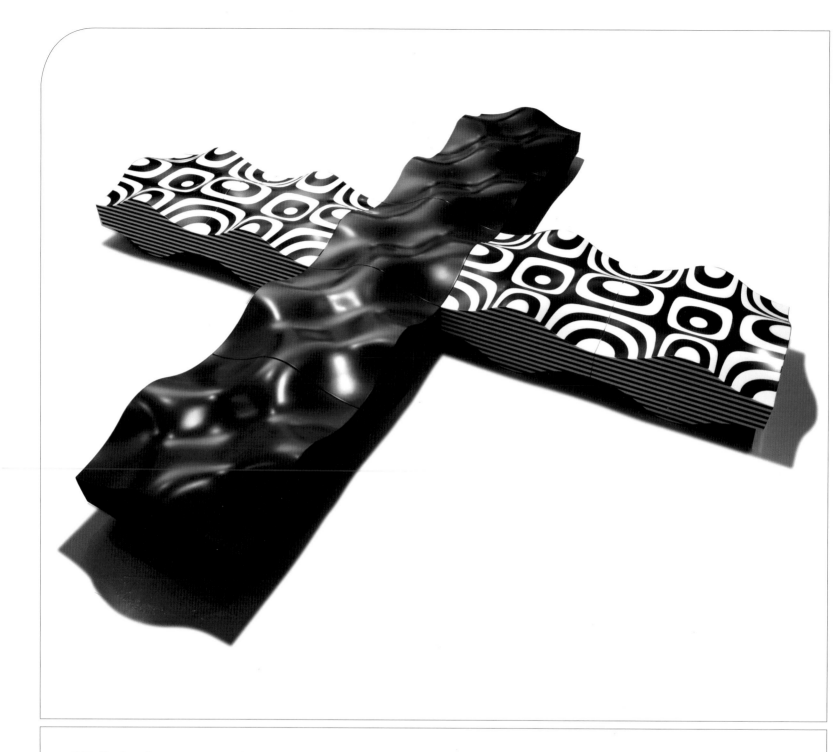

OPS Sofa | Studio I.T.O. Design for DuPont | 2006 | www.studioito.com

OPS, introduced at the 2006 Furniture Show in Milan, is a sofa that comprises various combinable units. For the manufacture of each of these units, asymetric pieces of Corian (a solid plastic material available in more than 100 different colors and with enough flexibility to be carved like wood, molded, thermoformed, or encrusted with other materials) are glued and layered together. These Corian units are then polished, which gives them the smooth and wavy finish that can be seen in the photos. Finally, the units are joined together to form one piece, which can be as large as the cus-

tomer wants and adapt to any arrangements desired. Aesthetically, the sofa presents a curved surface that obviously evokes the rhythym and waves of the sea, which is why the result is perfect for spaces where one might want to create an atmosphere of fantasy. The sofa's irregularity gives the observer a different view, depending on where he or she is standing, as if it were moving in space or imperceptibly changing shape. These pieces have been produced in black and in a black-and-white 1960s motif.

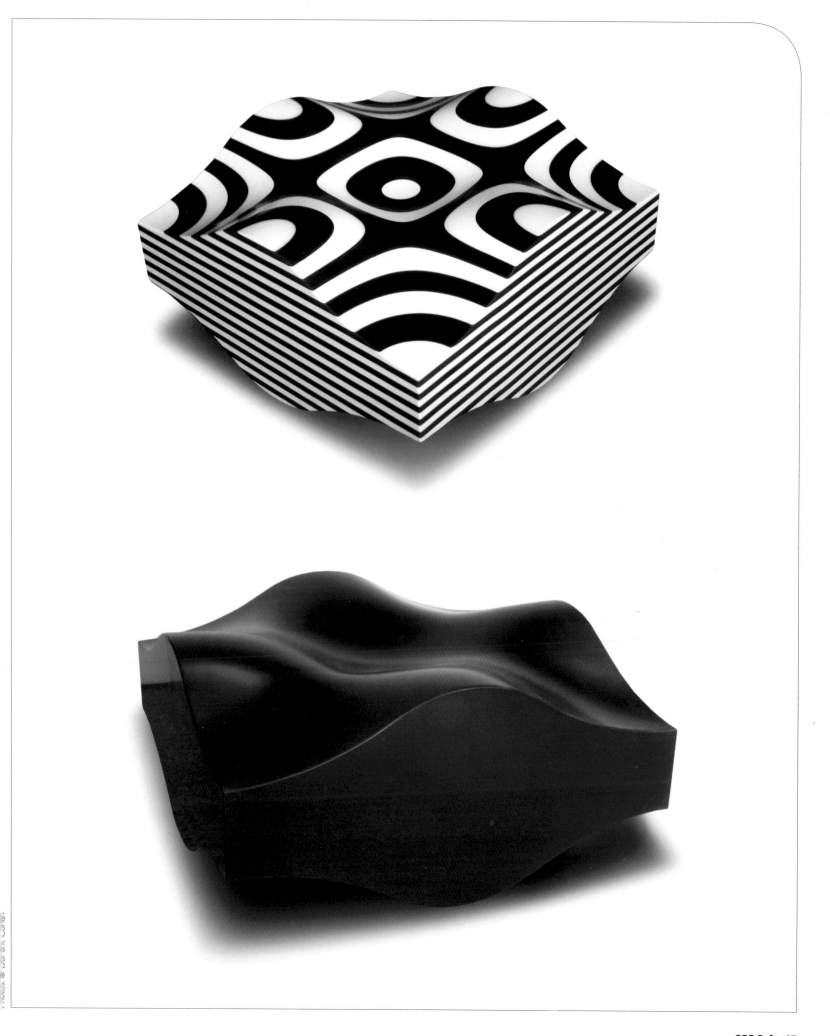

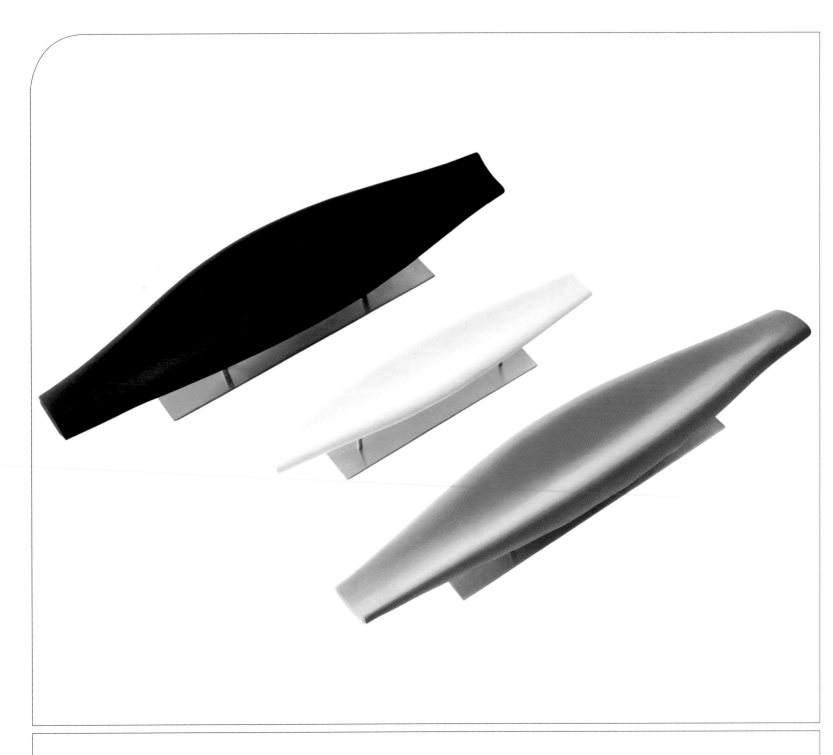

In Out | Studio Massaud for Cappellini | 2001 | www.massaud.com

The form of the 9.84-foot-long In Out bench recalls that of a muscle at rest and transmits the idea of strength, an infrequent concept in a contemporary industrial design world that habitually plays with concepts leaning more toward a supposedly feminine aesthetic. Nevertheless, its designers use the word "sculpture" when it comes to defining it, as In Out was designed in order to go beyond the usual customer's expectations of living room furniture. The piece is designed for use in both interior and exterior spaces. In Out is available in two different finishes: one, a shiny gel similar in appearance to lacquer, and the other a polyurethane foam. *Light, comfortable, elegant,* and *mysterious* are words that on more than one occasion have been used to define the In Out (at its presentation in the April 2001 Furniture Exhibition in Milan, for example), though its essence certainly centers on the classic notions of simplicity and minimalism.

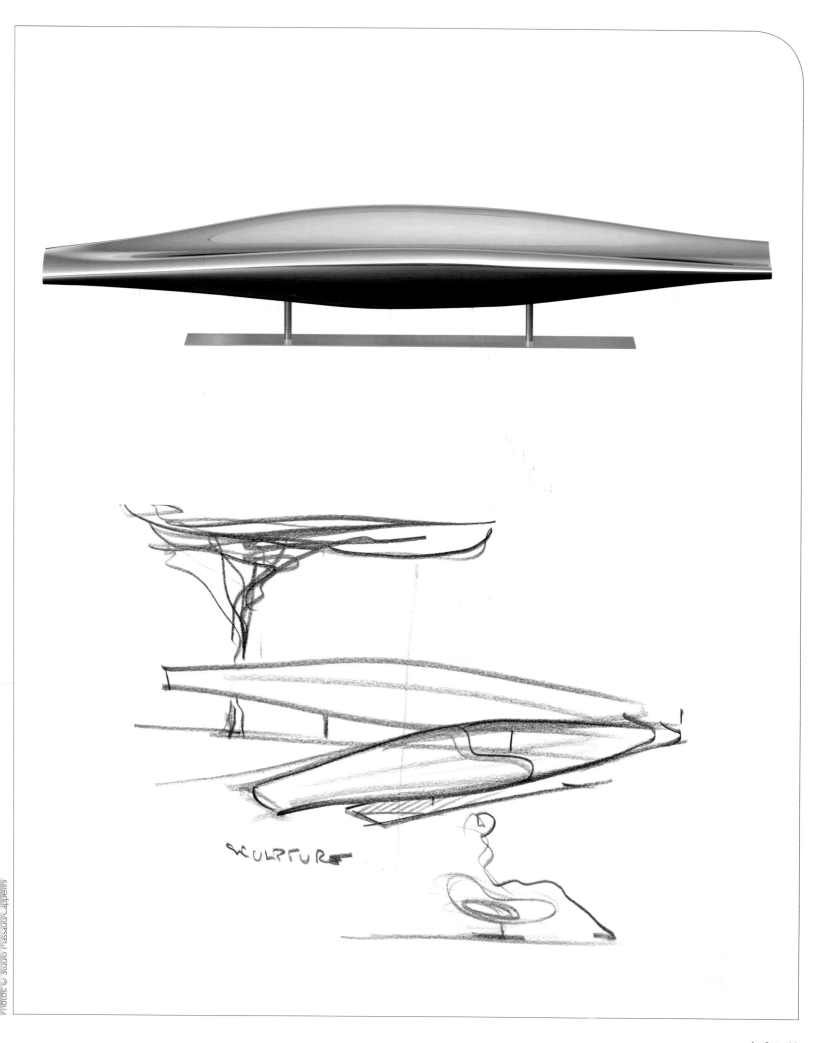

SCULPTURE

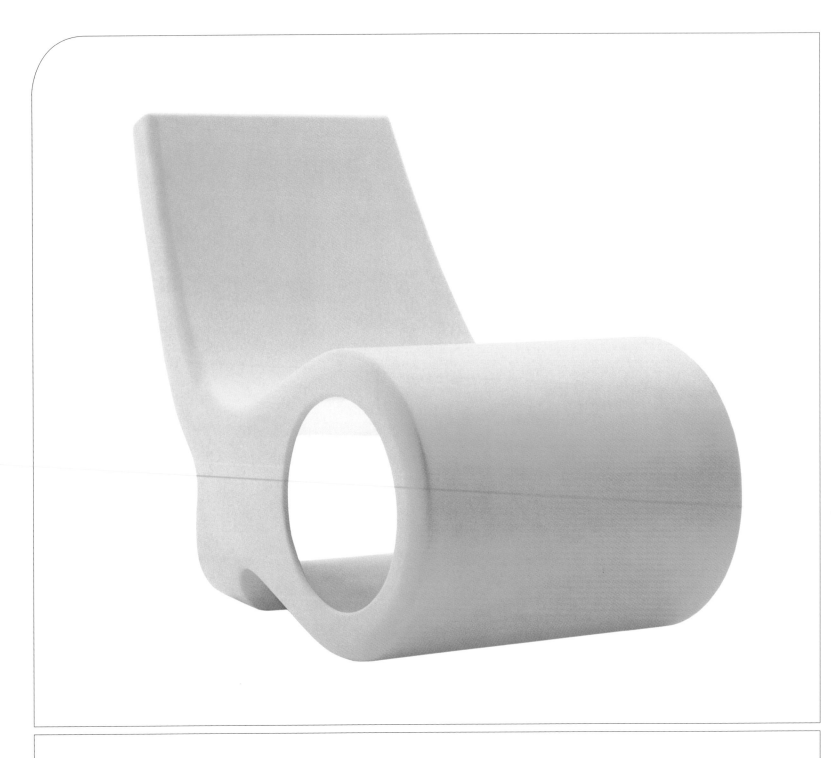

Fish Chair | Satyendra Pakhalé for Cappellini | 2005 | www.satyendra-pakhale.com

Satyendra Pakhalé, born in India but educated in Germany and Holland, is one of today's most admired industrial designers. This is due partly to the talent she displays when it comes to mixing Oriental art influences with the dominant aesthetic of Occidental industrial design and partly to her ability to mix manual labor with the most advanced technologies. The resulting body of work and products tend to leave no one feeling indifferent about them. In 2005 Pakhalé designed the Fish Chair for Cappellini, and its shape strongly resembles a typographic symbol. Fish is a small chair made with reinforced polystyrene and treated such in a way (by rotational technolo-

gy) that the final feel of the product is smooth and much warmer than usually seen in other types of plastic materials. The Fish Chair's outer surface is available in various attractive colors—among them, red, orange, blue, yellow, and green—while the interior surface (the one on the inside of the hollow space in the chair) is always white. Before hitting upon the definitive model design for the Fish Chair, Pakhalé tested different configurations for the rear supports. In the end, the one finally chosen can be seen at the top of the opposite page.

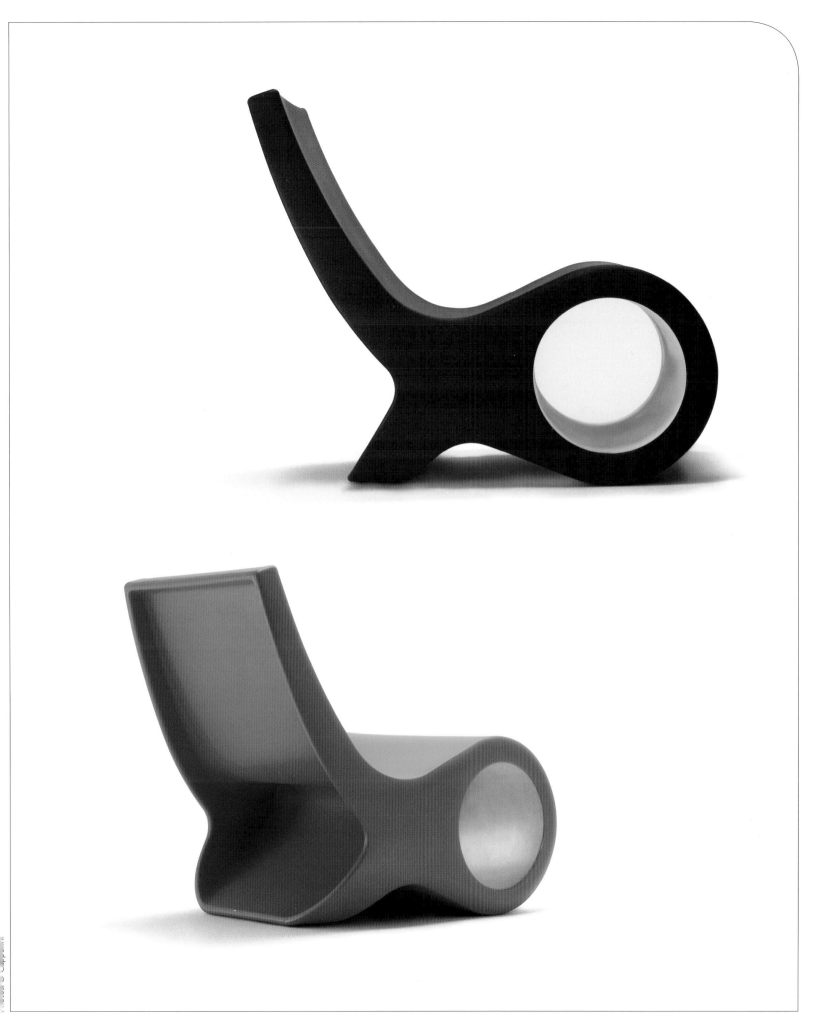

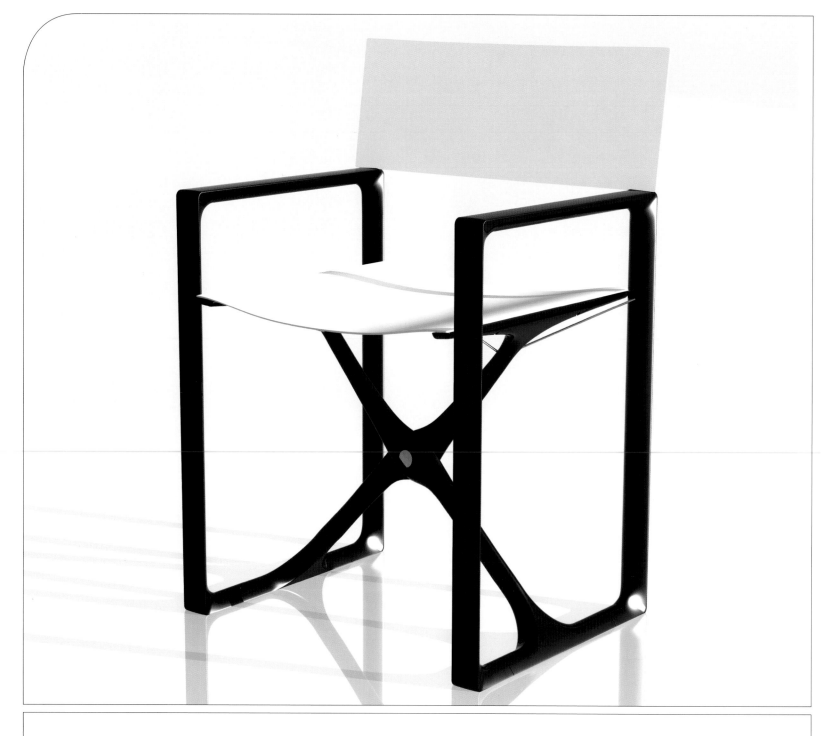

La Regista, Pile Up, Mummy | Michel Boucquillon for Serralunga | 2005 | www.michelboucquillon.com

The traditional "director's chair" has been revisited and majestically updated by Michel Boucquillon. Made in black carbon fiberglass with a silver finish for the backrest and seat, La Regista is an extremely light chair, perfect for indoor, as well as outdoor, use. Once folded, the chair is hardly more than 5.5 inches thick. The fabric used for the seat and backrest is soldered to the chair's structural support and is similar to that used on the exterior of pleasure boats.

Pile Up, a stackable bar table, is also perfect for both the indoors and the outdoors. The top of the table has a carbon sheet 0.15 inch thick and sup-

ported by a rod in the shape of an inverted cone. Only the legs of the table are made using the casting technique. All this keeps the table somewhere between its actual light weight and its seemingly "heavy" and "strong" aesthetic.

The Mummy table, on the other hand, was conceived practically as a challenge to the laws of physics. Its shape, elegant and minimalist, seems incapable of proper balance, yet it is really very stable. This apparent structural miracle is achieved by the table's curved belly, the true mark of its identity.

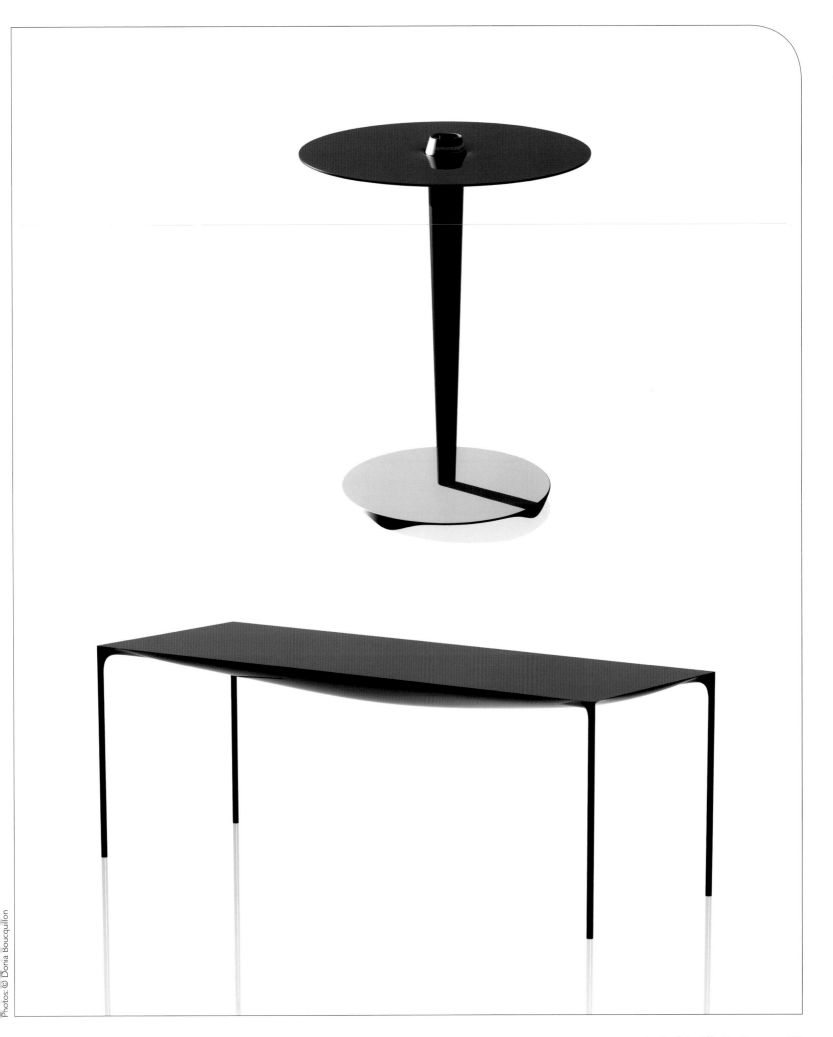

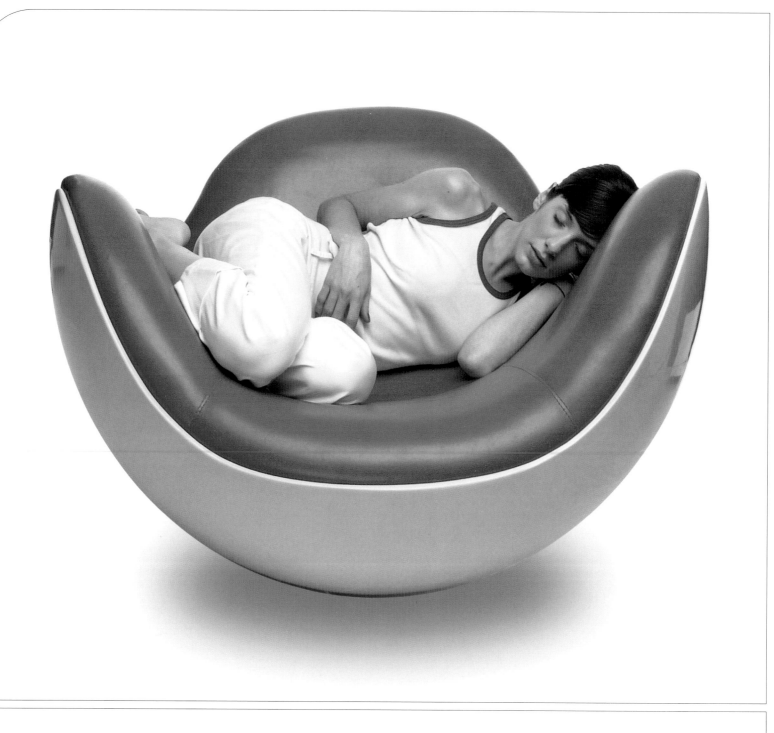

Placentero | Brion Experimental by Batti | 2006 | www.brionexperimental.com

The designers at Batti used the uterus as a starting point when designing the Placentero. In fact, the name Placentero (in Spanish) is nothing more than a play-of-words on the term placenta. Once this starting point was determined, the only prerequisite in designing the Placentero was a natural one: This sofa-chair should be able to hold a curled-up person without any difficulty. The outer shell and the upholstery's interior base are made of fiberglass finished with a gel coat, allowing for easy repair with polishing paste in case of scratches or cracks in the shell. This, in turn, reduces the possibility of scratching or cutting the user. The Placentero, which measures

43 inches in diameter, 28 inches in height, and weighs 71 pounds, achieves its balance by using the user's own weight, although a 33-pound counterweight has also been installed in its lower part. In reality, the color of the outer shell is a very light gray, almost white (cool gray 1C by Pantone). The Placentero permits the user to move about comfortably and allows him or her to assume practically any position without losing stability. The Placentero "revolves" and "rolls" without a hitch and, in this sense, is as flexible as any lounge chair with these characteristics.

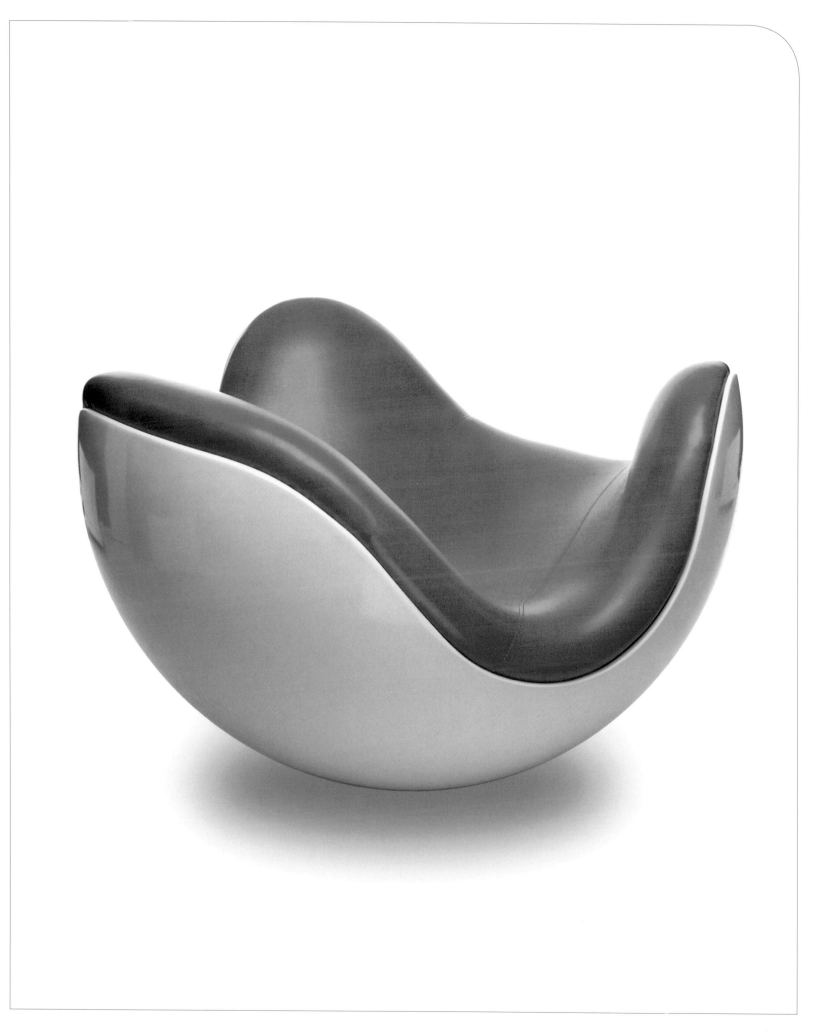

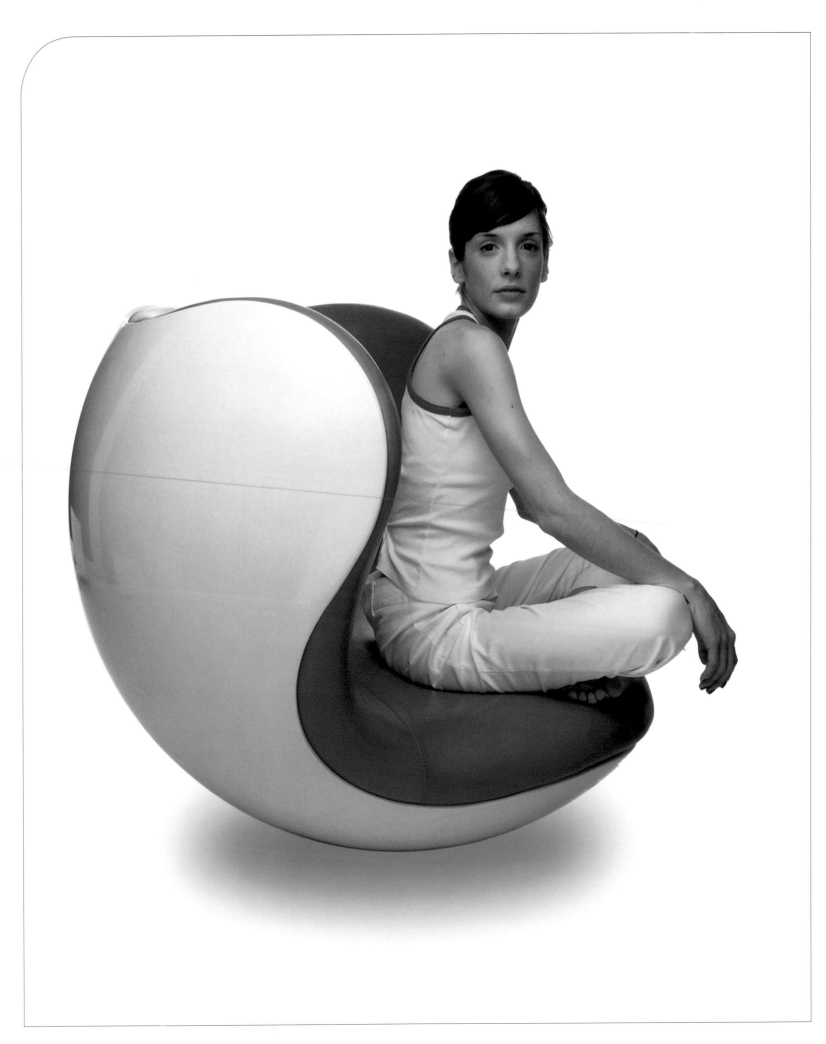

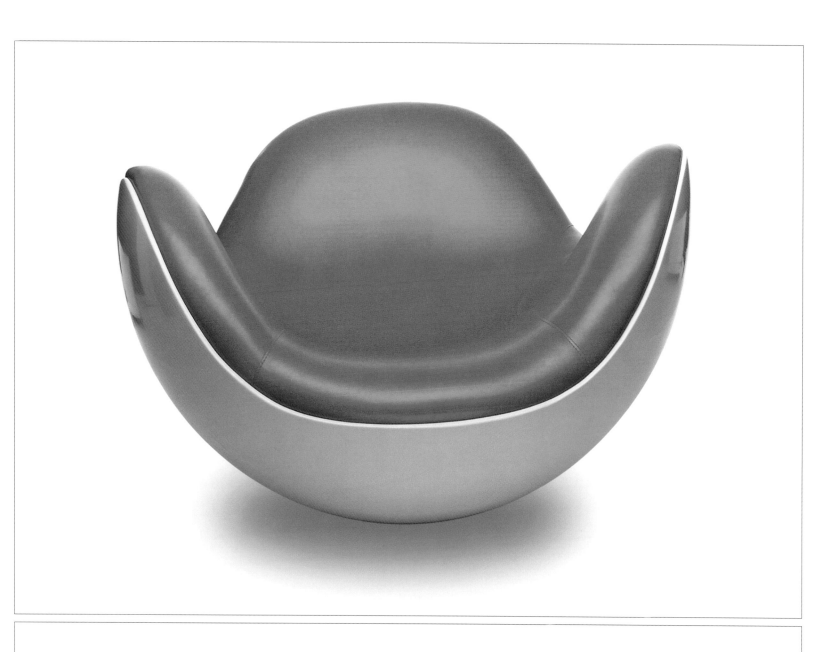

The Placentero can adapt itself to any posture the user may assume thanks to an ingenious design that plays with the user's weight and the counterweight situated in its lower portion. Each of these balances out the other. That's to say that the exterior part of the structure that touches the floor will change in appearance according to the posture chosen by the user.

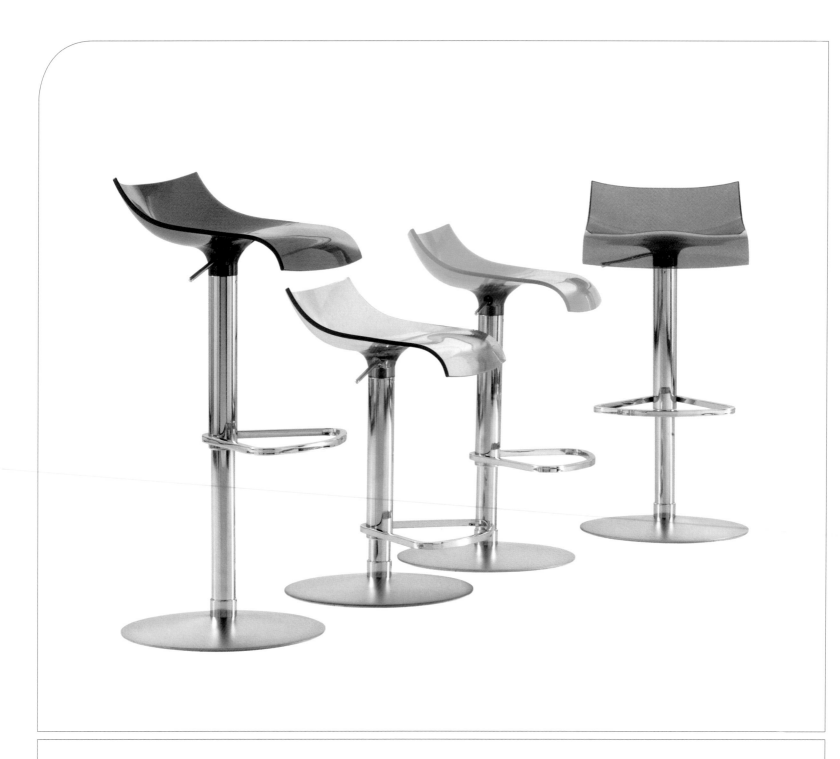

Pam | Studio Archirivolto for Ligne Roset | 2003 | www.archirivolto.ita

What is the ideal bar stool? If we think about it for a minute, we might conclude that the ideal bar stool should look suspiciously like the Pam, designed by Studio Archirivolto. Pam unites aesthetics with functionality like no other product of its kind on the market today; this thanks to a series of unique characteristics: a gas piston that adjusts its height, an attractive, ergonomic seat made of PMMA (although it is also available in oak, walnut, and "synderme" leather), and a matte-chromed metal frame with a shiny chromed footrest. The height is adjusted by means of a small, almost mini- malist designed lever situated underneath the right side of the seat. This provides an adjustable height of 1.64 to 2.49 feet high (in other words, the total adjustable range is 0.85 feet). The footrest is not integrated into the base of the stool itself but is built in such a way that it "hugs" the stool. This makes for a unique look, much more modern than usual. The seat measures about 1.37 × 1.37 feet. The result is an elegant and fashionable bar stool, equally at home in that retro-oriented bar designed for young patrons as it is in the more elegant private home.

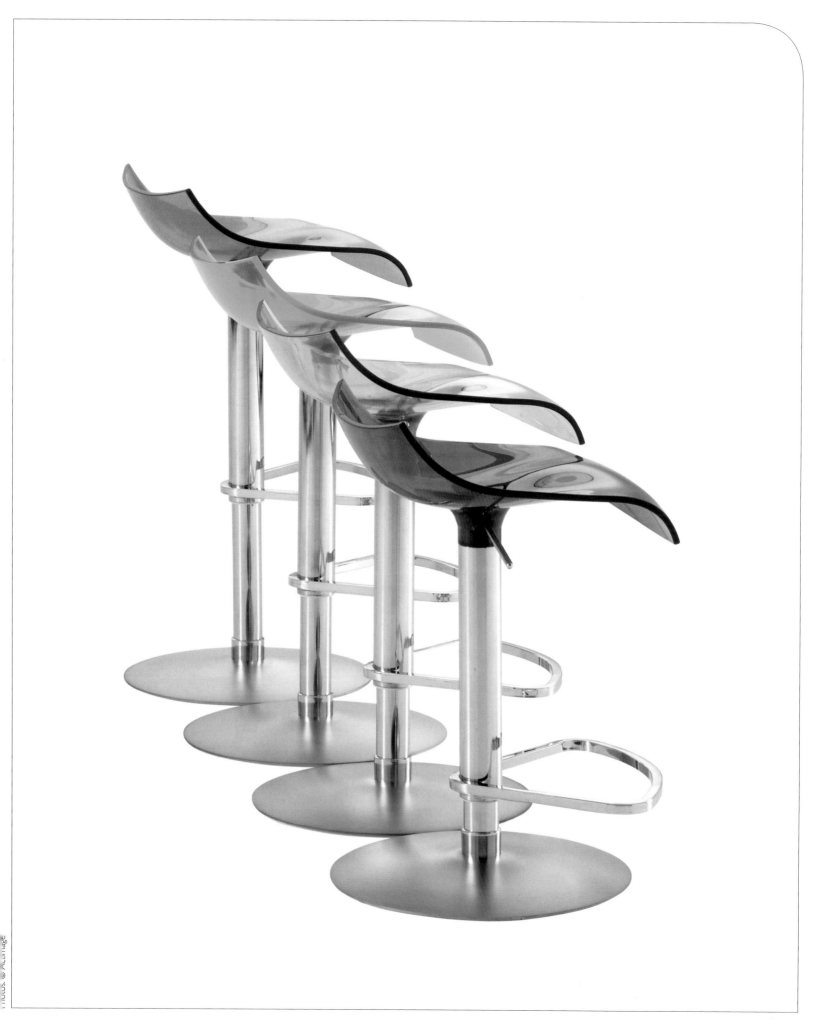

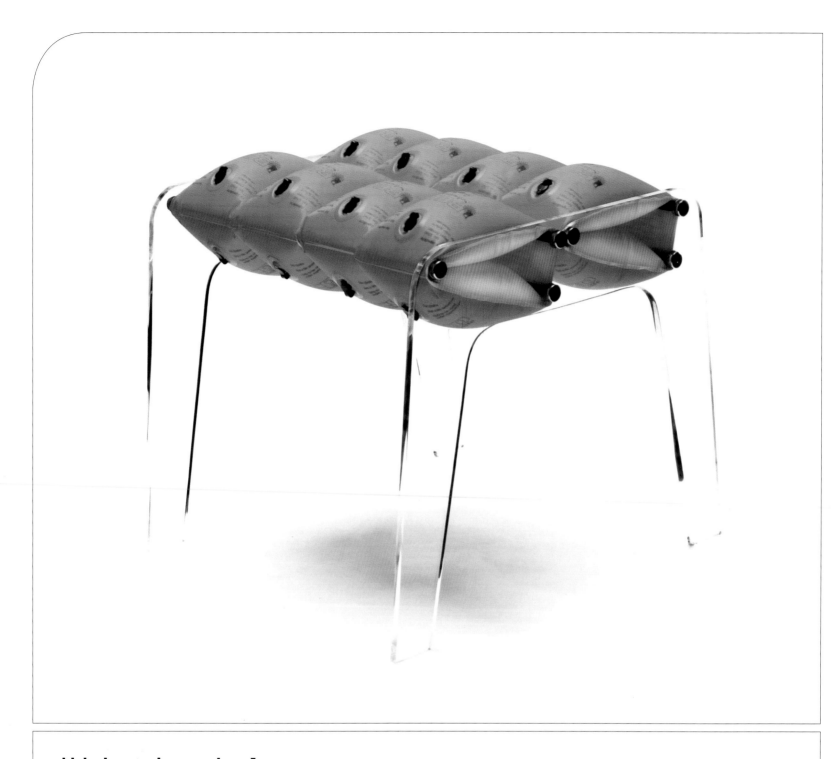

Waterwingsstool | David Olschewski Produktdesign | 2006 | www.davidolschewski.de

What are the potential uses of a simple set of water wings, aside from the obvious? Possibly, David Olschewski would say, many more than we might initially think. To give a completely new use to an object about which everything has already been said is a favorite task among the more daring designers, those who don't limit themselves to walking the beaten path but choose instead to venture beyond that with which everyone is already familiar. Waterswingstool is an example of this. It's a stool made with two sheets of acrylic plastic (the legs), joined together by six metal rods that, in turn, serve as supports for eight water wings, which double as a seat cushion, substituting for the traditional stuffed cushion. The result is a piece of furniture that, contrary to the usual, is aware of its own eminently experimental and purely aesthetic character: The aesthetic experience of the piece goes far beyond its mere functional aspect. The sense of humor demonstrated by the Waterswingstool is without a doubt one of its strong points, as is its innovative aesthetic, which promises to attract attention, aided by the fluorescent orange color of the eight water wings.

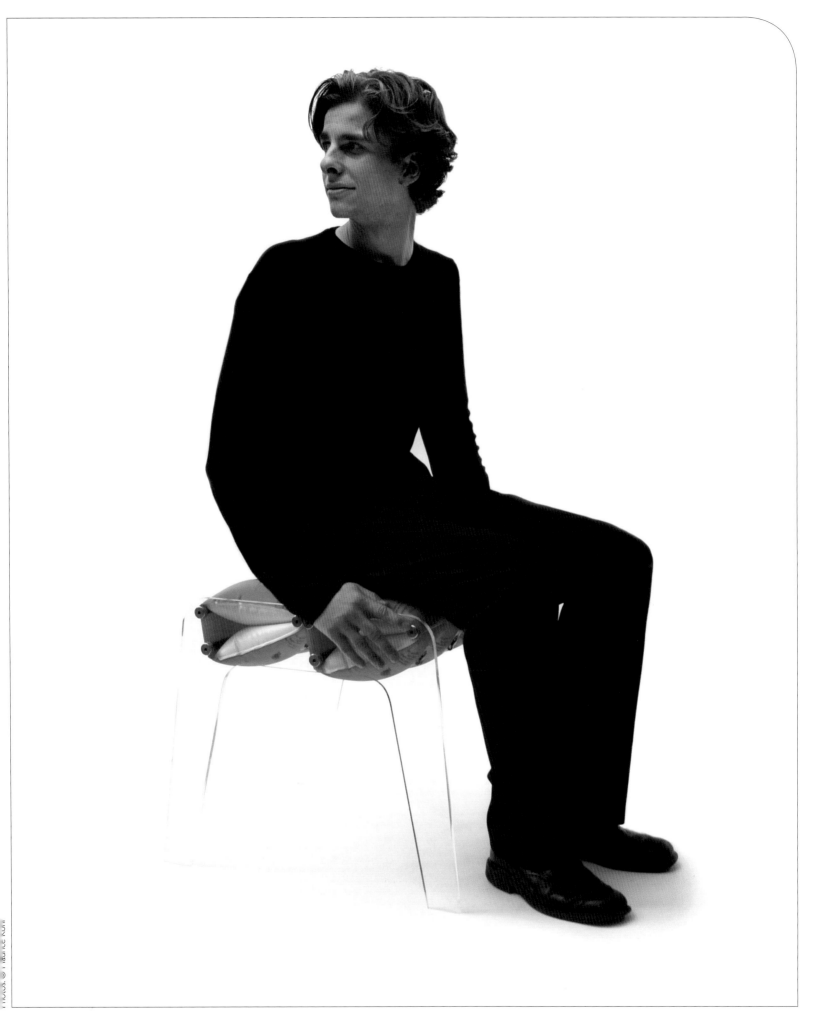

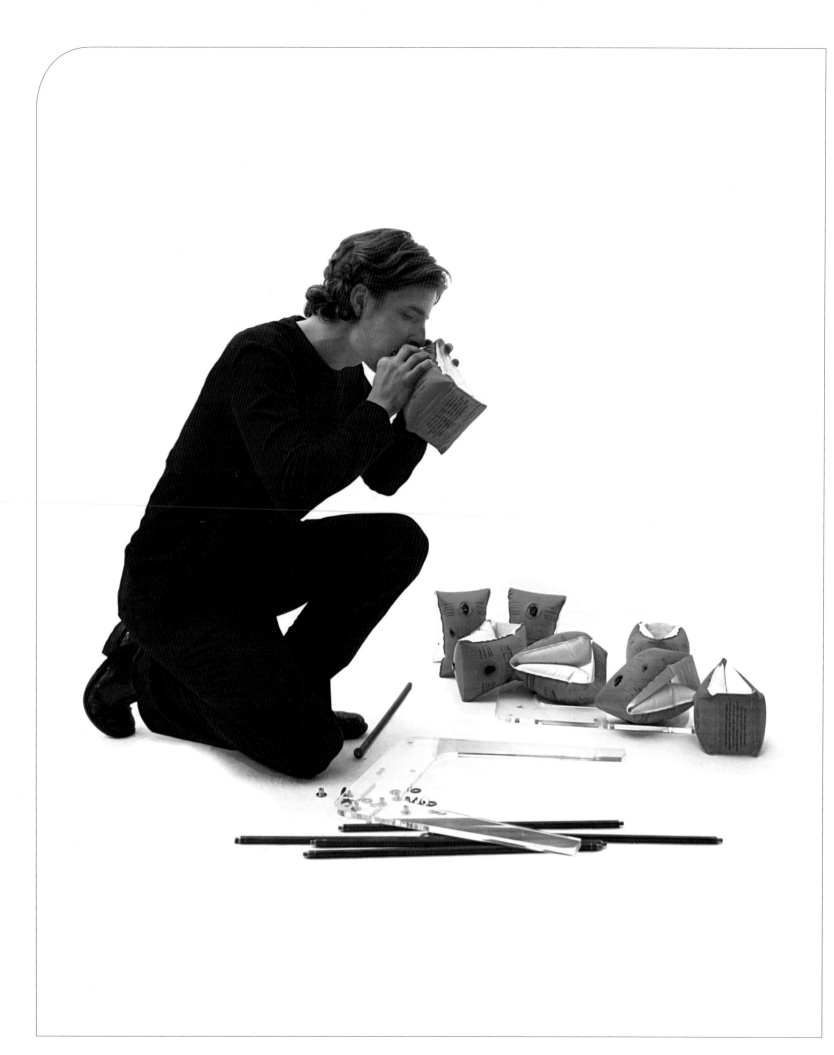

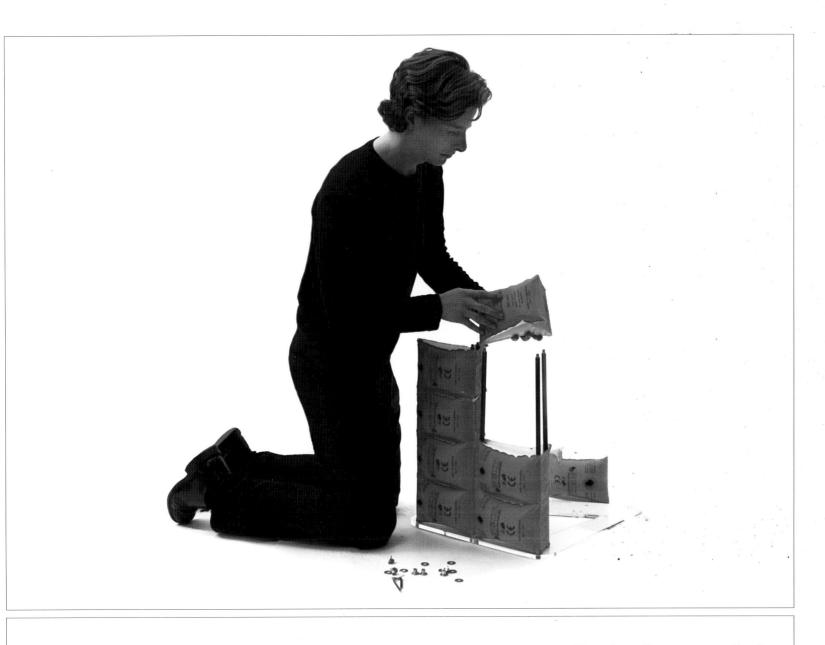

Waterswingstool is very easy to assemble and take apart, which means it can be stored away without any problem in a matter of minutes. Its simplicity makes it ideal as a "spare" chair in situations in which that one extra seat is needed for a guest.

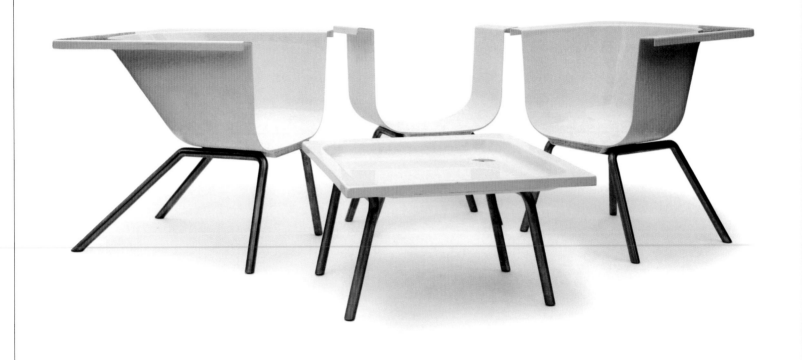

Bathroom | David Olschewski Produktdesign | 2006 | www.davidolschewski.de

German designer David Olschewski is an authentic expert of alternative, or "lateral," thought in the world of industrial design. If any object, any piece, or any furniture has a use beyond which the average designer would never venture to attempt, Olschewski perceives this as a challenge in every way, one to which he must immediately respond with some heterodoxical interpretion of his own. Bathroom is a perfect example of this. Where others see only a conventional shower floor and bathtub, Olschewski sees a table and three easy chairs. Original? Yes, and a daring, unconventional and breakthrough design. Made of Plexiglas, Bathroom comprises four pieces: three chairs that, when put together, resemble a bathtub and a center table that in reality is a shower floor with legs. All four of the set's pieces have stainless-steel legs. The root of the project is the article "The Open Work Of Art," by professor of aesthetics Umberto Eco (author of the books *In the Name of the Rose* and *Foucault's Pendulum*). In this article, he reflects upon the different possible interpretations of the same piece of art. The result is a product that, in the words of David Olschewski, "invites the user to experiment with it sensorially."

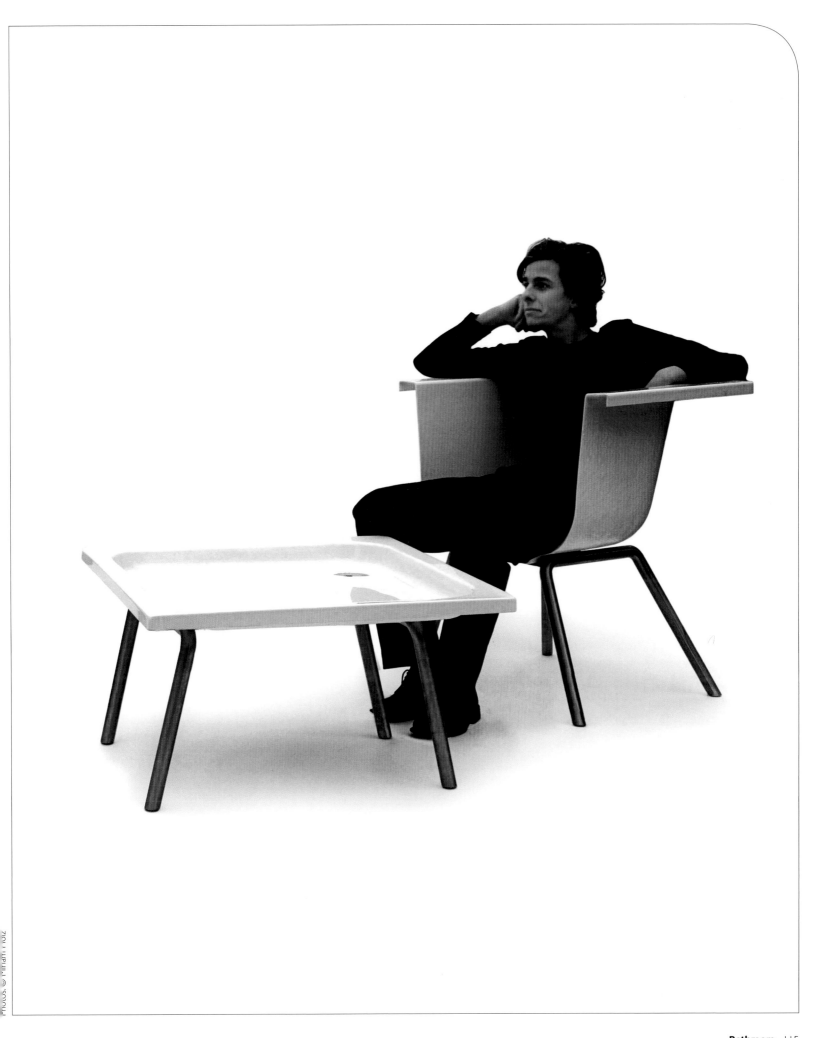

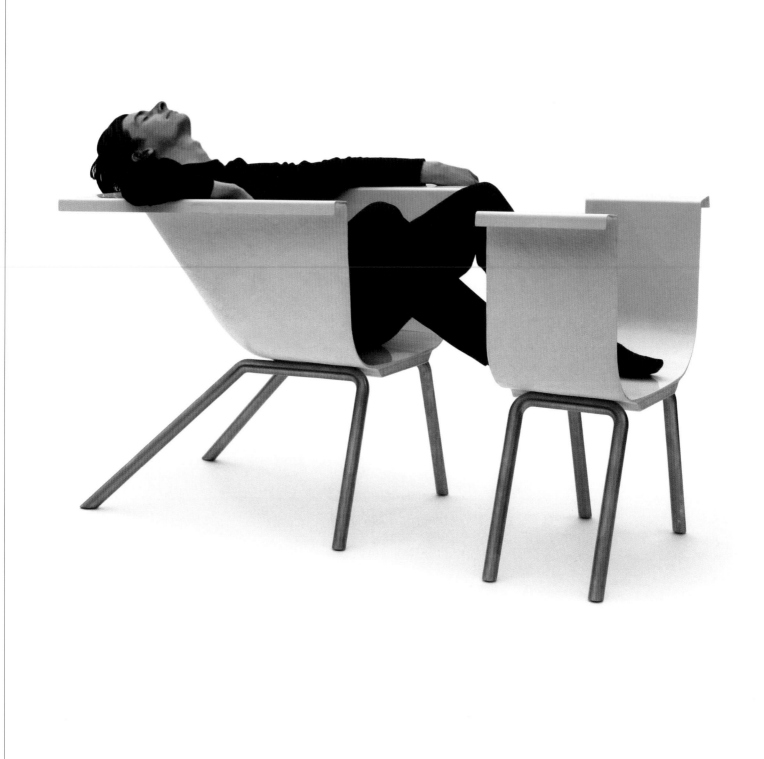

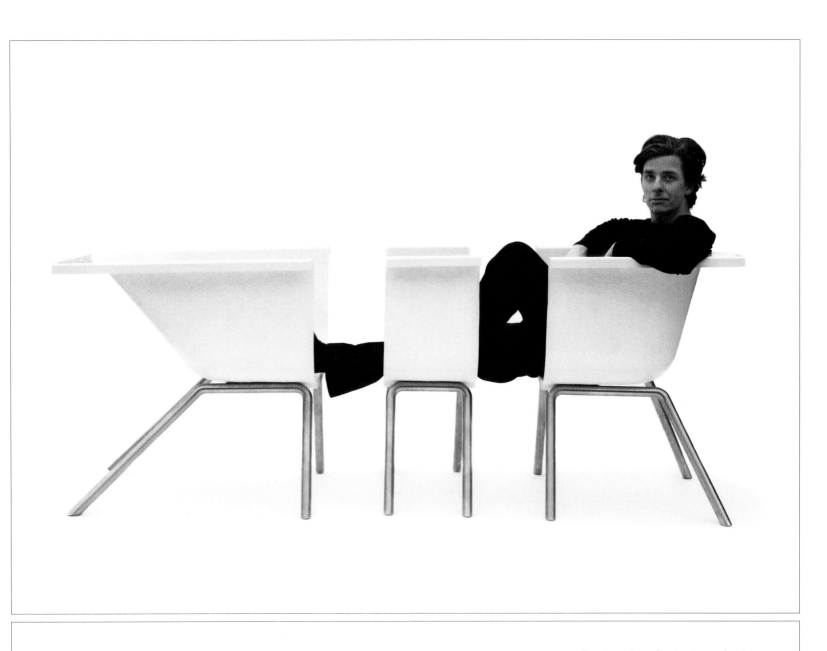

The three pieces forming the set function as chairs or armchairs, with and without backrests, but also as a footstool or perhaps as an extra, or even central, table. The main characteristic here is flexibility, which allows the arrangement of the three pieces in a variety of ways, thus changing their primary purpose.

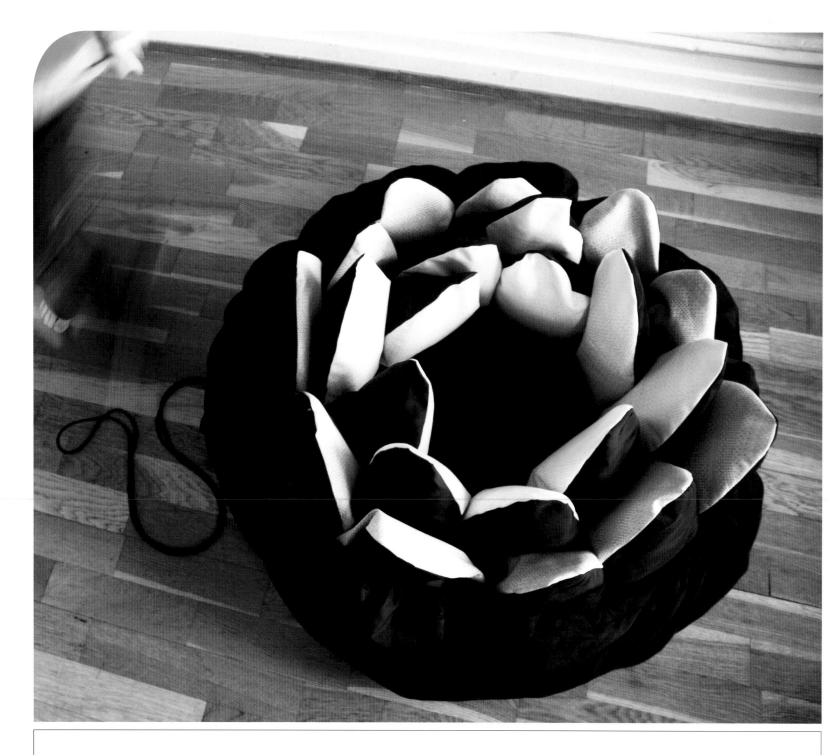

Dream Bag | Ulrika E. Engberg, Kasper Medin | 2007 | www.ulrikaengberg.com

Shown for the first time at the Stockholm Furniture Fair, in February 2007, the Dream Bag is a giant cushion, made of foam-filled polyester and Beaver Nylon, that opens up as if it were a flower. When closed, the Dream Bag looks like a large cloth bag supplied with an elastic band that closes it tight and allows the user to comfortably pull it around the house. Once opened, the Dream Bag is converted into a flower-shaped cushion made up of various smaller cushions (the flower petals) and a circular base. The petal cushions give the Dream Bag its volume and are perfect for children to play with, since each one moves independently of the next. Nevertheless, the Dream Bag also has an intermediate "position," at which point it seems more like a sofa than the aforementioned giant cushion. This happens when the petals are enveloped in the object and no part of them can be seen coming out the top. The elastic band must also be partially loosened, just enough so the bag doesn't open completely. In this fashion, the Dream Bag adopts the shape of a soft and comfortable chair. At the moment, the Dream Bag is only a prototype and its designers are looking to find a producer to manufacture and sell the piece.

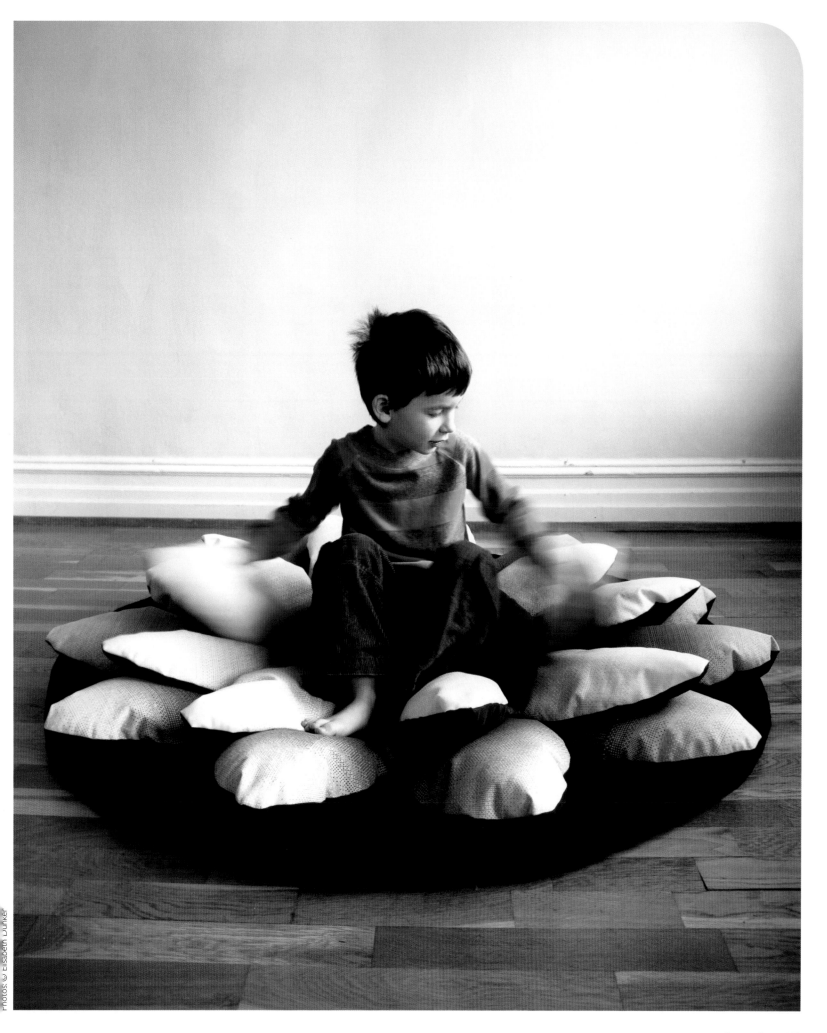

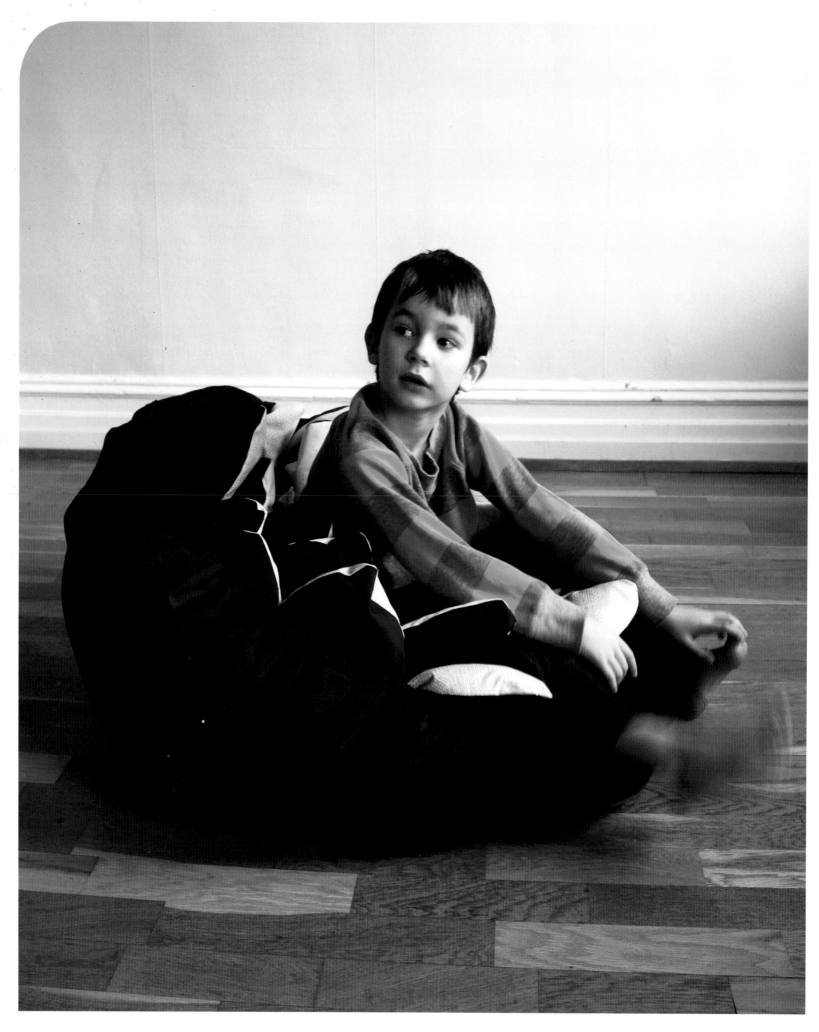

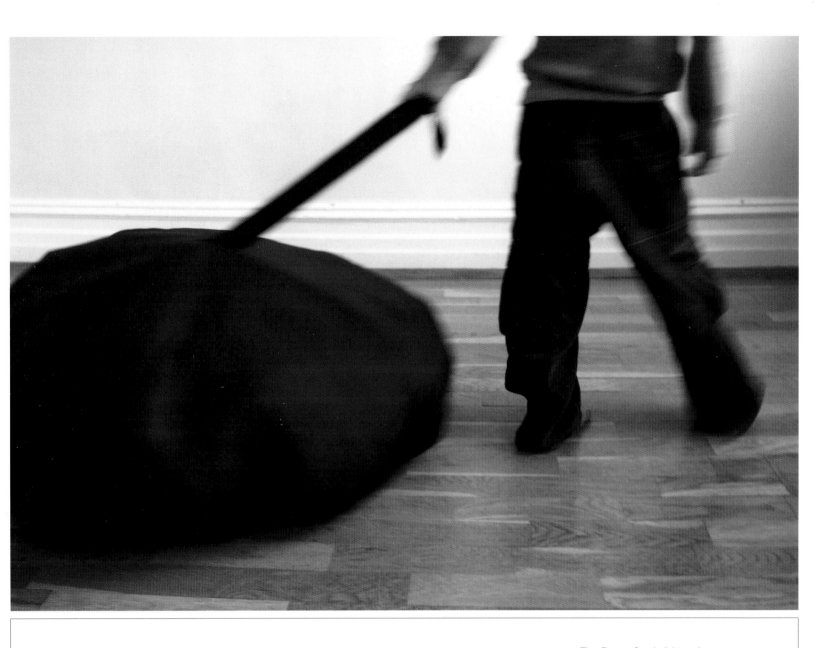

The Dream Bag is light and easy to move. Once the bag that contains the cushions is tightened and closed, it can be stored in any closet, although the elastic band that closes it shut permits it to be hung on any wall.

P Tree | Tanya Aguiniga | 2006 | www.aguinigadesign.com

Made of carved polystyrene, a polyurethane coating, and steel tubing, P Tree is the result of designer and creator Tanya Aguiniga's reaction to having experienced the cycle of the seasons. Aguiniga grew up in the city of Tijuana, Mexico, and the only nature that she'd had contact with, before moving to a wooded area was the kind created by people in an urban environment. This piece is Aguiniga's answer to the necessity of living life with some kind of permanent contact with nature or, when this is impossible, with some kind of object designed and shaped to bring nature to mind. The result is a tree trunk made of plastic that conveys, even though it is man-made, all the beauty of unspoiled nature. Although, as Aguiniga says, "it's glossier and easier to clean". P Tree is really a chair, though it may also function as a purely decorative element or as a substitute for any other type of similar household furniture (a clothes-horse, for example). P Tree measures 48 inches high, 36 inches wide, and 36 inches deep at its base. The piece has a shiny lacquered finish, which makes it almost a work of art.

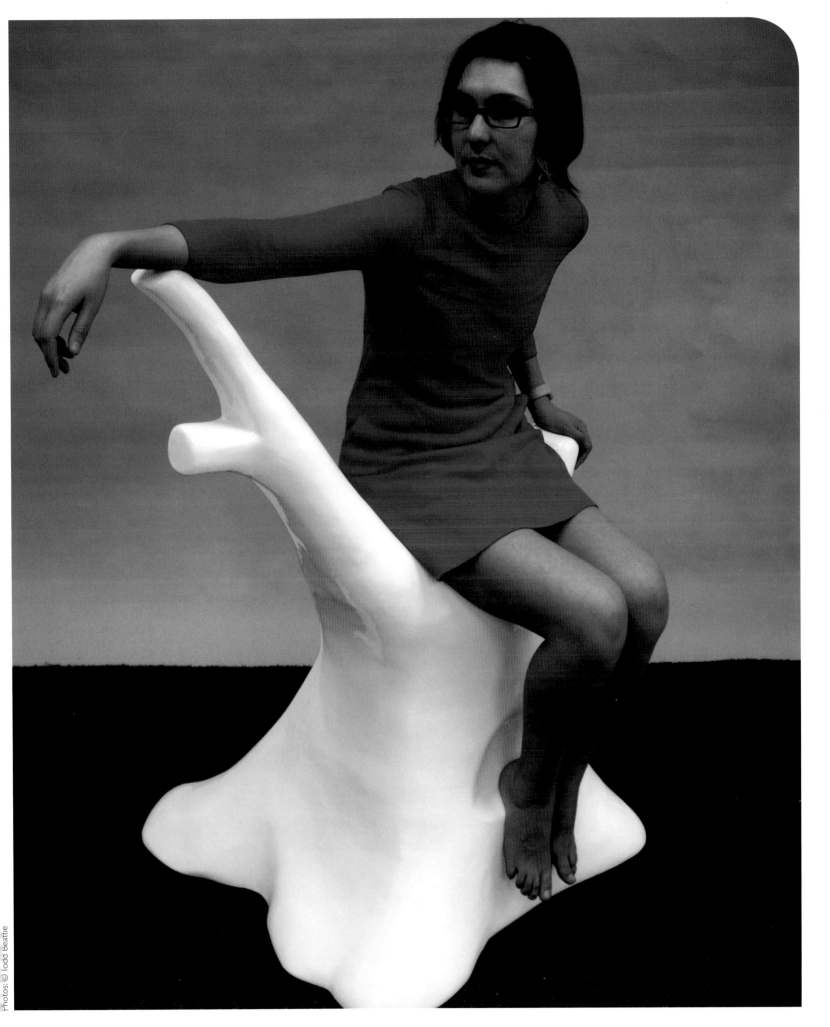

High-tech

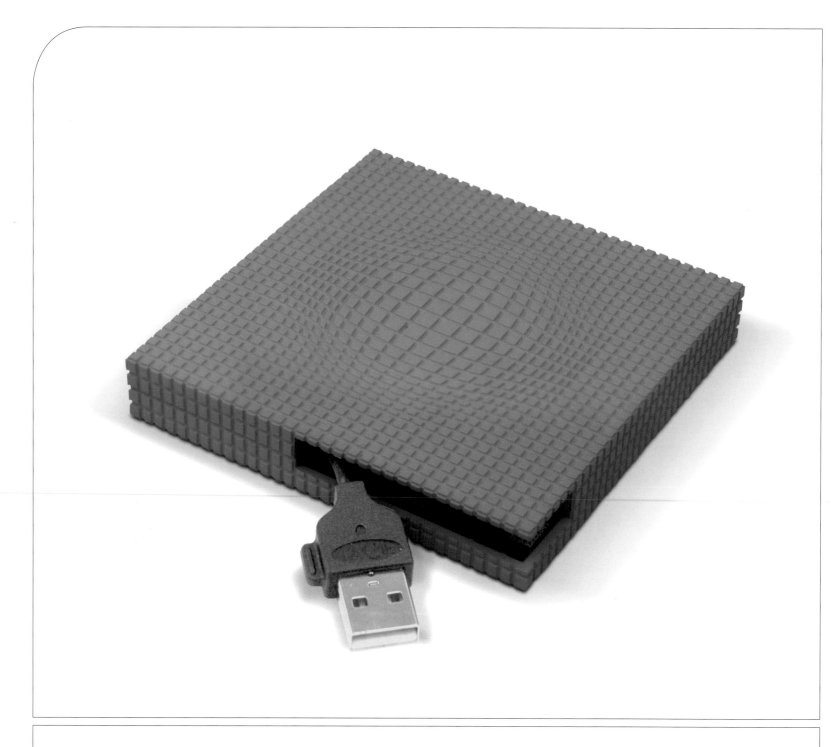

LaCie Skwarim | Karim Rashid for LaCie | 2006 | www.karimrashid.com

Fashionable designs have finally reached the portable USB memory device. Of course, the LaCie Skwarim, designed by Karim Rashid, is not your conventional portable USB device but an authentic portable hard drive with 30 and 60 gigabytes whose small size allows it to be stored in purses or even in the pocket of your typical double-breasted jacket. Karim Rashid's choice as designer to give a free-spirited, modern air to such cutting-edge technology was not mere circumstance: Amongst his clients are Prada, Umbra, Miyake, and Method. In the words of Olivier Mirloup, senior product manager at LaCie, "LaCie is known for making external information-storage devices that aren't just functional but also elegantly designed. LaCie Skwarim is the example: a simple hard drive, functional and fun for people who want to personalize and complement their look with a storage device of the latest technology. It's completely different from any other product available on the market today." The relief stamped into the rubber-textured plastic that covers the device is not an accident either: it attempts to symbolize the flow of information, facts, and creative energy that circulate day after day from one place in the world to the other without our ever being completely conscious of it.

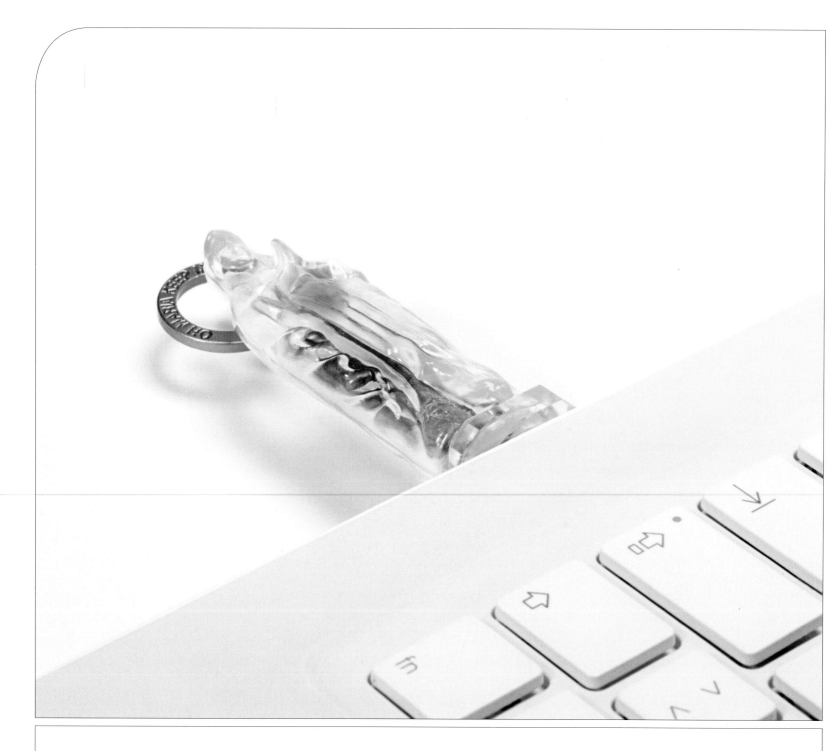

Maria USB | Luis Eslava for ABR | 2007 | www.luiseslava.com

Why does information stored properly on a computer or USB device mysteriously disappear? How can multiple gigabytes of information be stored in a device no bigger than 1.6 or 1.9 inches? Maybe science has an answer for this, but the Maria USB has been made for those who don't have total faith in it and prefer to reserve a small bit of skepticism in their beliefs about the mysterious and the unknown. With a storage capacity of up to 512 megabytes, the Maria USB is manufactured with two different plastics: The body of the device is made with an injected ABS translucent plastic, while the hood, halo, and base of the Virgin Mary are made with injected PS plastic painted a translucent gold. A red LED light signals when the Maria

USB is active and receiving or sending data. Weighing in at under half an ounce, it measures barely more than 3.5 inches. The Maria USB is an ironic answer to the avalanche of high-tech products with high-tech design that have flooded today's market. Also, the contrast between function (the storage of digital information) and aesthetics (something as traditional as the Virgin Mary) lends the USB a sly and humorous aspect that is anything but subtle. The Maria USB is one more on the long list of uniquely shaped USB drives being produced.

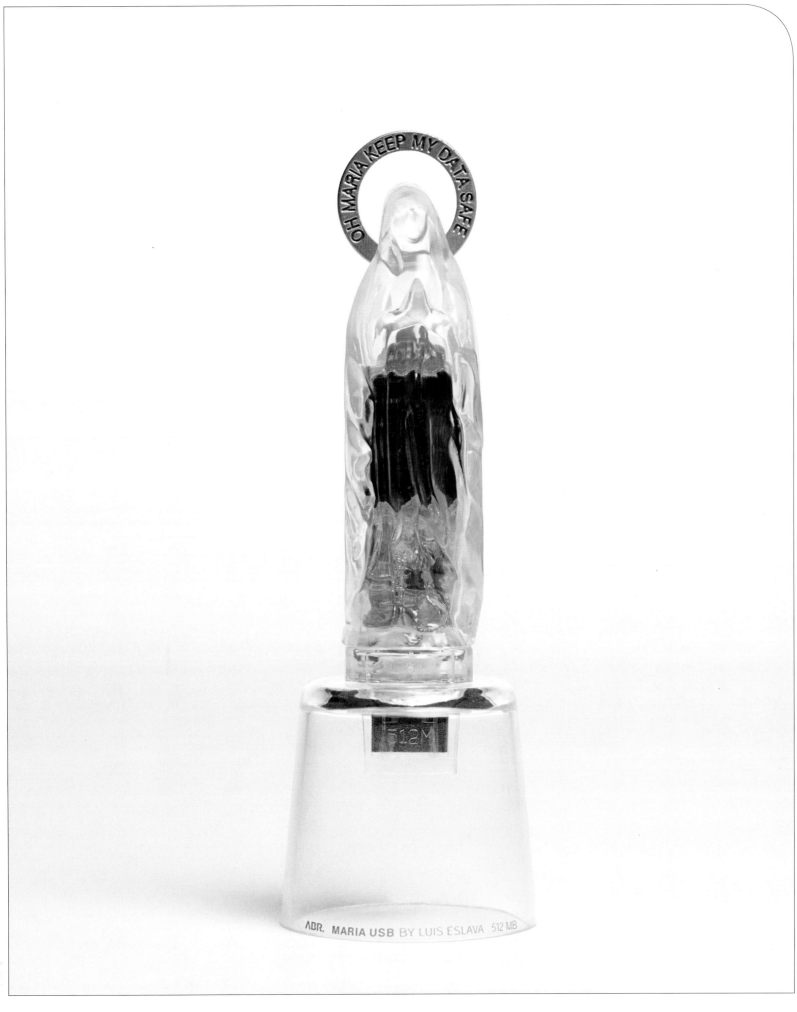

OH MARIA KEEP MY DATA SAFE

512M

ABR. MARIA USB BY LUIS ESLAVA 512 MB

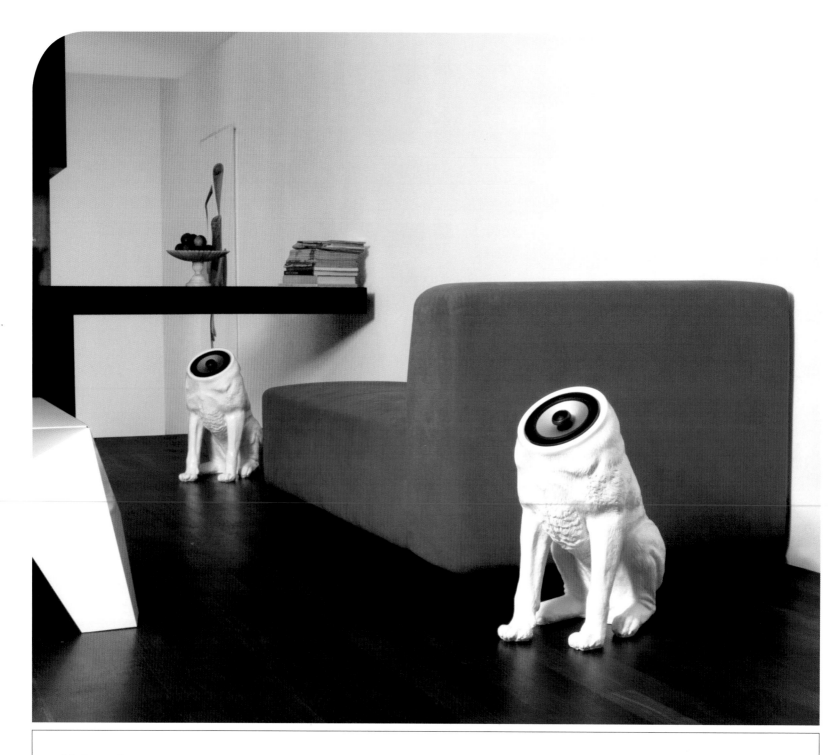

Woofer | Buro Vormkrijgers for Cultivate | 2006 | www.burovormkrijgers.nl

Can a kitsch object become something more than a… kitsch object? If you've seen the Woofer, apparently yes. No one should think, however, that in this case the word kitsch is a pejorative term: Sander Mulder and Dave Keune themselves have categorized the Woofer as "functional kitsch." The Woofer is nothing more than a conventional speaker for stereo sets, only it's in the shape of a porcelain dog and the speaker face is where the dog's head should be. And, of course, the dog isn't made of porcelain, it's made of polyester. The Woofer measures 1.4 by 0.9 by 1.6 feet and weighs approximately 18 pounds and is capable of 60-180 watts RMS and 4 ohm impedance. Although it is obvious that the speaker's quality cannot be com-pared with that of the more expensive and technologically advanced mod-els available on the market, it is good enough to enjoy a favorite cd with-out any problem. That is, as long as one can ignore the fact that that the music is coming from the neck of a decapitated dog. In this manner, an object that would never be considered anything beyond a merely decora-tive piece of kitsch becomes, thanks to the speaker inside, an object of desire that plays with ugliness and the most baroque of aesthetics with irony and humor. The proof is in the name: Woofer, adapted from the ono-matopoeia of a dog's bark.

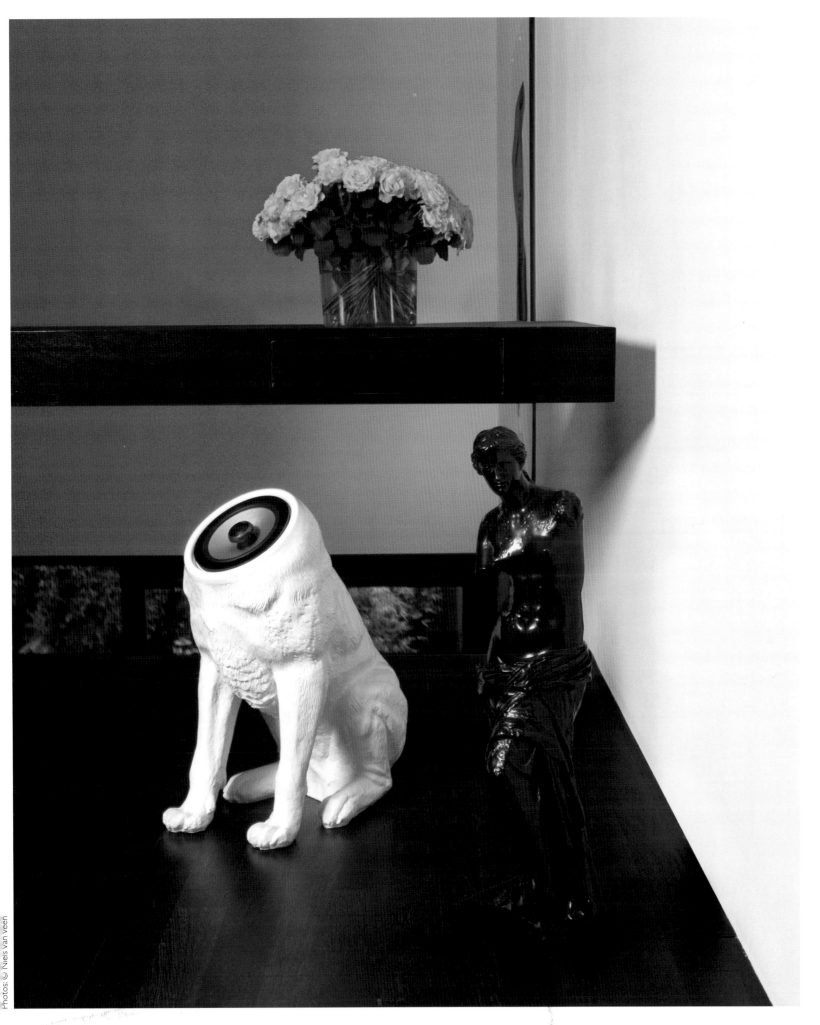

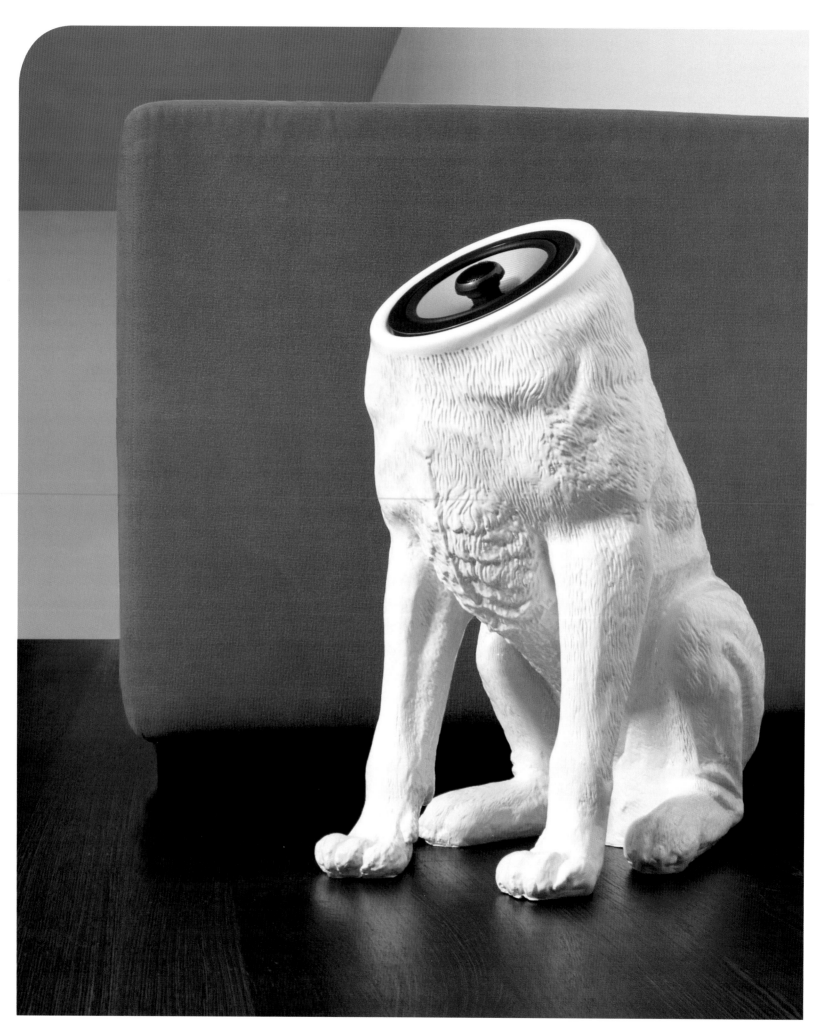

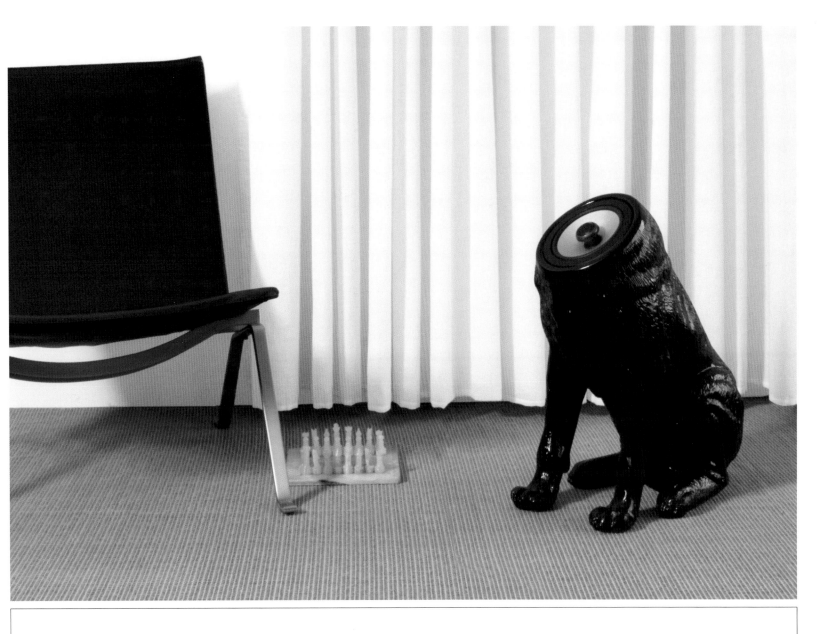

The fact that the speaker "points" toward the ceiling at an angle and not a straight line allows the sound to reach practically every corner of the room. Its lightweight speakers allow it to be easily moved around.

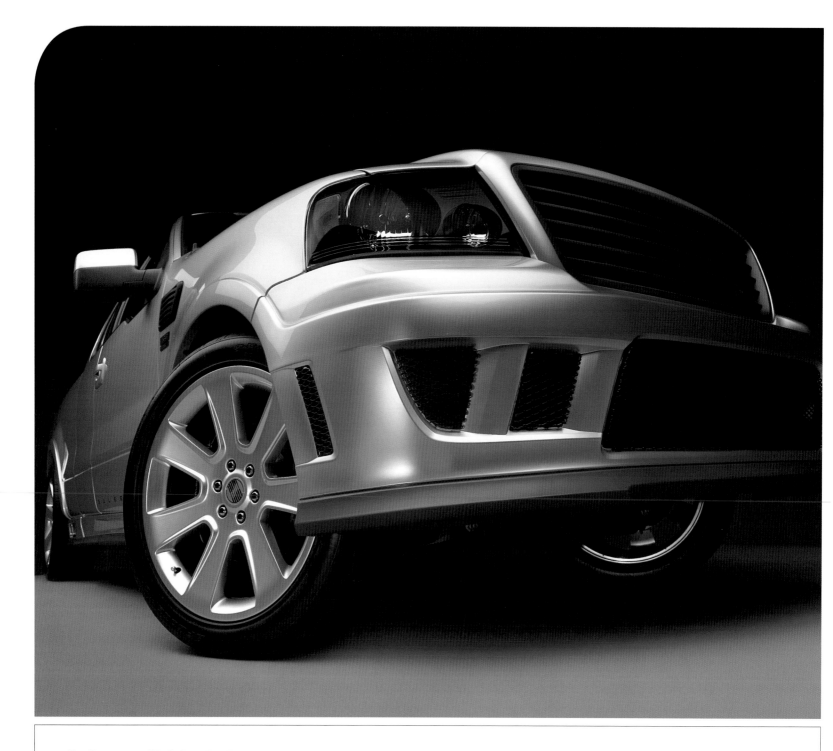

Saleen S331, Saleen Parnelli Jones | Phil Frank Design for Saleen | 2007 | www.phil-frank.com

For some time now, all types of plastic materials have been a regular part of industrial automotive manufacturing. This is because these materials have improved greatly in terms of durability, resistance, flexibility, and dependability. Perfect examples of this are the two vehicles shown in these pages. Both the 2007 Saleen S331 Sport Truck and the 2007 limited-edition Mustang Saleen Parnelli Jones use injection-molded ThermoPlastic Olefin (TPO) for all the exterior components, including front and rear fascias, front and rear grilles, fender flares, side skirts, spoiler, and interior gauge pod. Plastic mate-rials allow a wide variety of possibilities in the world of automotive engineering and can be found in practically each and every corner of the vehicles we see on the roads each day. Modern plastics and contemporary manufacturing processes have united, bringing to light pieces of sculptural beauty and depth of detail. In the Mustang's case, the directive was to create a series of components while making best use of the aforementioned plastic materials, would respect the brand-name aesthetic and image of one of the greatest classics of all time in the automotive world.

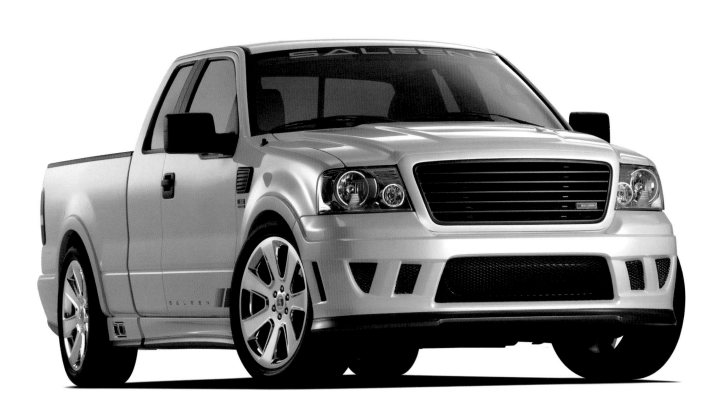

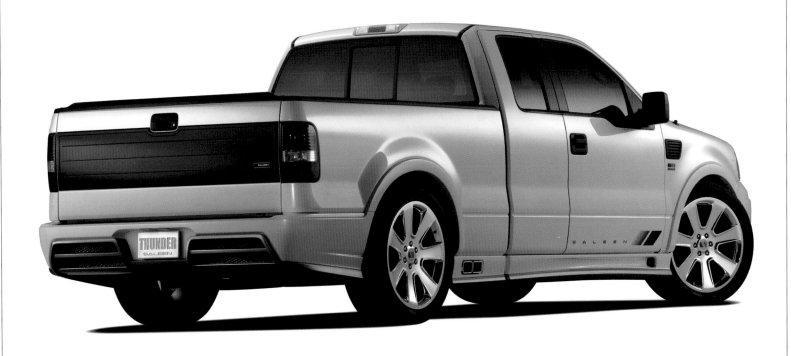

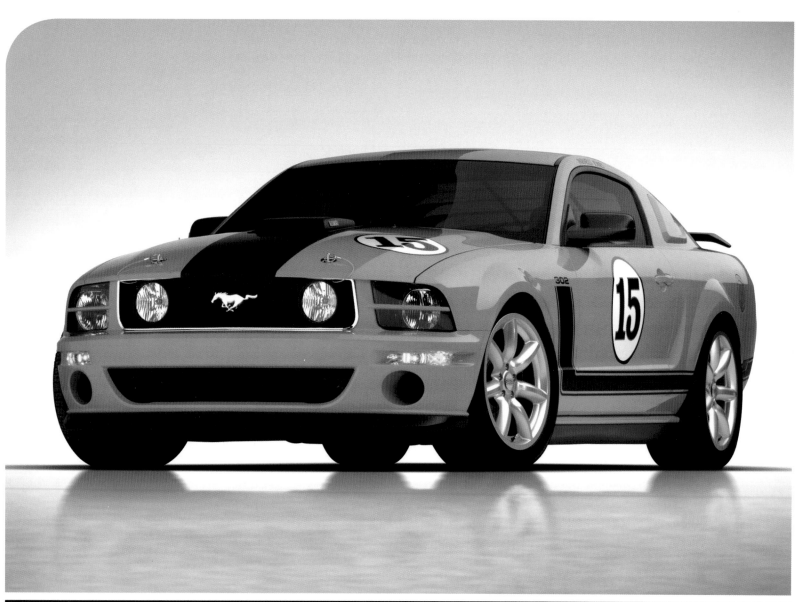

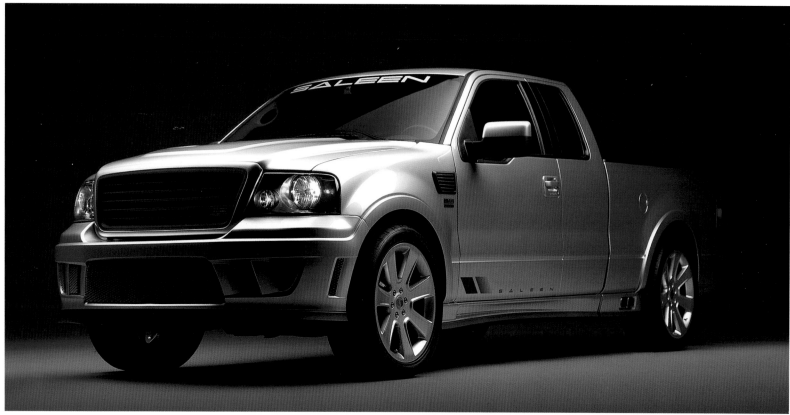

The Mustang is a key icon in North America's automotive industry. The mythology that surrounds it and gives it cult status is similar in many ways to that of the Harley-Davidson name. Phil Frank approached the job of designing a series of components that would modernize the brand's image with a respect that stems from this iconic name.

Mus2 | Art.Lebedev Studio | 2006 | www.artlebedev.com

Mus2 is a two-button, wireless mouse made to resemble the traditional pointer that navigates across our computer screens. Though its shape might at first seem uncomfortable, the mouse has been designed to adapt perfectly to the user's hand. A small light goes on when the mouse's batteries have died or are about to die, informing the user that he or she must recharge it. The Mus2, made with a nice matte plastic, is compatible with Macs or PCs, connecting with a USB. It has a functional range from 6.5 feet, which means that the user can navigate his or her computer screen from that far a distance away. If the user stops using the mouse and a few seconds pass by, it will go into sleep mode. Its size is practically identical to that of Microsoft's optical mouse, the kind normally found at most workstations. It is also slightly larger than a mouse made by Apple. Mus2 also comes in a simpler version, called Mus, which has a shiny finish and only one button. Though right now it is merely a prototype, Art.Lebedev Studio is considering the possibility of adding another button and a movable roller.

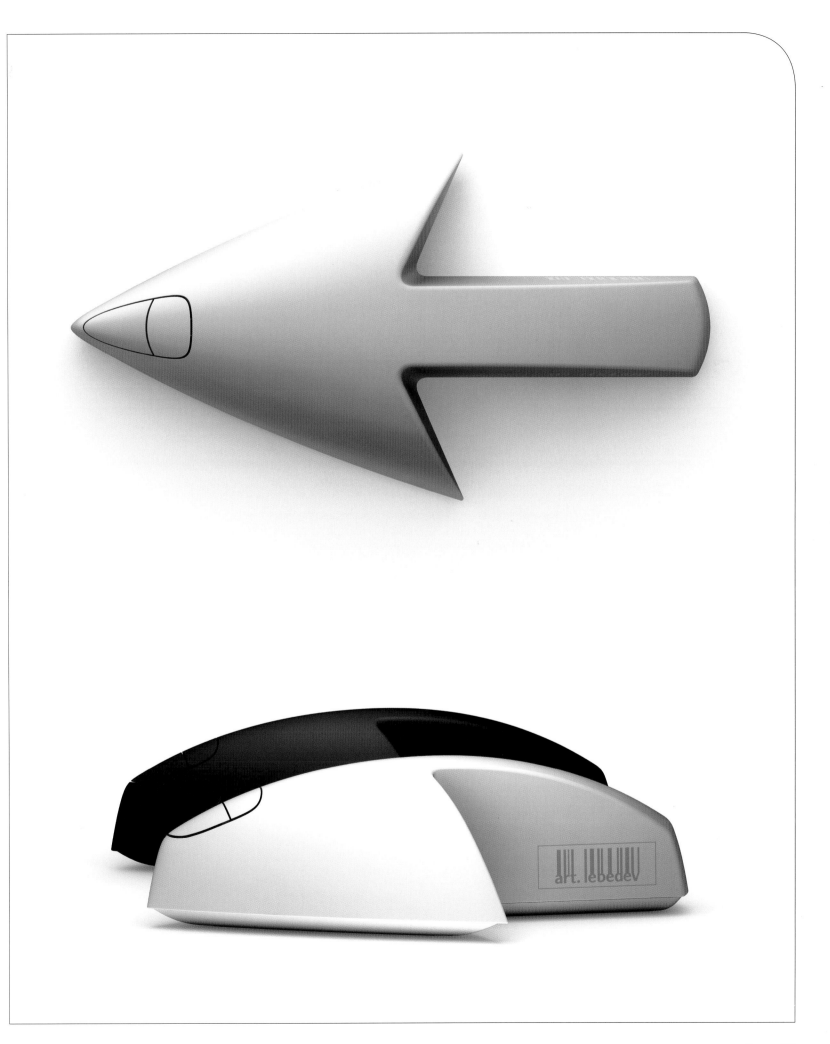

Kitchen
and bath

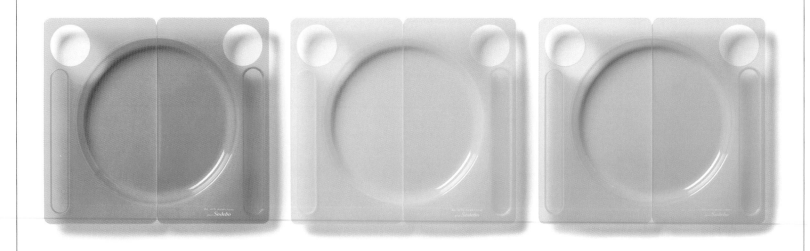

Din_Set | Matali Crasset for Sodebo | 2005 | www.matalicrasset.com

Matali Crasset was charged with designing an easy-to-clean, transportable plate aimed at the lunch-on-the-run crowd for the food-manufacturing company Sodebo. The result is a piece made from injected polypropylene, Din_Set. It is, in the words of Matali Crasset, "an individual tablecloth, a serving tray, and a plate all in one." The Sodebo project made no attempt to reinvent an object about which everything has already been said, attempting instead to "reeducate" people about appreciating the lunch time moment of rest. In reality, the plate is a folding tray, easily stored, with two holes for cups (one on the right, the other on the left) and two long recesses (also one on either side) for utensils. It is available in three different colors to highlight its "fun" aspect, and its tactile effect is smooth and pleasant, with no sharp edges. Once opened, the Din_Set will maintain rigidity without any type of pressure on the user's part, which makes it very comfortable. Its light weight and small size (once folded) make it perfect for transport in a briefcase or purse. It can be easily cleaned, owing to its lack of hidden corners where food might accumulate, and it is extreme-temperature-resistant.

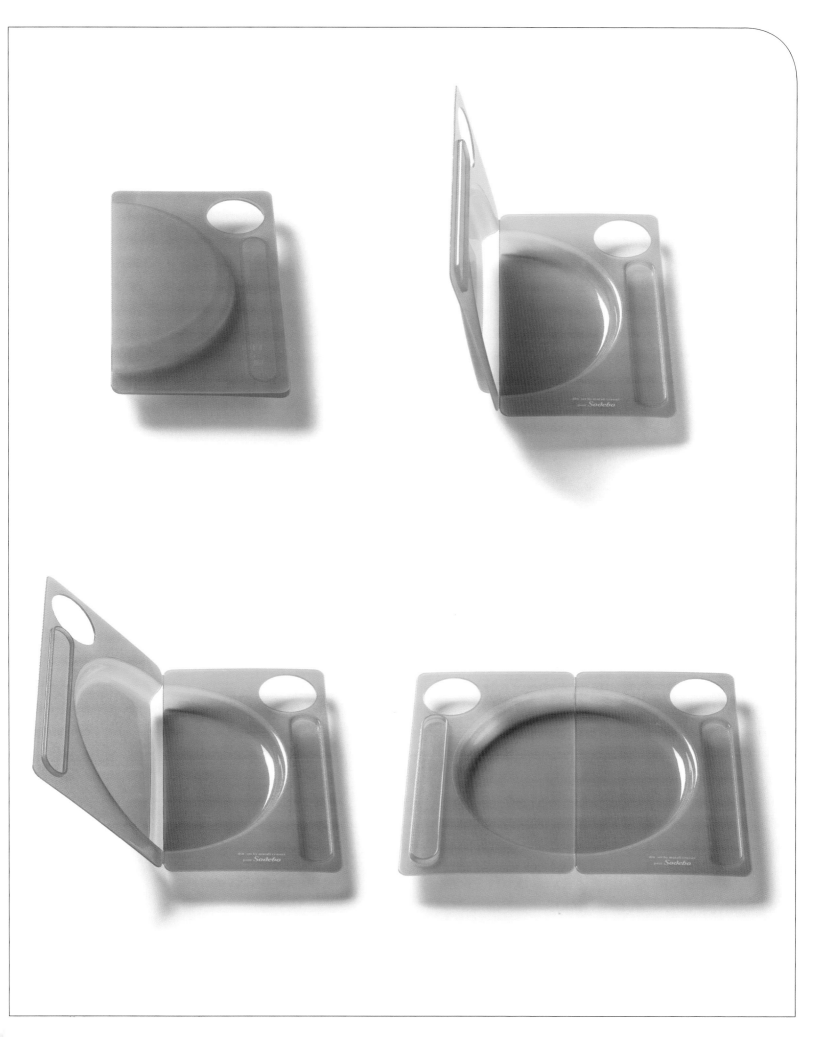

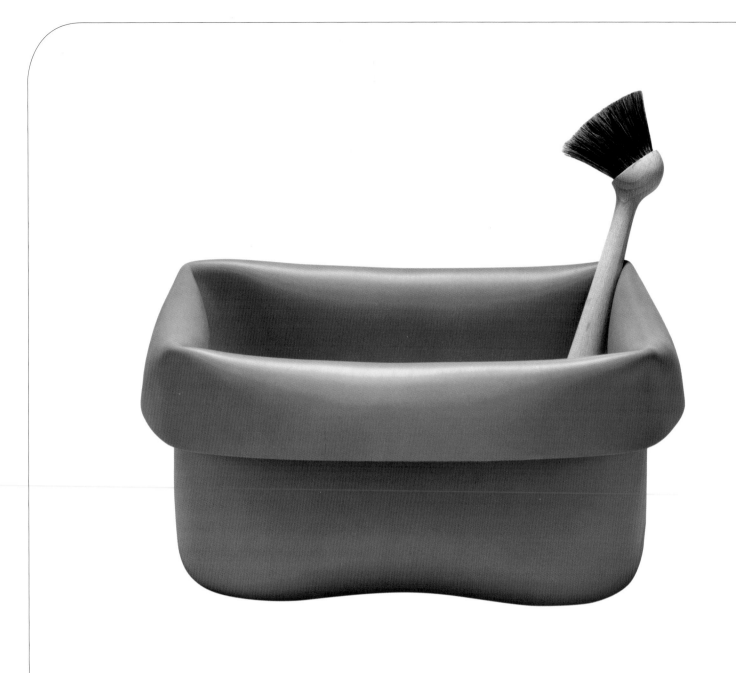

Washing-Up Bowl and Brush | Normann Copenhaguen by Ole Jensen | 2002 | www.normann-copenhagen.com

As has been well defended in liberal economic theory, the ego is the engine of change and human progress. When designer Ole Jensen rebelled against his stainless-steel sink, refusing to continue to risk washing his prized porcelain china and crystal glasses in such an inflexible space, he got the idea for the Washing-Up Bowl: a flexible rubber bowl capable of adapting itself to any of the almost infinite shapes of a modern kitchen's objects. The Washing-Up Bowl's design is the result of many hours of work, although the effort has had its rewards. Currently, the Washing-Up Bowl can be found in the Museum of Modern Art's (MOMA) restaurant in New York, although its use there is slightly different from the original intent: It is used as an ice bucket for champagne. In any case, the Washing-Up Bowl has continued to evolve through the years. The first models were available only in black and red, a nod to car and bicycle tires, but now it is possible to find them in pink and light blue, yellow and green. The Washing-Up Bowl was awarded the prestigious International Design Plus prize by the famous Phaidon Design Classics, which classified the Washing-Up Bowl as one of the 1,000 most relevant and noteworthy designs in the history of design.

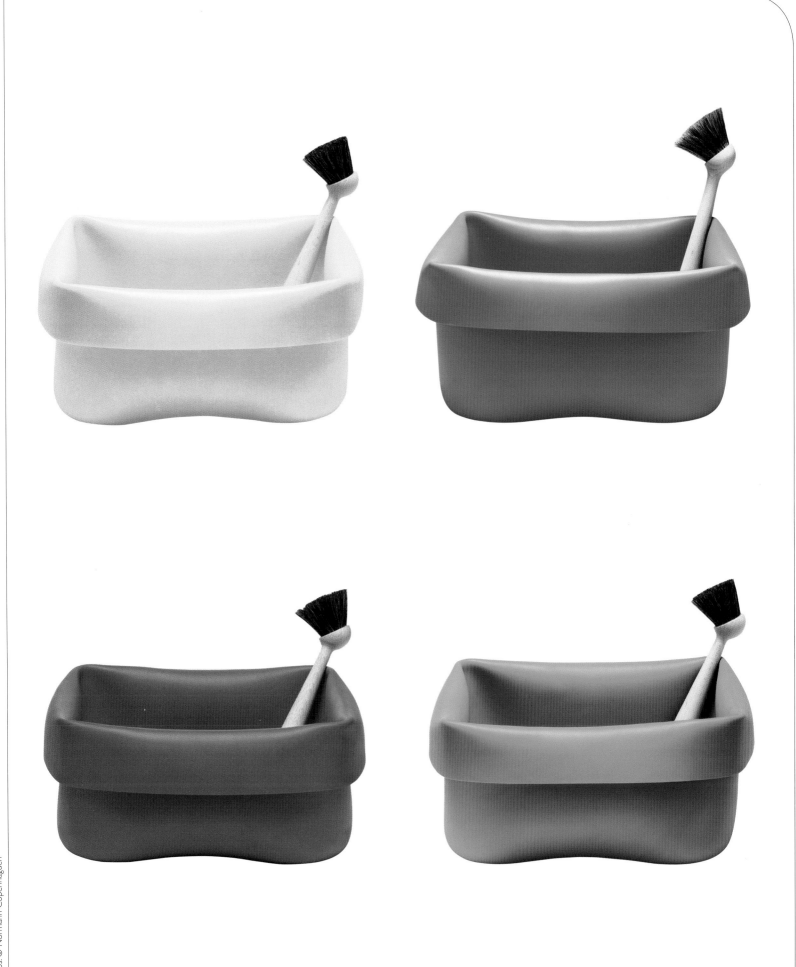

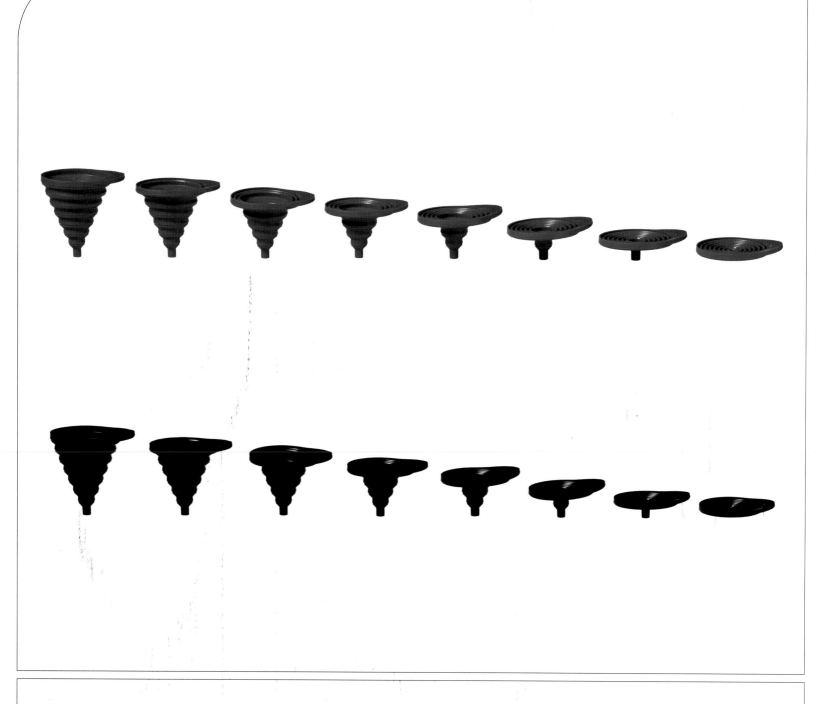

Collapsible Strainer | Normann Copenhaguen by Boje Estermann | 2005 | www.normann-copenhagen.com

The kitchen seems to be one of the industrial designer's most hated living spaces in the world, no doubt a result of the seemingly never-ending production of impossible-to-store kitchen utensils designed for it. Certainly, the hardest object to stow away among all stowable objects is the strainer, followed closely by the blender and kettle. This is what Boje Estermann thought the day he came up with the solution to our daily sufferings over traditional strainers. The Boje foldable strainer is an adaptation of the funnel that was designed some time ago for Normann Copenhaguen, consisting of a simple top layer of Santoprene (a type of very flexible rubber that is odorless, tasteless, and heat-resistant up to 205 degrees Fahrenheit) finished with a stainless-steel strainer grating. The strainer is made to withstand the weight of pasta or boiled potatoes, is easy to clean, and can be placed in a dishwasher alongside other kitchen implements without a problem. Once used, it can be stored easily in any cabinet or even in the slimmest of drawers, since it occupies a very small space once it is folded.

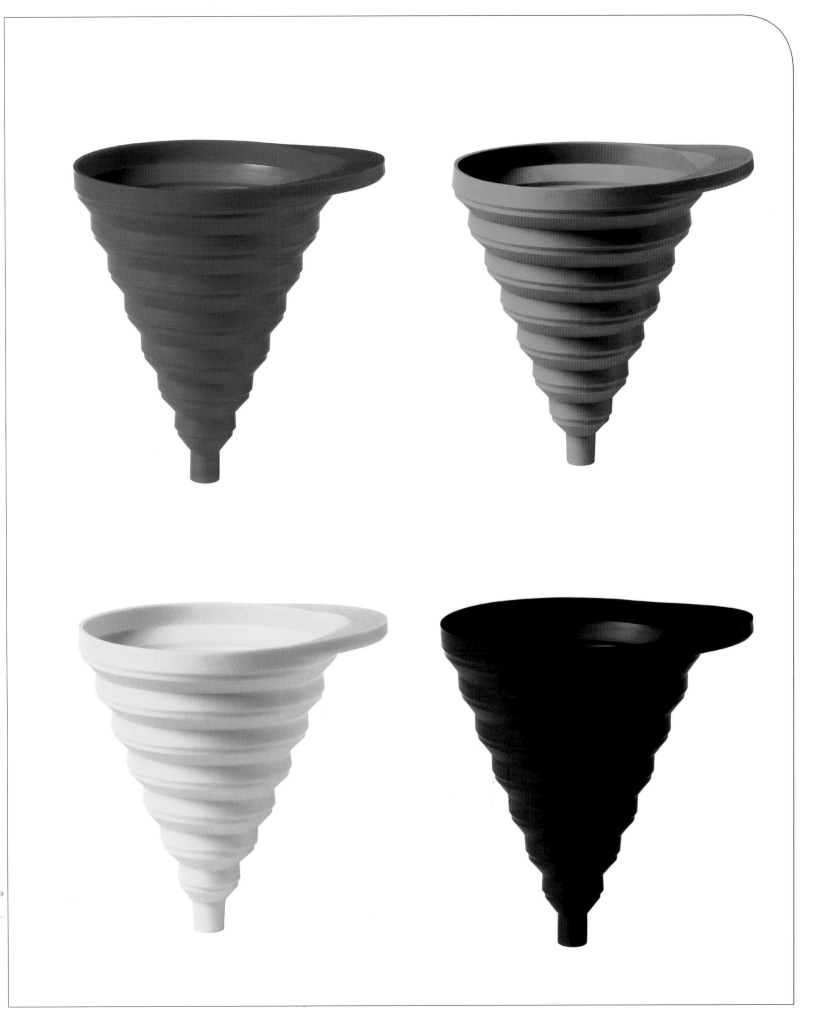

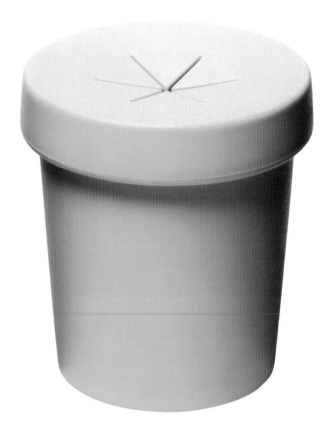
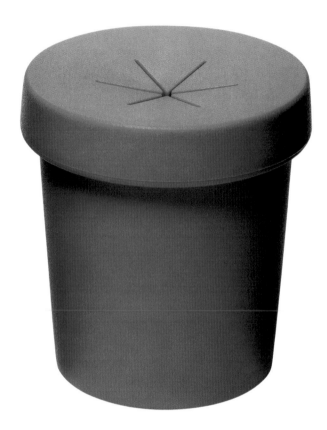

Pot for One Flower | Komplot Design for Normann Copenhaguen | 2006 | www.komplot.dk

Is it possible to reinterpret a classic object without falling into an abyss of empty aestheticism or unbridled kitsch? "The inspiration for Pot for One Flower arose from the classic shape of the everyday flower vase, the one known all over the world since anyone can remember. Only, in our case, we've given this classic design a new personality. Take the vase in your hands and you'll see what we mean. Our flower vase is not just a flower vase, it's an image. An iconic flower vase." That was Boris Berlin, one of Komplot Design's designers, who along with Poul Christiansen has given the traditional flower vase a radical turn. In truth, the Pot, constructed in rubber, is

a vase for just one flower, the stem of which must be fitted into the center of the star shape that has been cut into the lid of the vase. This star is, precisely, the iconic representation of the flower, with which the vase's design may be in turn called "metadesign." At barely 3 inches tall, the Pot for One Flower design stands out with a radical simplicity that suggests an ironic, fashionable, and revitalized insight on the part of its designer, all bestowed upon a decorative object as simple and apparently innocuous as the flower vase.

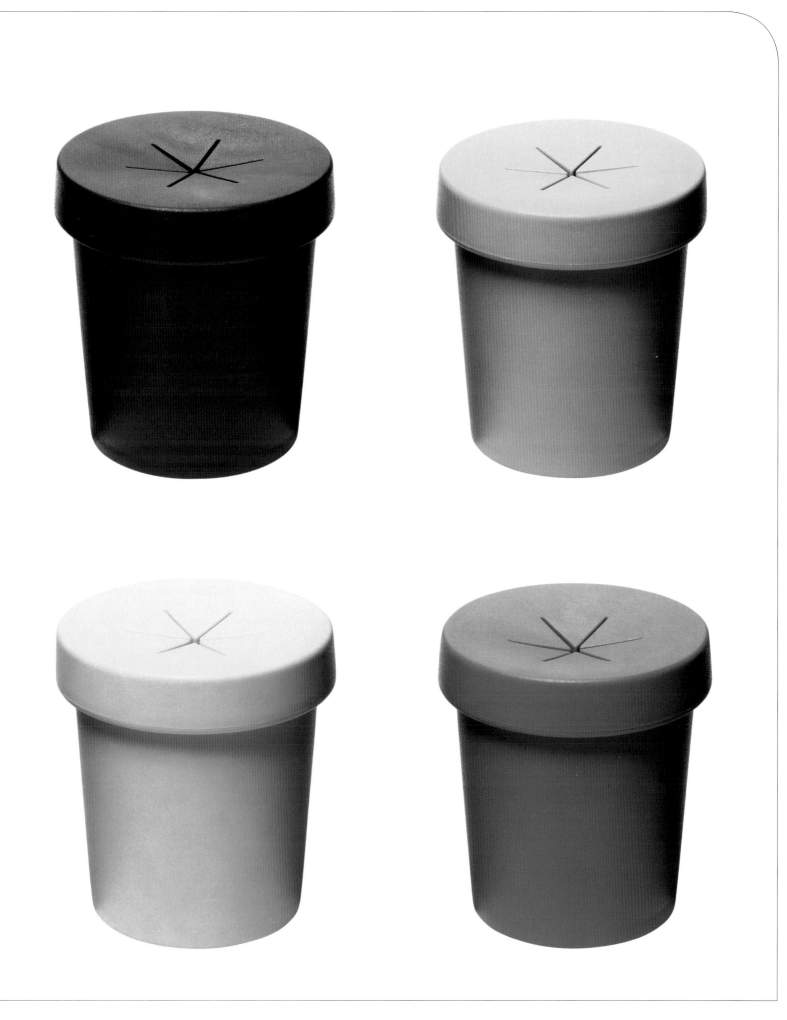

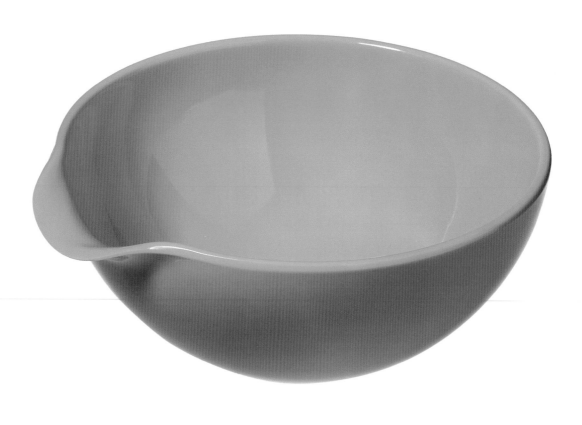

Jensen Bowl | Normann Copenhagen by Ole Jensen | 2004 | www.normann-copenhagen.com

Let's be honest: A bowl isn't exactly the most dreamed-about object for the recently graduated alumni of industrial design. It's one of the most basic shapes we can encounter in the realm of kitchen utensils, and every possible alternative and variation has already been tested by other designers without the most encouraging results (this is precisely why bowls continue to be spherical instead of having a hexagonal shape, for example). True? Not exactly. Designing an object as simple as a bowl may prove to be a much harder challenge to the designer than, say, designing other, more baroque, more "flexible" utensils. Let's not forget the ease with which one may detect the faults in simplicity, the opposite of which occurs with more complicated designs. The poetic idea in designing a bowl might best be described as "finding the extraordinary in the ordinary." Without a doubt, the Jensen Bowl, made of melamine, is a perfect example of this. It has a wider slope than usual, making it perfect for pouring either light liquids or thicker sauces, a slip-proof bottom and perfect proportions of height and width. The complete package consists of five different-sized bowls that fit one within the other for easy storage.

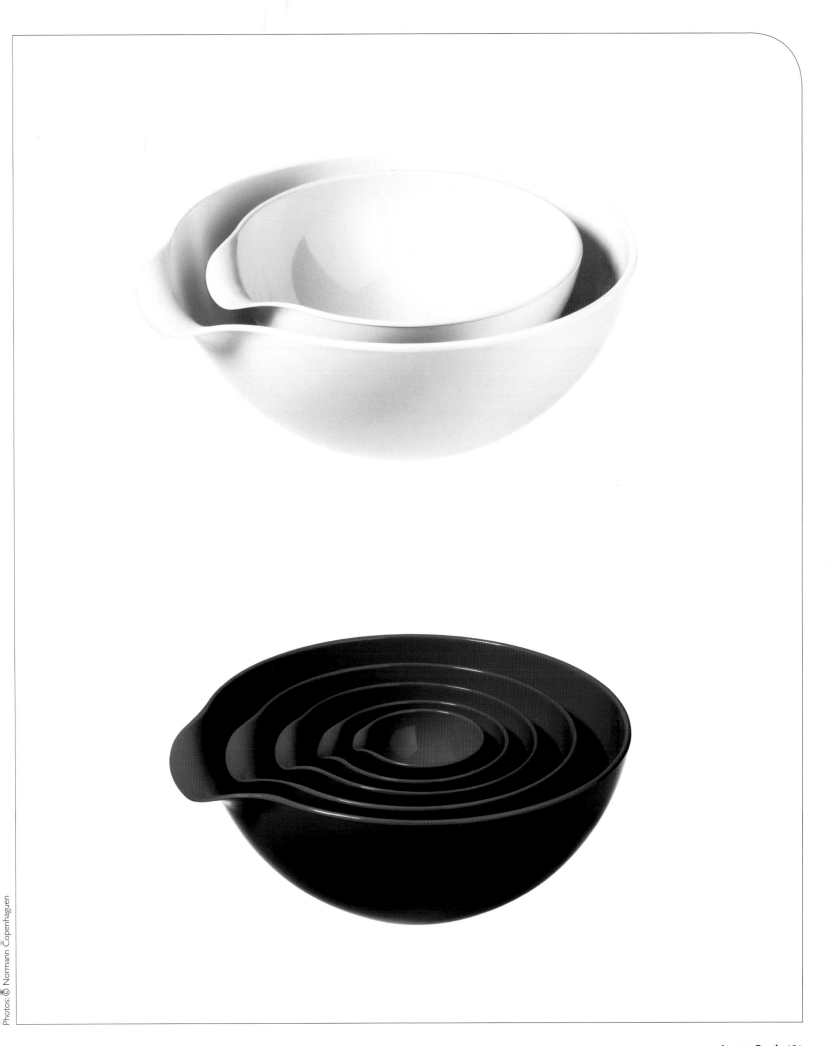

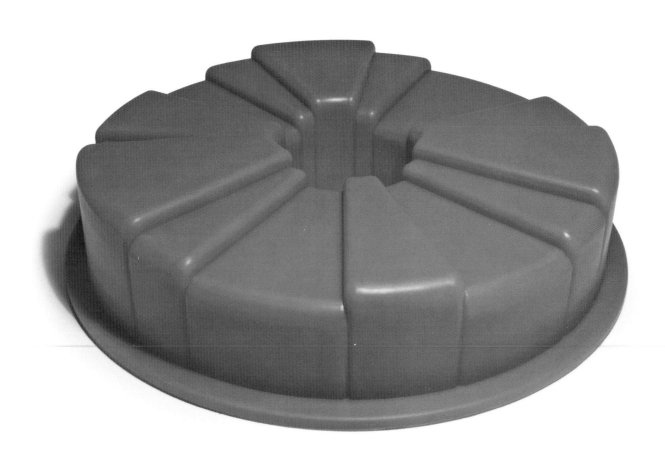

DeinBack | Ding3000 for Konstantin Slawinski-Housewarming Objects | 2006 | www.ding3000.com

There is a Spanish saying that goes, "He who divides and shares takes with him the best part." The truth in this adage, in its kindest form, can be seen when it comes time to eat the cake at a friend's birthday party. DeinBack may best be translated as "your cake." It's a silcone molded pan determined to end once and for all the friendly but ironically arbitrary disposition of the one holding the cake knife come dessert time. With DeinBack, the portions are "marked off" in the pan beforehand. This way, once baked, 14 democratically separated pieces may be easily removed from the pan, each in a completely different size from the next. The pan measures approximately 0.98 feet in diameter, 0.19 feet tall and is orange in color. The different portions vary not only in thickness, but in height as well. The pan has a hole in the center to facilitate the slicing of up to 14 individual portions. Without this hole, the user would know where to start the slice but not where to end it, a method that would allow for "cheating" simply by guiding the knife to a point slightly off-center. Once baked, the cake is released from the pan by being turned upside down. The only remaining step would be to complete the slices using the pan's separating lines as a guide. The rest is a piece of cake.

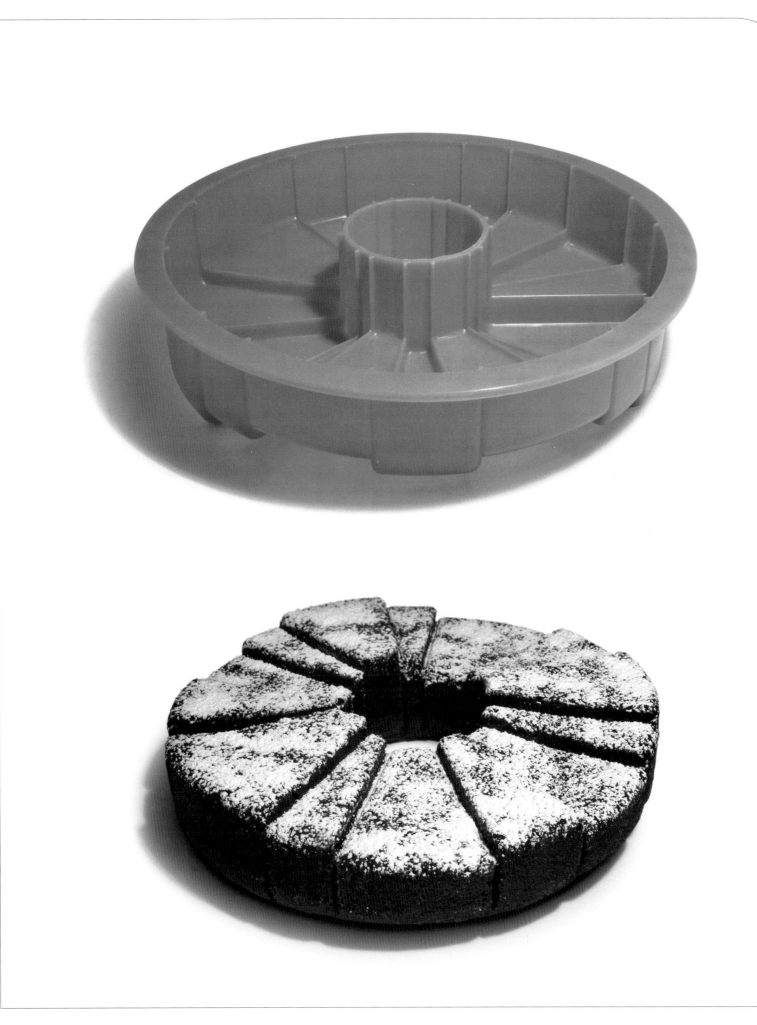

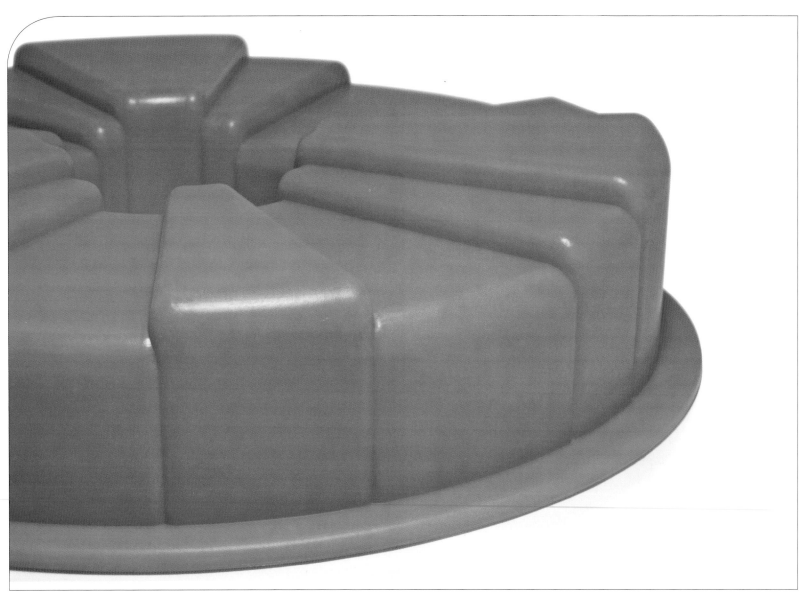

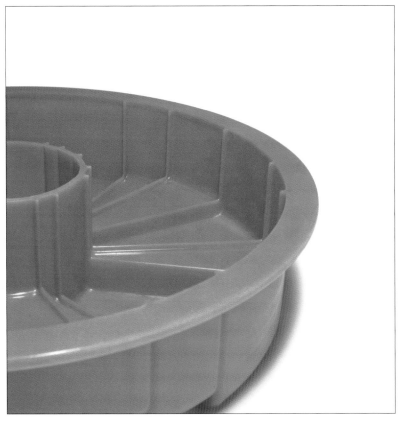

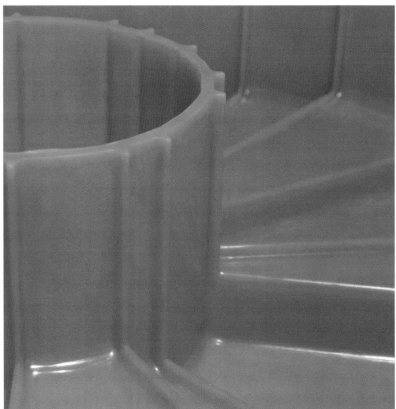

Silicone is an odorless, colorless polymer made of silica. It is inert and stable at high temperatures; because of this, it has gained popularity in the manufacture of kitchen utensils, primarily in baking pans and Silpat sheets. (In actuality, Silpat is a commercial brand name, but the term has become popular to describe all silicone sheets.)

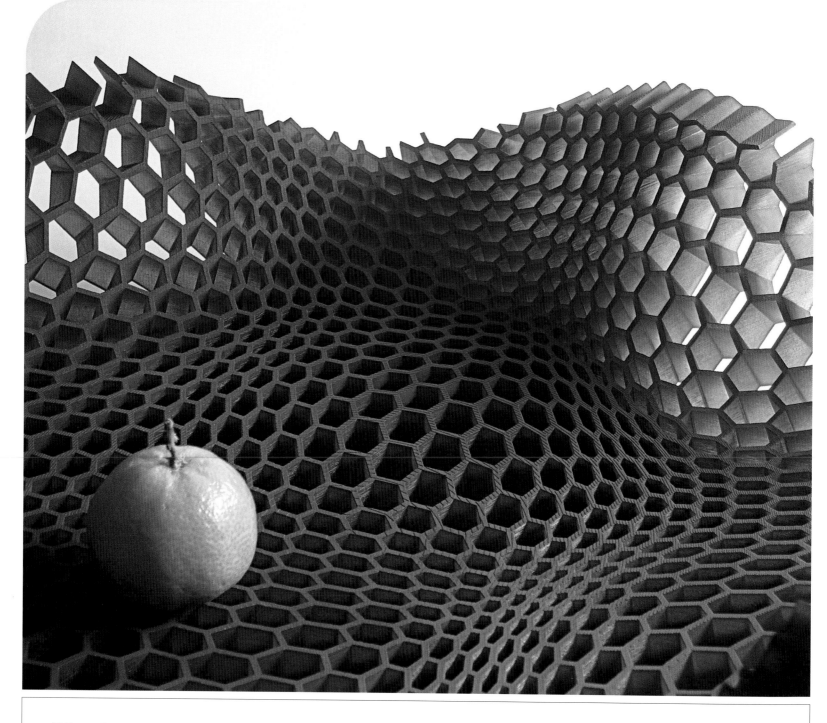

Black Honey | L Design for MGX by Materialise | 2005 | www.ldesign.fr

The name is no lie: The design for the Black Honey fruit bowl is based on the honeycombs a bee will make and incorporates the same series of hexagonal cells. There are two different Black Honey models available. The first is completely flat, while the second (the one shown in these pages) is been curved to more closely resemble the traditional fruit bowl people are accustomed to seeing in every house. The irregularity of the curved Black Honey attempts to evoke, in designer Arik Levy's words, "the sensation of a flowing biological material frozen in movement." Black Honey is made with epoxy, measures 17 inches wide, and weighs about 2 pounds. This weight is necessary so that the piece will be able to support that of the fruit without having to re-balance itself or lose equilibrium.

Arik Levy works various disciplines simultaneously: product design, exhibitions, interiors, set design, packaging, and corporate design. This is why his designs, particularly that of the Black Honey, center as much on function as they do on the "poetic." For this, Levy experiments by bringing the concepts of one discipline to another, bringing to light innovative and simple designs that are useful and aesthetically attractive.

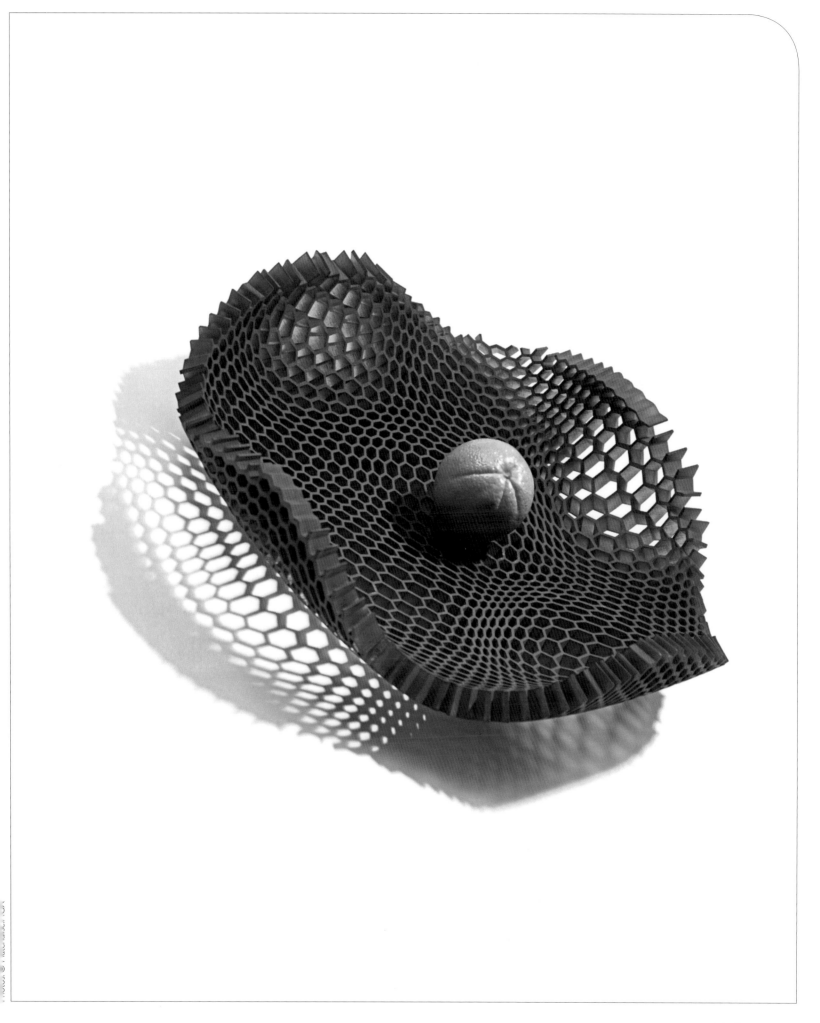

Strip | Michel Boucquillon for Aquamass | 2005 | www.michelboucquillon.com

Known as the architect who designed the famous and symbolically charged semicircle at the European Parliament (in Brussels, Belgium) before having even reached the age of 30, Michel Boucquillon has also explored, in dozens of designs, the realm that unites architecture with industrial design. In particular, through the use of a material called DuPont Corian, he has used to designed basically sophisticated products and elements for the bathroom, like the freestanding bath Strip designed for the Labels Design by Aquamass collection. The Strip, which measures 6.5 feet long by 1 foot wide, has been designed so that the tub can be made from a single sheet of DuPont Corian. By doing away with all types of manipulation, gluing, and further processing, the manufacturing technique used for the Strip manages to reduce costs to a minimum. In this way, a product initially targeted to up-market clientele can be made available to a much larger consumer base. Strip is available in two colors, black and white. In the future, the Strip will be part of an array of products, including a smaller Strip (5.9 feet by 31 inches wide), a conventional bathtub, a shower, and a sink (which can be seen on the opposite page).

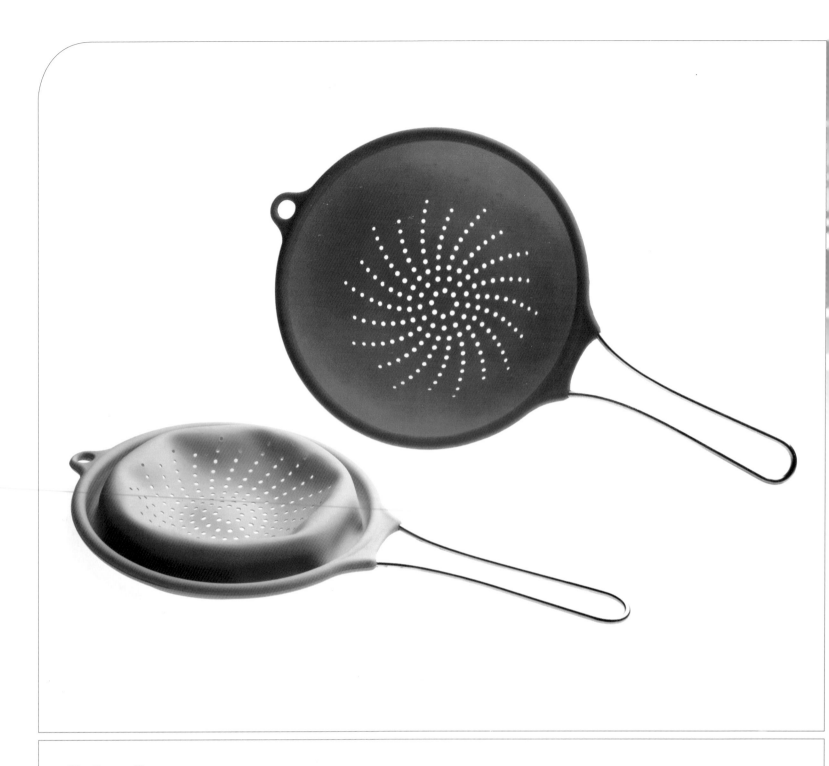

Drip, Popsy | Designtrip for Silicone Zone | 2006 | www.designtrip.it

Drip and Popsy are two of the products designed by Designtrip for the Hong Kong company Silicone Zone. Drip, a silicone strainer with a stainless-steel frame, has been specifically designed so that it may be easily stored in kitchen cabinets. The silicone's flexibility allows the strainer to be compressed so that it is almost flat. Only as thick as its frame when stored, it can fit into any drawer or on any shelf. The silicone is temperature-resistant and the strainer can be placed in the dishwasher.

Popsy, on the other hand, is a cone-shaped mold for frozen treats, ice pops, or pudding pops. In the case of ice cream, all you need to do is pour the liquid, put the ice-cream stick in and wait for it to freeze. Silicone makes removing the treats smooth and easy. Plus, this type of plastic does not retain odors, which allows it to be used with many different ingredients and with no worries about odors mixing. The mold comes with six polypropylene ice-cream sticks. Like Drip, Popsy is easy to clean and can withstand the high temperatures of a dishwasher. Popsy made an appearance at the New Italian Design Show by the Triennale of Milan in 2007.

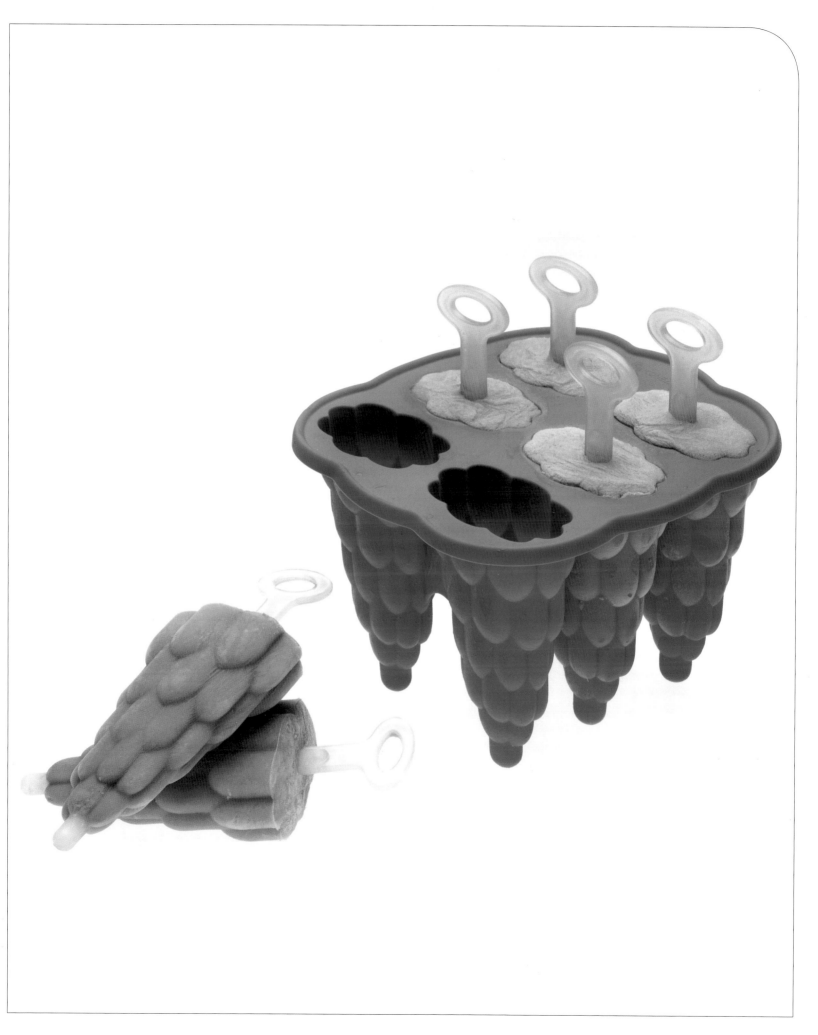

I Love Cake | Designtrip for Fratelli Guzzini | 2005 | www.designtrip.it

The I Love Cake collection comprises seven baking molds manufactured with FDA-approved food-grade silicone, a special type of plastic able to withstand temperatures between 40 below zero and 500 degrees Fahrenheit. Once removed from the oven, it is capable of returning to its normal temperature quickly, which helps reduce the possibility of the user being burned while handling. The mold can also be used in the microwave, put into the refrigerator, and placed in the dishwasher . Its high-gloss, nonstick finish makes removing baked goods easy. This silicone is odor-free, flexible,

easy to store, and portable, and durable enough to encourage the company to use the term "lifetime guarantee." The collection's name, I Love Cake, makes obvious reference to the heart-shapes used to decorate the different molds, which range from traditional containers to elongated rectangular molds, molds for madeleines, muffins, and the traditional circular shapes, as well as, of course, a heart-shaped mold. These are sold in three colors, so it's easier to distinguish them: red, blue, and yellow.

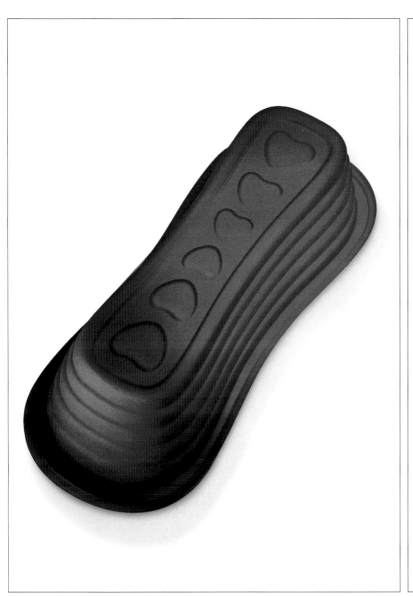

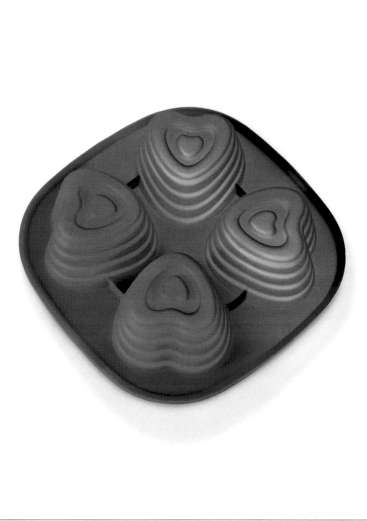

The flexibility of the silicone used in the manufacturing process of the I Love Cake collection makes it very easy to pull baked goods from their containers. In fact, the collection has been designed in such a way that it is not necessary to use butter, oil, or any type of grease when baking with these products.

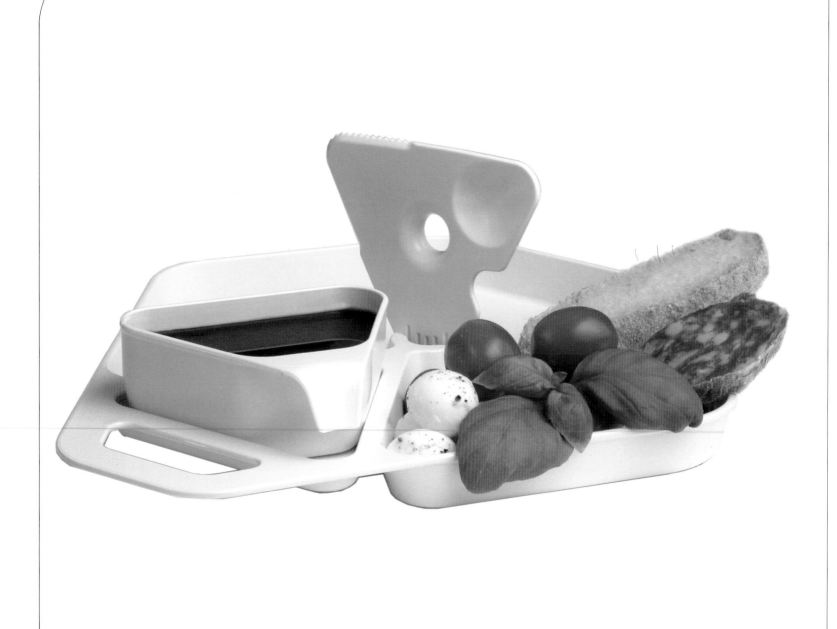

355 Gram Picnic Set | Studio Wagner:Design for Simplicitas | 2007 | www.wolf-udo-wagner.com

The 355 Gram Picnic Set is a portable tray for picnics, backyard parties, and rushed midday meals. The set includes a hexagonal tray, five small triangular containers, and another triangular piece that functions as a spoon, knife, and fork. It is made with ABS plastic. Because of the complexity of the product, its development was delayed almost two years. Wagner is a huge admirer of the films of Stanley Kubrick and the unique futuristic aesthetic of *2001: A Space Odyssey*. He based the 355 Gram Picnic Set's retro-futuristic look on this film, a set you can easily imagine floating along in the zero-gravity corridors of the *Discovery* space-ship. The tray set is part of the Urbana family of products, a collection designed for modern city living. The 355 Gram Picnic Set's light weight stems from this ideal, and allows it to be transported from one place to another without difficulty. In Wagner's own words, "I have always found it rather amazing that many people care so much about travel-light products when camping and hiking but not as much for urban environments. I believe people in the future will also be more and more aware of weight issues regarding daily accessories." The 355 Gram Picnic Set is stackable and is closed by means of a central screw.

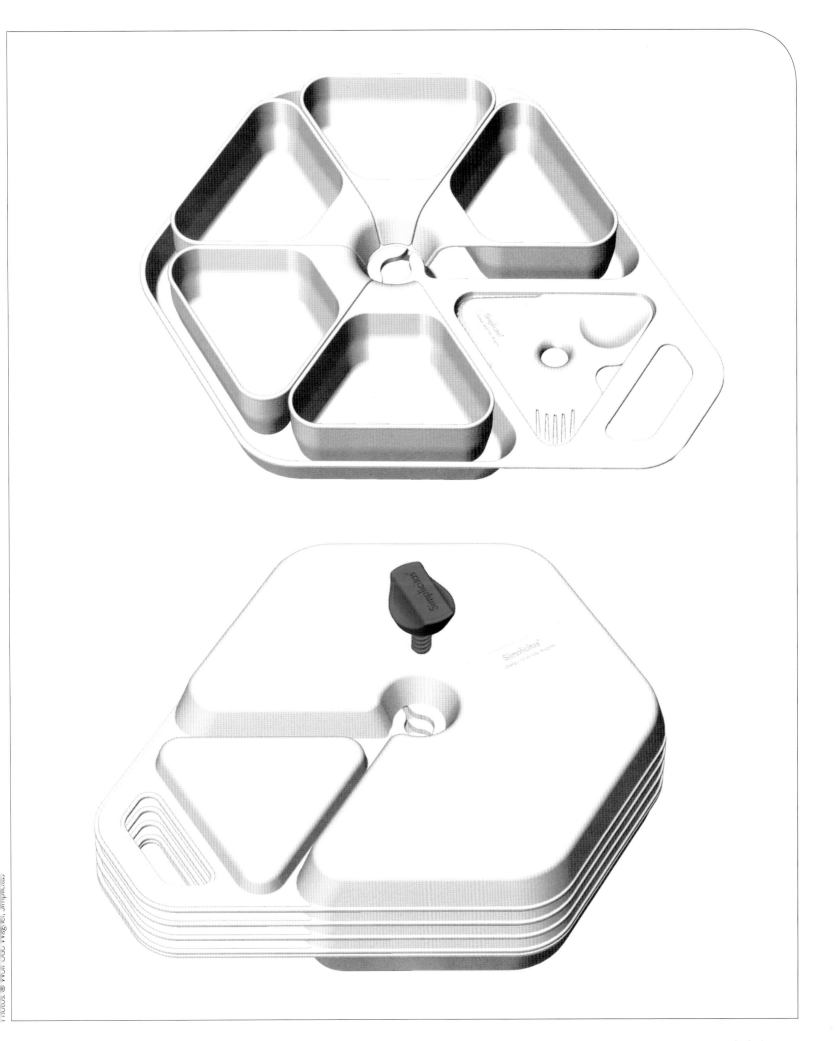

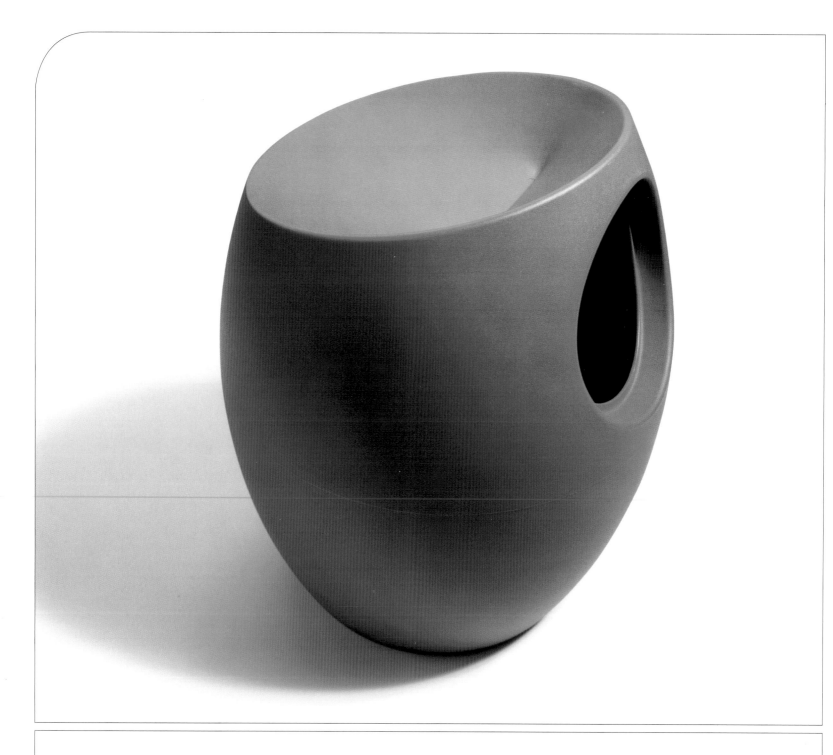

Simplex | Azúamoliné for Cosmic | 2005 | www.azuamoline.com

Simplex is the name with which Azúamoliné has baptized a family of versatile and simple (as the name suggests) products for the bathroom, that are capable of performing and adapting to a variety of alternative functions distinct from their traditional uses. The first Simplex family member is a rotomolded polypropylene washbasin that, as can be seen, is perfect for the bathroom. It's useful in other places as well, such as installations, utility rooms, garages, storage rooms, prefabricated structures (as long as they are connected to potable-water sources) and even exteriors like gardens for example. The washbasin can be used with a hose or a faucet, which makes it just as adequate as a conventional wash-basin or as a watering source. The second Simplex family member is a plastic acrylic stool that has dual functions: On the one hand, it can be a regular stool; on the other, it serves as a container and storage space, thanks to its hollow interior, accessible from a hole in its side. The advantages of this stool are obvious: It saves precious space while serving two completely different functions: that of a stool and a container.

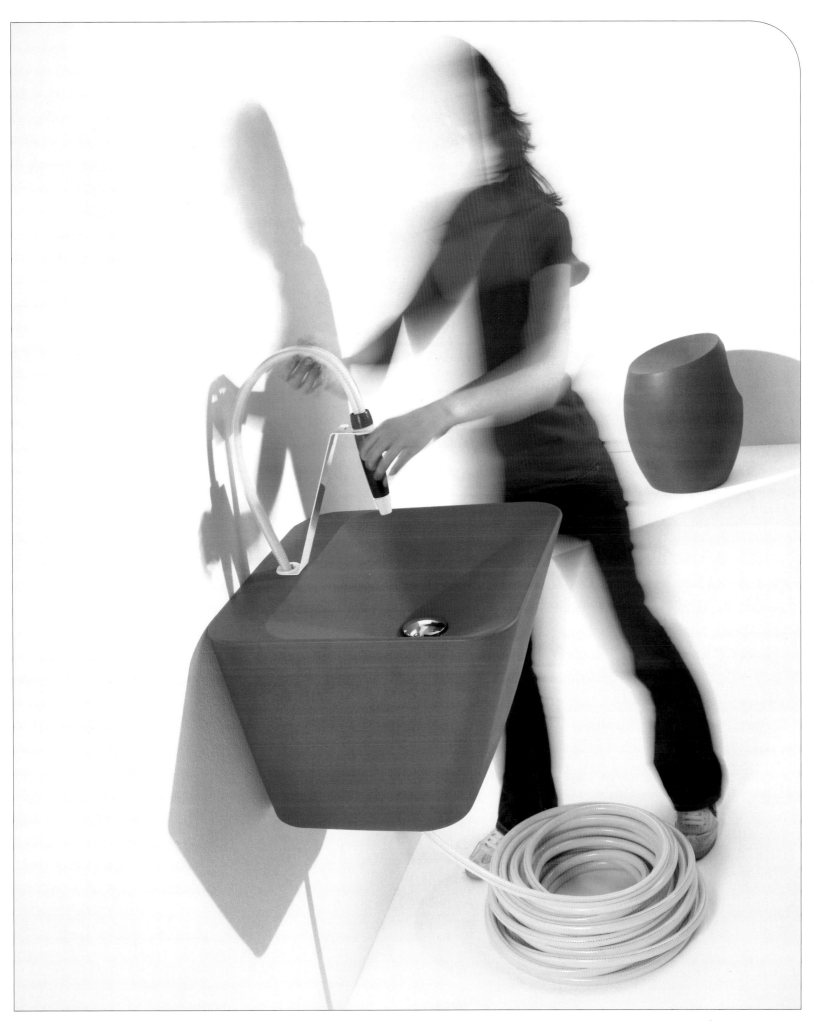

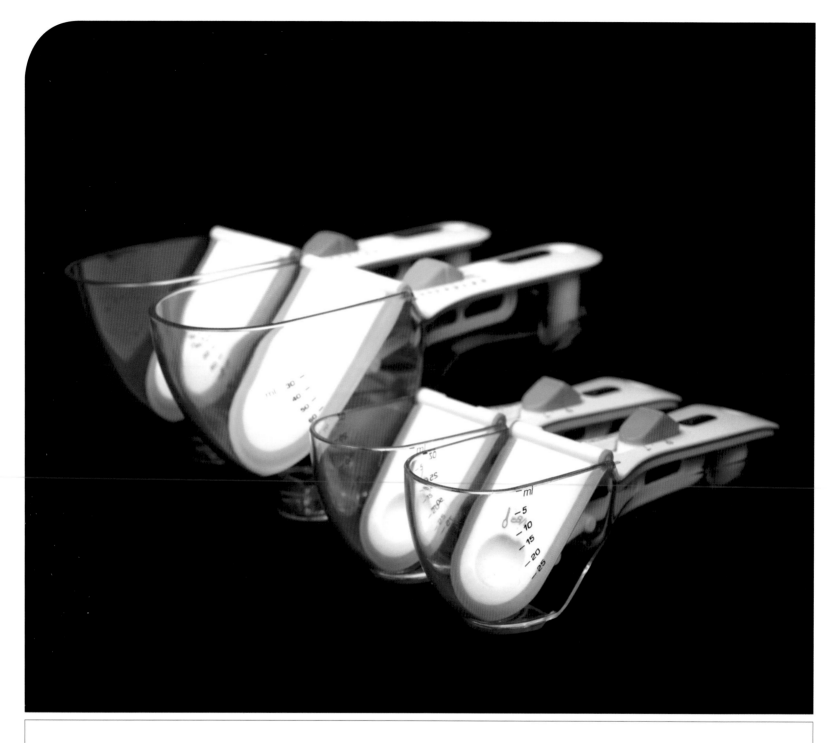

Nuscüp | Pollen Design for DallaPiazza | 2005 | www.pollendesign.com

Measuring cups are without a doubt the "great forgotten" utensil in the world of industrial design. Maybe this is because of their uncomfortable aspect or their difficult storage adaptability. That was all before Pollen Design was commissioned to design a measuring cup for the Dalla Piazza Switzerland company. Nuscüp, which uses a sliding seal and has been made with durable ABS and polycarbonate, is the first measuring cup on the market able to measure both dry and liquid ingredients. The measuring cup adjusts to measurements from 2 tablespoons to half a cup with a slide of the thumb-switch on its ergonomically rounded handle. Before designing it,

Pollen Design analyzed the majority of measuring cups on the market to determine their faults and virtues, to understand how these instruments are actually used in daily life—beyond the designing table. On one side of the scoop measurements in both millimeters and ounces are visible. With Nuscüp, disassembly and cleaning are easy. It is available in a range of colors (which is essential to the success of any item in the housewares market) and in two sizes. Last but not least, it boasts an embedded magnet, which allows it to be stored on any metal surface—a refrigerator door, for example.

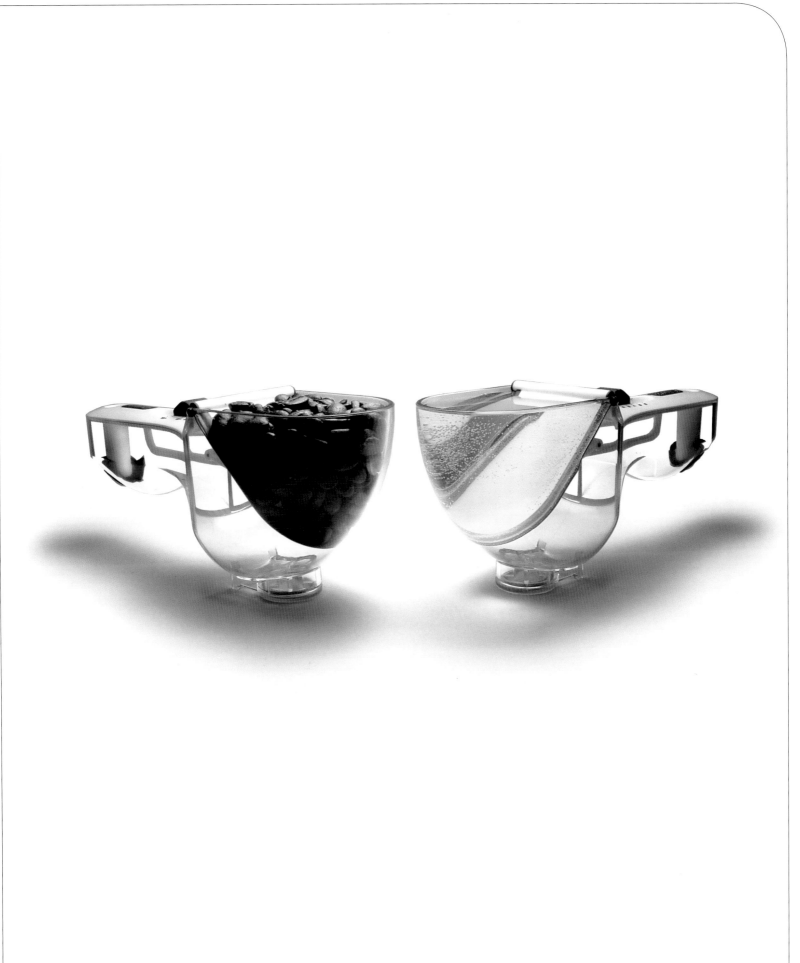

Oyon | Michael Bihain | 2006 | www.bihain.com

Although it may seem so, the photo shown here has not been turned 90 degrees. The Oyon is an authentic fruit basket, but designed not to rest horizontally on a dining room table, but, instead, to hang on the wall. The Oyon is also modular, which means that pieces can be added and combined at will, to form even the most whimsical of designs on the wall of a kitchen or dining-room. However, the detail that gets the most attention from fans of attention-grabbing designs such as this one is that the pieces of fruit, once placed in their respective compartments, act as pixels with which to draw across our wall-canvas the most bizarre designs: from a likeness of Mario the video-game character (for which we would need many blue fruits and vegetables) to the now mythic spaceships from the game Space Invaders. The Oyon is available in black, white, and transparent polycarbonate and measures in at 1.60 feet long by 1.44 feet wide and almost 1.9 inches deep. This makes it ideal for medium-sized fruits like apples, oranges, and pears. The Oyon is designed in such a way that the pieces of fruit are held in perfect balance within the different spaces that make up the fruit basket without ever falling to the floor.

Furniture

Self | Ronan & Erwan Bouroullec for Vitra | 2000 | www.bouroullec.com, www.vitra.com

The modular shelving unit Self is probably one of the most perfect examples of "à la carte" furniture available on the market today. Self is composed of two distinct elements, interchangeable in such a way that the end result is an always-changing shelving unit, flexible and totally adaptable to the user's needs. The first of these elements is the thick horizontal shelves; the second element, the vertical separation panels (available in different colors). The user may combine up to five horizontal elements as desired, to create a variety of Self configurations. The vertical panels may be installed in the middle of the unit or on the front or back of the horizontal shelves. The shelves themselves are made of blown polypropylene, while the vertical panels are made of polycarbonate. The structure is held together by galvanized-steel rods. The unit serves as a conventional bookcase, as a display for decorative objects of all kinds, or even as a room divider similar to a screen.

Reanim | 5.5 Designers | 2003 | www.cinqcinqdesigners.com

5.5 Designers claims that the furniture industry has moved from its goal of "durability" to one of "renovation." In other words, furniture that used to last a lifetime now has a shorter lifespan, maybe two or three years, a phenomenon underscored by the popular success of chains like IKEA, a manufacturer of inexpensive, not-very-durable furniture. In view of this, why not create a furniture hospital to prolong the life of our most beloved pieces of furniture and help contribute to the protection of our natural resources at the same time? It's not about restoring the piece (as in restoring it to its original state) or transforming the piece (as in changing its functionality) but

about reeducating it, reinvigorating it with a systematic process that can be applied to all kinds of furniture. Much in the same way that allopathic medicine uses surgical prostheses, 5.5 Designers uses different types of PPMMA (plasma polymerized methyl methacrylate) plastics to renew furniture best described as "sick," rescuing them from horrible fates in the gutter, in abandoned apartments, or flea markets. Furniture "cured" in this fashion isn't sold as a unique design piece or an artistic object, as some other industrial designers are fond of doing. Instead, they are sold as conventional furniture.

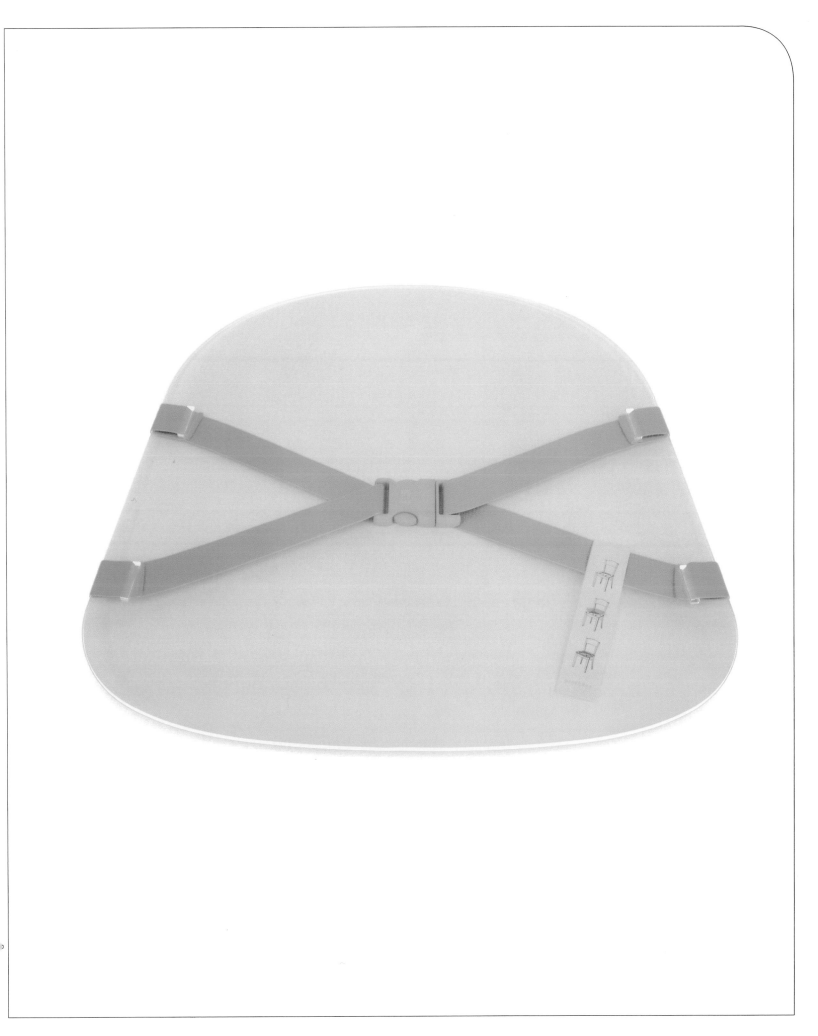

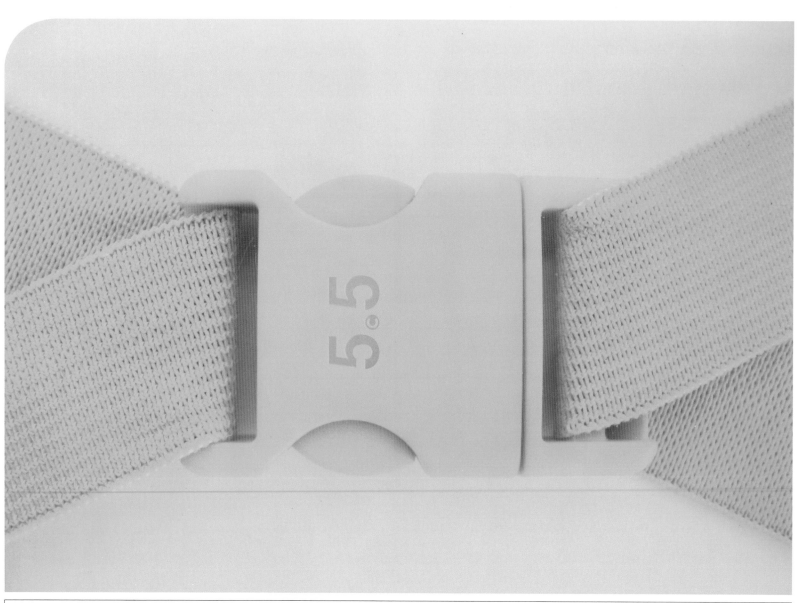

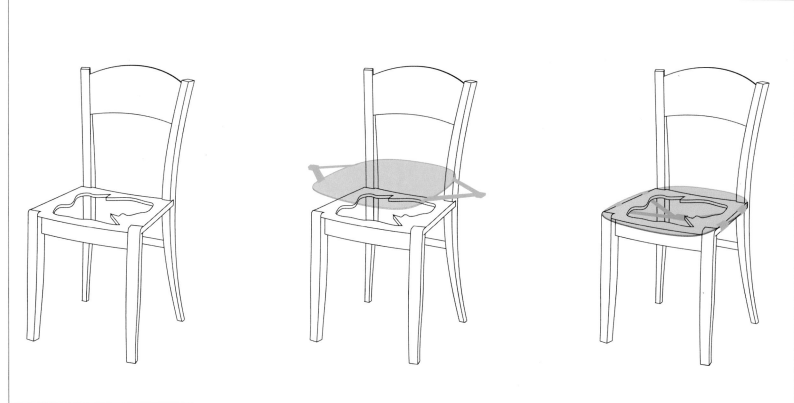

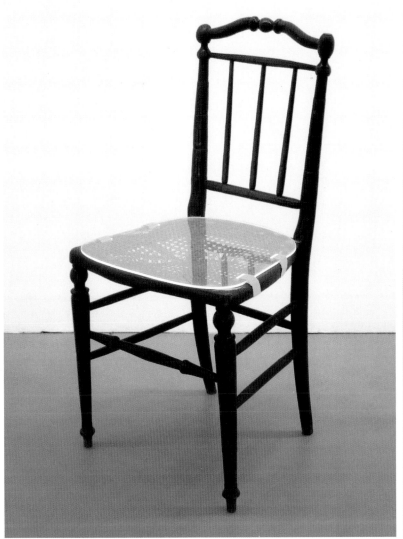

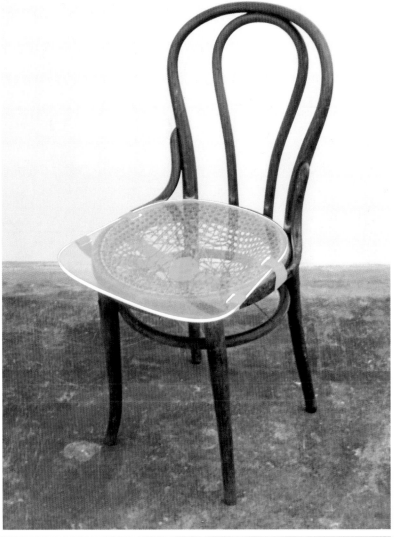

This same prosthesis, seen in these pages, will function perfectly for different types of furniture, each time maintaining the same standardized "curing" process. The final result, unexpected but always interesting, varies in relation to whether the prosthesis is cut to match the piece's original size or not.

greffe

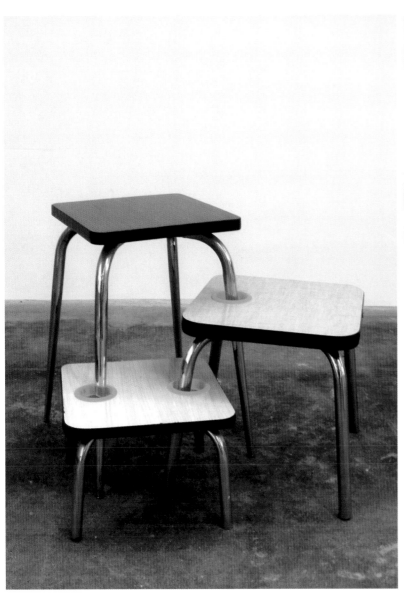

A simple plastic hoop is used to inject a second life into a set of neglected stools, each a different height. In this case, the tallest stool can continue to serve its original purpose, while the smaller ones can be recycled into low tables for magazines or any other items, decorative or otherwise.

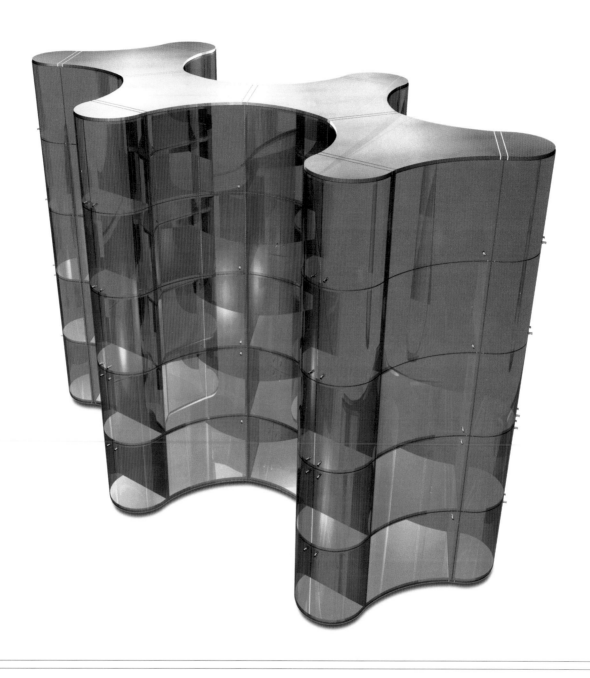

Paesaggi Italiani | Edra by Massimo Morozzi | 2003 | www.edra.com

Flexibility is probably one of the most overly abused words used to describe all kinds of objects in the realm of industrial products. Flexibility may be applied to the broken and torn; practically speaking, it may be bandied about incorrectly as a synonym for *collapsible*, *small*, *comfortable*, *easy-to-use* or, in the worst of cases, a *product of indeterminate uses*. But on some occasions or, better said, few occasions, the word is used to describe a product's perfection. This is the case with the Paesaggi Italiani, a modular system of shelves and space dividers whose various shapes, sizes, and colors permit its use in practically any home or office space. Each piece, made of acrylic plastic, fits into the next, allowing a wide spectrum of arrangements and enabling the user to either put it against a wall or use it as a room divider. It may be used as an independent element or a purely decorative one. Although the model shown on these pages is the curved one, the Paesaggi Italiani system also comes in a conventional "straight-line" version and is available in all types of finishes: wood, metallic, and fluorescent, to name a few.

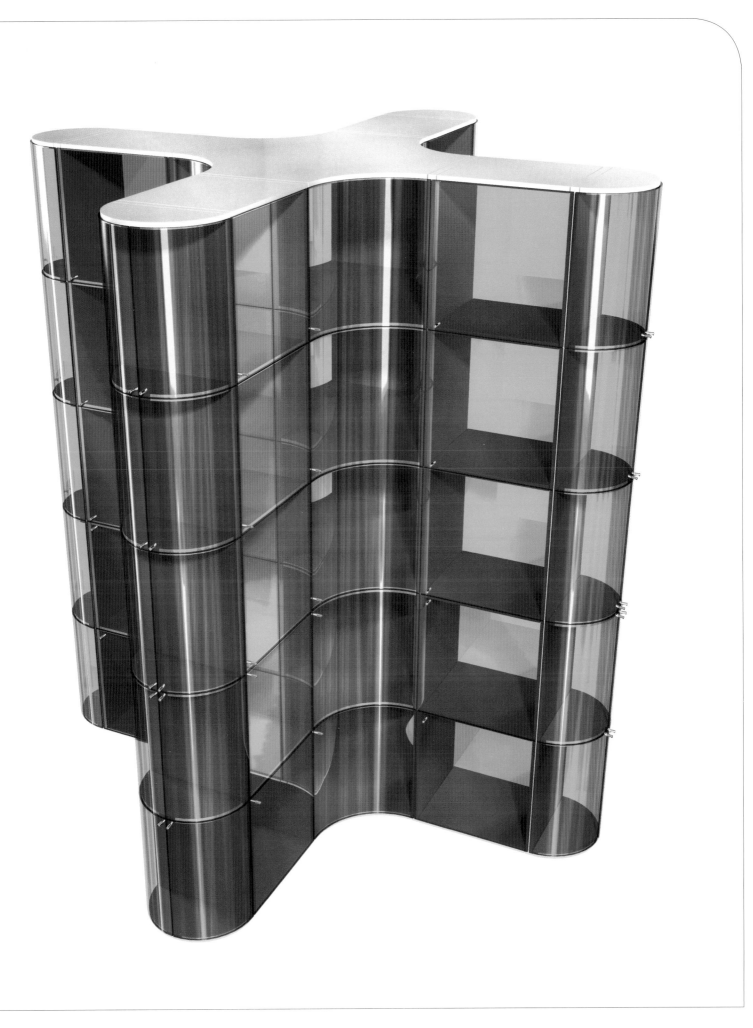

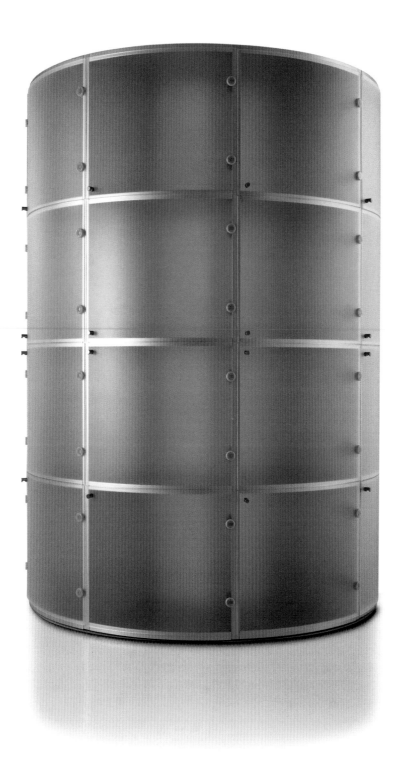

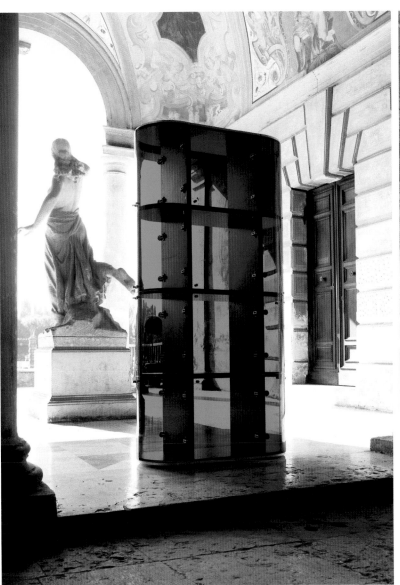

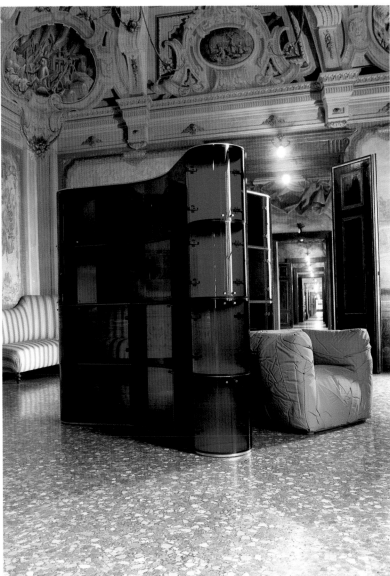

The colors chosen for the more eccentric Paesaggi Italiani models are those found in pop aesthetic furniture. Bright colors like violet, green, and red reinforce the characteristics typically associated with plastic: a youthful look, uncomplicated, cheap, and adaptable.

Box | Ronan & Erwan Bouroullec for Vitra | 2004 | www.bouroullec.com, www.vitra.com

Single-use furniture is beginning to be a thing of the past, giving way to those pieces that allow their user greater flexibility. Box is a multi-functional table that permits all manner of storage while serving principally as a small side table. Made of a hard polyurethane integral foam, Box is covered, internally as well as externally, with a fine layer of knitted 100 percent polyester; its cap is made of lacquered MDF. In Box's interior, we find a hole that permits the hiding and passage of power cables in case its tabletop is used to support personal computers, small televisions, reading lamps, or any other object that may need to be plugged into an electric current. Box is part of a long line of furniture and objects for the home for which the designer has not attempted to predetermine the pieces' functionality; this is left to the customer. In this sense, Box fits neatly into the eminently urban Do-It-Yourself philosophy. Its light weight, small size, and multi-functionality permit adaptation to any decorative tendency and lifestyle, from the sedentary to the most changeable imagination.

Box |89

Cloud | Ronan & Erwan Bouroullec for Cappellini | 2004 | www.bouroullec.com

The Cloud bookcase allows the construction of a library as large as one could wish for, simply by adding units to the structure through an original connecting system of special clips. Each unit is sold with two clips. In theory, there is no limit to the size of the library, which may branch out as if it were a spiderweb until it completely covers a wall or whatever flat surface on which it may be installed. Cloud is made by means of rotational technology of a high-density polystyrene and is available in four colors. The bookcase can be leaned against the wall or stand freely on its own, serving in this case as a space divider for interior locations. It measures 73.8 by 15.75 by 41.4 inches. Once installed, the structure bears a striking resemblance to the bee's honeycomb. The position of the books, or any other item we put on any of the circles that make up the Cloud, will depend on their quantity and size. In any case, the books will almost never be in a completely vertical position, and it would be very hard for two books on separate circles to have the same degree of inclination. This lends a visual element of chaos to the Cloud's minimalist aesthetic.

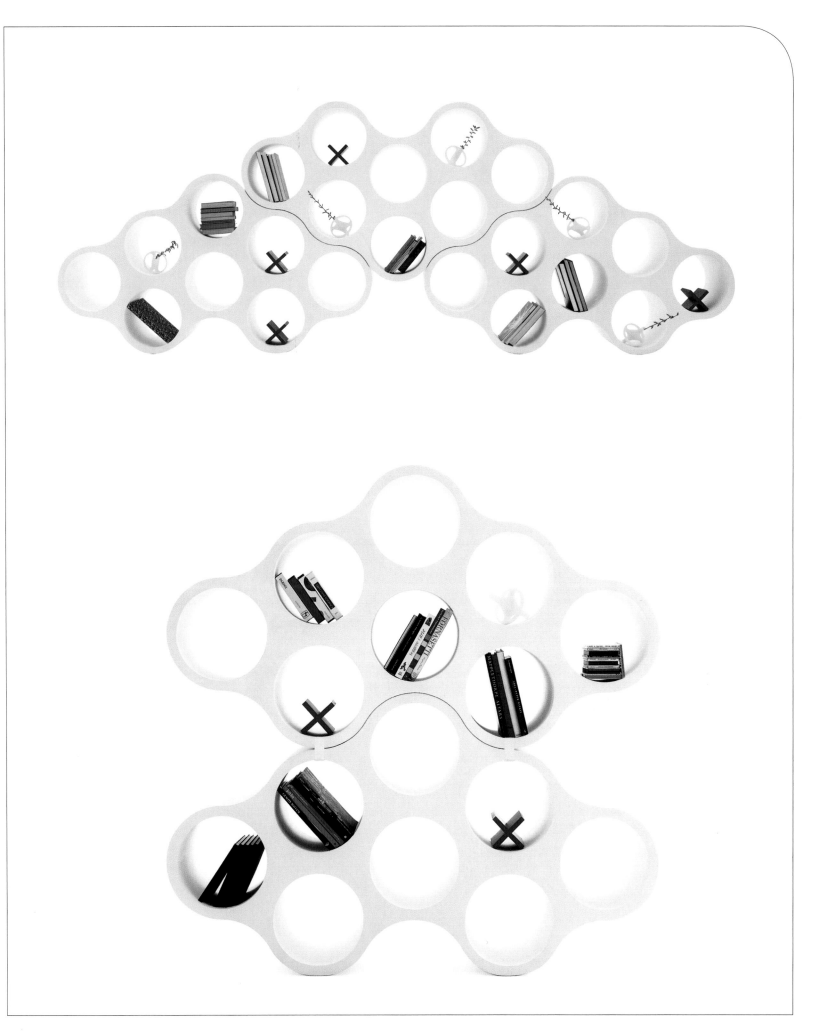

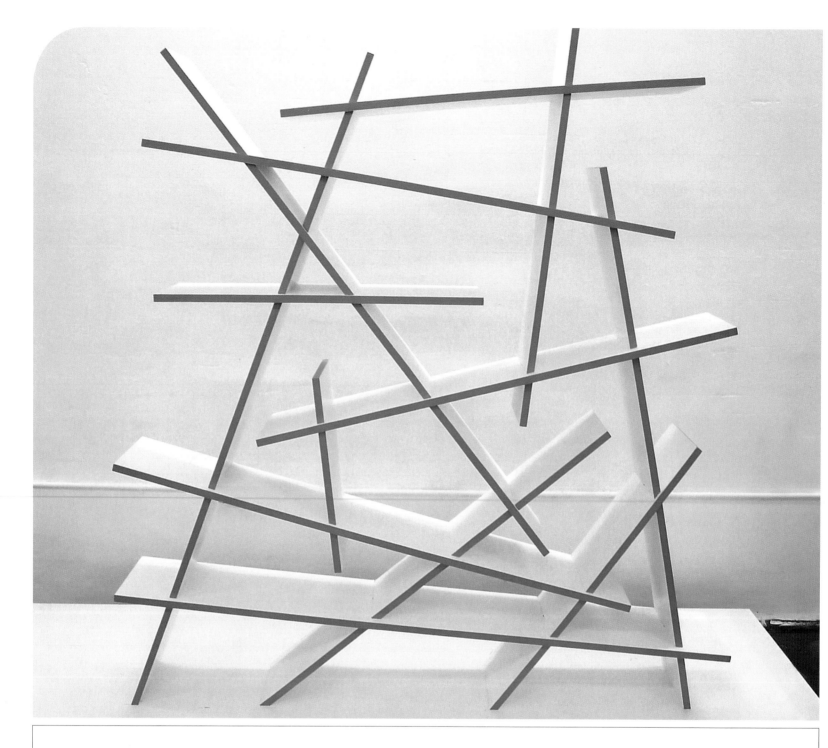

Crash | Rainer Mutsch | 2006 | www.rainermutsch.net

Crash is a bookcase that has clearly been influenced by the Expressionist movement, as represented by films like *The Cabinet of Dr. Caligari*. The objective of the Crash is to introduce a chaotic element into the organized spaces of contemporary apartments. Crash, made of CNC milled multiplex and lacquered in various different colors, measures 7.8 feet tall by 5.9 feet wide by 13 inches deep. The bookcase can be put together and disassembled with ease, without the need for any tool at all thanks to an original design system in allows the different panels and shelves fit with each other (thus allowing for easy transport). The different angles at which the shelves and panels connect are exactly what gives this piece its stability. In fact, Crash has been designed so that it is at its most stable when filled with as many books as possible. The bookcase may be placed against a wall or stand freely and be used as a room divider. Currently, Crash is being manufactured on a small scale by the Rainer Mutsch Studio and is being marketed by the Austrian independent-furniture store Das Möbel, but its designers are hoping to find a manufacturer capable of automated mass production.

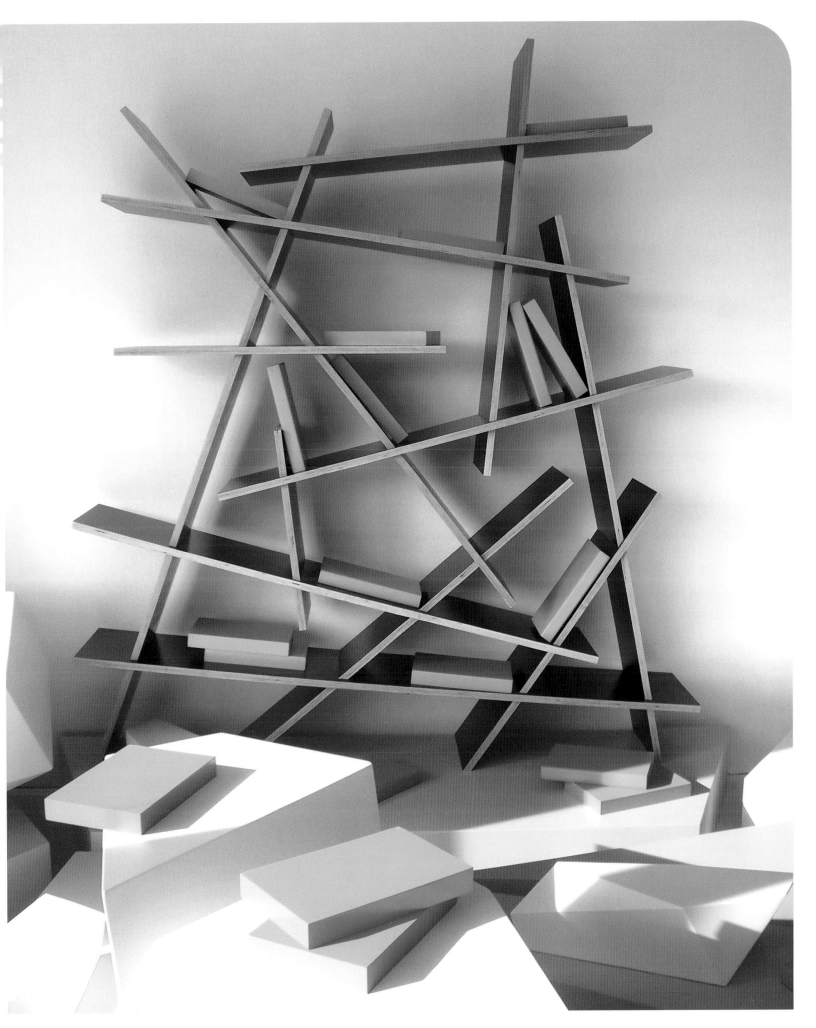

Just for fun

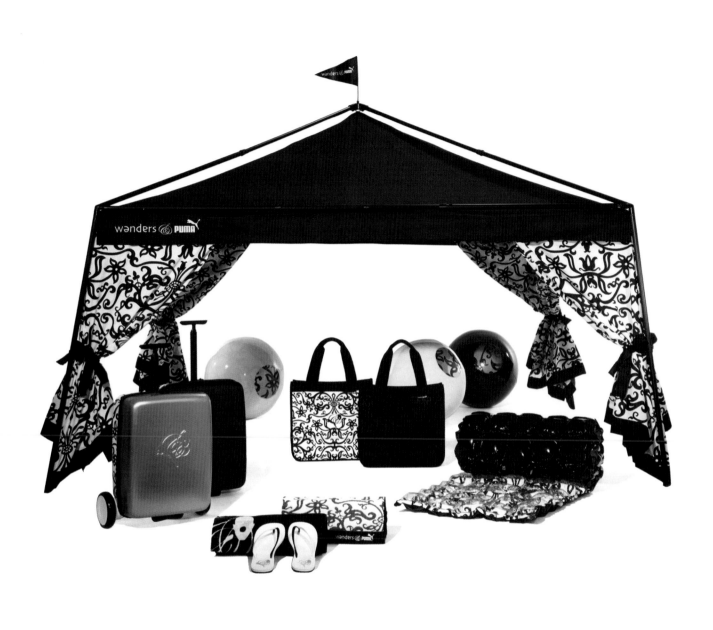

Villa, Beach Ball, Bubble Lounge | Marcel Wanders for Puma | 2007 | www.marcelwanders.com

"I hate to go camping, but I love to do it in style." So said Marcel Wanders; and Puma could not have thought up a better slogan for its collection of products created by designer Wanders for the outdoor lifestyle. The Dutch designer is without a doubt one of the most admired and renowned professionals in his field today. His previous work for such brands as Capellini, Bisazza, and B&B Italy led him to Puma, with which he announced an agreement in 2006 to create a collection of portable products for city dwellers who feel the need to spend a weekend outdoors every now and then but prefer not to leave behind their creature comforts. The collection comprises the Villa tent, the insulated Cool Case to keep beverages cold, the Bubble Lounge, a Beach Ball, the Summer Shopper bag, a towel, and a pair of flip-flops. Plastic is the predominant material in this collection, primarily because of its practical and aesthetic advantages: it's lightweight, durable, and has the ability to attain a practically infinite variety of shapes and colors. "We want a certain level of luxury when we go camping outdoors: We want the champagne to be cold and wallpaper in our tent. I've worked a lot with Puma's fantastic team and appreciate their commitment to making this collection fabulous."

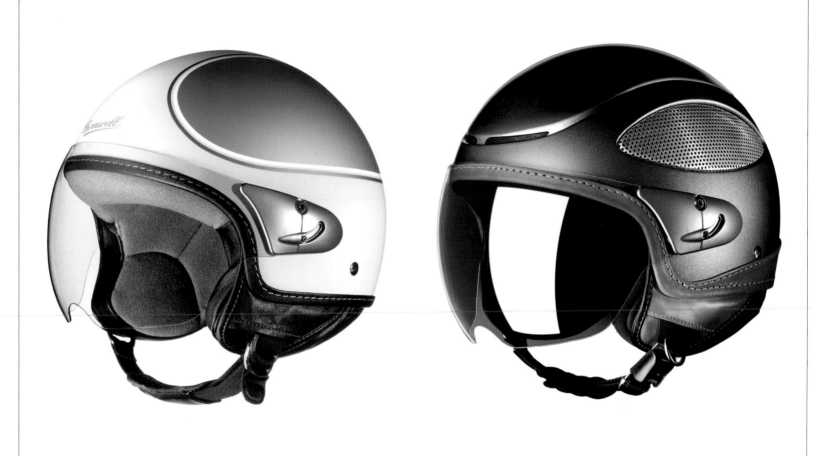

Hurricane, Spitfire | Integral Studio Vinaccia for Cromwell | 2005 | www.vinaccia.it

Cromwell, a legendary brand in the motoring world, has achieved something unique in marketing. A product may become so identified in the public's eye as the premier example of its type that the brand's name becomes a cultural identifier for that item, regardless of the various competitors in the field. In France and Germany, for example, a certain type of helmet is always called "The Cromwell." Cromwell's Spitfire and Hurricane models present a series of technological advances that convert them into authentic pieces of industrial-design art. In the Spitfire's case, the outer shell has been manufactured with a practically unheard-of combinaton in the realm of motorcycle helmets: thermoplastic polymers and DDQ steel, a special type of rustproof steel that provides a high level of safety despite its unbelievably light weight. The result is a graceful piece that combines the most advanced technology with a retro design in homage to motoring's storied past. The Hurricane, on the other hand, recalls the Swinging London years, thanks to its two-toned look. This helmet's exterior is also made with thermoplastic polymers. The visor, like the Spitfire's, is made with a type of polycarbonate that has been specially treated against fogging. In all probability, Lawrence of Arabia, the most famous wearer of Cromwell's helmets, would give these two his approval.

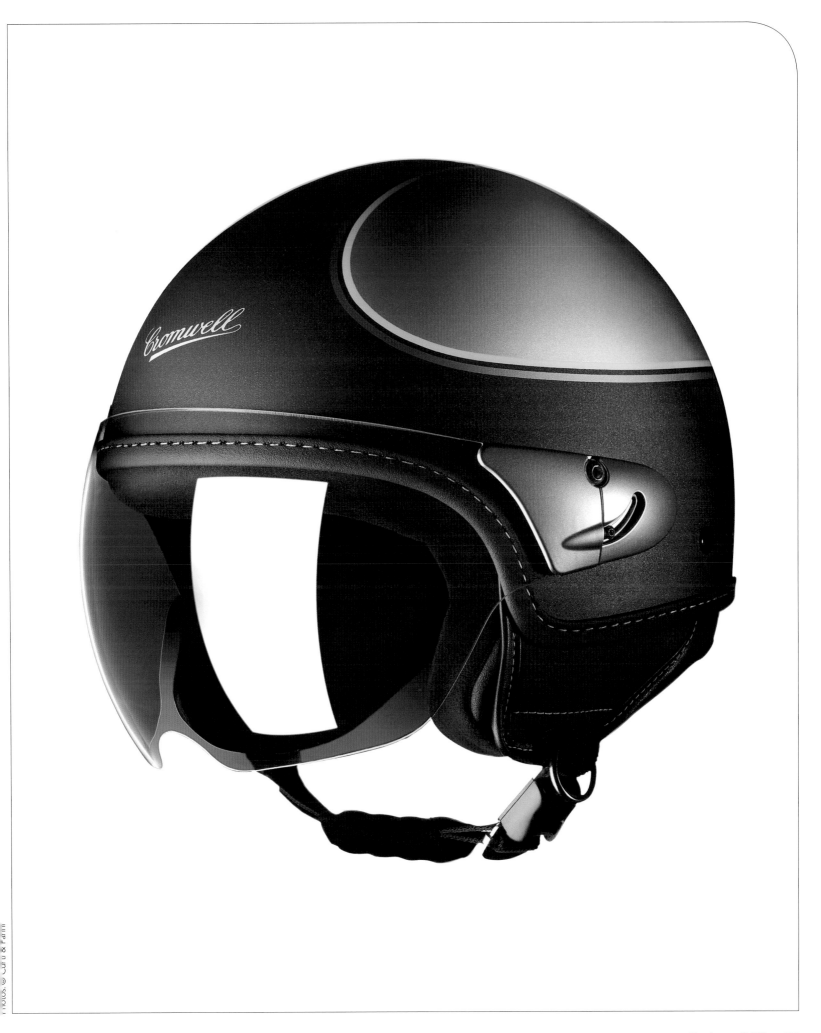

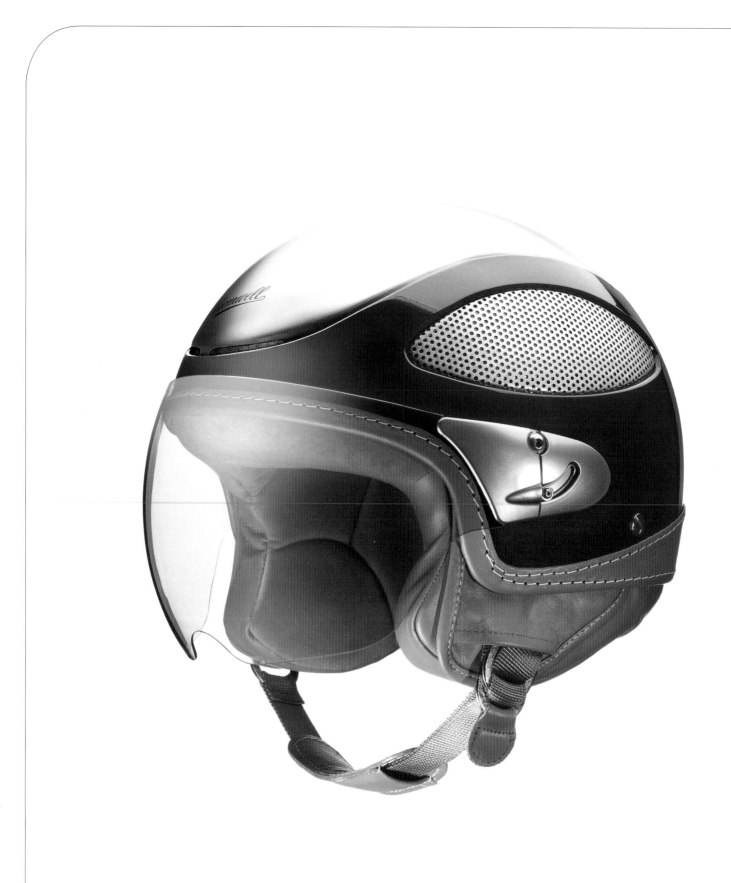

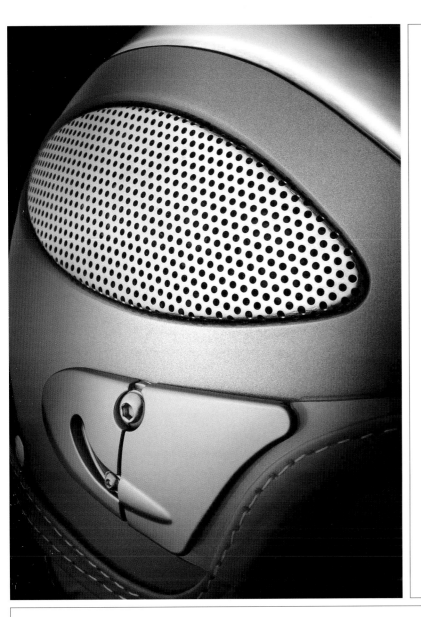

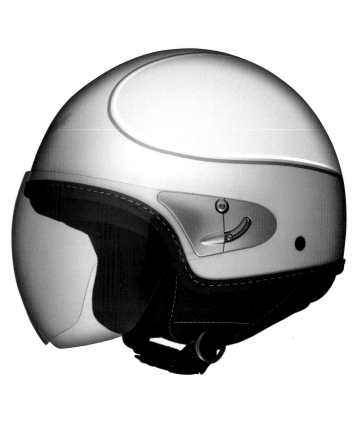

The Hurricane model pays homage to the legendary graphic designs of the earliest motorcycle gas tanks with its colors, a silver base outlined with gold trim. The retro "winks" don't stop there but extend to the interior lining and its chosen colors: Jaguar Green, Imperial Blue, Smoked Gray.

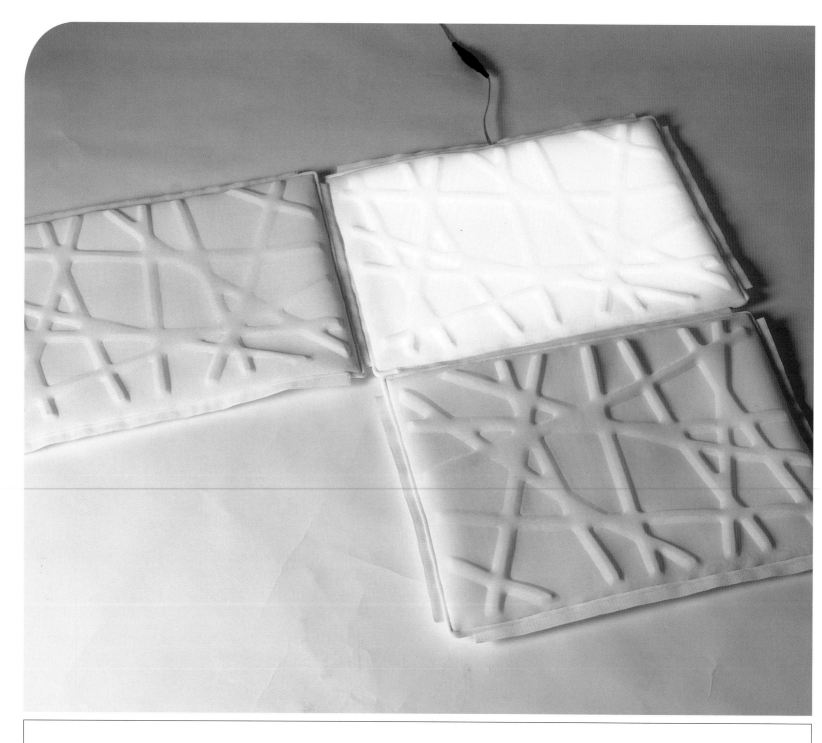

Kolee | Studio Mikko Laakkonen | 2006 | www.mikkolaakkonen.com

Bed, lamp, and blanket: the Holy Trinity of the winter cold, all in one piece. The Kolee quilt is made up of various rectangular 18 by 24-inch pieces consisting of 3-D thread. These pieces can be combined to form an infinite number of arrangements and sizes, as large or as small as the customer desires. The interesting advance in the Kolee quilt is that each of these pieces contains a fully integrated light source that is invisible, except, of course, for the cord that supplies its power. This light source can be integrated into the quilt at any point: in the middle, in one of the corners, at the bottom, or at the top. This quilt will facilitate reading while lying down or sitting beneath it, eliminating the need for any other light source, natural or artificial. The quilt can function well as an ambient or focused light source. However, it is not very bright and cannot be used as a general light source. The quilt is decorated with irregular lines that criss-cross in a manner similar to that of the sneaker sole. Thus, each completed Kolee quilt is different, depending upon how the customer chooses to combine the distinct rectangular pieces.

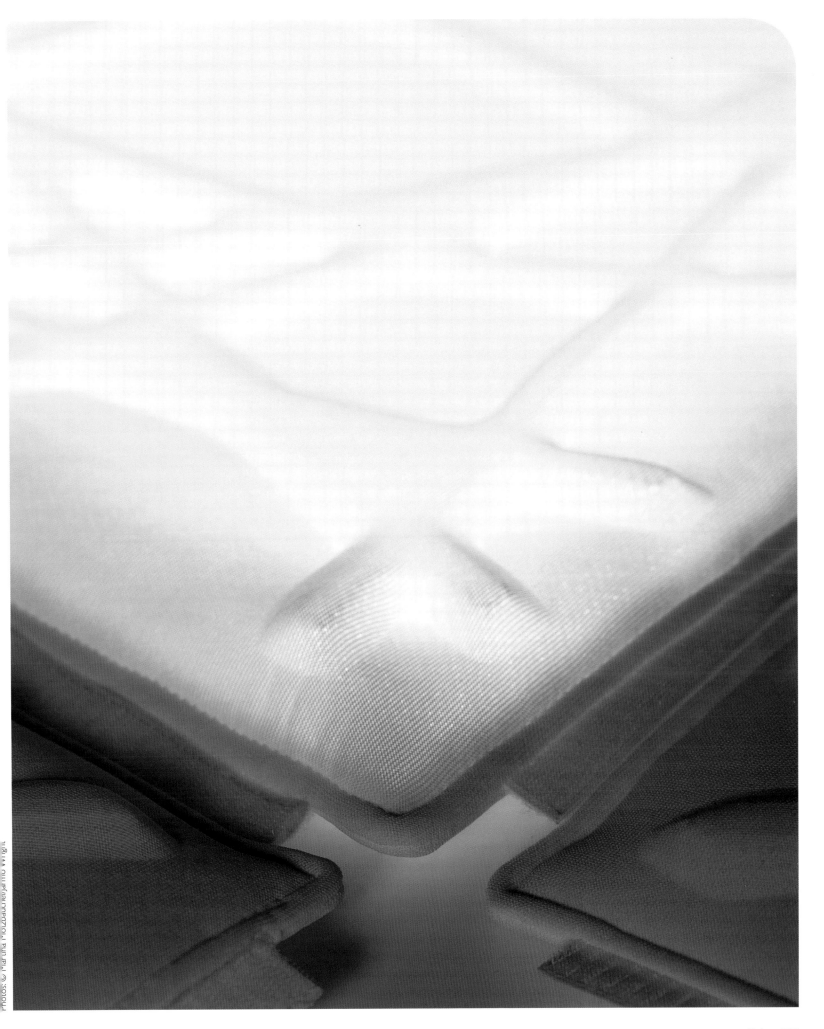

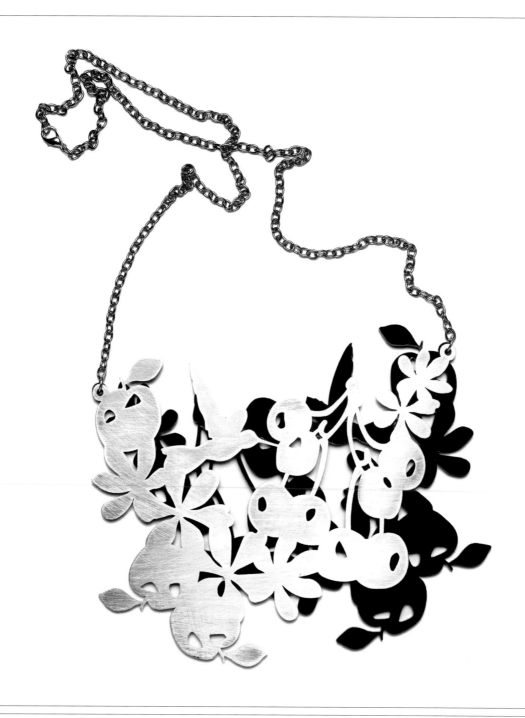

Jewelry Collection | Tatiana Sánchez | 2007 | www.jaleajalea.com

In 2006 the young Mexican designer Tatiana Sánchez embarked upon a "100% Mexican" project that she christened Jalea Jalea. Jalea Jalea's philosophy is simple: Design accessories and clothing made solely from material recycled or produced in Mexico and combine artisanal methods with only the most advanced industrial technology. The resulting collection of pieces pays heed to the social context of Mexico in the twenty-first century without setting aside their ornamental function. Little Kingdoms, Amulet Surplus, Candy Candy, and Rainbow Catchers are accessories collections, made with plastic, that form part of the Jalea Jalea project. From small lollipop and candy-bar shapes to diamonds and other precious stones to an amalgam of gold and black flowers set one upon the other, the pieces from the four collections included in these pages demonstrate an imagination both fantastic and fun, halfway between pop and kitsch. They have brought Sanchez frequent praise in the pages of such international magazines as *Elle* and *Glamour*, and on the web at mocoloco.com.

The Rainbow Catchers collection is without a doubt the most colorful of all the collections under the Jalea Jalea banner. The necklaces are reminiscent of those worn by little girls, simple cords to which are added colorful pieces of plastic trinkets in different shapes and sizes. This collection's pieces are differentiated by the size and thickness of the trinkets that form each necklace.

Corona | Ding 3000 for Authentics | 2006 | www.ding3000.com

Subtlety is on the rise in the world of contemporary industrial design. The Corona clock, designed and manufactured in plastic by Ding3000, is a perfect example. The Corona is completely white, devoid of any other color element. In principle, this would make the clock's hands, which are also white, and the perforated holes that mark the hours, nearly impossible to see (unless, of course, if in this last case the clock were mounted on a dark-colored wall). The Corona's uniqueness lies in the orange glow that emanates around its perimeter from a light source in its back, thus allow-ing the hands to be seen. The hands themselves are also illuminated from behind, and this makes them clearly distinguishable from the clock face. The visual effect is that of a crown of light that surrounds the piece and its hands, lending the clock volume and, if placed on a white wall, an almost ghostly quality. The Corona's minimalist design, without any other unneccessary decoration, helps center the viewer's attention on its lighting characteristics, giving the clock personality and converting it into an attractive and original piece.

Cascata | Korzendesign for Algren Products | 2006 | www.korzendesign.com

The design of a product manufactured in accordance with completely eco-logical methods or that contributes to environmental sustainability has reached what may be its zenith, becoming, in essence, a completely inde-pendent and autonomous branch of industrial design with dozens of pub-lications and web pages dedicated to the subject. The Cascata is a perfect example. Tom Korzeniowski designed this modern amphora with the objec-tive of collecting as much rainwater as possible. The point is to avoid the further waste of this precious natural resource. Plastics played an essential role in its design and manufacture, from the functional point of view as well as the purely aesthetic. No other material would have lent itself this well to shaping, so as to differentiate itself from other, similar products already on the market (at one point, ceramic manufacturing was considered instead of plastic polymers). Plastic also resists extreme temperatures, is cheaper, includes parts made from recycled materials, is worked without much trou-ble (its flexibility is amazing), and, above all else, can be recycled when the object has outlived its usefulness.

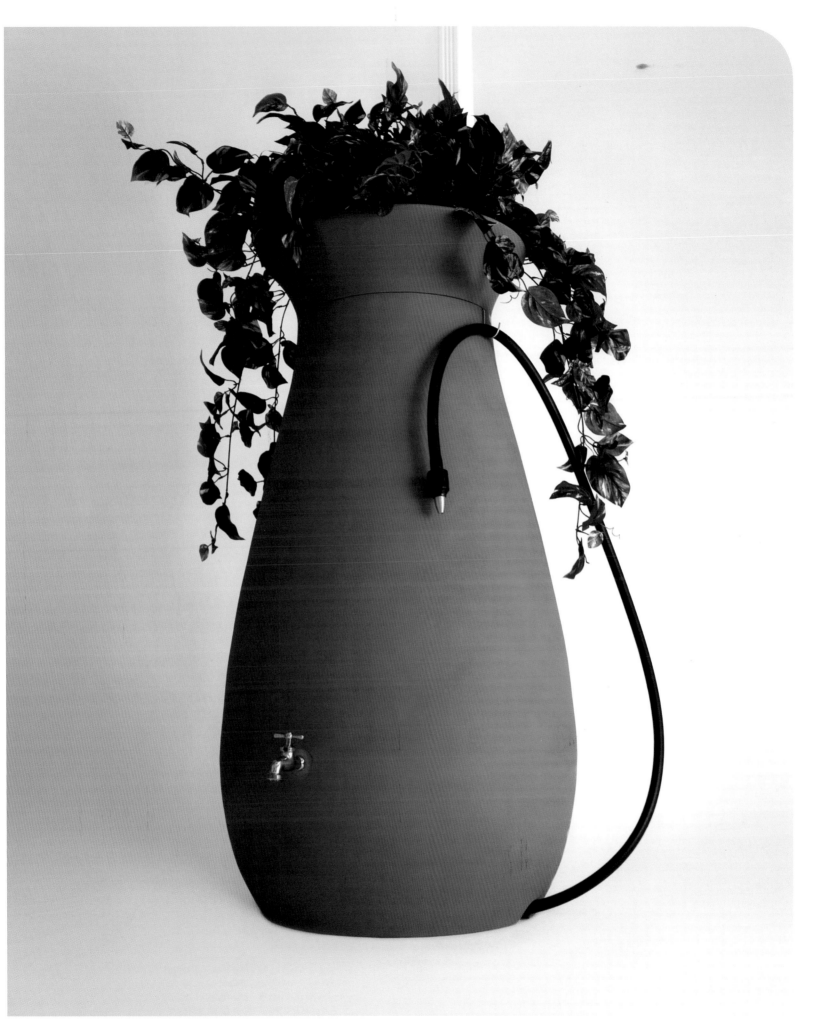

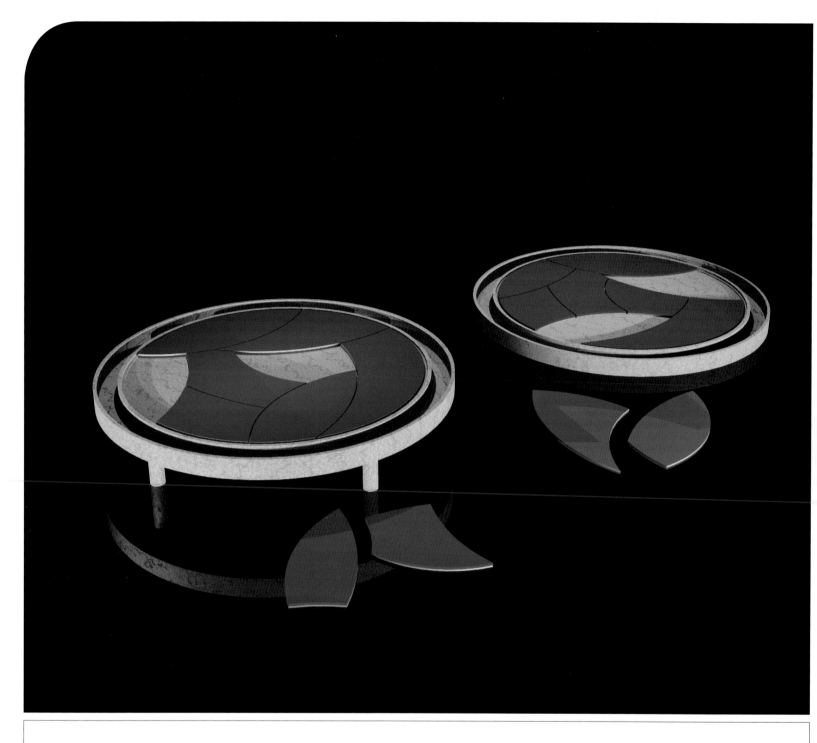

Puz-It | SEED International | 2005 | www.seed-international.com

There is still some room left for imagination and traditional childhood games in this era of latest-technology gaming. Puz-It is a perfect example of this. Puz-It, a puzzle made by Seed, is available in two different shapes: a square-framed model and a round model, both made of Oak. What makes Puz-It different from other puzzles available on the children's market are its plastic pieces, which boast a unique quality: On one side of each puzzle piece is a chalkboard finish on which children can draw. The pieces can be fitted together on both sides, allowing for various arrangements. One half of the puzzle might be its colored side, the other half its chalk-board side, or all the pieces could be put together to form a conventional chalkboard. The round Puz-It is composed of curve-shaped pieces, while the square-shaped Puz-It has conventional puzzle-piece shapes. The framed perimeter of each version has been designed to store pieces of chalk, an eraser, or any other small item; the legs have been designed to be attached or removed without the need for tools, allowing the Puz-It to be easily stored.

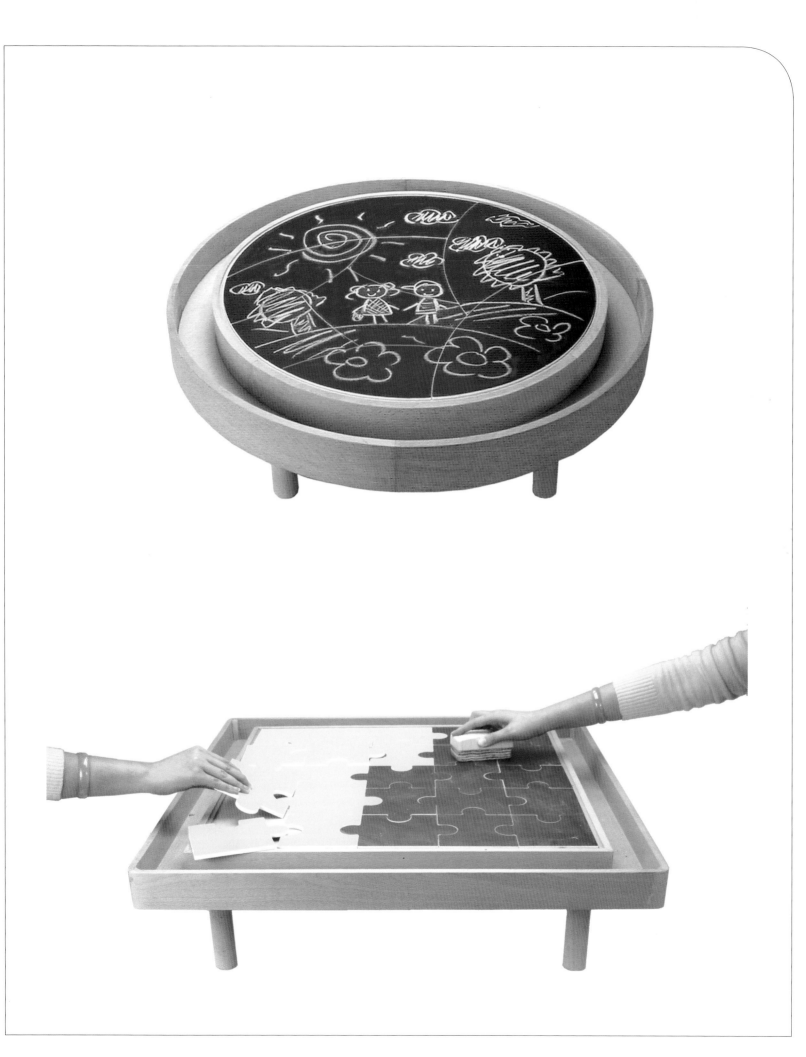

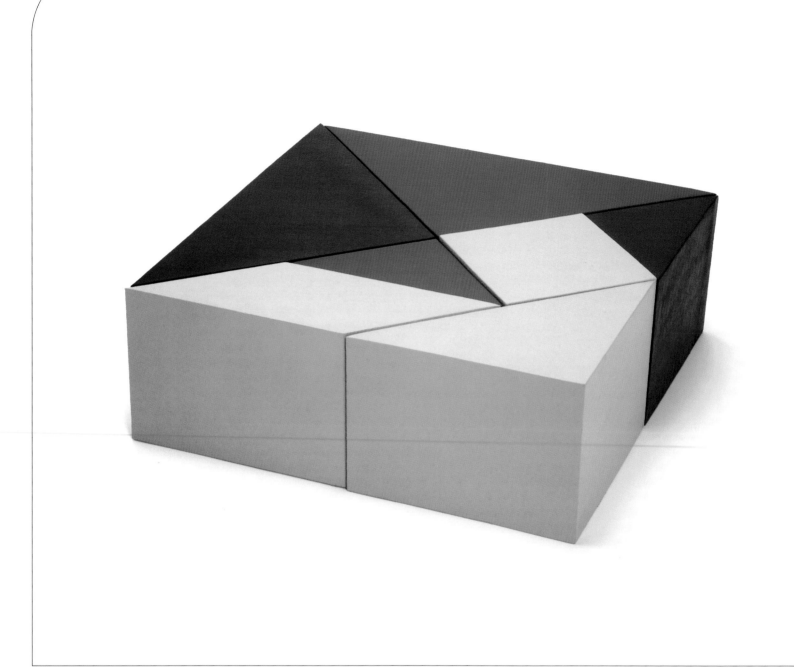

Tangram | SEED International | 2004 | www.seed-international.com

Who hasn't gone crazy at some point when trying to penetrate the mysteries of a certain tangram puzzle, a puzzle for which two or more pieces always seem to be missing? SEED's Tangram offers us the solution to these impossible figures and, in turn, permits us to sit comfortably on one of the pieces as we while away the hours mulling over the mystery itself. Made with polyether foam and a polyurethane finish, the Tangram by Seed is composed, like the traditional Chinese tangram on which it is based, of seven distinct and basic geometric shapes (a square, five triangles, and a rhomboid) that can be reconfigured to assume the shape of animals, human beings, or objects. A second option is to combine these pieces not to form any predetermined shape but to shed light on a new type of furniture of the most whimsical shapes imaginable. The Tangram is available in four different-colored combinations using yellow, red, gray, and black. It is also available in two different sizes: one for adults and another, smaller one for children. Remember: The piece that you're missing is, very possibly, the one you're sitting on. The Tangram by SEED received a jury selection at the Salone Satellite of Milan in 2004.

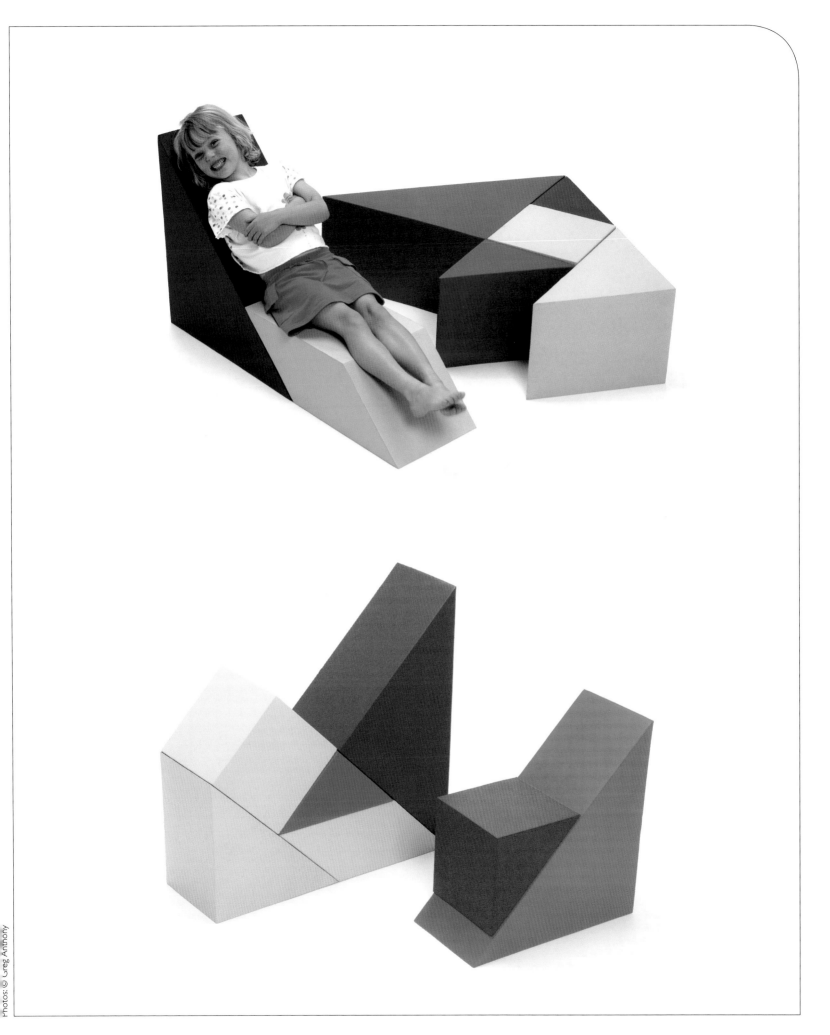

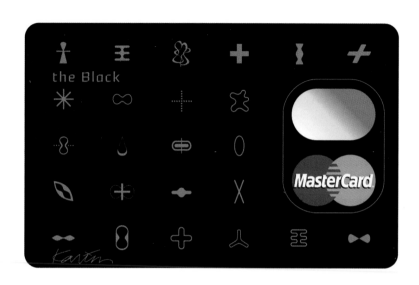

Black MasterCard | Karim Rashid for Hyundai | 2005 | www.karimrashid.com

A very popular urban legend has it that there is in existence a black credit card, available to only a select group of people in the world, that has no spending limit whatsoever. It is said to be able to open the doors of any of the best international stores—at any hour, regardless of normal operating hours. It's possible that this rumor is merely an exaggeration of the Centurion Card by American Express, popularly known as the Black Card (and a habitual character in hip-hop lyrics). Its annual fee is around $2,500 and it is thought that there are no more than 10,000 of them in the entire world. Most of them are in the hands of multimillionaires and celebrities (even some fictional characters have it, too, like James Bond in *Casino Royale*). But

it is also possible that from this moment on, the rumor may apply to the limited-edition Black MasterCard designed by Karim Rashid for the Korean company Hyundai. This new card has quickly established itself, ranking fourth in the list of "most prestigious credit cards", behind the aforementioned Centurion Card by American Express, the Infinite Card by Visa, and the World Signia by MasterCard. This card is made of various layers of laminated plastic, though its core is made of PVCA, a resin that mixes well with many materials, such as plastifiers and inks, and gives the credit card its unique texture and appearance.

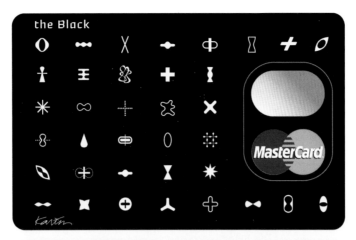

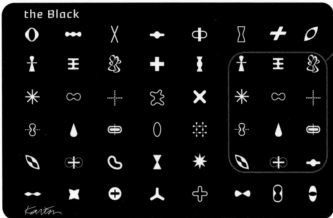

I just repeated them, because they are not shown anyway.

EXPERIENCE	MULTIPLICITY	SIN	ACUITY	TECHNO	KISMET	VELOCITY	PLEASURE
LIFE	ENERGY	FUTURORETRO	HEAL	SENSUALISM			
PHENOMENA	KORPUS	IMMATERIALITY	ORGANOMICS	UNIVERSAL			
SPIRIT	FLUID	ETERNITY	AIR	MATRIX			
SENSORIAL	PERFECTION	BIRTH	TIME	KOSMOS			
LIGHTNESS	EQUALITY	COMUNITY	DIGITALIA	LOVE	INFINITY	SOUL	MIND

How_Box (How-Fusion) | Studio I.T.O. Design for Nava | 2005 | www.studioito.com

The uniqueness of any great design lies in part in its simplicity and, more specifically, in its "why didn't any designer think of this before?" aspect. Better said, in its "insight." The How_Box (How-Fusion) by Studio I.T.O. Design is a perfect example of this. It is a set of simple office organizers constructed of shiny recycled Plexiglas that boasts a unique trait: They fit together to form the symbols of ying and yang, becoming a light and comfortable compartment for documents and magazines, that is easy to transport and completely secure. The How_Box (How-Fusion) comprises two pieces that fit together, one over the other, with the help of a small lip on the upper part

that fits neatly into the lower. The two pieces, which are similar in appearance, become harmonious opposites once united. Available in different colors, the organizers can be in all one color or combined with orange, black, white, and transparent. The Plexiglas, which is injected directly into an industrial mold, creates a light and impact-resistant organizer as attractive in fun and informal offices as it is for those of a more severe aesthetic. Its transparency allows the user to look into the box and see what is inside without needing to remove everything inside piece by piece.

Beauty Products Packaging | Studio I.T.O. Design for B&C Laboratories | 2006 | www.studioito.com

It is known that attractive packaging may lift sales of certain cosmetics by 20 to 30 percent (sometimes even more). This is the reason the cosmetics industry places so much importance on its packaging. In this case, Studio I.T.O. Design opted for a motif that reinforced the product's promotional message instead of going the traditional route of designing something plainly pretty or purely ornamental. The Agediscuss Cellremind and Nolinepassport packaging designs underscore the product's more important qualities: smoothness and tightness. In the packaging, the curved line predominates (smoothness), though there are some straight angles (tightness) as well. The contrast between these two concepts adds up to what B&C Laboratories describes as the "tensing" capacity of the two products.

Both packaging styles make avail of two "layers" of superimposed plastic. The first layer, the exterior one, is similar to ice, translucent enough to see through to the interior red. For manufacture, two different plastics were used: Acrylonitrile Styrene Acrylic and polypropylene. From the contrast of both these materials comes the aforementioned "smooth-tight" description.

V-Bag | Freedom of Creation | 2005 | www.freedomofcreation.com

What might have become of the troops under the command of Scotland's hero, William Wallace, if they'd only been able to make use of a couple hundred V-Bags in the battle of Falkirk? They might have been able to protect themselves from the arrows of the feared archers of Edward I and consequently win the battle with ease. Would Scotland today be independent from England? The V-Bag is clearly patterned on the metal armor used by knights in the Middle Ages. Only (and this is where our argument fails), the V-Bag is not manufactured with metal of any kind but with nylon, a type of synthetic polymer belonging to the polyamide family. The customer, in any case, has the option to order (ahead of time, of course) a V-Bag made with the metal of choice should she decide to invade England. Janne Kyttänen, one of the designers of the V-Bag along with Jiri Evenhuis (the bag is based on one of his 1999 designs), is a pioneer of design and research who specialises in design for rapid manufacturing by means of laser sintering. The result is a flexible bag 24 inches high with a unique aesthetic quality, a strong personality and a world apart from any other similar women's product on the market today.

Self-Vase and Light-Up | Matali Crasset for Deknut Decora | 2002 | www.matalicrasset.com

When the Belgian mirror shop Deknut Decora thought of expanding and renovating its collection of decorative mirrors, it asked various international creative talents to design new and innovative models. In the end, one of the obvious choices was the mirror designed by French designer Matali Crasset. For Deknut Decora she created three completely different mirrors (two of which are shown on these pages: the Self-Vase and the Light-Up). The first, the Self-Vase, consists of a tray that contains six hand-mirrors in very different, whimsical shapes. Made of acrylic plastic and aluminum, each mirror measures 13 inches high. Light Up, on the other hand, is a standing mirror, also made of acrylic plastic, that not only imitates the look of a conventional lamp but doubles as one too. This is made possible by a small light source embedded within. The innovation here is that the mirror, which is not meant to lean against or be hung from the wall in the customary fashion, permits the user to move it easily from one side of the room to the other, while the light recessed into it makes looking for an alternative light source a thing of the past. From the side, Light-Up looks like a conventional lamp that has been cut in half, "half a lamp" to be exact, an effect reinforced by the lamp's base: a perfect semi-circle.

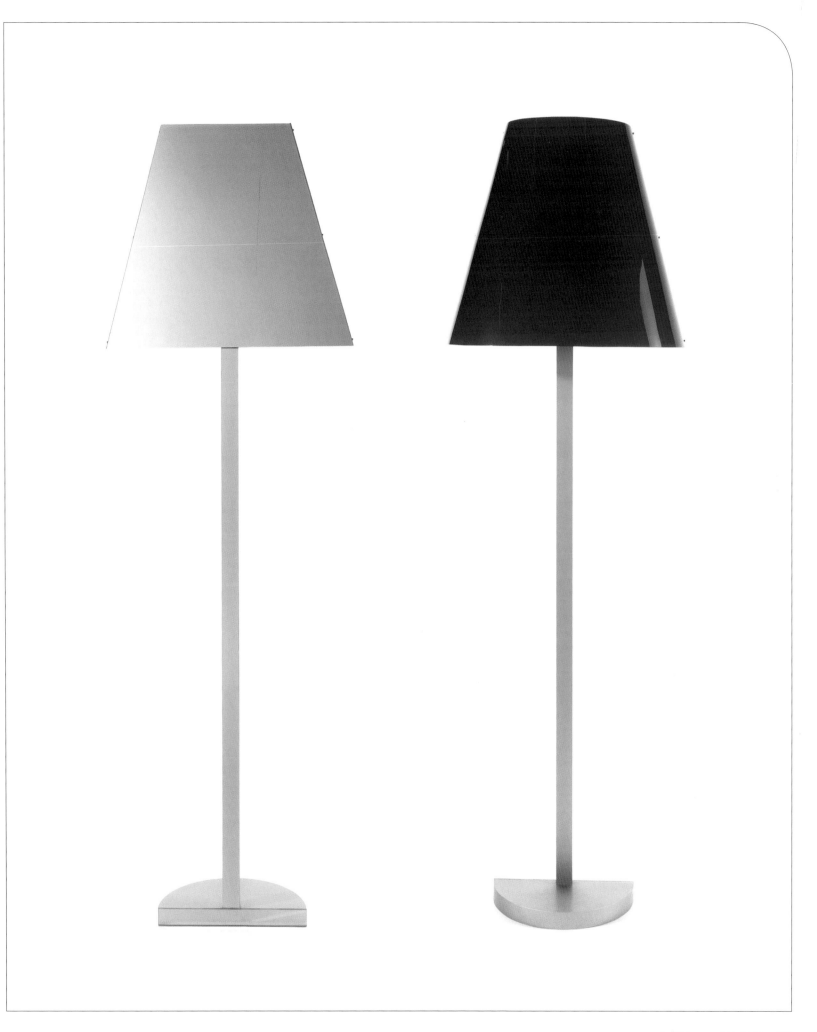

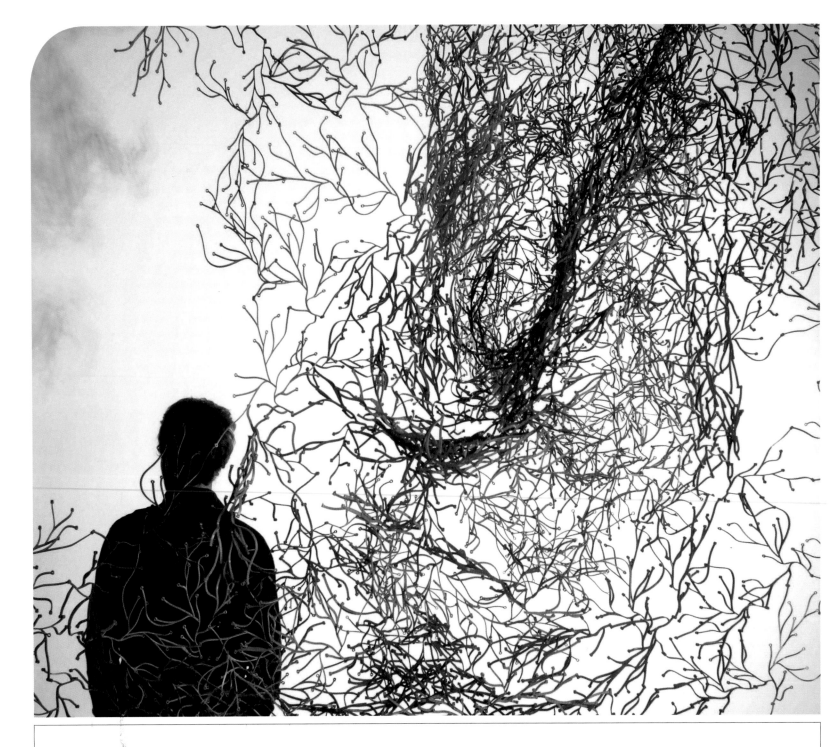

Algue | Ronan & Erwan Bouroullec for Vitra | 2004 | www.bouroullec.com, www.vitra.com

Gaudí himself might have felt envious of the ways in which Ronan & Erwan Bouroullec have used as slippery a natural element as algae to give shape to so prodigious an industrial design as this, a decorative object that is able to double as a purely functional element in any interior space's design. The Algue is comprised of pieces of injection-molded plastic similar to, as the name indicates, algae. These pieces may be combined and inter-woven to create a web of objects as diverse as a curtain or a completely opaque stand-alone room divider. The Algue, available in many colors (red, white, black, and, obviously, green), comes in packets of 50 or in six-piece gift packs. To completely cover, say, 10,764 square feet of space, one would need 25 pieces. The resulting web is light-weight and can be arranged so that in some places the curtain may have a heavier or lighter thickness than in others, a property that may recall the groups of algae sometimes found along the sea-shore. This permits us to play with light and its effect on near-by objects. The result, organic and mobile (their light weight permits the Algue pieces to be easily balanced with one another), has as many practical applications as the imagination is capable of.

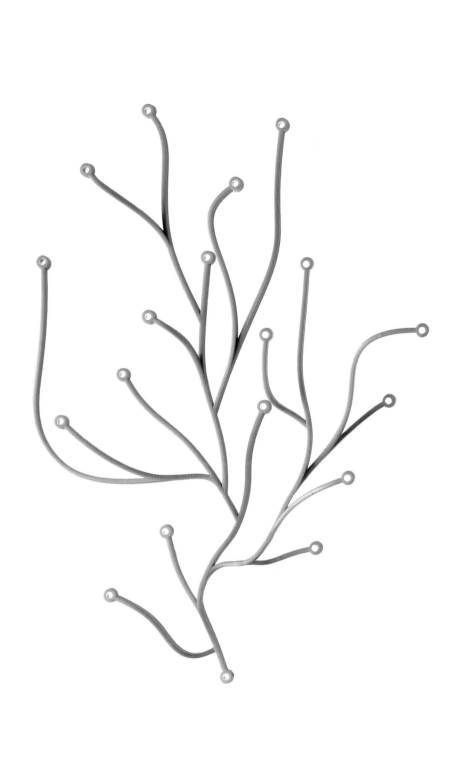

Hidden | Jellylab Studio for MGX by Materialise | 2006 | www.jellylab.com

Some (good) designs play with the viewer's imagination. Popular wisdom holds that a work of art has achieved its objective if two people are capable of reasonably interpreting it in two completely different ways. This is the case with Hidden, a flowervase barely six inches tall and manufactured in polyamide (nylon) by means of SLS (selective laser sintering) technology. Where some see a bird's nest or the root of a plant (or maybe the root of the flower placed in the vase), others see the tentacles of some alien creature landed on Earth to conquer the human race.

Another unique aspect of the Hidden vase is that it not only can be used as a conventional vase, but it also allows the user to easily weave a variety of plants or other decorations through its "branches." The result is, aside from decorative, paradoxical: an object made of plastic, perhaps the most artificial material created by mankind, that imitates the branches of a tree and serves to hold, within and around itself, any type of flower or plant. Like all of the products to come out of Materialise, Hidden was created via rapid prototyping technology, a 3-D prototyping process that offers unlimited freedom of design when constructing an object composed of extremely small pieces.

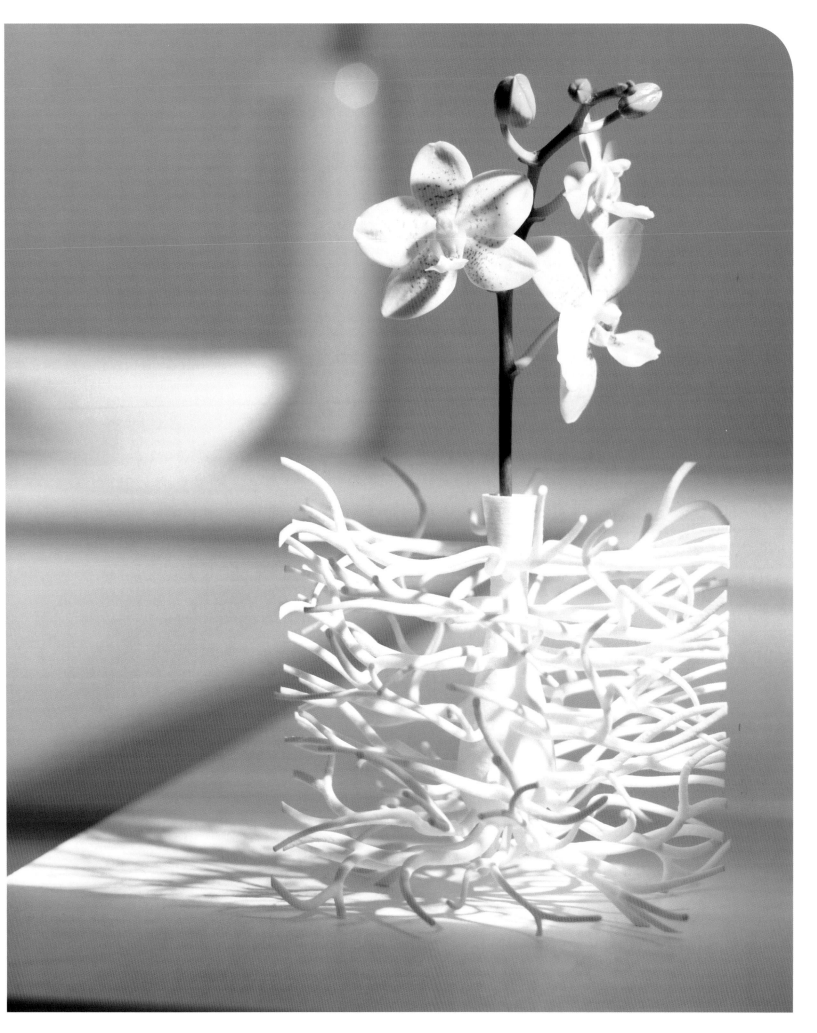

Vynil, An Alternative To Wallpaper | 5.5 Designers | 2006 | www.cinqcinqdesigners.com

In the past few years, vinyl has become a cheap, flexible, and convenient alternative to traditional wallpaper. Dozens of designers have launched the design and commercialization of vinyl products that are already commonly seen in apartments and cities all over the world. Vinyl as an alternative to wallpaper has been a success, as was expected, among the young. Vinyl can stick to and peel away from the wall with ease, it's easy to clean as well, and it's also able to be easily substituted for another vinyl design. There's all kinds: the conventional kind, which maintains a similarity to traditional wallpaper designs, the heterodoxical, the radical, colorful, small and large, the ironic and fun and playful. 5.5. Designers rises above all the other vinyl designers, because of the variety of their vinyl collections. In these pages we can see, in order of appearance, the following models: Guitou the Cat, Coloring Wall, Pieces of Wallpaper and Shoelace Lesson. Each carries out a dual function: On the one hand, they are decorative elements. On the other, they are Surrealist-inspired works of true art, an example of the theater of the absurd and the most Dadaist cartoon delirium, all applied to our daily surroundings.

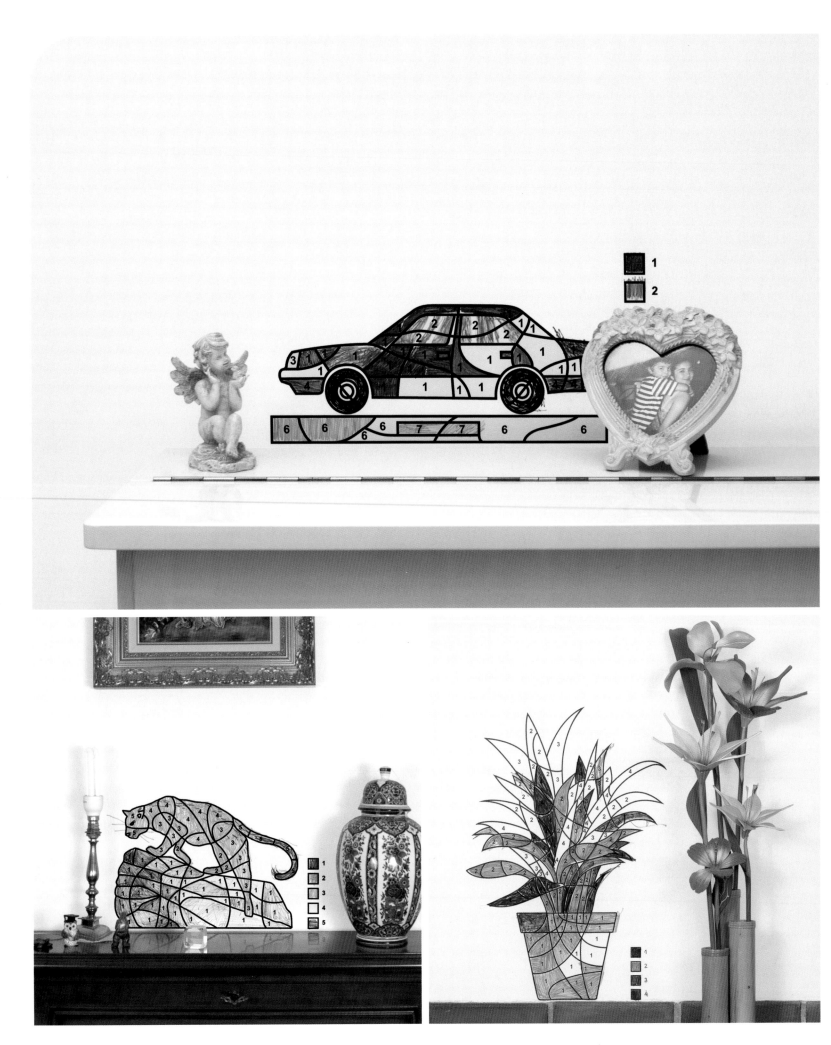

The Coloring Wall collection comprises various vinyl pieces in easily recognizable shapes (a car, a leopard, a flowerpot, and so on), the surface of which has been divided into numbered sections to be colored by children and adults alike, as if they were the pages of a children's coloring book.

Shoelace Lesson is composed of various vinyl pieces that demonstrate the step-by-step completion of an elaborate type of sailor's knot, obviously referencing the traditional pictures of sailor's knots that are seen today on the walls of some coastal-region restaurants. Putting them up out of sequence will accentuate their "surreal" effect.

Ordinary Objects | 5.5 Designers | 2005 | www.cinqcinqdesigners.com

Ordinary Objects is a project that attempts to return lost glamour to a whole series of daily-use objects (plugs, flashlights, chairs). It's about anonymous and purely functional objects that end up abandoned in the back of a drawer or a remote shelf somewhere when they are not being used. In the words of 5.5 Designers, "They are so much a part of our daily lives—mass-produced, functional, cheap but suffering from a lack of image." These iconic designs are then reinterpreted by means of adding other elements to them, what 5.5 Designers calls "placebos." The goal is to return to the abandoned object its self-esteem. The objects selected for "healing," like the elements and the prostheses that are added to it, are, for the most part, made of plastic materials (vinyl, polypropylene, silicone). After all, this is precisely the type of material usually chosen for manufacturing these types of ordinary, anonymous, daily, cheap, mass-produced, functional objects. In the reinterpretation of the object, no decorative element is ever added and the point is never to hide the original function, which prevails over form. Once they've been moved from their natural situation to one of greater "prestige," we place them on the pedestal that helps us to quickly forget their former, everyday function.

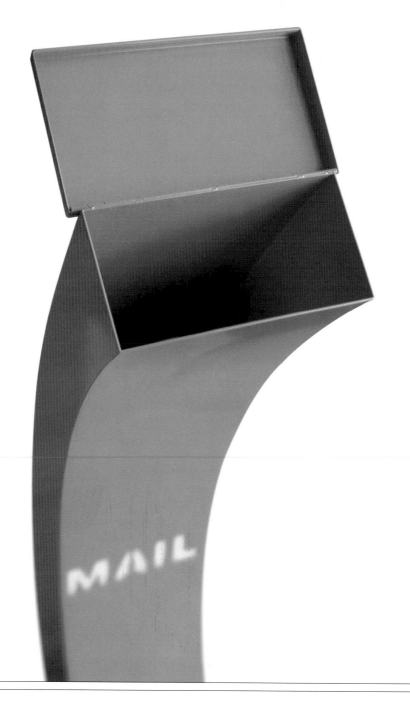

Edith | Adriean Koleric / ITEM | 2005 | www.thinkitem.com

Generally speaking, mailboxes tend to be odd elements, capable of breaking the predominant aesthetic of our home. Because of this, Adriean Koleric decided to design a mailbox that could reclaim its inalienable right to stand before our home, alongside trees, hedges, fences, and any other traditional element integrated into the landscape. The result is Edith, a heterodoxical mailbox that seems to have grown from the ground itself, like the pink root of some as of yet unknown plant instead of the mailbox made of powder-coated steel and fiberglass that it really is. In fact, the Edith's organic shape encourages one to believe that the mailbox magically grows a few inches taller each year, blossoming in spring and shedding its leaves in the fall. The frosted Plexiglas "mail" text that we can see on the Edith's front part is meant to be backlit from within the box. An electronic cell, sensitive to light levels, turns on when the sun sets and turns off when the sun rises. This is because, if and when the light were turned on during the day, nobody would be able to make it out from the surrounding structure. Before manufacturing this piece, tests were done with different prototypes to determine the ideal height for the user.

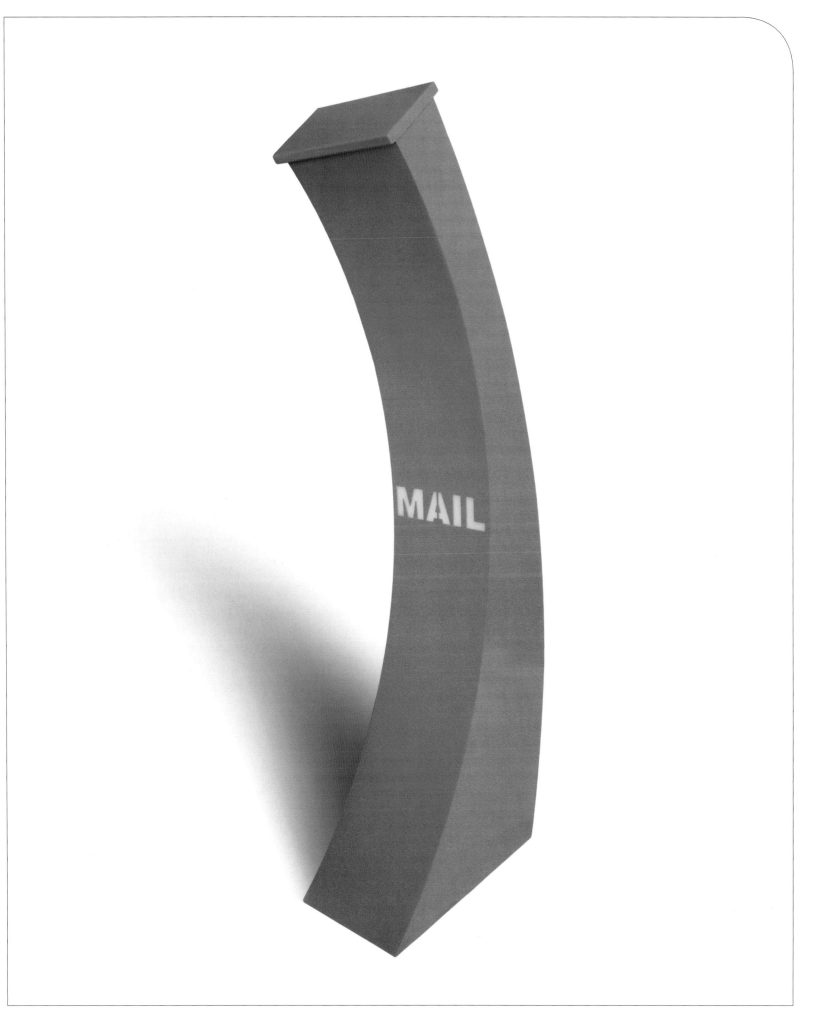

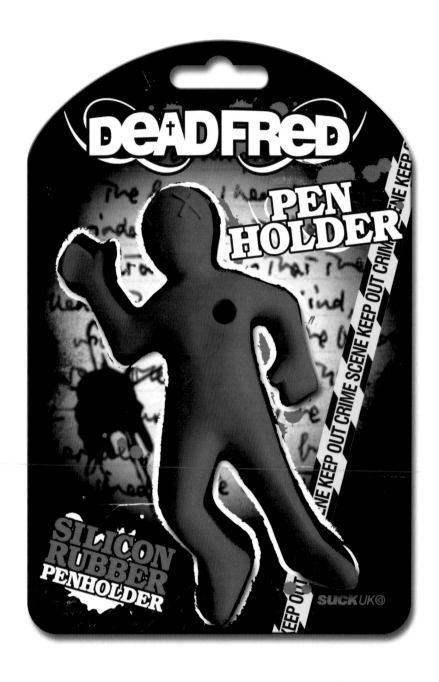

Dead Fred | Yann Le Bouedec / Suck UK | 2006 | www.suck.uk.com

Are you having a bad day? Sublimate your murderous instincts with Fred, the rubber doll that will never complain, no matter how many times he's stabbed in the heart with a pen. In fact, as the ad for Fred says, "He won't mind 'cause he's already dead. What's more, your colleagues won't dare mess with you once they have seen you in murder mode." Conceived to be an ironic voodoo doll, Fred is made in blood-red silicone rubber. Its function, obviously, isn't so much about allowing its user to release tension, but to be a fun alternative to more traditional pen and pencil holders. In fact,

it's very unlikely that the pens used to stab Fred will ever get lost, even if it's only because the doll attracts attention and is difficult to ignore. Fred is just one of hundreds of joke items available in gift shops that have been manufactured mostly with plastic materials. These are the only materials that allow an almost infinite amount of flexibility when it comes to creating, designing, molding, and producing products of all shapes, textures, and colors. The Fred doll measures 4.7 inches tall by 2.8 inches wide by 0.8 inch thick.

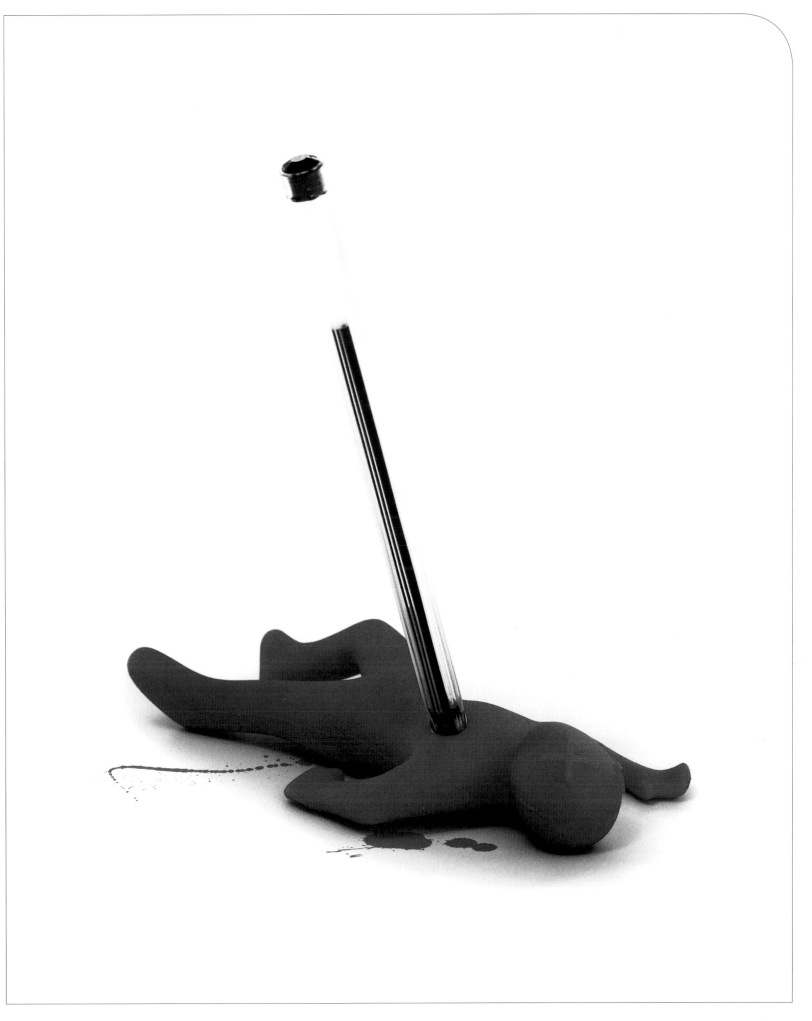

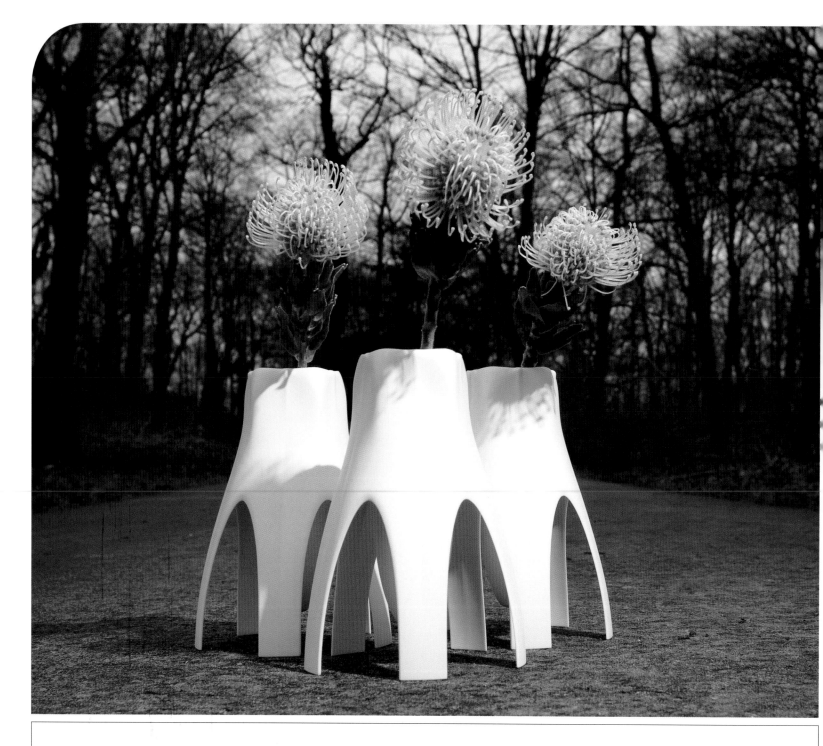

The Flo | Studio Bizq | 2006 | www.bizq.nl

Flo is the first product that Studio Bizq developed for Newdeqo. The Flo is a flowervase vacuum-cast (semi-automatic) in a silicone mold from high-tech, two-component polyurethane resin. The piece assumes the shape of a flower ("which never wilts," in the words of the designer) and its attraction lies in that it's not necessary to put a bunch of flowers in it for the vase to have "presence"; one lone flower will do. The Flo vase is characterized by a contemporary application of decorative details and by its shape, which echoes the natural form of the flowers inside it.

Flo measures 8.2 inches tall and is been hand-made, in a very limited series, with artificial resins. It is available in various colors, although if a client wants a specific hue for decorative reasons, it's possible to make it for him or her in quantities of no fewer than five pieces.

Another innovative aspect of the Flo is the short period of time from design to manufacture to availability, thanks to the fact that the designer is also the inventor, artist, and manufacturer. In the words of Timo Voorhuis: "In fact, this is nothing new. Artists have been doing this for hundreds of years. However, what is innovative is to work like this with a consumer item."

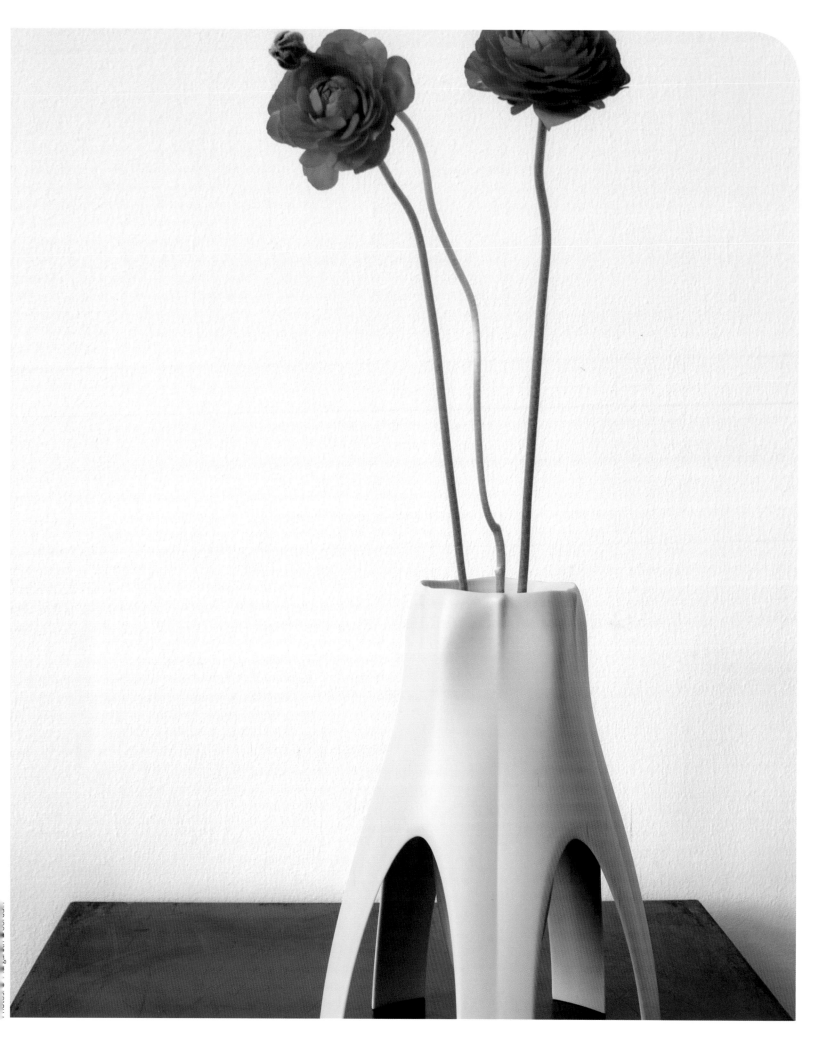

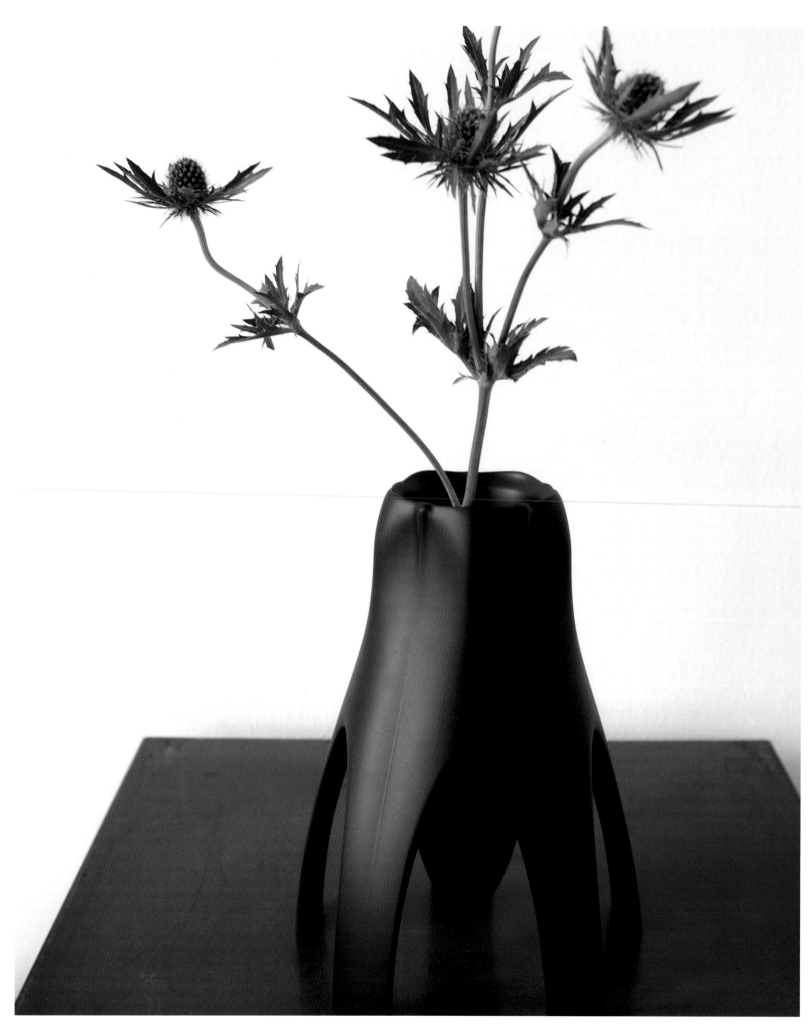

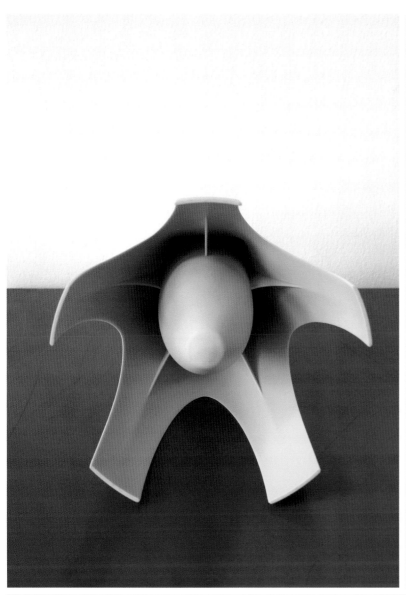

The Flo's original sketches are converted into a virtual three-dimensional model with the help of 3-D software. The vase is "drawn" with a laser in a stereolithography machine. From this a cast is made in the traditional method, and is manually colored afterwards.

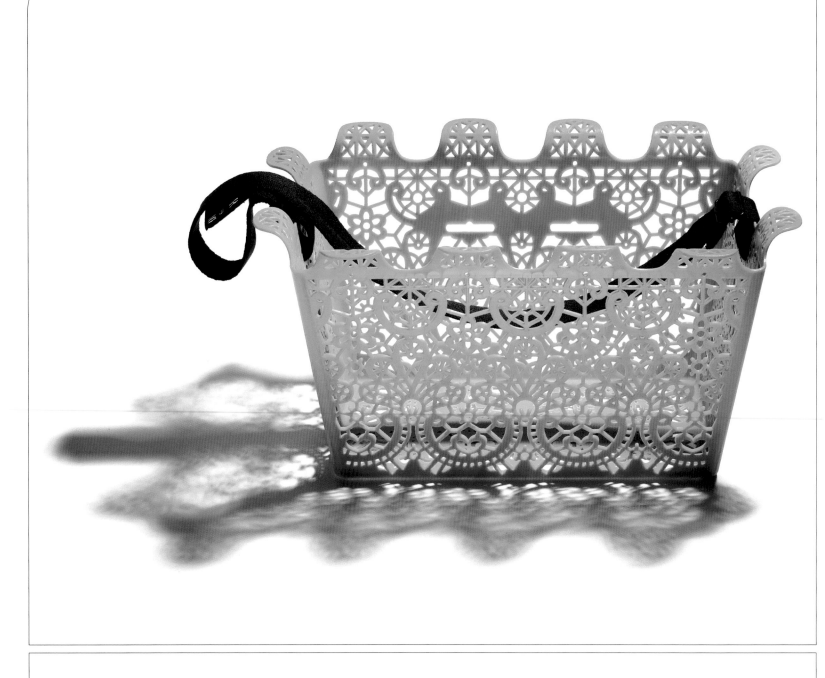

Carrie | Marie-Louise Gustafsson for Design House Stockholm | 2007 | www.marielouise.se

Carrie is a plastic acrylic basket to which a set of small metal hooks have been attached so that it may be hung on the handlebars of a bicycle. The basket also has a polyester strap that allows the basket to be used as a purse when it's not attached to the bicycle.

Carrie's initial concept is an evolution of the traditional tablecloth, perfected according to the motto "*Fika* meets Japanese Tea Time" for the 2004 Tokyo Style Exposition in Stockholm. *Fika* is the Swedish word for "coffee break," and Marie-Louise Gustafsson's favorite *fika* is a picnic in the countryside after a nice bicycle trip. It was a short step to the idea of creating a basket with which to transport the food and drink for a picnic. In fact, the crochet design used for the Carrie was chosen by Gustafsson because it reminded her of her grandmother, who used to offer six different types of cookies for a *fika*, serving them on a finely embroidered tablecloth. The Carrie is also very functional: Turning the basket over converts it into a little picnic table, thanks to its rounded edges.

There is also a Carrie model adapted for shopping. In that model, the metal hooks have been removed, along with all the other reinforcements necessary for bicycle-use installation.

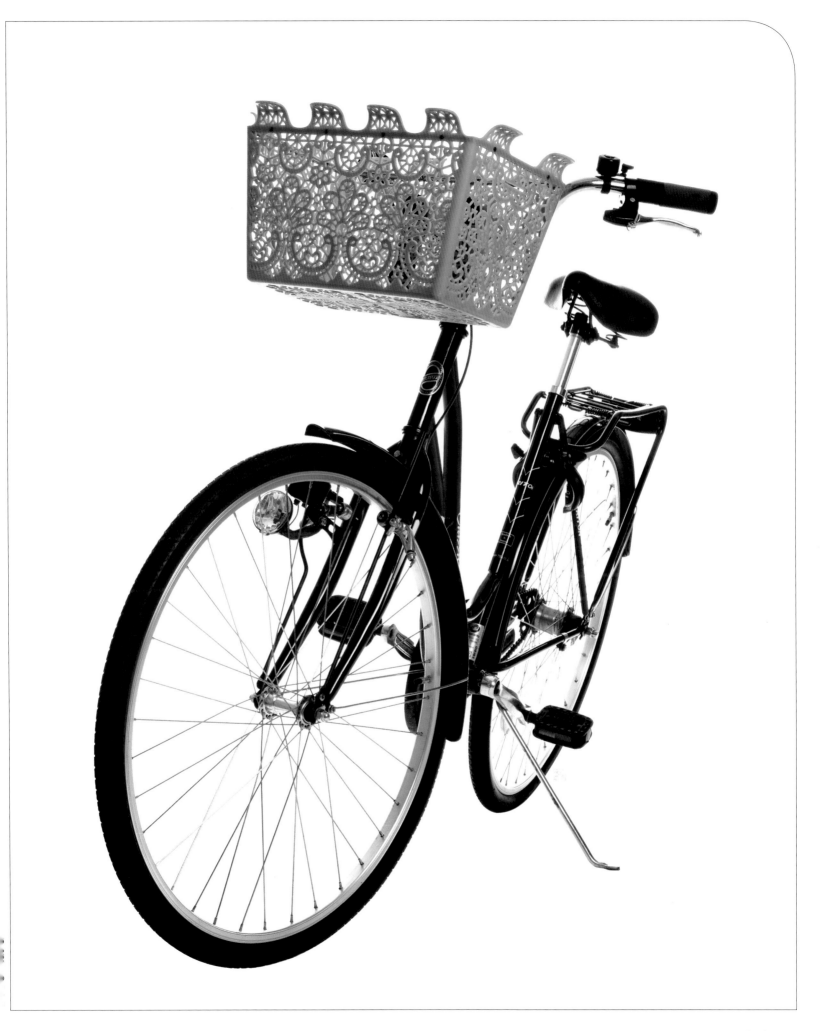

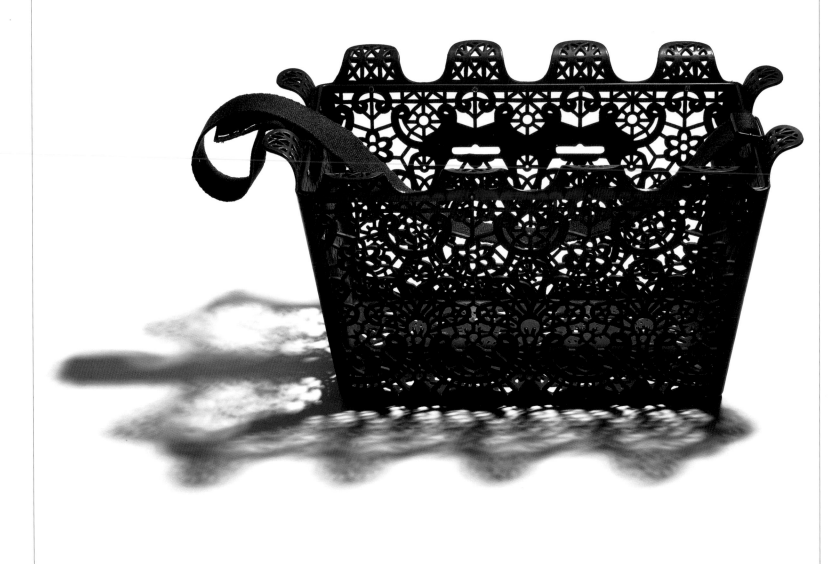

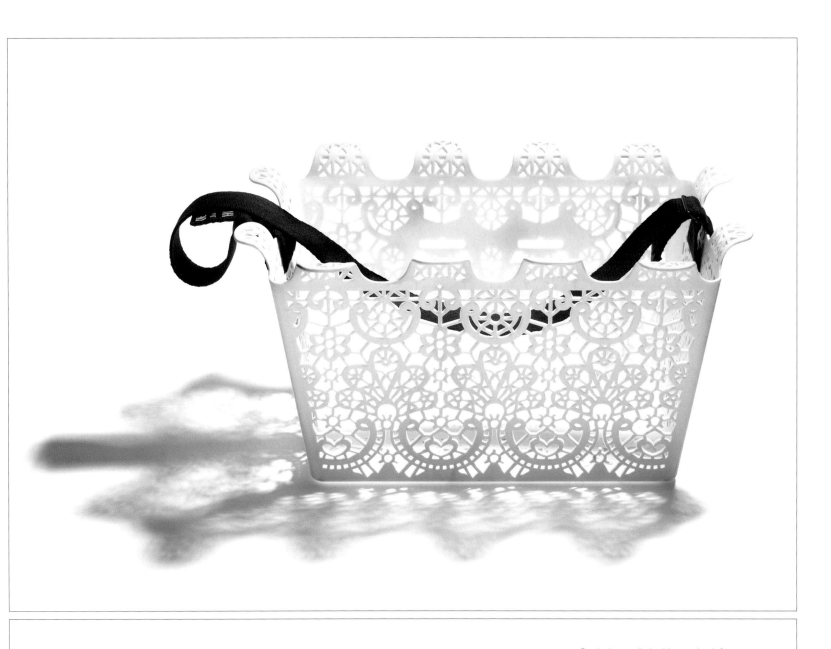

Carrie is supplied with metal reinforcements so that it may be firmly and strongly attached to the bike's handlebars, making it hard for the basket to fall off when you hit a bump. The Carrie can also be used to store bath towels or flower-pots or even be used as a purely decorative element.

Fanplastic Ornament Sets | Fanplastic | 2007 | www.fanplastic.net

Generally, the history of industrial design's milestones reaches us with convenient embellishment closer to myth than reality. This is not the case with the Fanplastic family of ornaments, considering its press file, which mentions that "Fanplastic was created one night, over drinks and steaks at Taylors, by Mike Lohr, Kimberly Murray, and James Randall". No more, no less: no Bauhaus influences or postmodernism or complicated theoretical reasons. A simple meeting between furniture designers Randall and Murray, and graphic designer Lohr fired the starting shot for Fanplastic Ornament Sets. Their point in common was their shared love of Plexiglas. The result is a family of decorative pieces for a tree or window made from translucent Day-Glo Plexiglas. The ornaments are categorized by theme or series. The series seen on these pages are, in order of appearance, Transportation, 1,600, Abstract 2, and Living Large. In these we may find anything from facsimiles of some of the more popular old video-game characters (Pac-Man or Space Invaders), to simple abstract shapes with no meaning at all or the iconic symbols of transportation normally seen at airports or on highways. These also come in more prosaic shapes like palm trees, sunglasses, and the initials of Los Angeles (LA).

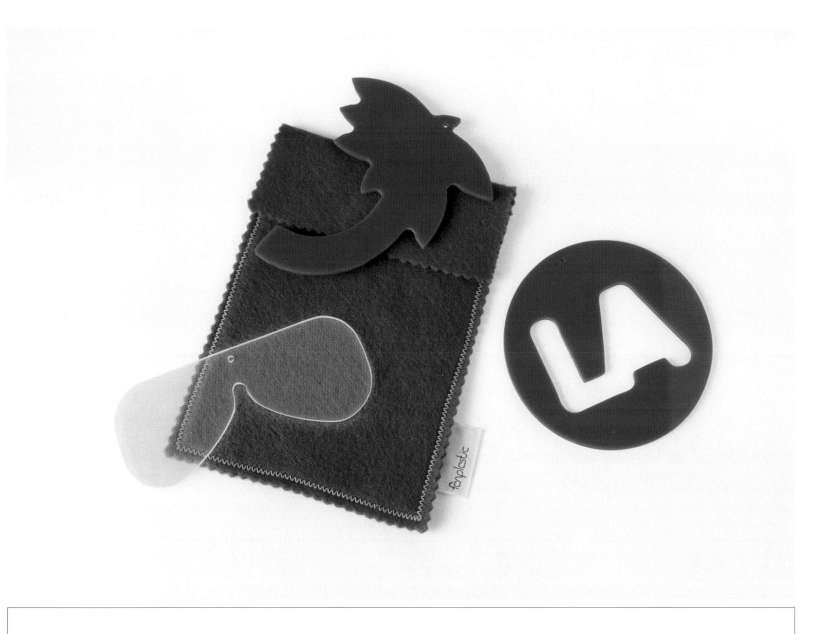

These plastic ornaments are sold in felt bags sealed with Velcro. Each bag contains three pieces of different shapes and colors in which a small hole has been formed and from which a thread can be pushed through so that the ornament may be hung from a Christmas tree, a window, or any other place.

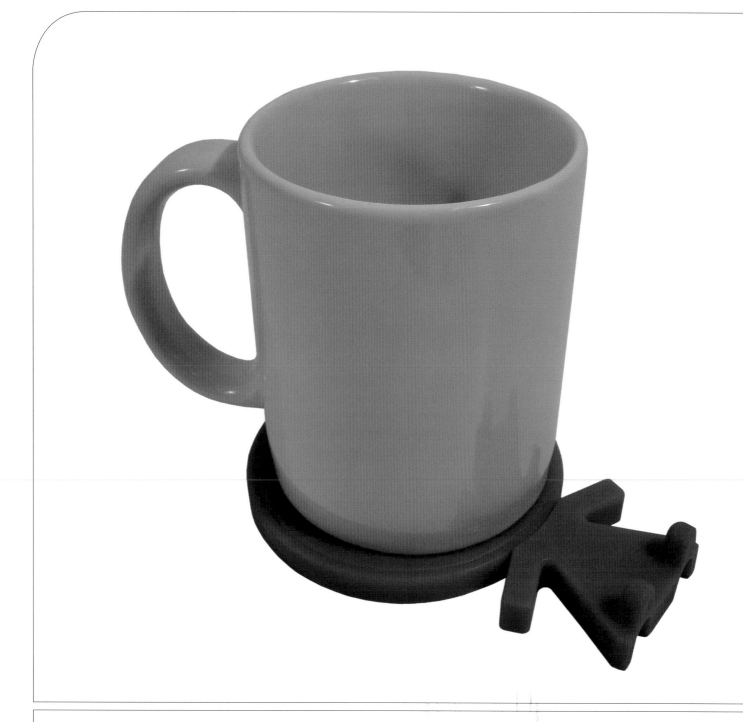

Big Head Coasters | j-me | 2006 | www.j-me.co.uk

If your name is Big Head, you've been made with injection-molded thermoplastic rubber and you're a fun and colorful coaster; so, having a big head is definitely an advantage. In this case, having a big head isn't just no problem at all, it's actually an undeniable advantage come time for this coaster to be used as a support for cereal bowls, glasses of tea, cups of coffee, and cocktails of all kinds. The anthropomorphic Big Head is an extreme-temperature resistant-coaster that is easy to store. One of the principal features of the Big Head coaster is that when it's not being used as one, it can function as a decorative element, thanks to the rubber "feet" that help it stand up. Big Head comes in two different types: One is a boy, and the other a girl, easily distinguishable by the dress on the latter (as seen in these pages). The fact that the coaster comes in two different models, boy and girl, and in a whole array of different colors, ensures that drinks will never be confused again. The coasters are sold in packs of four (two boys and two girls) and measure 3.5 inches wide by 4.7 high by 0.8 thick.

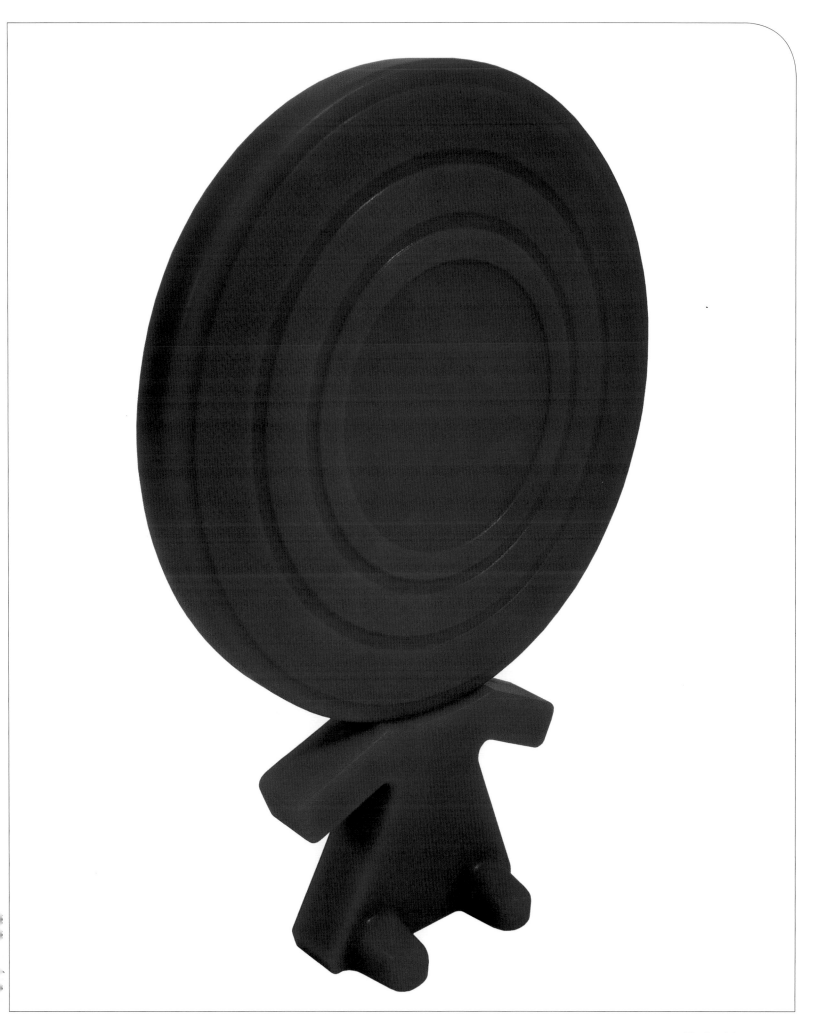

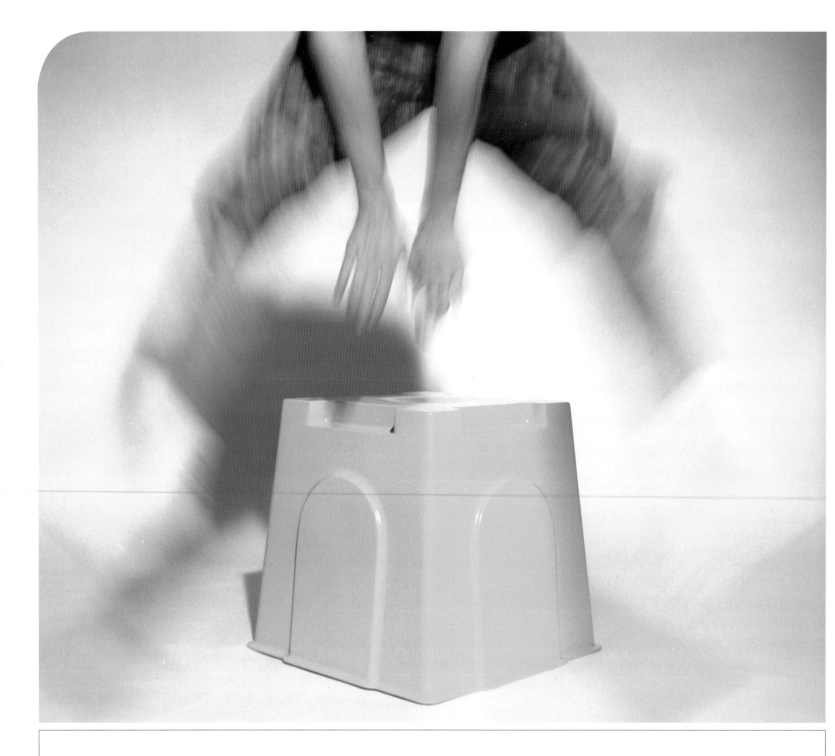

Sandcastle Stool | Designandstuff | 2006 | www.designandstuff.net

The Sandcastle Stool belongs to a family of products that Designandstuff has created for the beach, following their line of theme-based products that has become the company's trademark. In that family of beach products we also find items like the Pic Chair, Pinhole Beach Hut and Time Flies. The Sandcastle Stool, made of polypropylene, was born of the need for furniture specifically designed for the beach. Based on a typical children's sand bucket, Designandstuff has created a larger one, big enough to be able to store all types of objects and durable enough to serve as a chair or play table. Obviously, the Sandcastle Stool also allows for the construction of sand castles that are much larger than usual, which would make the child who owns it the envy of all the children at the beach. Sandcastle Stool is light, easy to transport, and easy to store (even if you have more than one). Currently, it is just a prototype, although Designandstuff is in negotiations with prospective manufacturers with a view toward going into production in 2008.

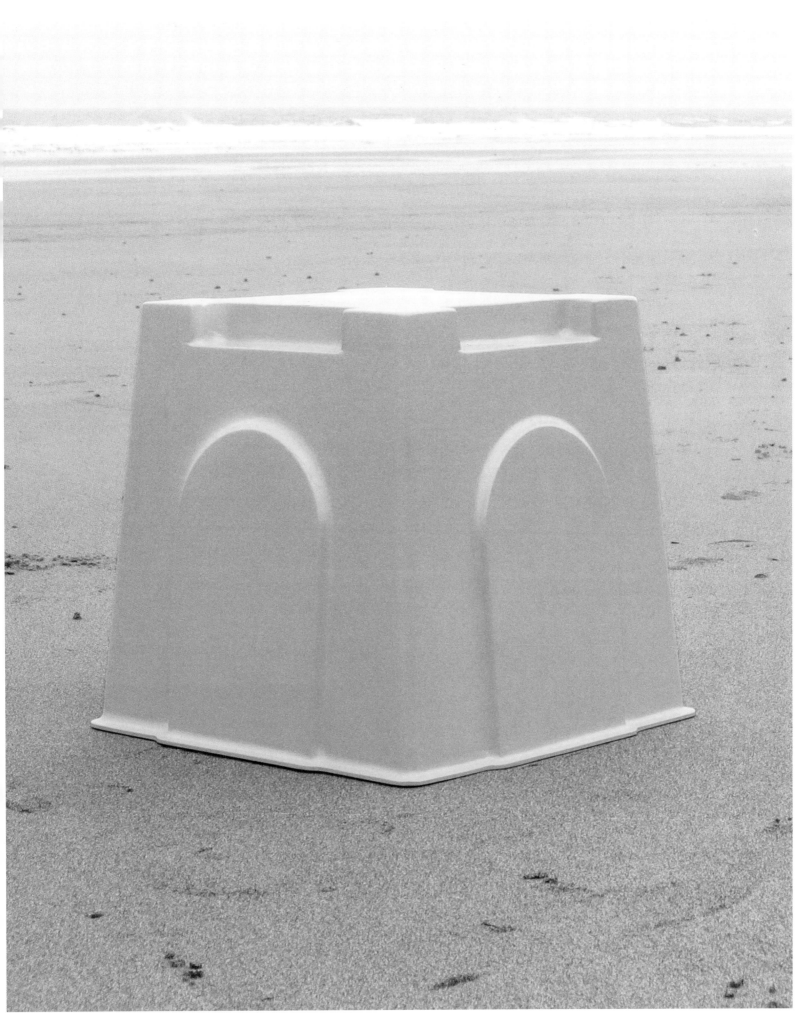

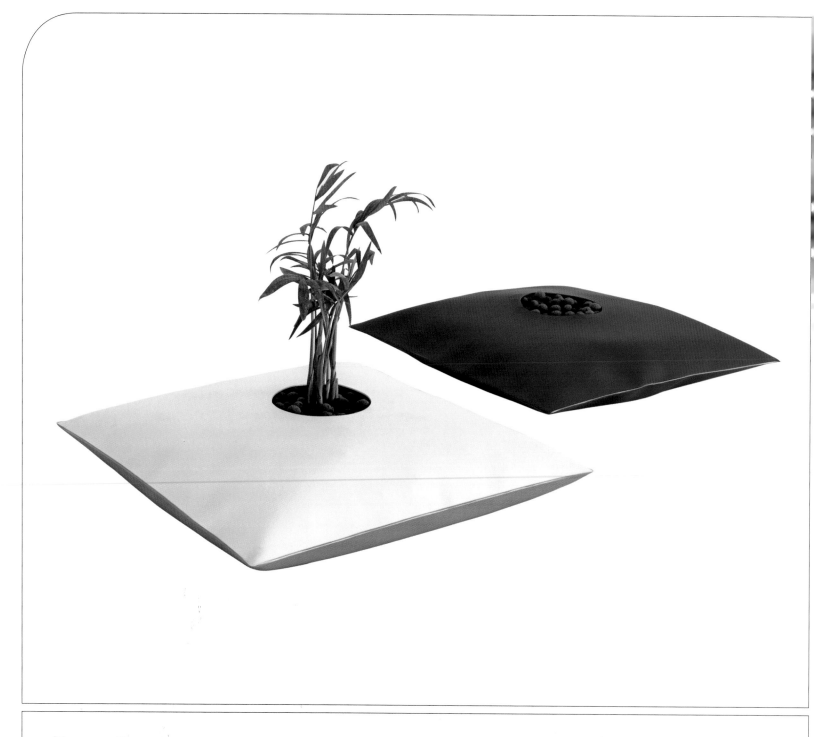

Grow Bag | Martino D'Esposito for Ligne Roset | 2003 | www.despositogaillard.com

Although it's true that no one complains about it much, it's obvious that each and every one of the flowerpots available today tend to force plants and their roots to adapt themselves to the pot instead of the other way around. The Grow Bag, nevertheless, is one flowerpot which adapts itself perfectly to the plant that it's holding. Made of polyurethane and similar in appearance to a conventional cushion, the Grow Bag has a hole in its top side a few inches wide through which the plant can grow. Being a flexible and elastic container, the Grow Bag adapts to the roots of a plant, allowing them to grow with no limitations. The bag is also waterproof, which means that it won't leak out or wet the PVC. A handful of balls of clay inside the Grow Bag permit the gases to circulate freely, preventing them from accumulating inside the "flowerpot", harming the plant. The clay also makes optimal use of the water and mineral salts that are so vital to the proper growth and care of the plant. The Grow Bag is a square measuring 12 inches a side. It's available in two different color combinations (orange-white and gray-anthracite) and is useful for all types of plants, particularly green ones.

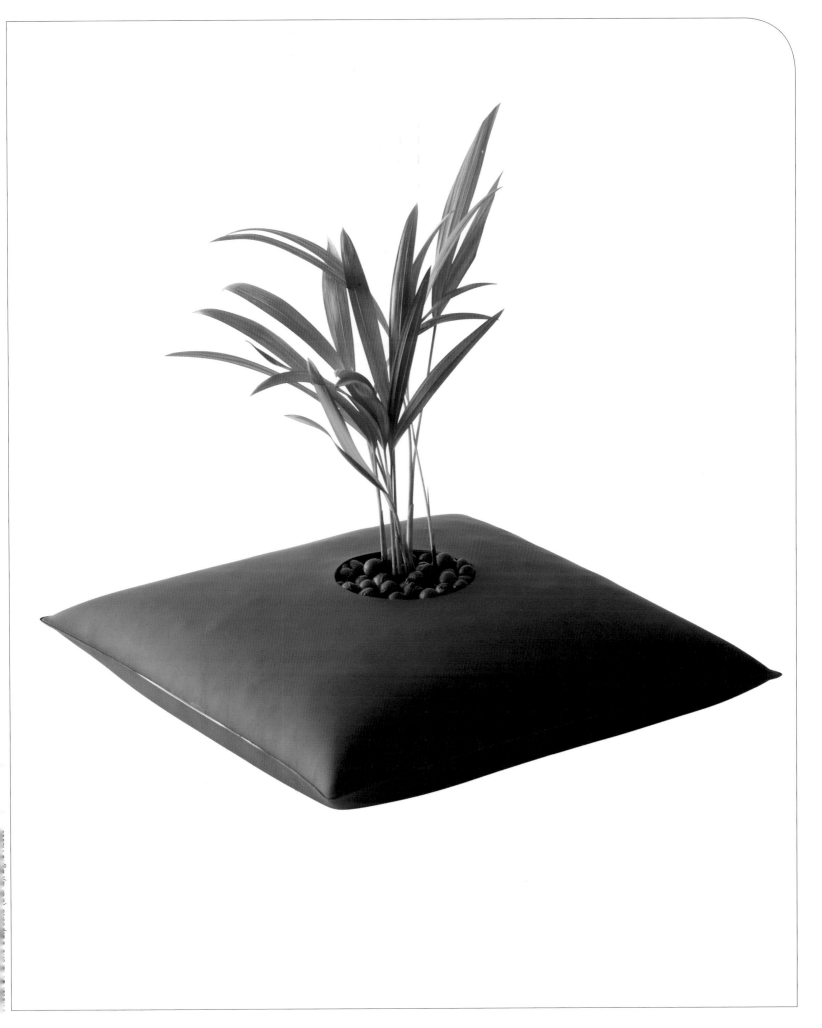

Architecture and
interior design

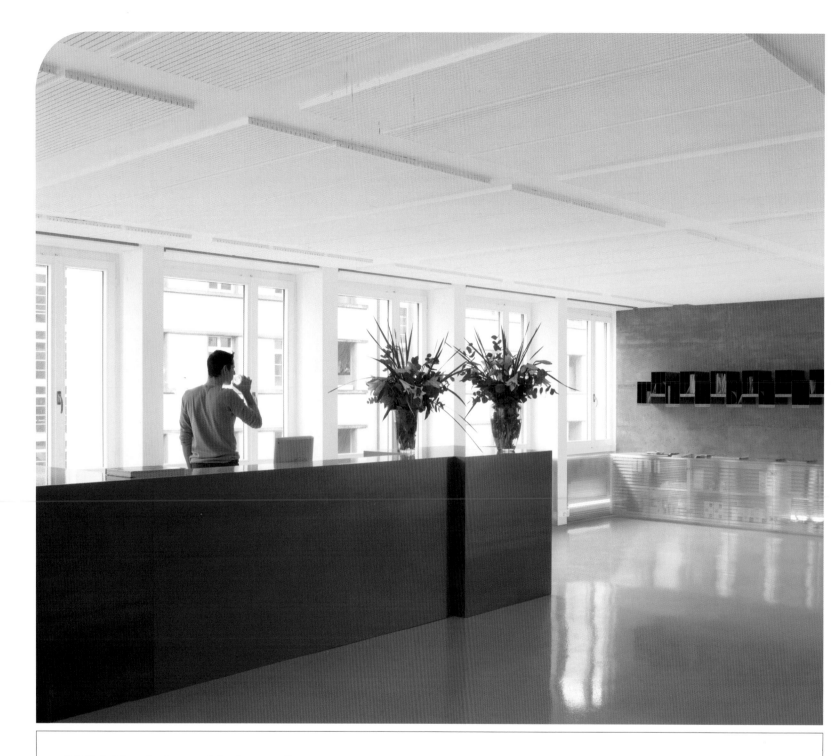

TBWA Advertising Agency | Gus Wüstemann | 2006 | www.guswustemann.com

Designing the new Zurich offices of the TBWA publicity agency presented a basic challenge: how to create an original and "cool" project, in the words of Markus Peeler, the agency's CEO, in a rather ordinary office building of the 1960s. A second challenge was the tight budget. A third was the agency's request for an atmosphere similar to that of Miami Beach. Gus Wustemann came to the following conclusion: It was perfectly possible to apply Miami's "striped" structure—the sea, the beach, the first row of build-

ings, and so on, in an office. The first step was to divide the two floors of the office into stripes in keeping with the concept and also the occupants' needs. The office's reception and lounge areas are the equivalent of Miami Beach in this space because these are the areas that receive the most natural light and offer the best views from their windows. Using plastic as the predominant material gave this breakthrough design its final touch, a design that attempts to bring a little tropical climate into the middle of a Swiss city.

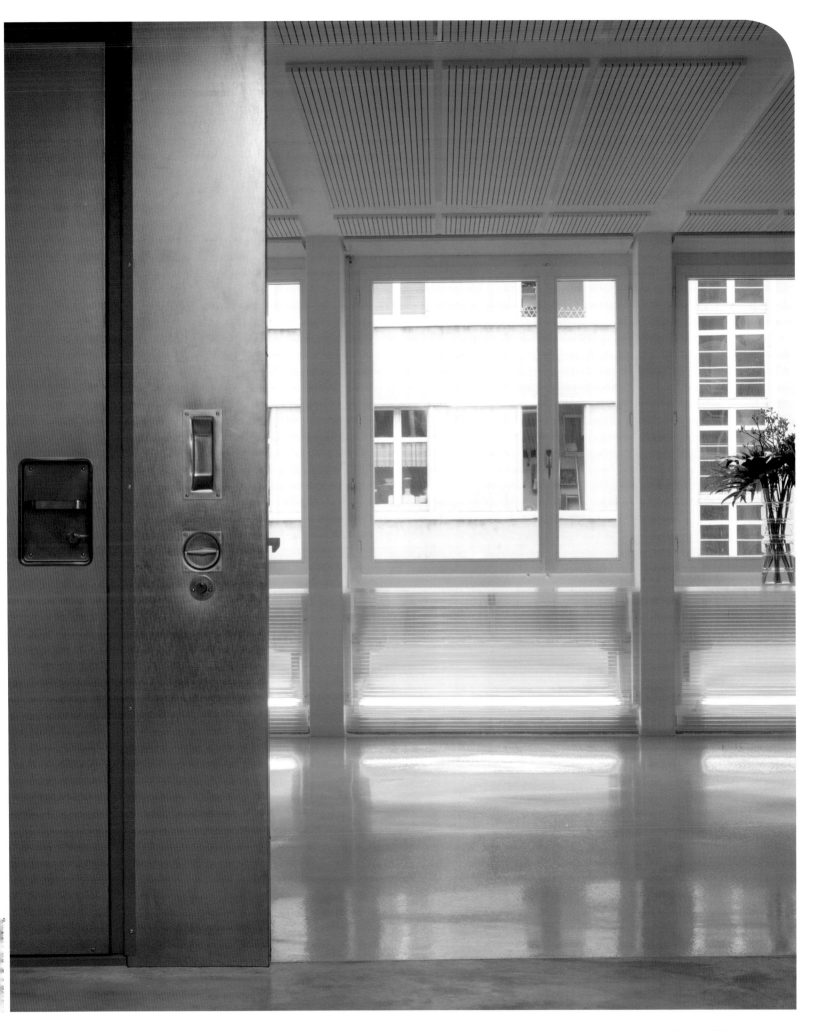

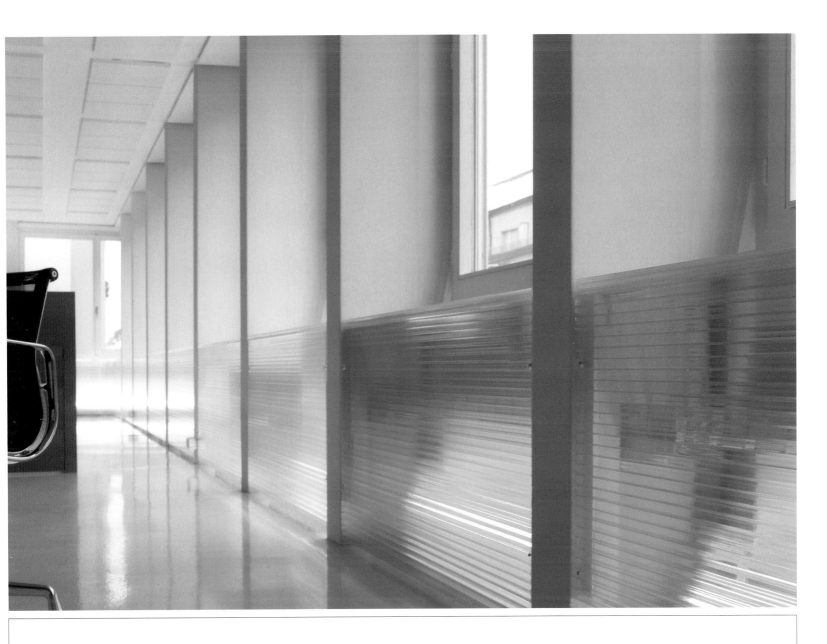

The floor is covered with a layer of real sand, on top of which a layer of transparent epoxy has been added. On the one hand, this prevents the workers from actually stepping on sand but, on the other, allows the grains to be seen as easily as if they were walking on a real beach.

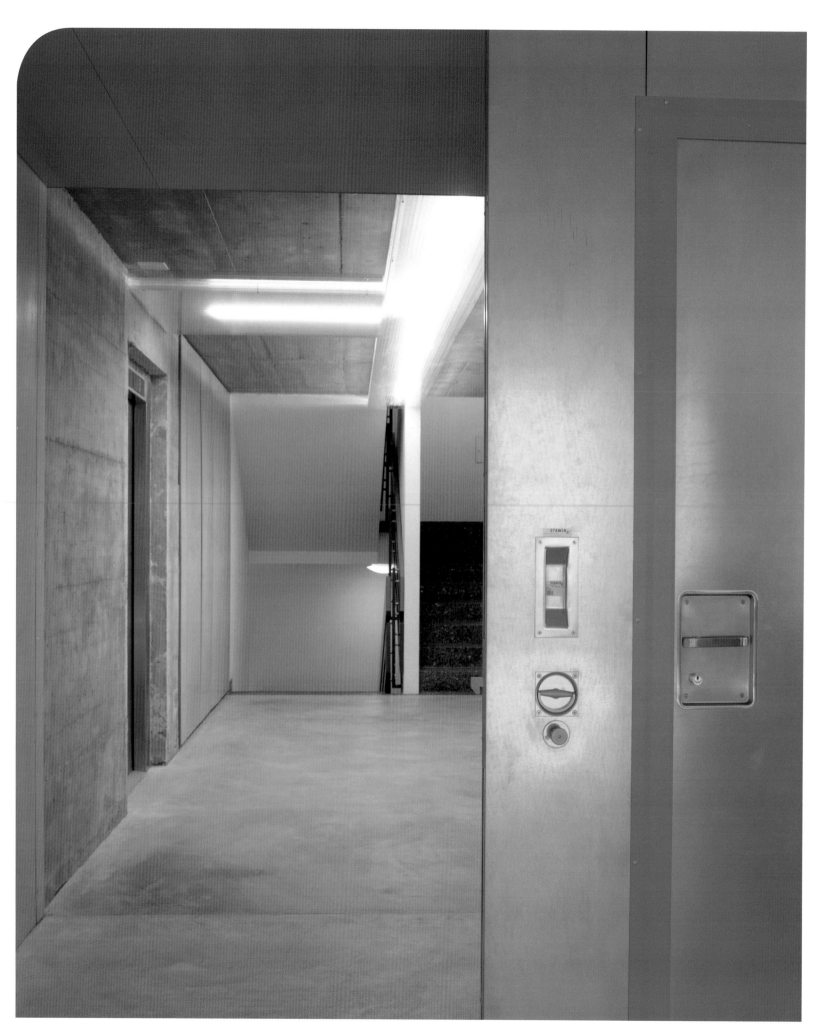

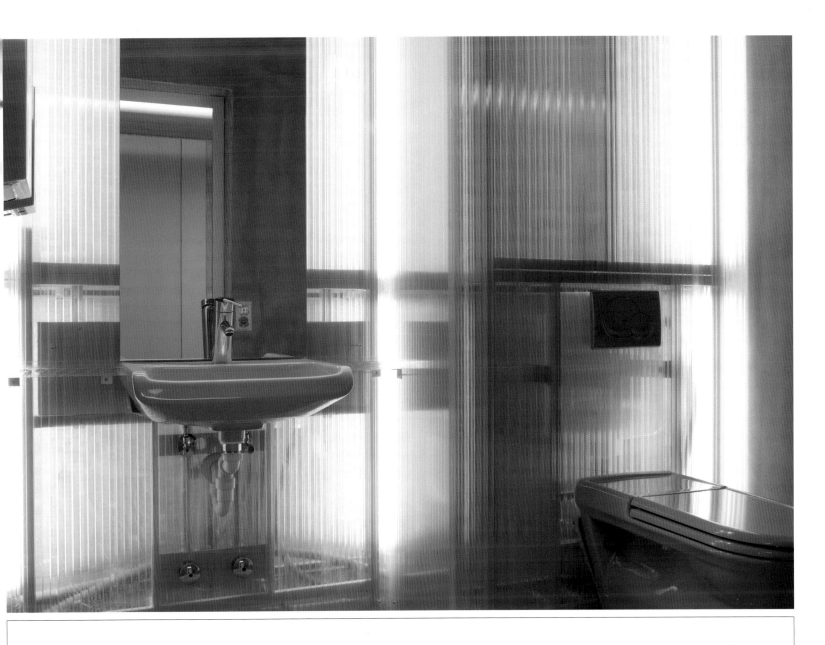

The plastic partitions in the bathroom help to visually lighten up the space, giving it the appearance of being larger and deeper than it really is and, thanks to their transparency, creating an interesting play of light. The walls are lit from behind in such a way that the piping and cables are intentionally visible.

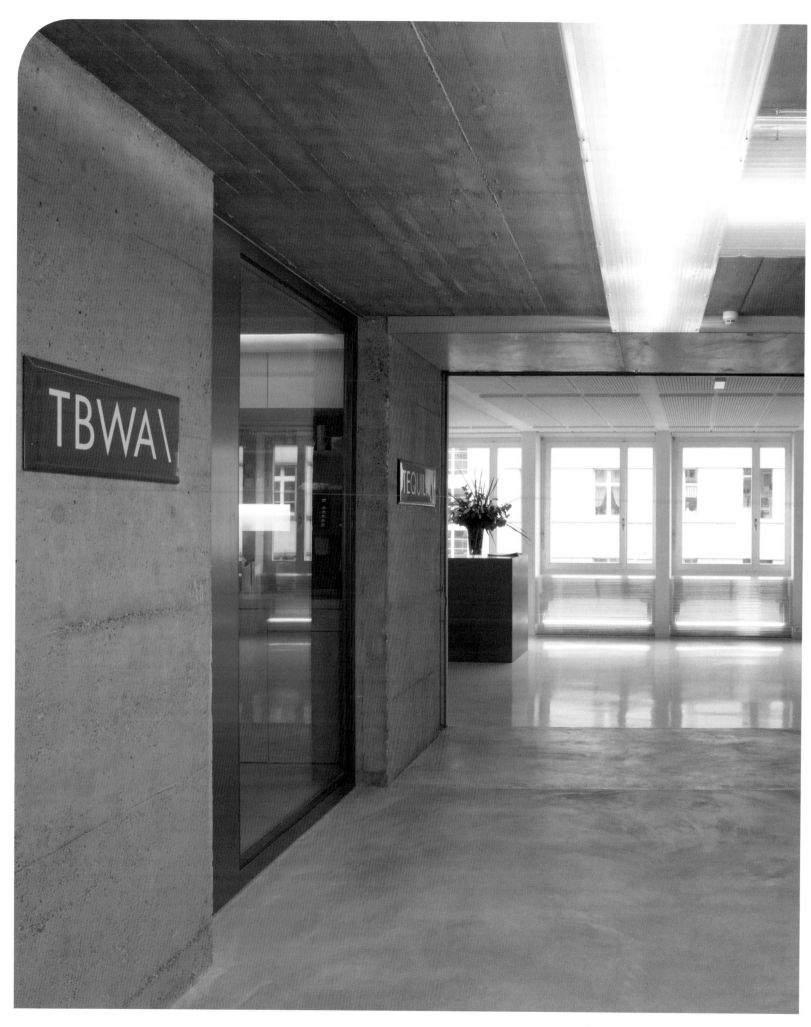

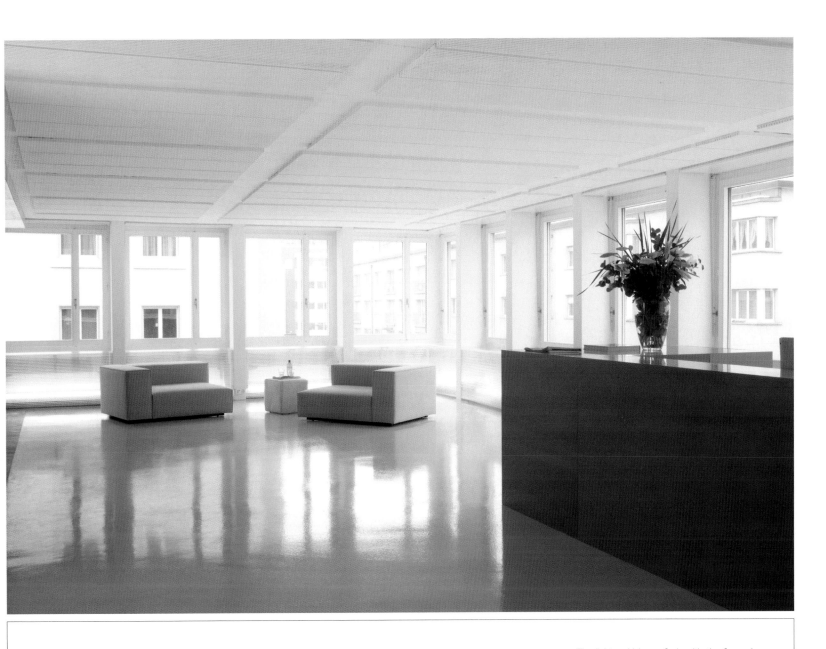

The lights, which are flush with the floor, play up the spectacular sand-and-epoxy floor's decorative effect. If the lights had been hung fromor embedded in the ceiling, the effect would not have been as powerful. The combination of abundant natural light and artificial task lights provides an interesting play of contrasts.

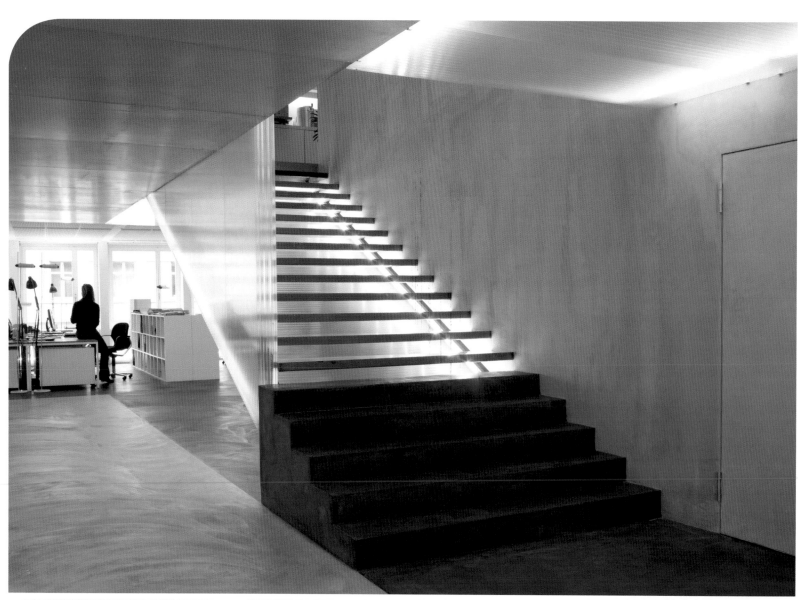

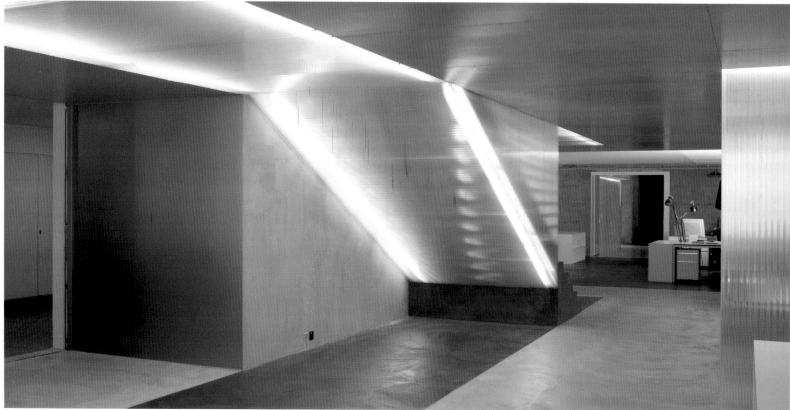

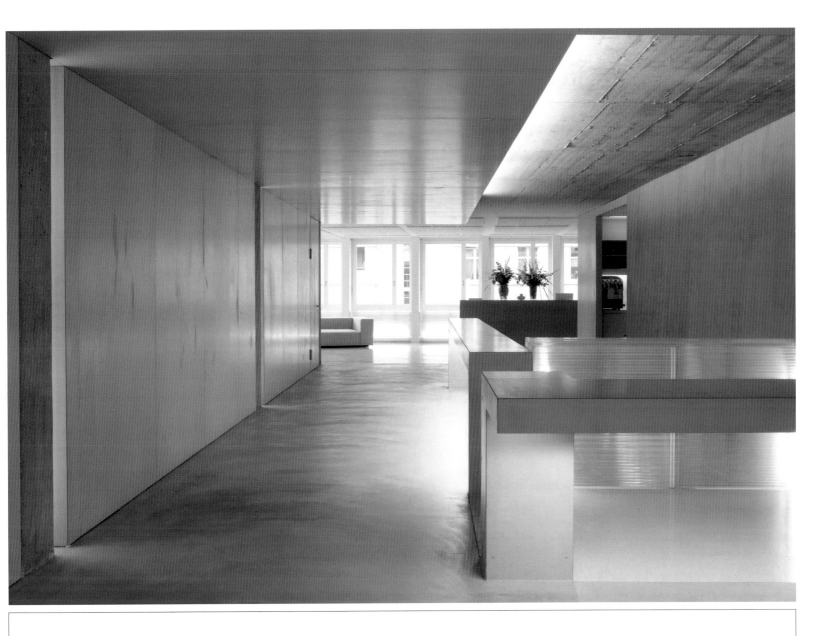

The combination of cement and plastic gives personality to the agency offices. A minimalist approach, in which no one detail takes precedence over another, helps to give the space a unique atmosphere, somewhere between the sober, the trendy, and the subtly futuristic.

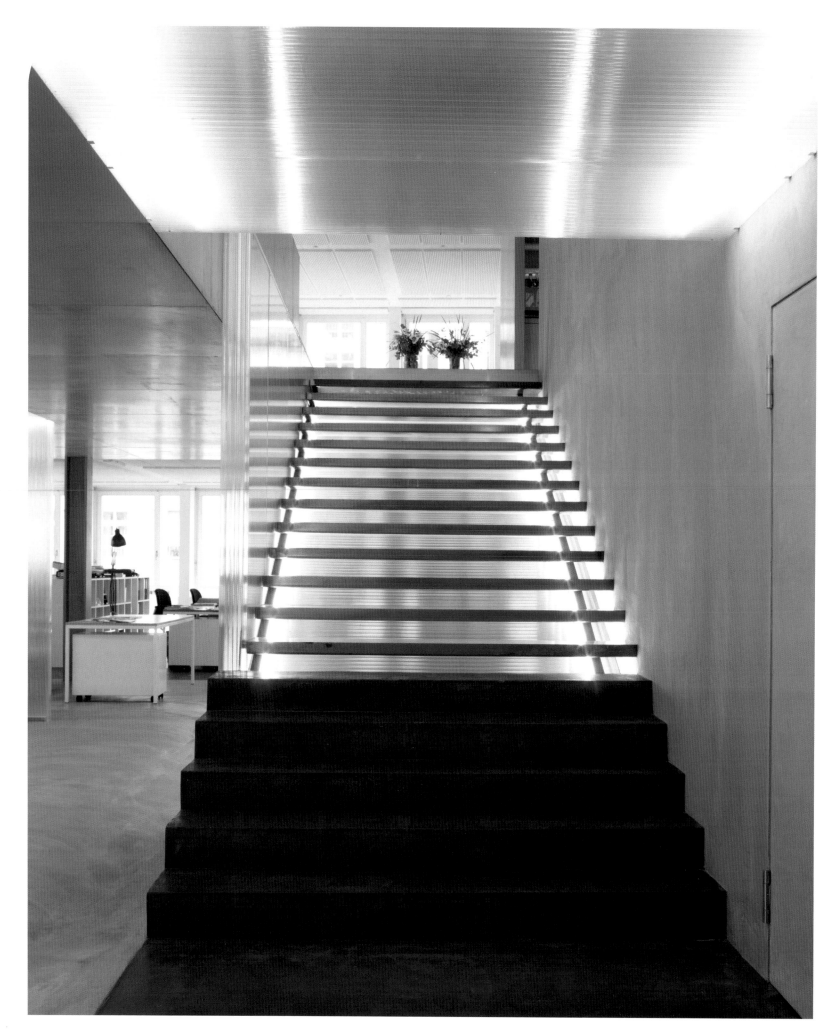

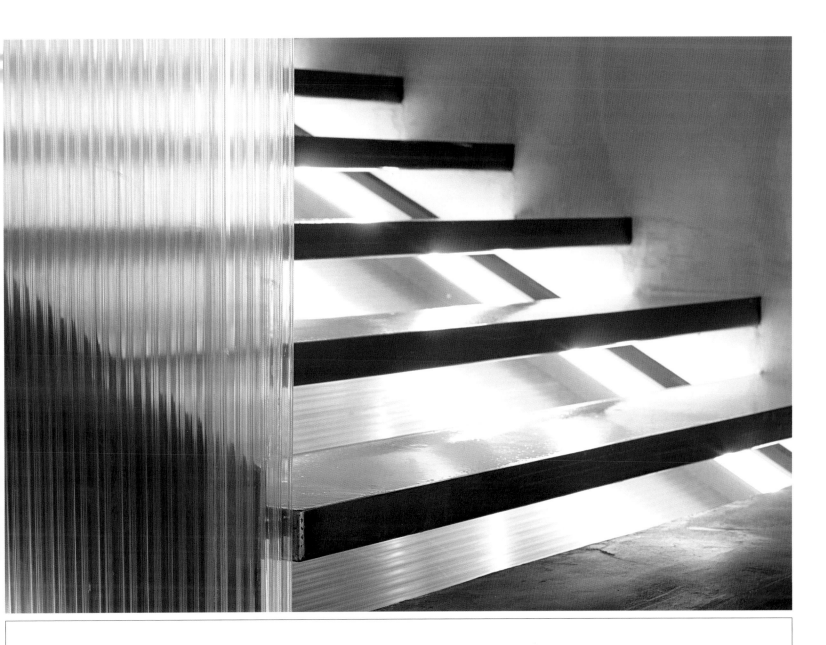

The small rails on the stairs that connect the two office levels are made of plastic panels that allow light to filter through them, converting them into another decorative element, and not just a structural or purely functional one. The effect is one of transparency and lightness.

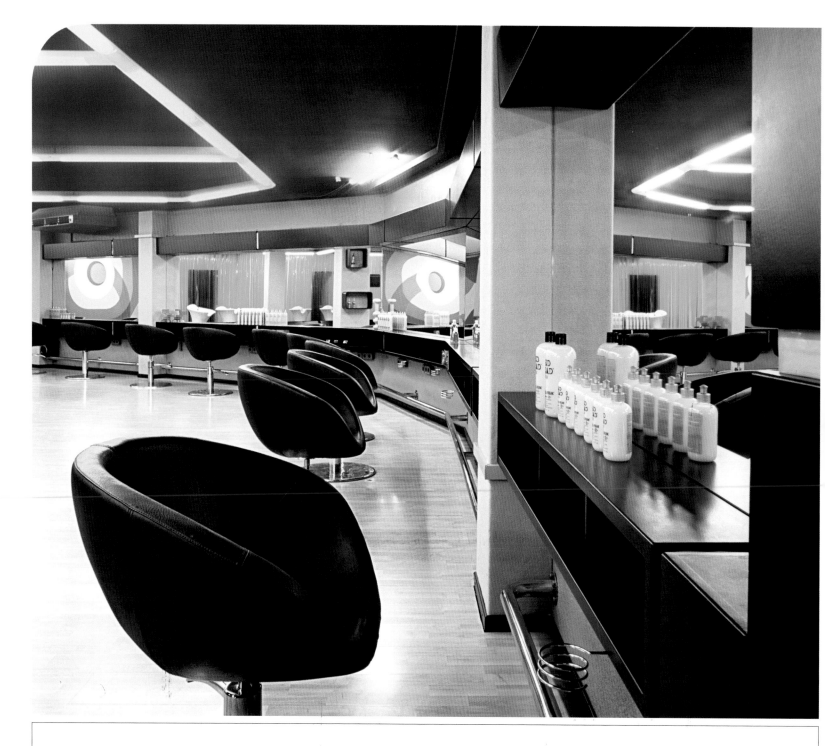

Aduho Hair-Salon | Pichiglás | 2003 | www.pichiglas.net

Situated in the center of the city of Granollers, some 16 miles from Barcelona, the Aduho Hair-Salon boasts an irreverent and transgressive design that attempts to reflect the originality of the stylings performed by the salon's owners. The plastic materials, especially the methacrylate, are used for their flexibility, which allows for the curves we see in the shelves, chairs, hair-washing stations, stools, and even in the ashtrays. The salon has three floors. On the first, at street level, we find a showcase, which welcomes the client, and the spectacular reception counter, which is approximately 18 feet long and was inspired by the steamboat. Downstairs we find the offices and the vending area for hair products, all painted orange and brown. Upstairs is the salon itself, where the main attraction is a 60-foot long boudoir with mirror, lacquered in black and sporting rounded borders in an homage to the 1970s pop aesthetic. A black skay sofa designed by Alfonso de la Fuente unites the eight hair-washing stations. The curtain of curved shapes visible behind the hair-washing stations is made with sheets of transparent green plastic, the exact color which gives the locale its uniqueness.

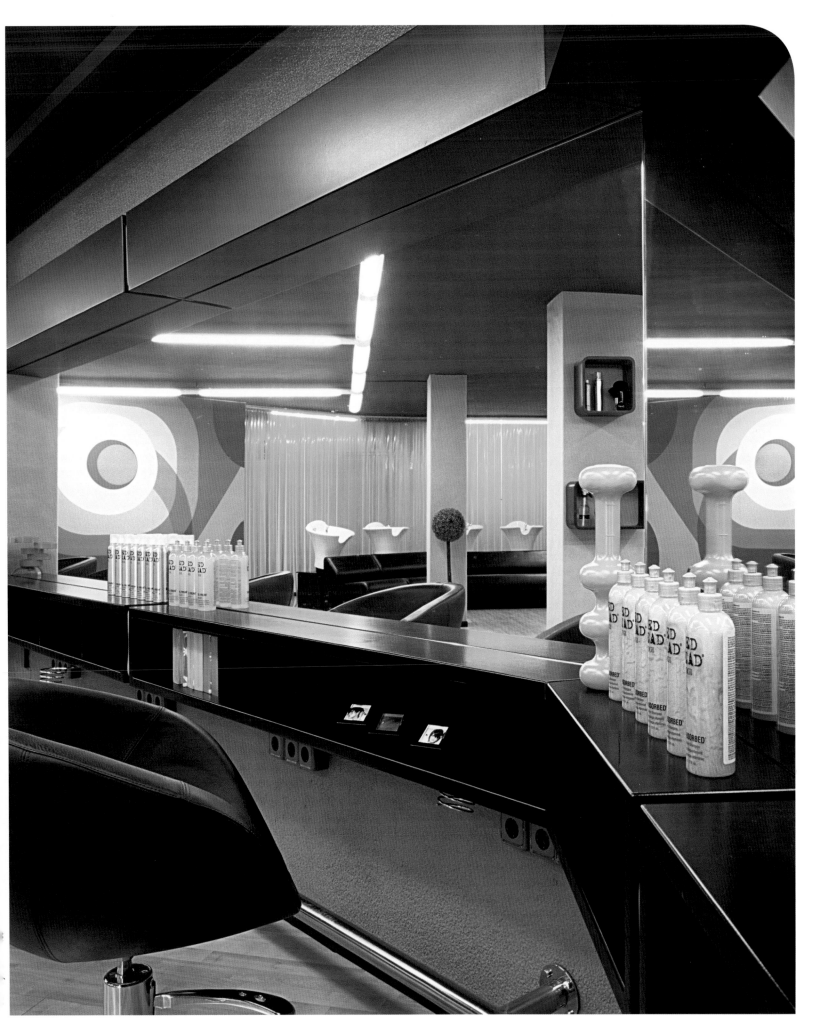

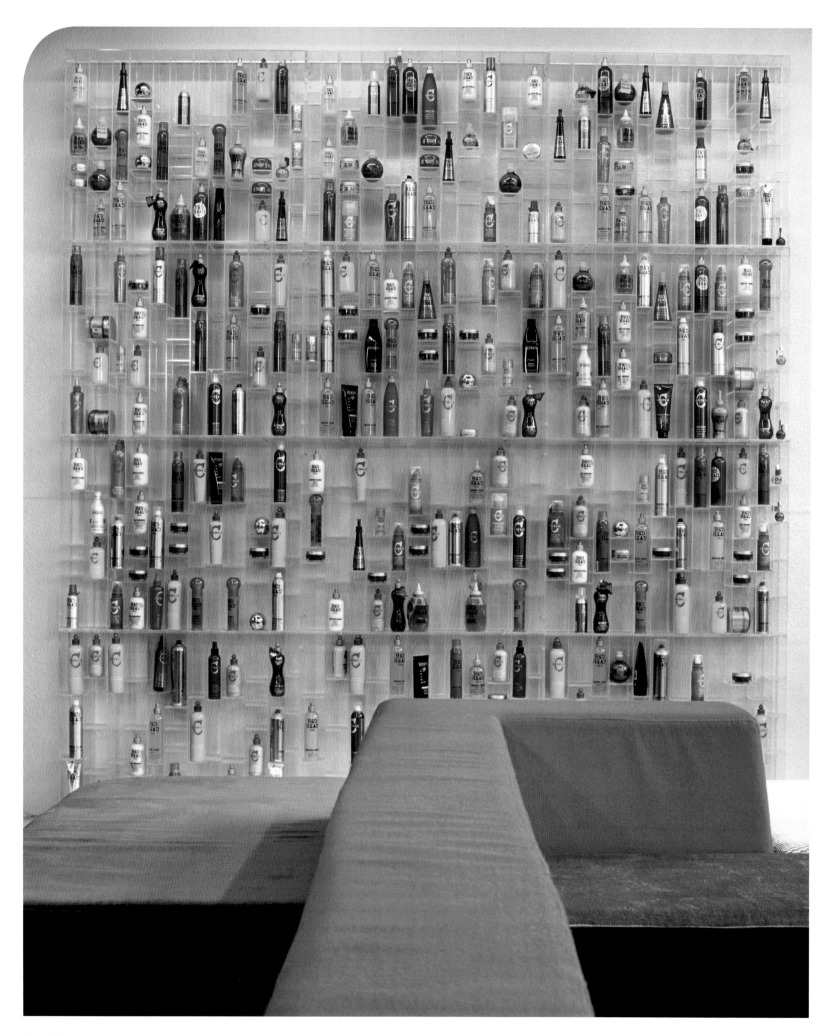

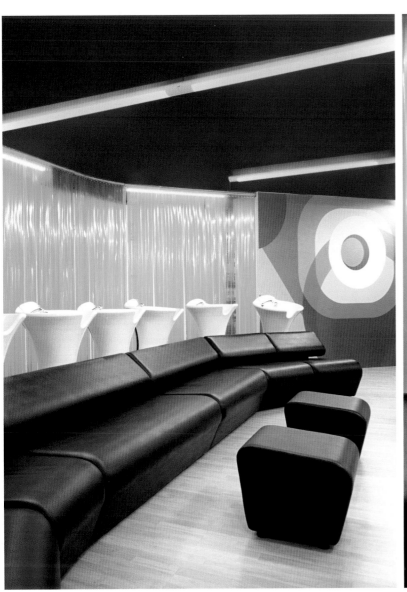

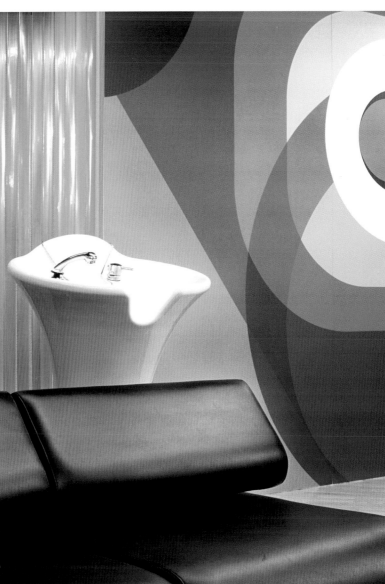

The walls have been decorated with abstract motifs of a pop aesthetic in warm colors like orange, red, and yellow. The ceiling is painted chocolate brown and the floor is made of beech-wood floating parquet, which provides a "natural" contrast to the abundance of plastic materials.

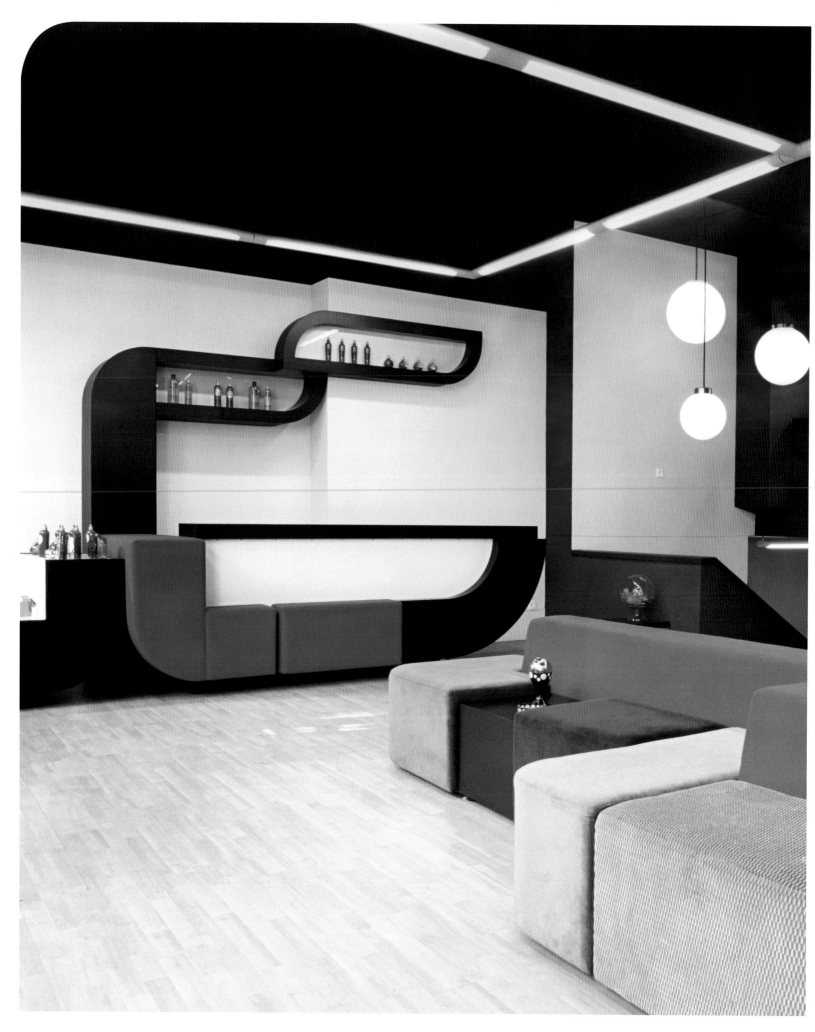

Hudson Bar | Philippe Starck | 2000 | www.philippe-starck.com

From its opening day, the Hudson Hotel in New York has been the center of all kinds of controversy, most of it surrounding the relation of design and functionality, in a case where neither is 100% compatible with the other. Evidently, the fact that its designer is the internationally famous French designe, Philippe Starck has only helped to fuel the debate.

The jewel in the Hudson Hotel's crown is without a doubt the Hudson Bar, one of New York's hottest nightspots. Methacrylate and other plastic materials are used abundantly in its design, but it is the lit glass floor and the impressive fresco, painted on the ceiling by Francesco Clemente, that usu-

ally gets all the stares from the club's hip clientele. That, along with the Versace lounge chair with armrests in the form of golden swans and the tree trunk to which has been added a backrest so that it may be converted into a bench. The look is as spectacular as it is shocking and ironic. Another one of the hotel's central elements is the spectacular escalator that leads to the hotel lobby.

The Hudson is impresario Ian Schrager's sixth hotel on which Starck has collaborated and, certainly, the one that has appeared most in design magazines from around the world.

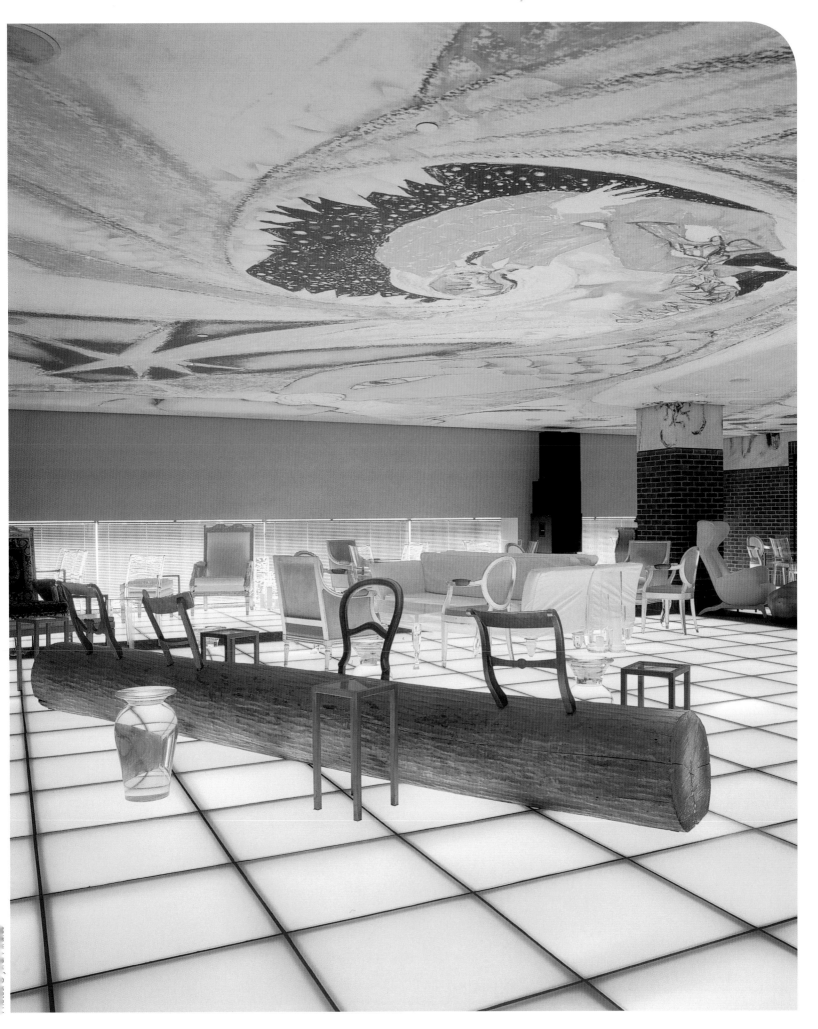

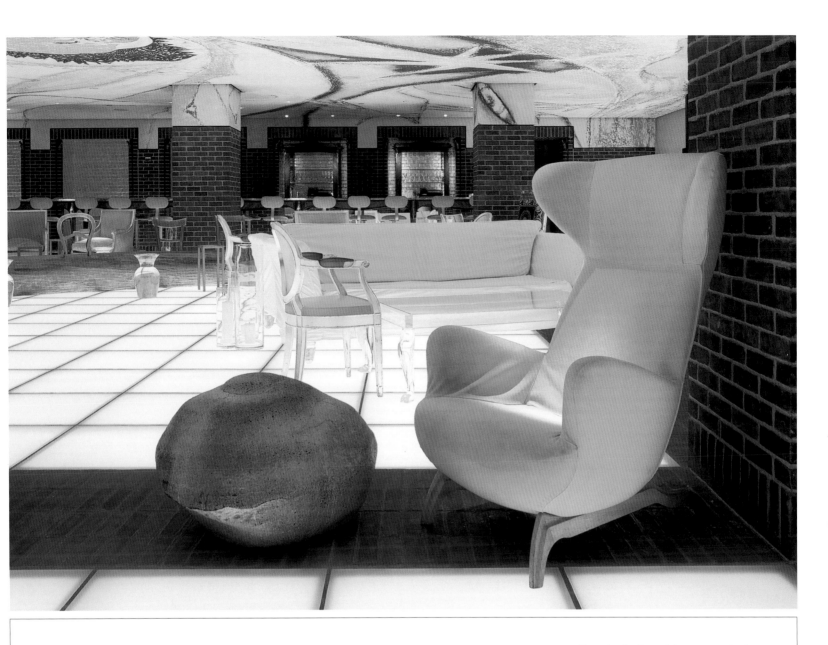

The mix of styles and the unconventional nature of contrasts are the point of fashion for the Hudson Hotel's bar. From this clash of completely different aesthetics a unique and utterly distinctive atmosphere is created, united by the color yellow and careful lighting techniques that highlight those elements and give the space its personality.

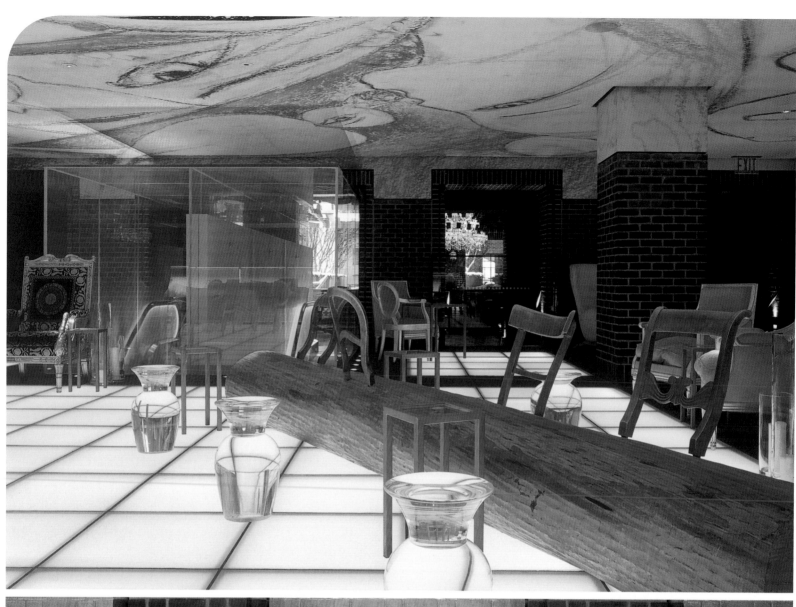

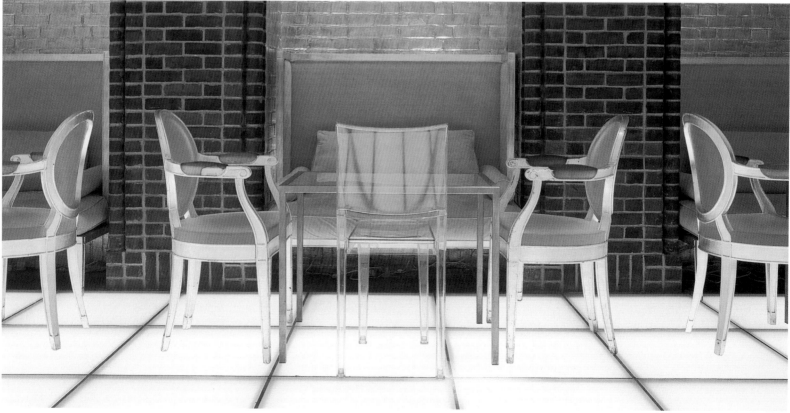

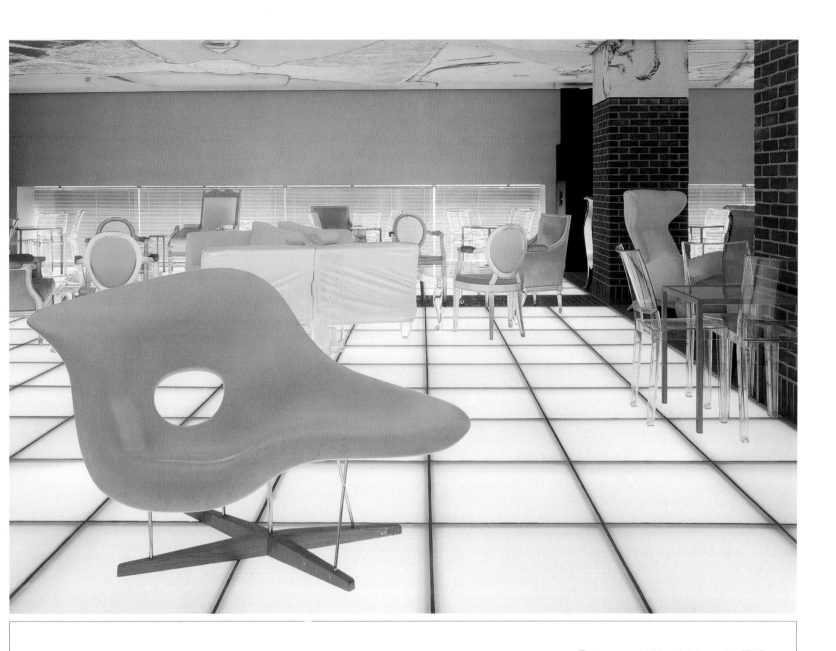

The transparent table and chairs, made of PVC and methacrylate, lend a lightness to the space and maximize the play of light. The contrasts are provided by the silicone Louis XVI chairs ("the same material from which fake breasts are made," in Starck's own words) and other pieces, which aficionados of classic furniture design will clearly recognize at first sight.

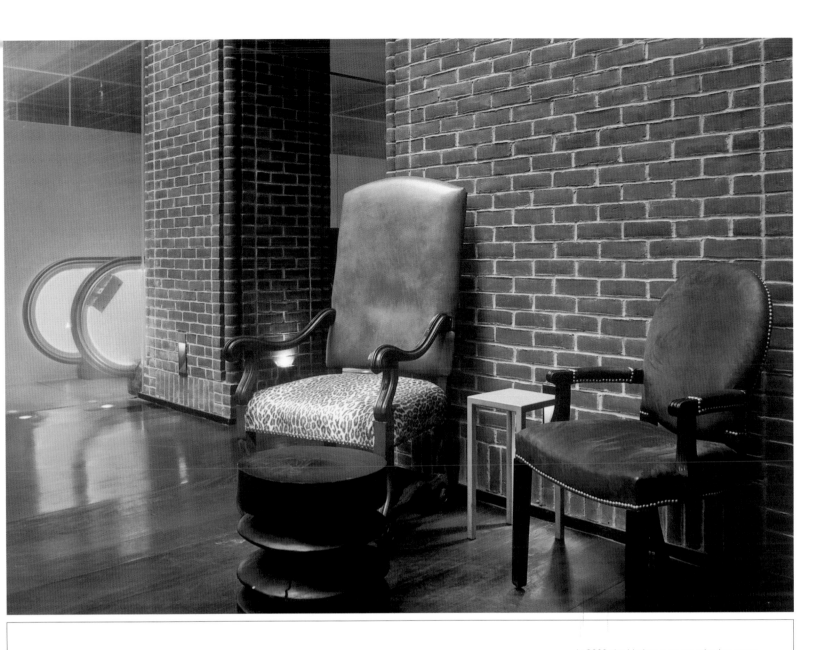

In 2000, the Hudson was conceived to counter the ruling aesthetic of the moment, radical minimalism. Maybe because of this, the hotel quickly grew to be one of the trendiest in the city, ahead of other, more expensive hotels that also boasted concepts by designers of Philippe Starck's level.

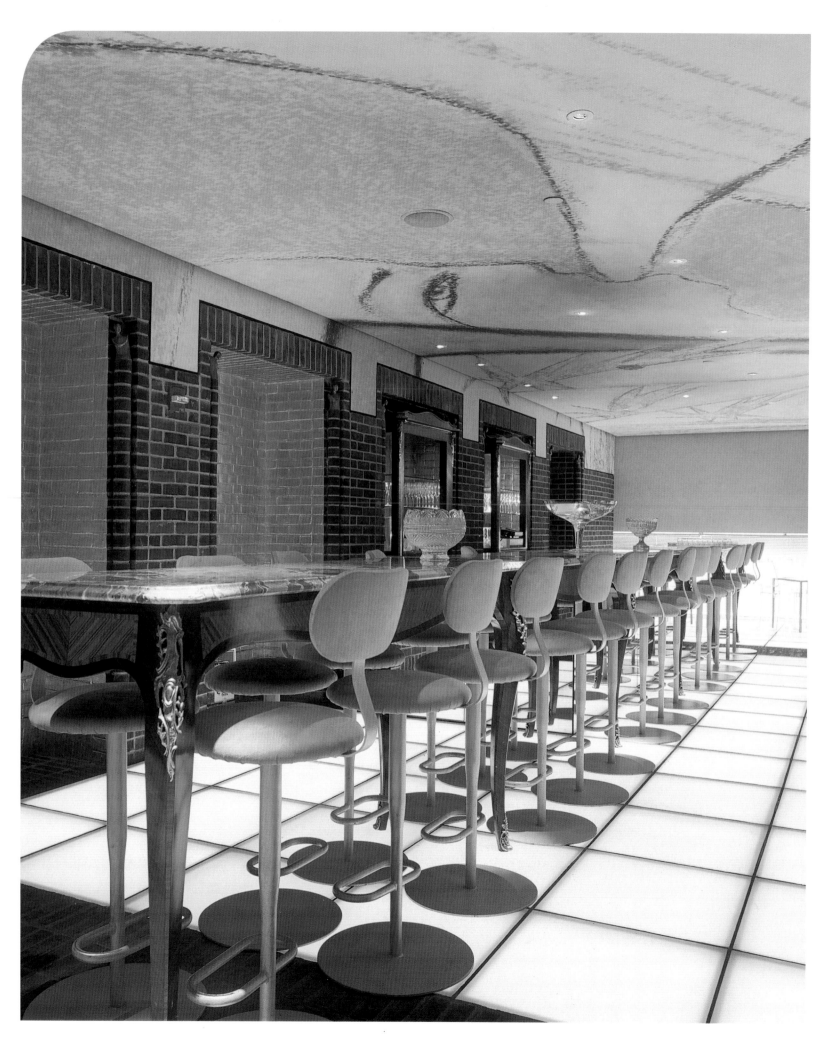

The public spaces in the hotel, like the lobby and the hallways that lead to the rooms, are of an extreme dramatic aesthetic, although in some select spots throughout the hotel, the baroque gives way to a more sterile atmosphere, perhaps so as to not disturb the client completely.

Fonfone | Pichiglás | 2004 | www.pichiglas.net

Situated in the middle of one of the busiest, most colorful, and multicultural neighborhoods of Barcelona, Fonfone is one of designer Alfonso de la Fuente's favorite projects. Methacrylate, the indisputable king of this space, lends the club a retro atmosphere along the lines of the 1960s and 1970s pop aesthetics. Fonfone is divided into two different parts. The first is green and the second is red, and this differentiates the two immediately. That the first of these two areas, the one closest to the street, has been decorated in green tones is the result of a clear objective: to subtly "direct" the client to the back of the club in search of warmer colors. In this green zone is a 40-foot long sofa made of fiberglass and skay. Across from the sofa is the bar, which extends all the way down to the "warm" zone. This bar was originally an American bar. To preserve it, three green methacrylate structures have been added to it in the shape of an L. These are decorated with a series of illuminated illustrations depicting a Caribbean beach. In the red zone, we find a 33-foot long sofa finished with PVC and inspired by the Spanish Talgo trains of the 1970s.

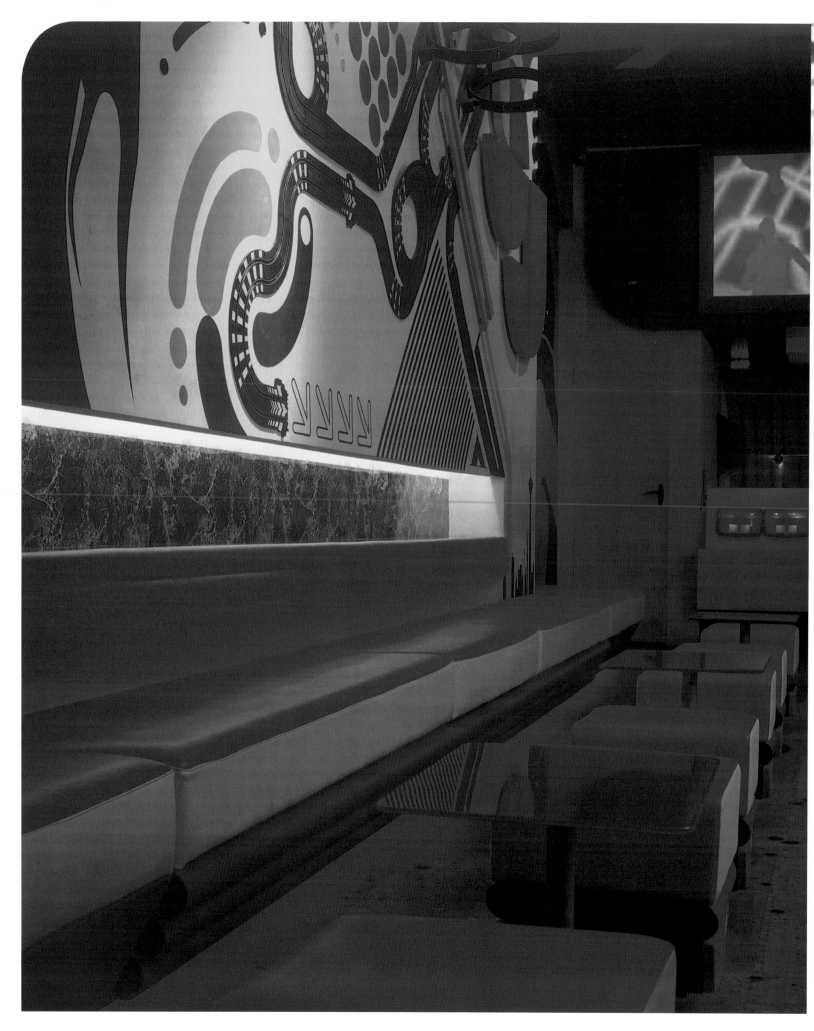

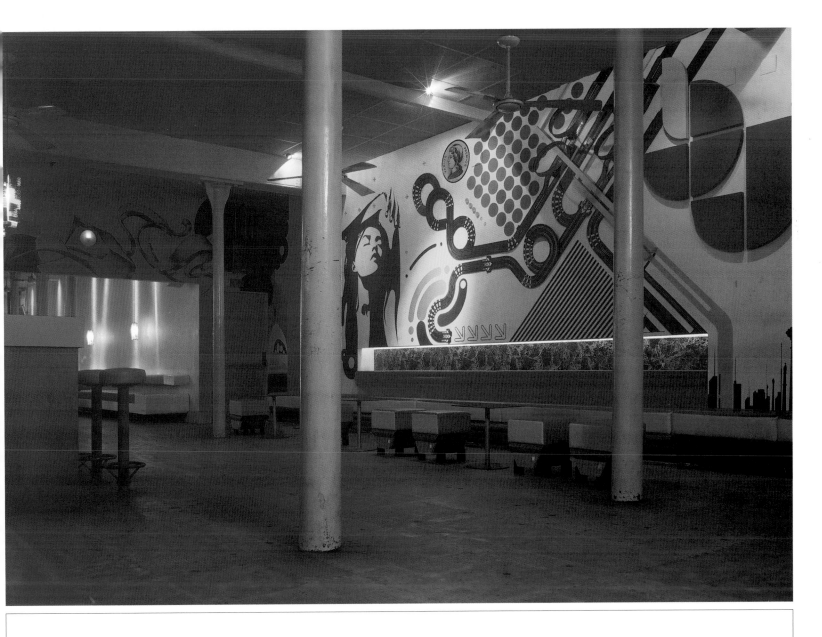

In the club's warm zone, colors typical of the psychedelic 1960s prevail, although its concept is based on the Tetris game (designed in 1987). Above the sofa, a gigantic mural measuring 26 by 16 feet features a Scalextric racing track, various plastic elements, and a drawing of a woman's face by artist Stuart Patterson.

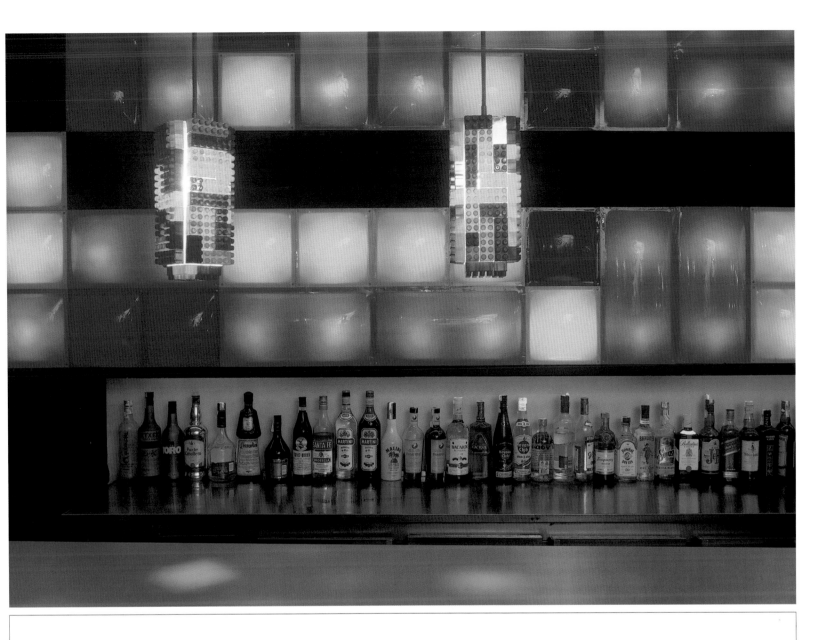

Over the bar, which spans the space from front to back, we can see the artisanal lamps designed and made by Alfonso de la Fuente specifically for this club. The material used to make them is truly unique: old computer circuitry in the green area and pieces of Lego® blocks in the warm area.

The DJ's booth and the bathrooms share the same aesthetic as the rest of the space. Above the DJ's booth is a giant screen with a fabric frame upon which all kinds of images are projected. For their part, the signs indicating the men's and women's bathrooms weremade by Pichiglás using a pixelated mosaic.

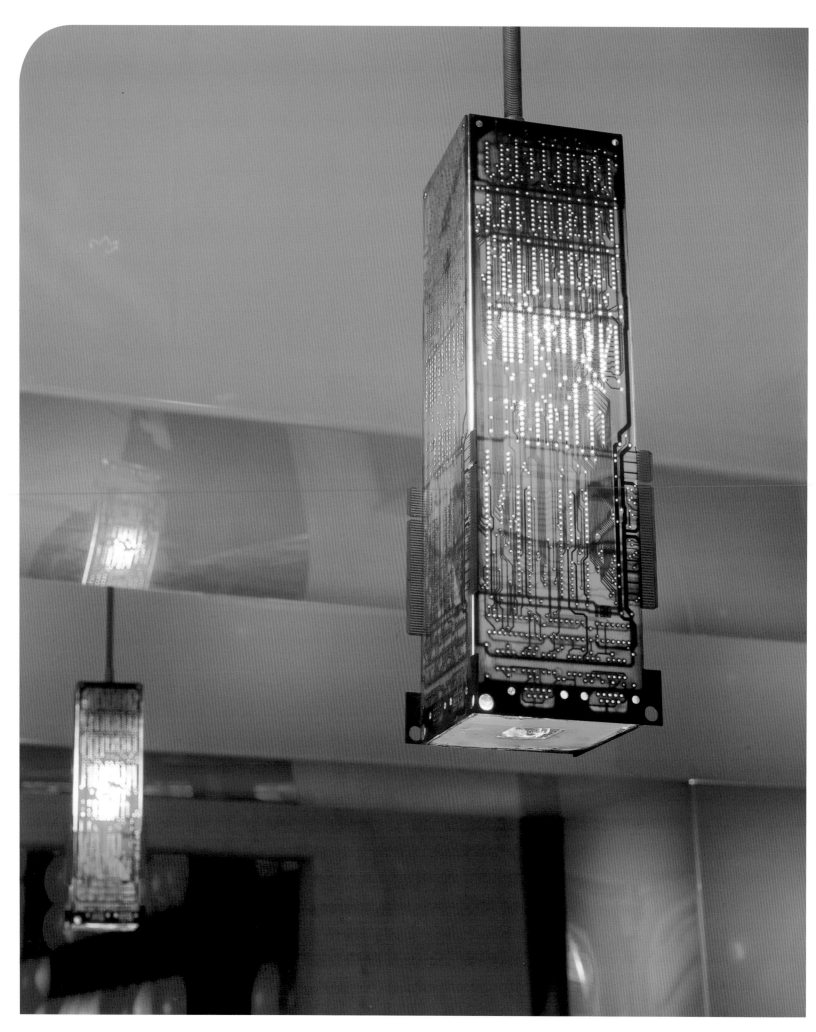

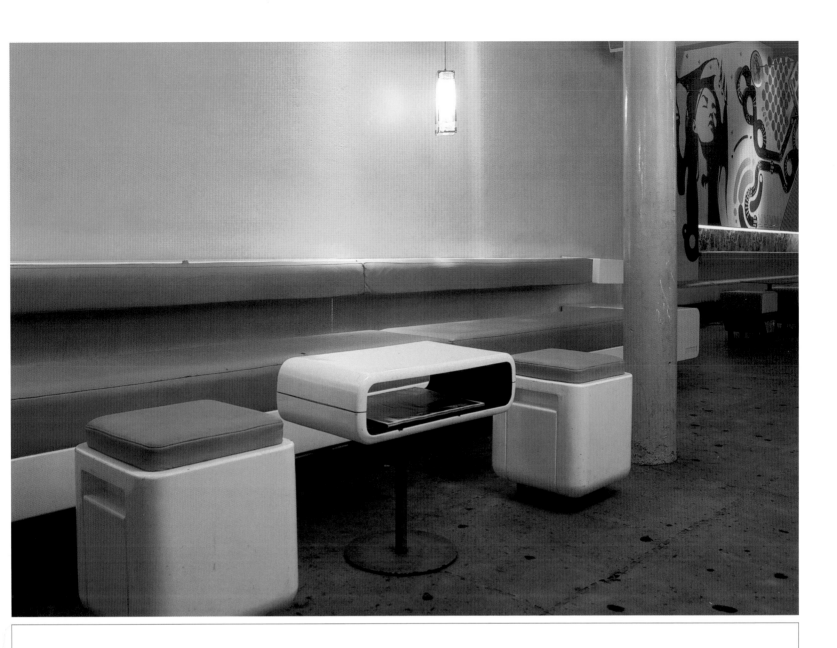

The sofa has a hollow bracketed-shelf behind the headrest that allows patrons to leave their glasses there without fear of their spilling or falling over. It's made of Formica with a marble effect, much like the stools, which were inspired by the famous "Martian" spaceships from the video games of the 1980s.

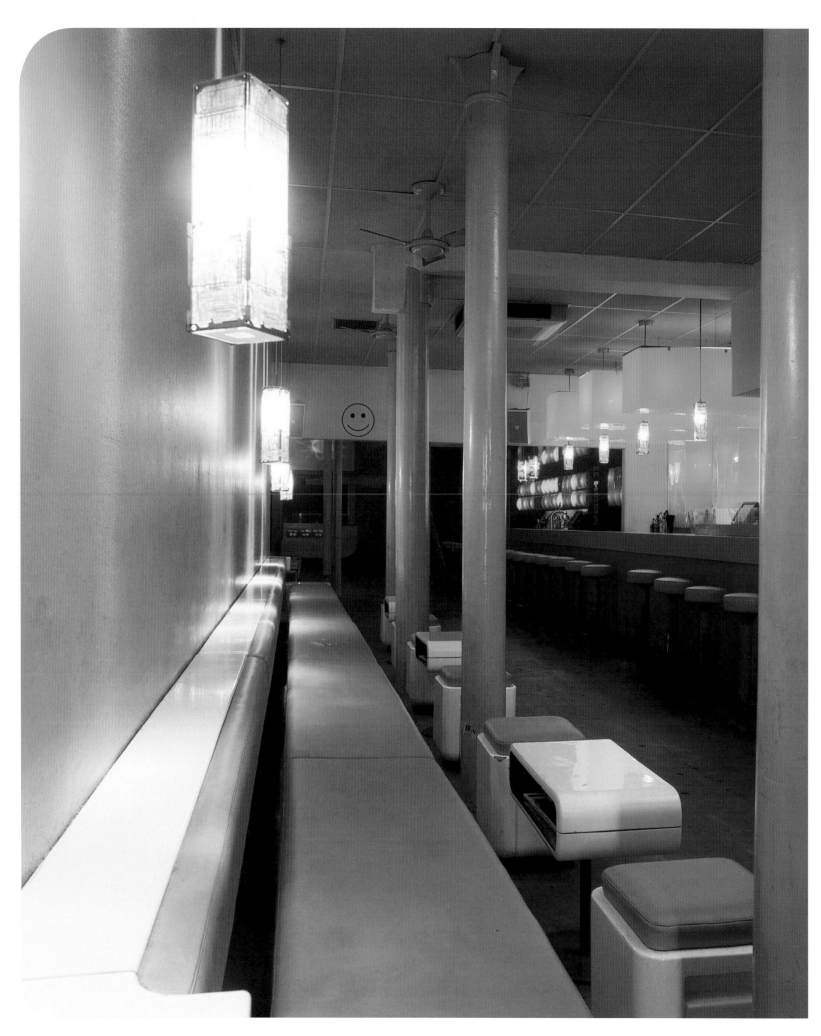

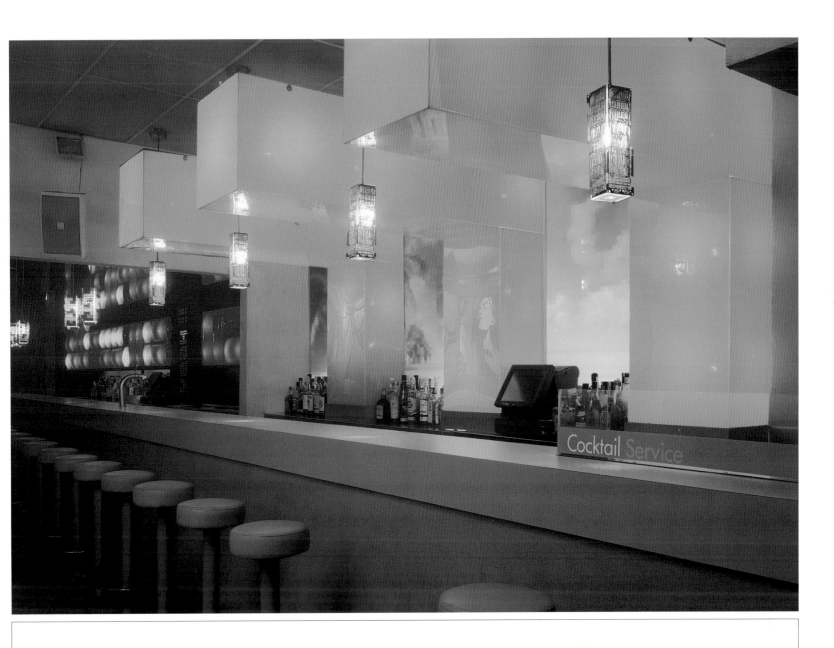

The green area has been conceived as the club's "anteroom," the club being, in fact, the warm area, which is why it's there that you'll find the dance floor. Keeping this first area (the one closest to the entrance) clear, ensures that no one will avoid entering the bar mistakenly thinking it "packed."

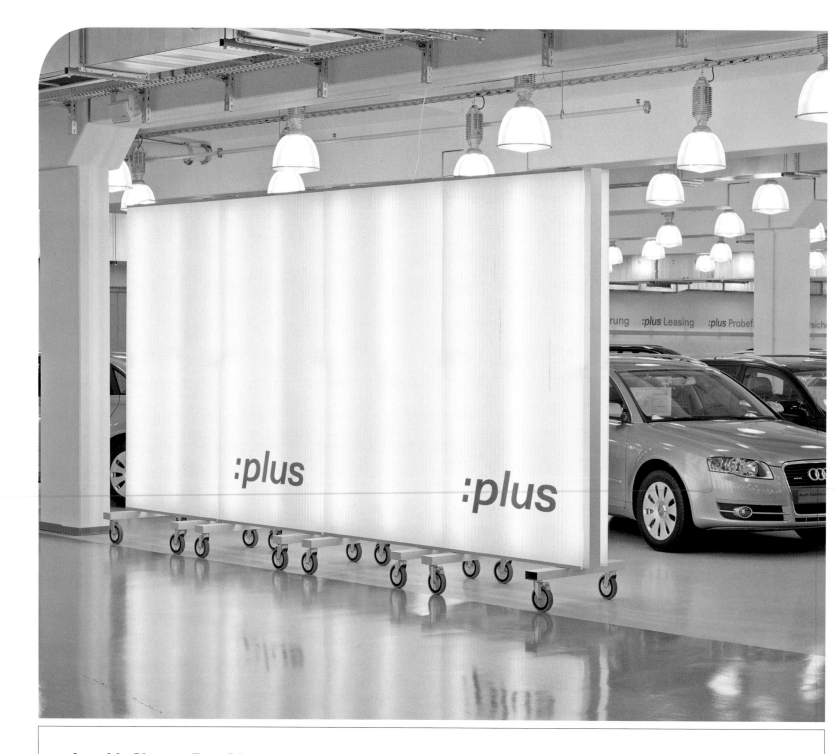

Audi Shop Berlin | Torsten Neeland | 2006 | www.torsten-neeland.co.uk

Though there may be quite a few difficult projects from the interior designer's point of view, perhaps none is as difficult as that of designing or remodeling a car dealership. How can aesthetic be combined with functionality? How can personality be given to a space that, by its very nature, must cede all attention to the product on display (in this case, something as rigid and unadaptable as a handful of two-ton vehicles)? If some of the principles put into practice by the German designer Torsten Neeland are applied, this delicate balance may be achieved. London-based designer Neeland counts Donna Karan, WMF, Estée Lauder, and Dornbracht Interiors among his clients, along with many others. For the new Audi dealership in Berlin, Neeland resorted to using Plexiglas and laminated plastics with the objective of giving the space a futuristic atmosphere without being too eccentric—an atmosphere in which the brand's omnipresent image would not end up confusing or overwhelming the customer. A singular and successful use of diffuse lighting, the true staple of his designs, helped round out the intentionally cold atmosphere. "If my designs enjoy a long life and become classics, then I can feel satisfied, because I will have achieved my objective", says Torsten Neeland.

The store's mobile advertisements are given their own independent, interior light source. This reinforces, on the one hand, their decorative potential and, on the other, their divisive function in an open interior space. In this manner, the store may adapt itself to different needs or remodel itself according to the number of cars displayed or any other practical consideration.

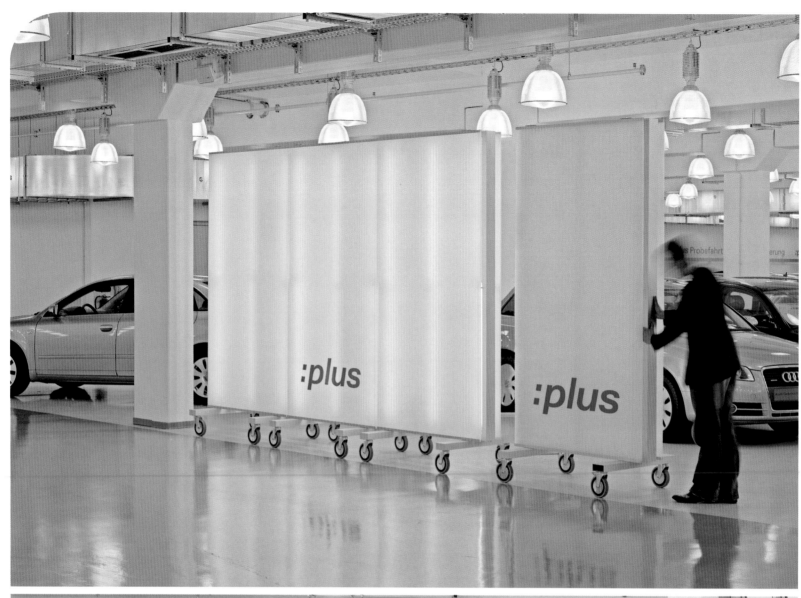

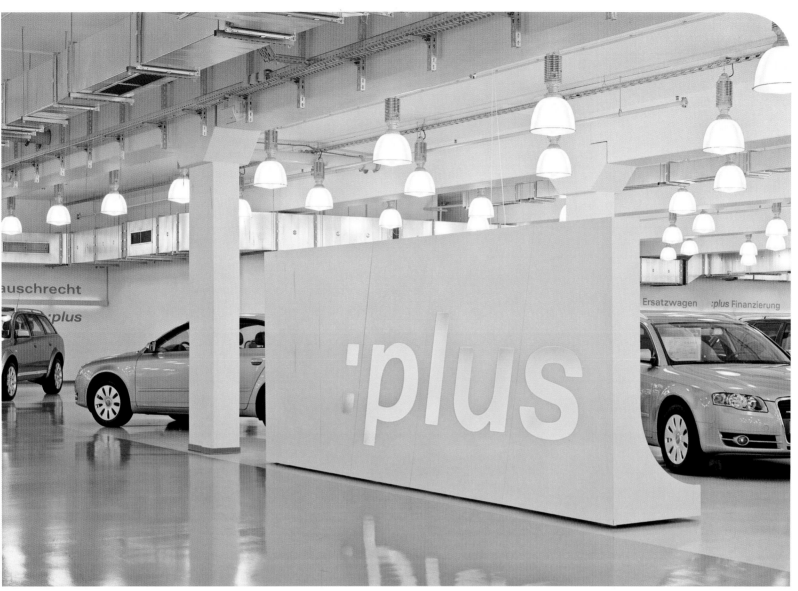

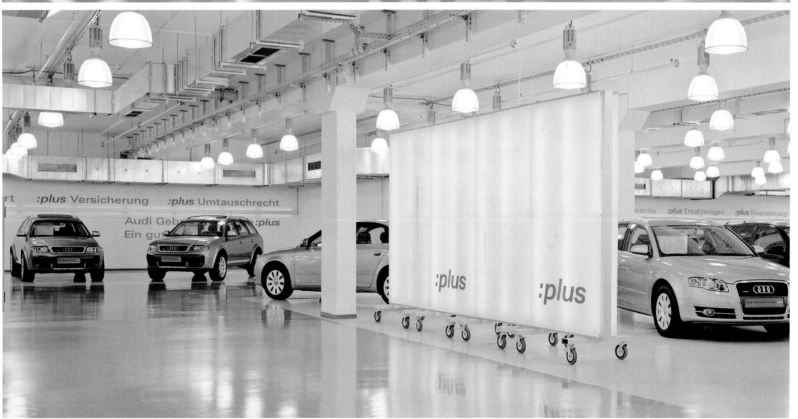

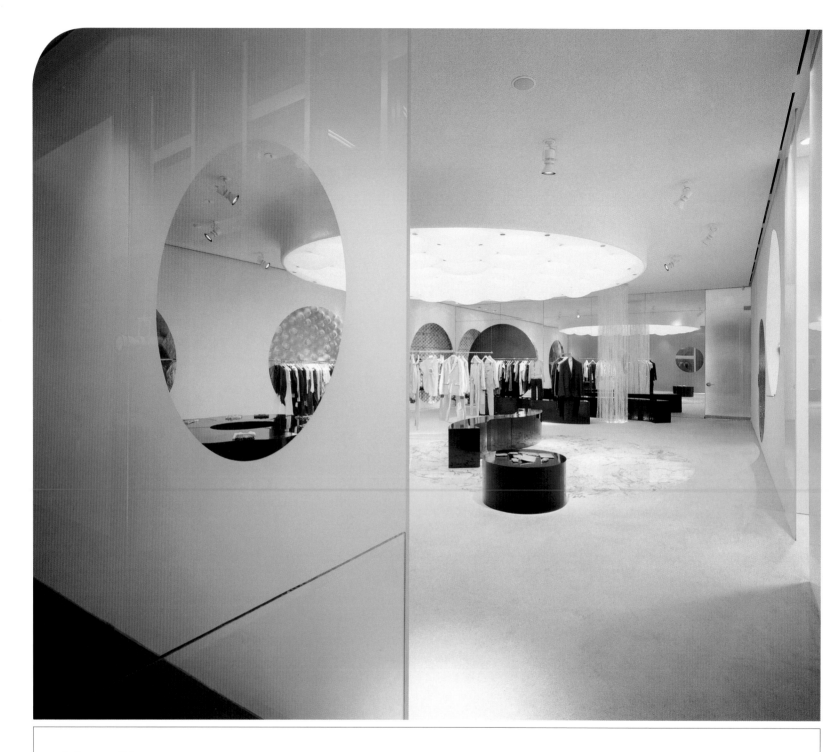

Mue Shop | Mass Studies | 2004 | www.massstudies.com

The Mue Shop in Seoul has been aesthetically divided into two complete-ly different parts, one for men and one for women, and they cannot be defined as anything less than radically ambitious. The shop's goal is "to go beyond passive consumerism" and utilize the space as a medium in which to promote a fluid interaction between not only the store's customers and its clerks, but between these very people and the garments displayed here as well—in this case, clothing designed by the best and most wellknown fashion designers in the world. Mue is more than just a store. It's an authen-tic sensory experience in which plastics play a predominant role, aestheti-cally as well as functionally.

The store's main area is on the ground floor. If it brings to mind a theater or an art gallery more than a clothing store, that's because, in fact, it's been designed in such a way as to be able to host all kinds of events and exhi-bitions. A hallway and a 16.4-foot-tall stairway lead you up to the next level, where a balcony offers a bird's-eye view of the ground floor and the clothes on display. This balcony not only gives a view, but it allows one to be seen as well—an appropriate advantage, considering the types of clothes sold in this store and the type of customer it attracts. Some of the walls in these two spaces serve a purely decorative function, while others serve as projection screens.

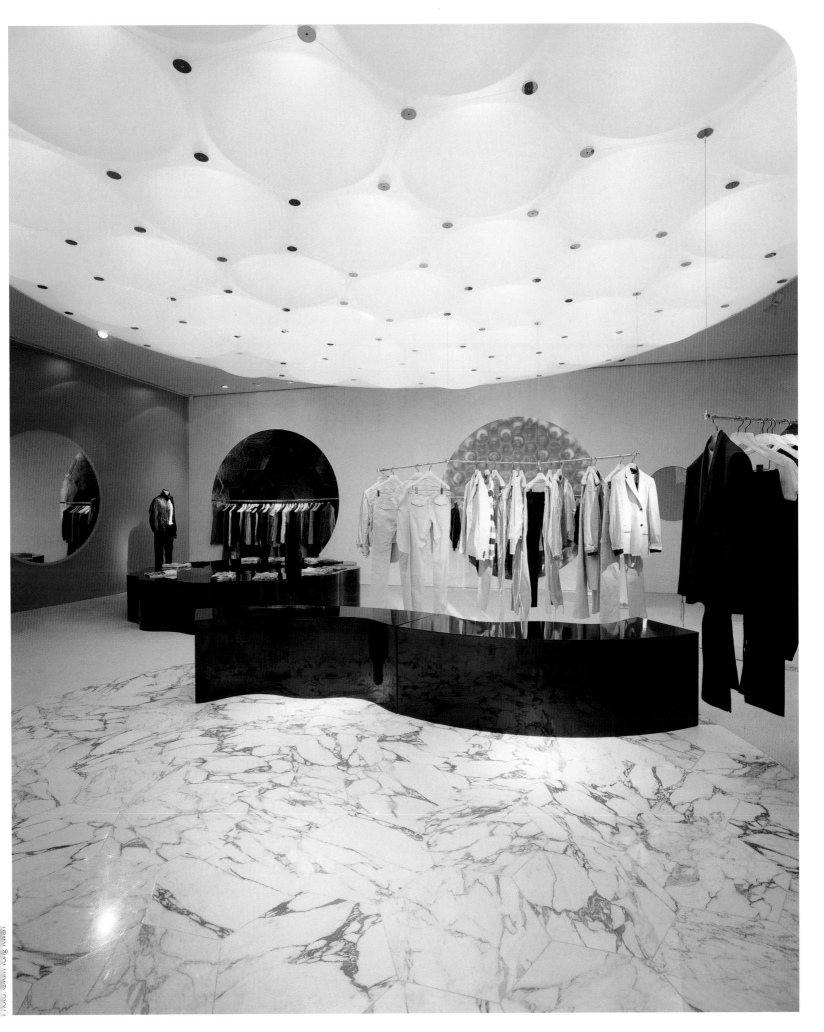

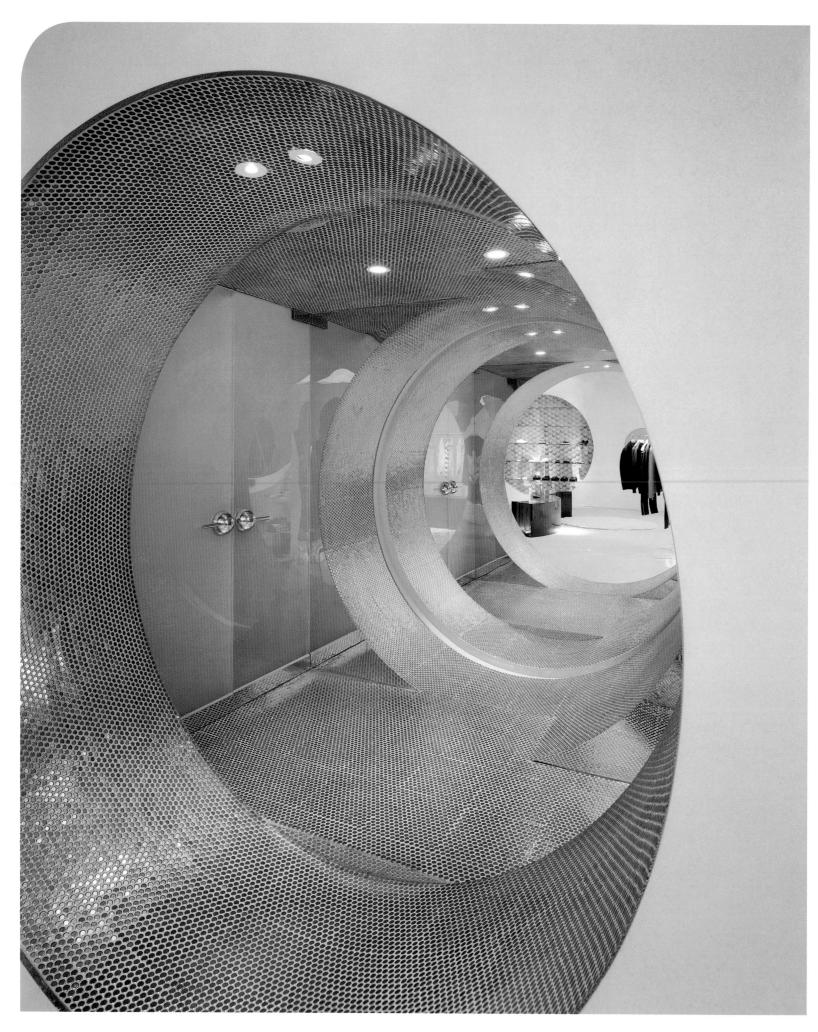

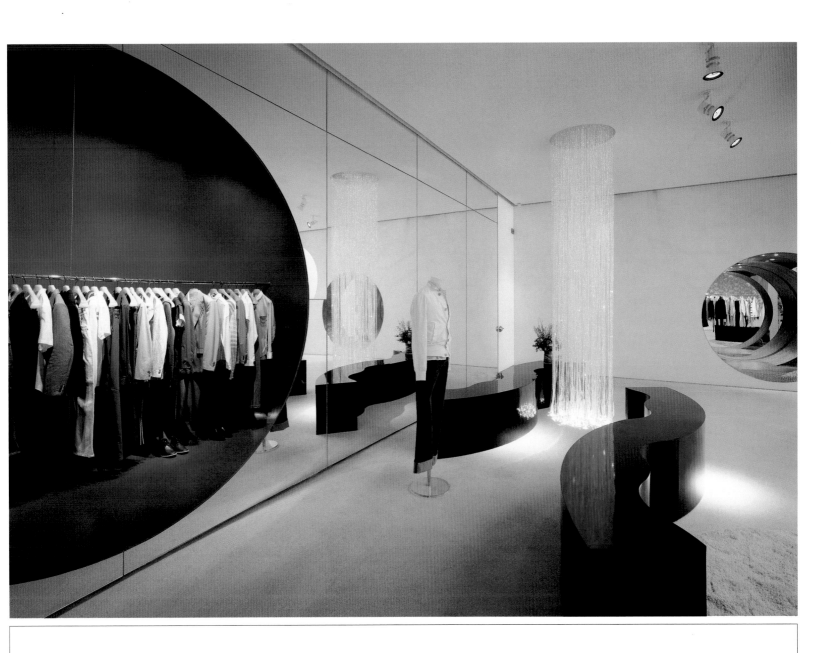

The second floor, dedicated to menswear, plays with a binomial series of theoretically opposed concepts: body-landscape, natural-synthetic, atoms-the Planet Earth, smooth-rough, reflection-absorption, two-dimensionality and three-dimensionality. From the large to the small, the natural to the artificial, and the modern to the classic, the store plays with provocative ideas, seeking the disquieting effect of opposites.

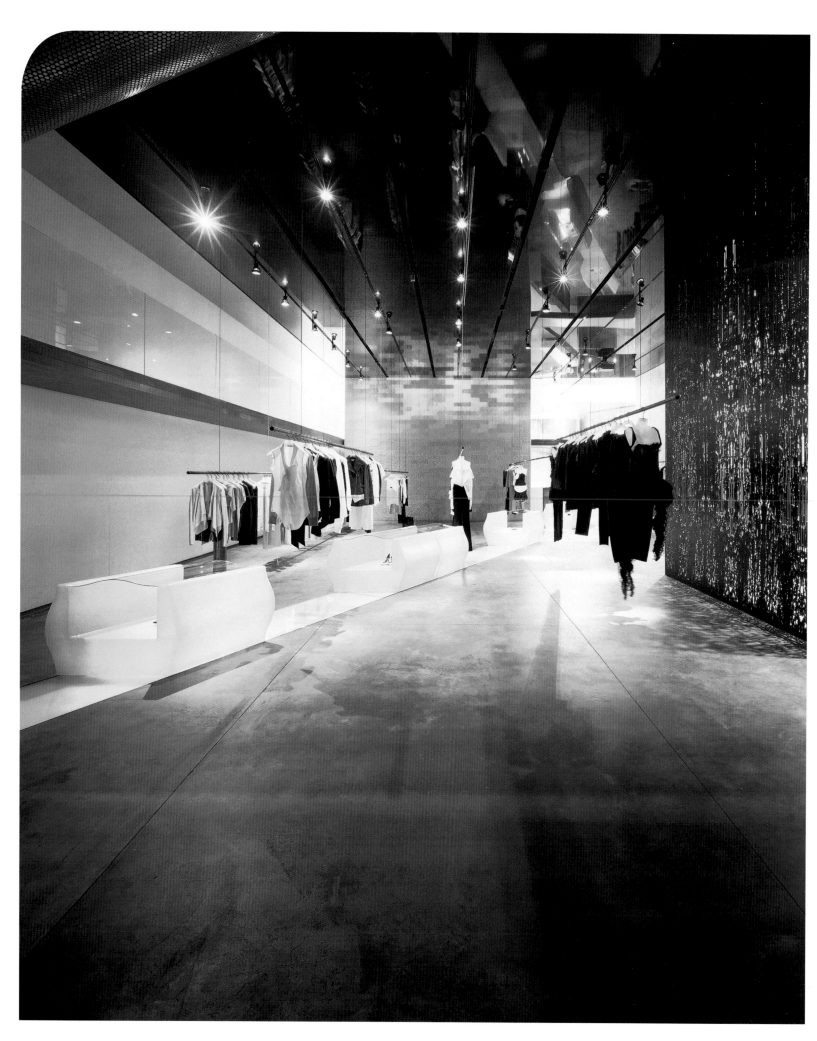

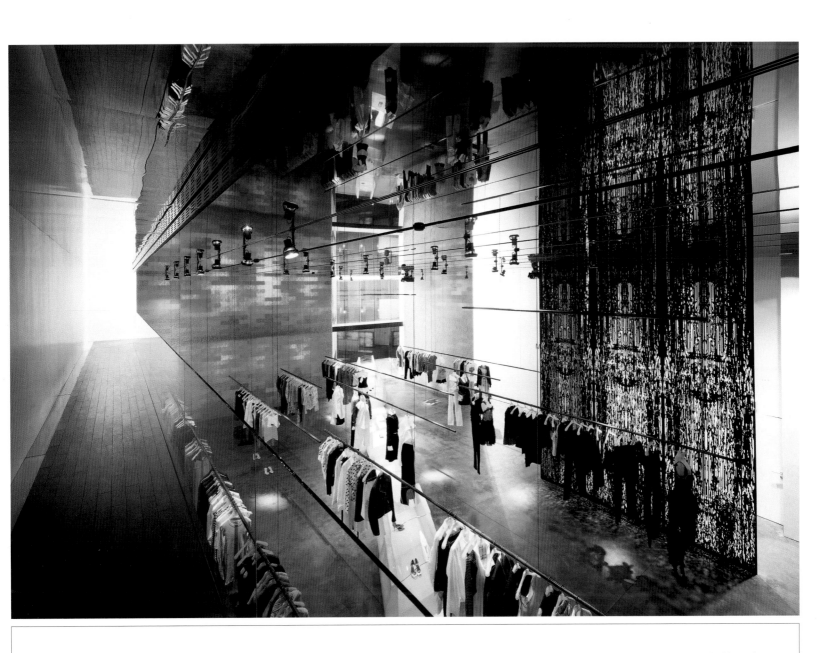

The first floor has been conceived in such a way that it may host (as it has many times before) other types of events: fashion shows, art installations, performances and parties. The objective is to go beyond the traditional clothing-store concept and offer both the repeat customer and the occasional passer-by a new type of stimulus.

Klorofil | Matali Crasset | 2006 | www.matalicrasset.com

The housing shortage, which is dire in some countries, has led to all types of more or less imaginative solutions devised over the years by industrial designers and architects alike. The majority of those solutions go no further than the four walls of the gallery or museum storing them, though on some occasions someone comes up with a frankly interesting idea. These may not necessarily be solutions, but they may well be valid starting points. Klorofil, by Matali Crasset, is one of those solutions "with possibilities." Klorofil is more than just a cabin. It's a platform from which one may see the world differently than usual. The structural support is metallic, and the rest is acrylic plastic (plastic-coated canvas). Klorofil consists of four elevated seats that can be reached by way of four little ladders, forming a lookout room under which is found a conventional tent. On the inside of the tent, eight metal columns support the shelter's weight. The objective is to create a scenic observatory capable of integrating itself easily into the landscape (the reason for its green color) and to open new "windows" on the reality that surrounds us. When one tires of looking at the horizon, the birds, and the clouds, what could be better than to take a little nap in the Klorofil?

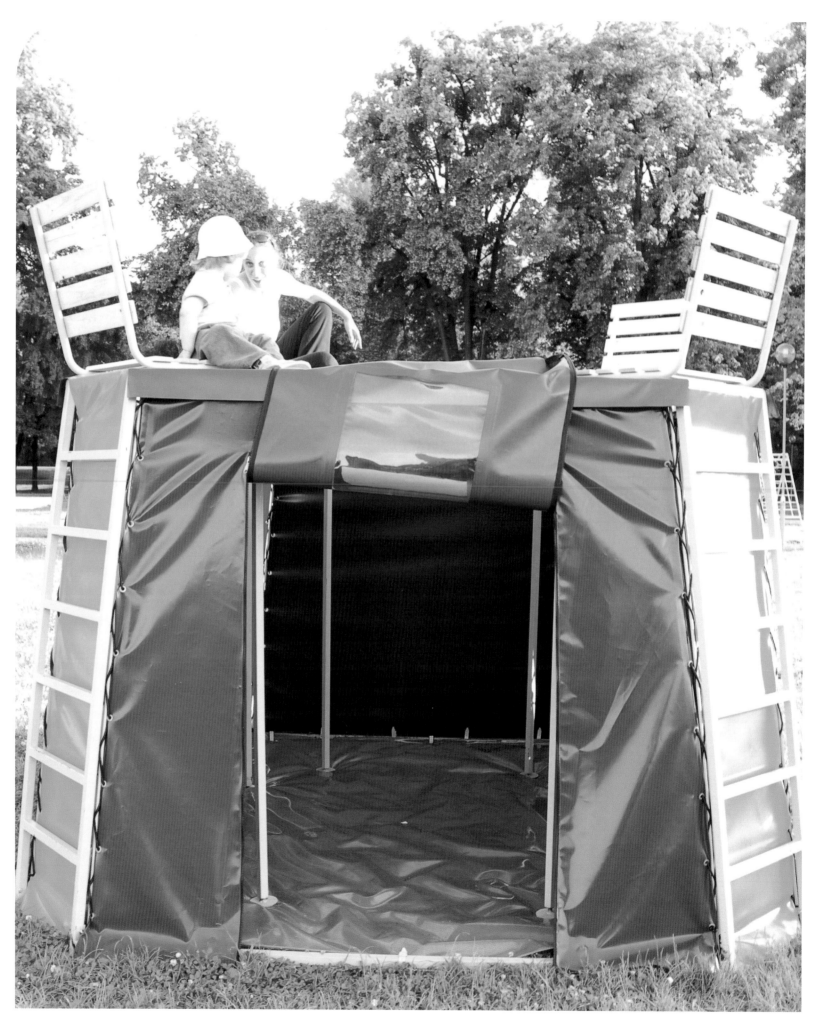

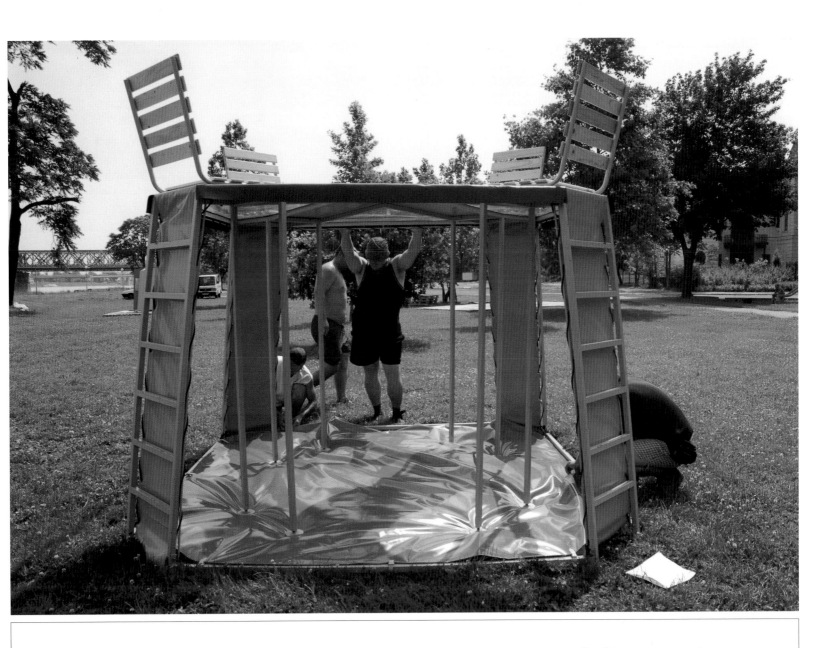

Klorofil is as easy to put together as a conventional tent, although it evidently differs from the tent in its much greater strength: It can easily support the weight of four adults seated on it. The acrylic plastic fabric is waterproof and keeps the Klorofil's interior completely dry on rainy days.

Loft in Puls 5 | Daniele Claudio Taddei | 2005 | taddei@milnor.net

This loft is situated in a building complex called Puls 5, which is in turn located in the Swiss city of Zurich. Daniele Claudio Taddei's objective during the loft's design was to emphasize its impression of openness and height in each and every one of its details, no matter the size. The central element in this apartment is the bathroom, in which a spectacular wall of light becomes the focal point. The lights have been installed behind the metal structure of a technical wall [?] erected in front of the toilet, shower, and sink. The wall gains its translucent effect from the use of sheets of Plexiglas,

a plastic that meets all the needs of the user. It's humidity- and high-temperature-resistant, hygienic, easy to clean, and flexibile, and it has a spectacularly modern look. Not to mention its low cost and its easy installation, which, in addition to the aforementioned qualities, made the decision to use this material in the bathroom that much easier. The luminosity of the Plexiglas wall and its hidden bulbs—together with the very large mirror on the bathroom wall—helps contribute to visually amplifying the space in this room.

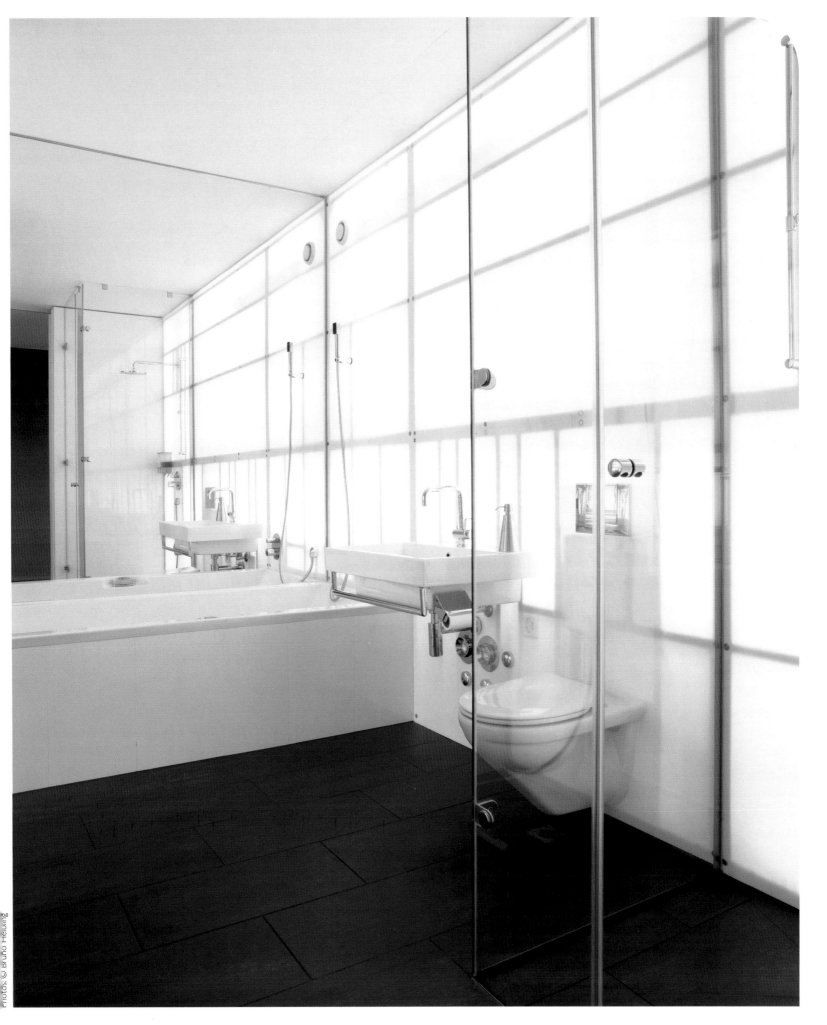

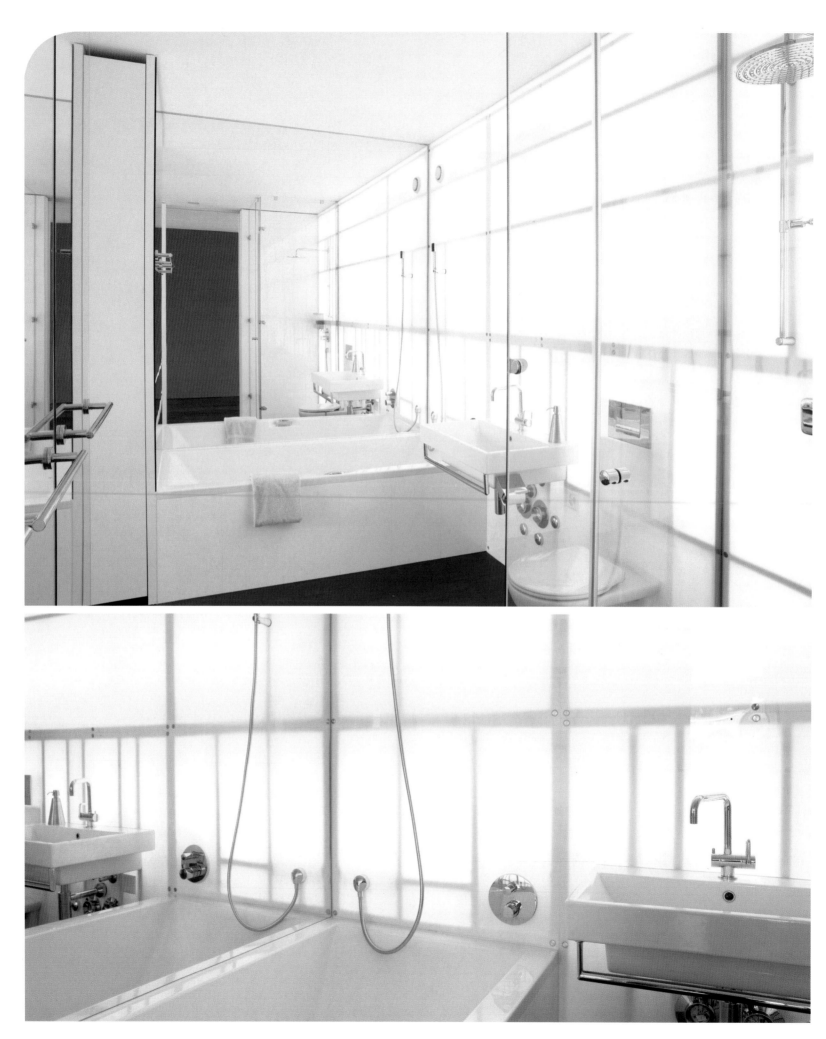

The loft's different areas can be divided according to the owner's needs with a mobile panel that doubles as a wall. In this way, the configuration of the apartment has many more possibilities and is much more flexible than that of your typical apartment.

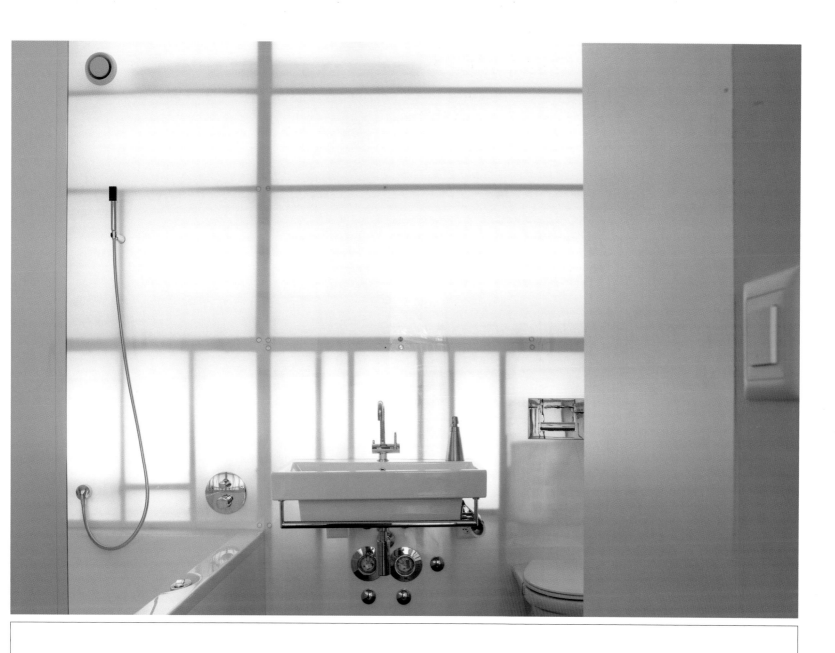

One of the advantages of the Plexiglas wall is the quality of light it gives off. It's completely uniform; so that no corner of the bathroom is left in the dark or insufficiently lit. All this makes extra lamps for illuminating smaller areas unneccessary.

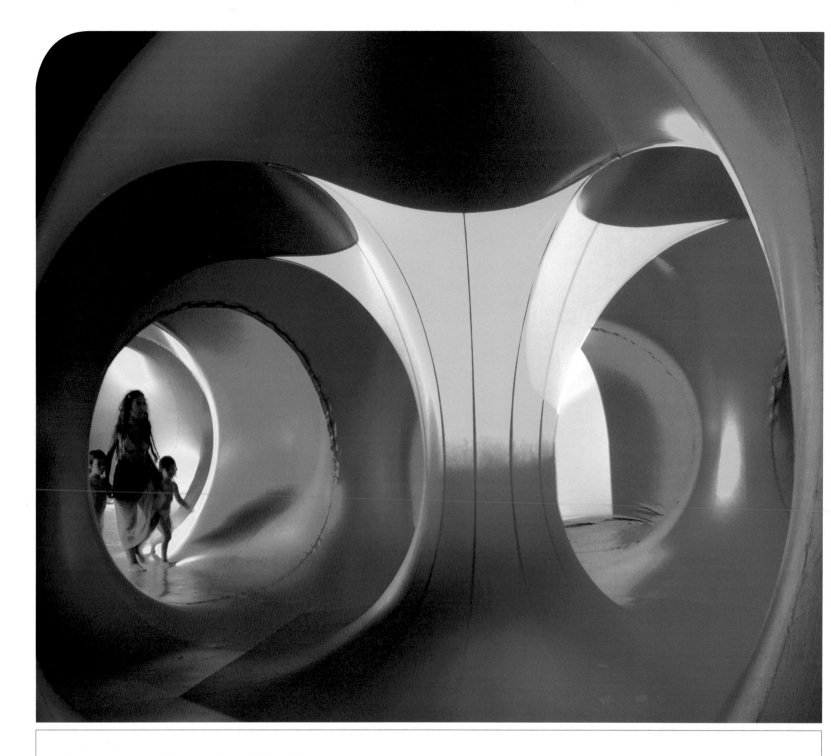

Luminarium Levity II | Architects of Air | 2005 | www.architects-of-air.com

The Luminarium is a gigantic inflatable installation of light and color. Architects of Air has designed, constructed and organized the subsequent world tour of the Luminaria. Since 1992, more than 2 million people have visited the Luminaria, which has toured more than 34 countries on the five continents. Levity II, designed in 2005, is the latest of the Luminaria designed by Architects of Air. Every year designers at Architects of Air, in Nottingham, England, construct a new Luminarium based on the designs of Alan Parkinson. The vinyl used to make them is produced in France and offers numerous advantages: It is flexible even at radically varying temperatures, it is durable and is highly fire-retardant. Visitors are given a map at the Luminarium's entrance and are asked to remove their shoes before entering. Inside, they find an explosion of colors that induces relaxation, an effect many people have coined "one gigantic chill-out." The Luminarium design finds its inspiration in pure geometric shapes, forms found in nature, and Islamic architecture, from which it borrows its domes and turrets. The work of such innovative architects as Buckminster Fuller and Frei Otto has also been a significant influence. Functionality is also important as a basic principle in the the Luminarium's design.

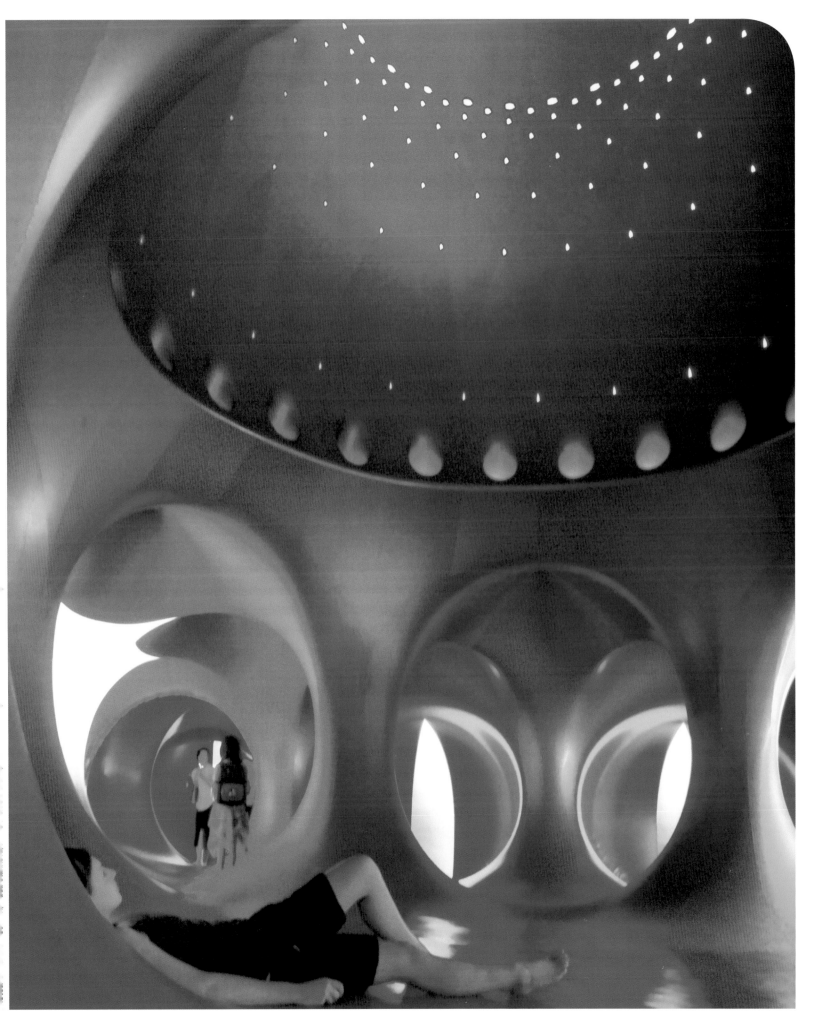

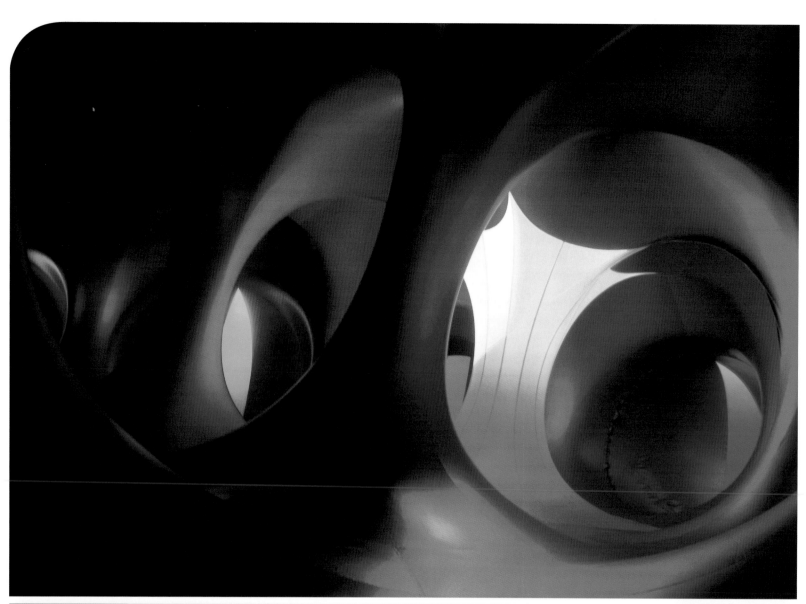

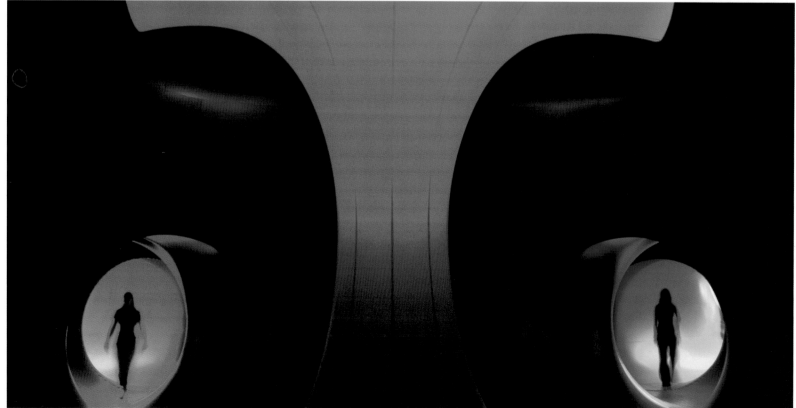

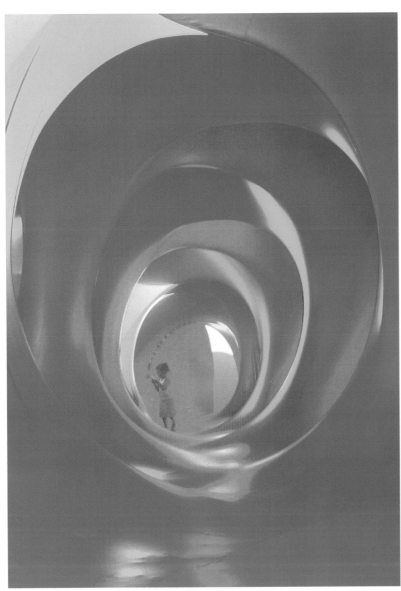
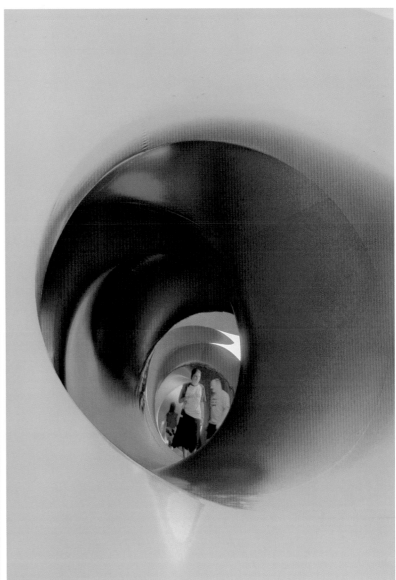

On occasion, a visit to the Luminarium may be enhanced by the presence of a musician or a storyteller, though most of the time, visitors are urged to enjoy the spectacle in all its simplicity. The Luminarium design appeals to both children and adults, providing an alternative to the traditional amusement park.

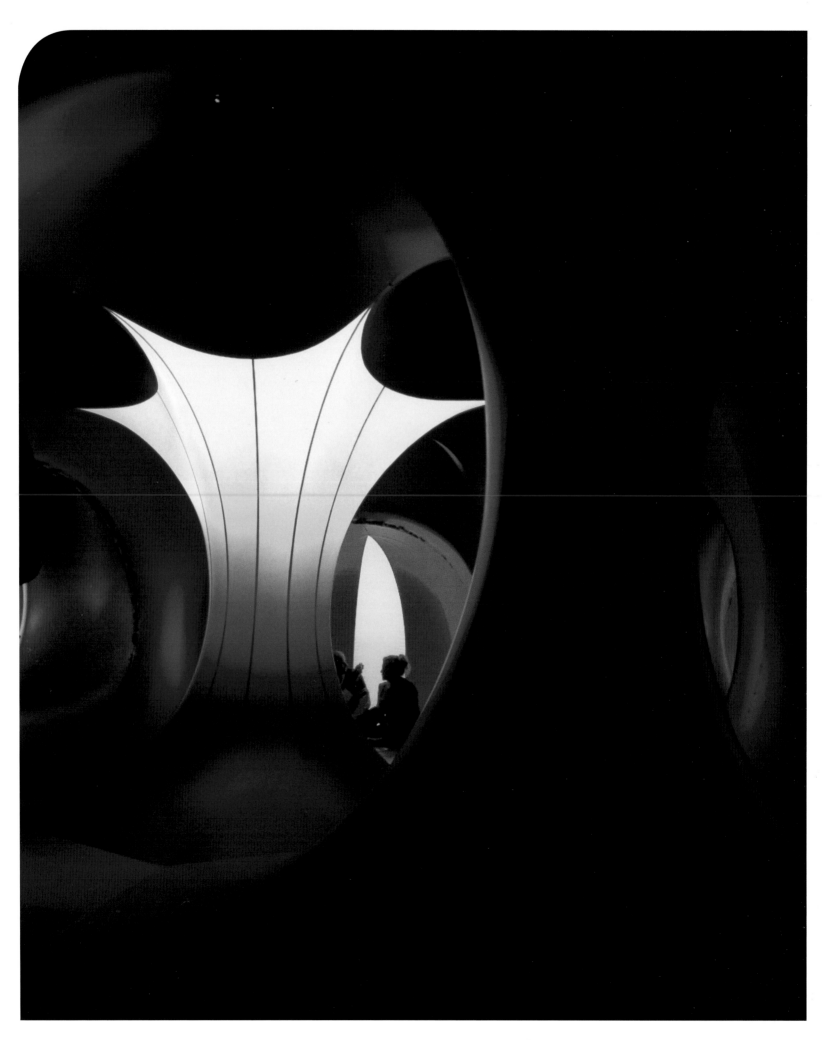

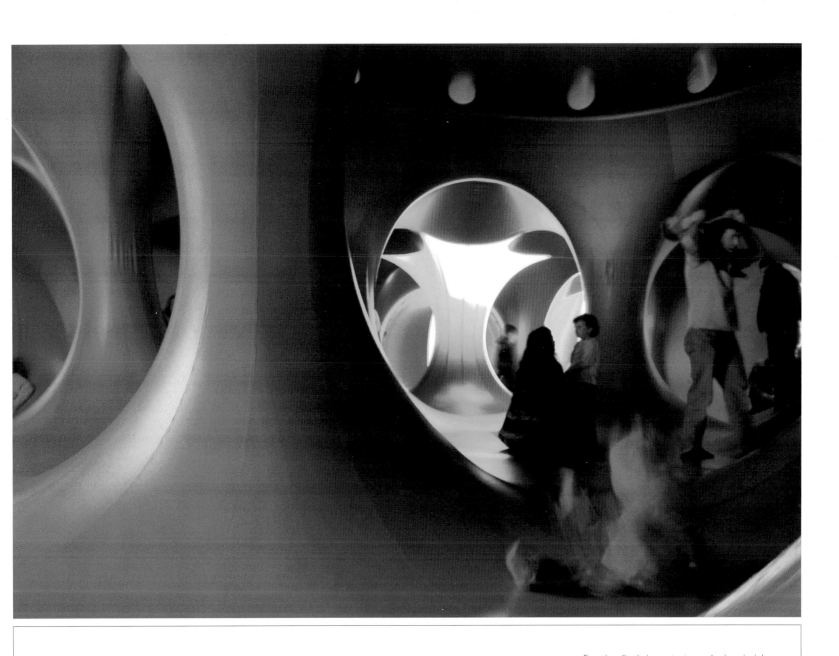

Functionality is important as a basic principle in the the Luminarium's design. This means that rainwater must be quickly drained away, wheelchair access must be made easy, and the installation's structure must be adaptable to the different terrain and neighborhoods of every city visited.

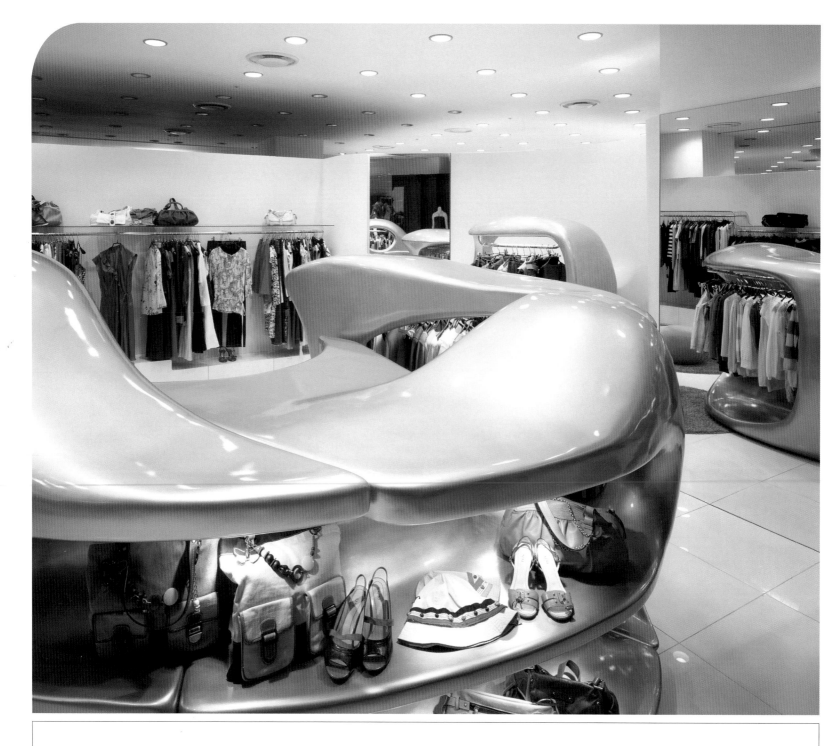

SJ SJ Shop | Mass Studies | 2005 | www.massstudies.com

There are two ways to look at a project requiring the design of a clothing-store display table. The first is to opt for discretion and design a table that is practically unnoticeable and turns all the attention to the garments on display. This is the conservative option. The second way is to opt for the opposite philosophy and create an attention-grabbing display table that acts as a visual enticement to passers-by. If so, why not opt for eccentricity? This last option is the elemental idea for the SJ SJ Shop centerpiece, a retro-futuristic display piece designed by Mass Studies. It comprises three independent elements that are brought together to form one unique display

piece made with FRP, a plastic that has become popular in the past few years. Used to make pipes, vats, and other specialized products, its chief advantage is its physical and chemical durability. The display piece has been manufactured in a golden color similar in appearance to traditional lacquer and is identified primarily by its rolling, hollow, organic shapes, on which garments may be hung or placed (here, shirts, handbags, shoes and all kinds of women's accessories). Its irregular, asymmetric shape would have been practically impossible to achieve with any material other than plastic.

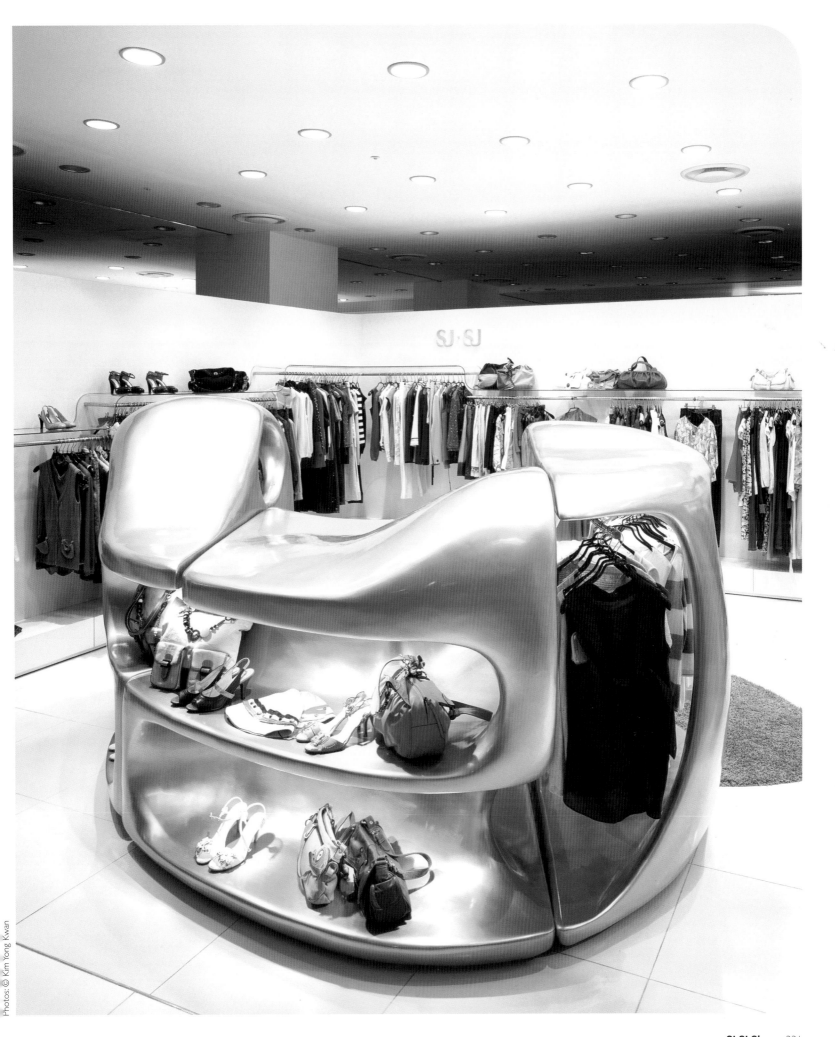

Directory

5.5 Designers
80, rue du Faubourg Saint-Denis
75010 Paris, France
ph. +33 1 48 00 83 50
info@cinqcinqdesigners.com
www.cinqcinqdesigners.com

A

Tanya Aguiniga
225 Madera Avenue
Los Angeles, CA, USA 90039
ph. +1 619 892 1506
tanya@aguinigadesign.com
www.aguinigadesign.com

Architects of Air
Oldknows Factory, Egerton Street
NG3 4GQ Nottingham, United Kingdom
ph. + 44 11 59 41 37 09
info@architects-of-air.com
www.architects-of-air.com

Art.Lebedev Studio
5 Gazetny per.
125993 Moscow, Russia
ph. +7 49 55 40 18 00
mailbox@artlebedev.com
www.artlebedev.com

Azúamoliné
Rambla del Prat, 8, 2° 2ª
08012 Barcelona, Spain
ph. +34 93 218 29 14
contact@azuamoline.com
www.azuamoline.com

Shin Azumi
mail@shinazumi.com
www.shinazumi.com

B

Michael Bihain
53, rue Nothomb
1040 Brussels, Belgium
ph. +32 47 270 72 02
info@bihain.com
www.bihain.com

Michel Boucquillon
Via Bandettini TR.V, 14
55100 Lucca, Italy
ph. +39 0 58 341 92 08
workshop@michelboucquillon.com
www.michelboucquillon.com

Ronan & Erwan Bouroullec
23, rue du Buisson de St. Louis
75010 Paris, France
ph. +33 1 42 00 40 33
info@bouroullec.com
www.bouroullec.com

Brion Experimental
Avenida F. F. de la Cruz, 1880
Buenos Aires, Argentina
ph. +54 11 4918 4265
info@brionexperimental.com
www.brionexperimental.com

Buro Vormkrijgers
Vestdijk 141 A
5611 CB Eindhoven, The Netherlands
ph. +31 40 213 25 47
info@burovormkrijgers.nl
www.burovormkrijgers.nl

C

Fernando & Humberto Campana
Rua Barão de Tatuí, 219
SP 01226 030 Santa Cecília, São Paulo, Brazil
ph. +55 11 3825 3408
campana@campanadesign.com.br
www.campanas.com.br

Charming Unit Design Studio
Tessins Väg 1 B
SE–217 58 Malmö, Sweden
ph. +46 40 30 22 03
louise@charmingunit.com
www.charmingunit.com

Matali Crasset
26, rue du Buisson Saint Louis
75010 Paris, France
ph. +33 1 42 40 99 89
matali.crasset@wanadoo.fr
www.matalicrasset.com

D

Denton Corker Marshall
49 Exhibition Street
VIC 3000 Melbourne, Australia
ph. +61 3 9012 3600
melb@dentoncorkermarshall.com.au
www.dentoncorkermarshall.com

Designandstuff
ph. +44 78 16 67 96 43
info@designandstuff.net
www.designandstuff.net

Martino D'Esposito
Chemin du Cap, 18
CH-1006 Lausanne, Switzerland
ph. +41 76 347 66 86
desposito@despositogaillard.com
www.despositogaillard.com

Designtrip
Corso Buenos Aires, 45
20124 Milan, Italy
ph. +39 0 22 951 74 00
carallo@designtrip.it, grandis@designtrip.it
www.designtrip.it

Ding3000
Braunstrasse 28
30169 Hannover, Germany
ph. +49 51 19 119 94 36
info@ding3000.com
www.ding3000.com

Tom Dixon
4th Northington Street
WC1N 2JG London, United Kingdom
ph. +44 20 74 00 05 00
debbie@tomdixon.net
www.tomdixon.net

Dot Kite
Cruquiusweg 46
NL-1019AT, Amsterdam, The Netherlands
ph. +31 62 161 01 28
info@dotkitedesign.com
www.dotkitedesign.com

E

Edra
P.O. Box 28
56030 Perignano, (PI), Italy
ph. +39 0 58 761 66 60
edra@edra.com
www.edra.com

Emmanuel Babled Studio
Via P. Cézanne, 5
20413 Milan, Italy
ph. +39 0 25 811 11 19
info@babled.net
www.babled.net

Ulrika E. Engberg, Kasper Medin
Svalebogatan 43 A
SE-414 75 Gothenburg, Sweden
ph. +46 731 59 06 07
info@ulrikaengberg.com
www.ulrikaengberg.com

Ersah Mobilya
Arnavutköy-Bolluca Yolu 342/A
Arnavutköy GO Pasa 34287, Istanbul, Turkey
ph. +90 21 2685 0142
pelin@ersah.com
www.ersah.com

Luis Eslava
Alboraya, 18, Puerta 8 Escalera A
46010 Valencia, Spain
ph. +34 66 122 93 33
luis@luiseslava.com
www.luiseslava.com

F

Fabrica
Via Ferrarezza
31020 Catena di Villorba (TV), Italy
ph. +39 0 42 251 63 09
fabrica@fabrica.it
www.fabrica.it

Fanplastic
255 1/4 S. Normandie Avenue
Los Angeles, CA, USA 90004
ph. +1 213 427 9281
info@designcafeteria.com
www.fanplastic.net

Freedom of Creation
Hobbemakade 85 hs
1071 XP Amsterdam, The Netherlands
ph. +31 20 675 84 15
info@freedomofcreation.com
www.freedomofcreation.com

G

Gaia & Gino
Abdi Ipekci Cad. 44/4
Nisantasi, 34368, Istanbul, Turkey
ph. +90 21 22 34 44 72
office@gaiaandgino.com
www.gaiaandgino.com

Bathsheba Grossman
3127th Branciforte Drive
Santa Cruz, CA, USA 95065
ph. +1 831 429 8224
b@bathsheba.com
www.bathsheba.com

Marie-Louise Gustafsson
Havregatan 7
118 59 Stockholm, Sweden
p. +46 70 492 28 58
info@marielouise.se
www.marielouise.se

H

Stuart Haygarth
33 Dunloe Street
E2 8JR London, United Kingdom
ph. +44 79 70 96 07 15
info@stuarthaygarth.com
www.stuarthaygarth.com

I

Integral Studio Vinaccia
Via Savona, 97
20144 Milan, Italy
ph. +39 02 47 71 92 77
info@vinaccia.it
www.vinaccia.it

J

Jellylab Studio
122, rue du Bac
75007 Paris, France
ph. +33 87 044 63 35
info@jellylab.com
www.jellylab.com

j-me
Unit 27 F2, N17 Studios, 784-788 High Road
N17 0DA London, United Kingdom
ph. +44 20 83 65 11 36
info@j-me.co.uk
www.j-me.co.uk

K

Adriean Koleric / ITEM
ph. +1 780 906 1821
info@thinkitem.com
www.thinkitem.com

Komplot Design
Amager Strandvej 50
DK-2300 Copenhagen S, Denmark
ph. +45 32 96 32 55
komplot@komplot.dk
www.komplot.dk

Korzendesign
93 Bosworth Crescent
N2E 1Y9 Kitchener, Ontario, Canada
ph. +1 519 574 2778
tom@korzendesign.com
www.korzendesign.com

Jos Kranen
Eindhovenseweg 104
5582 HW Waalre, Netherlands
ph. +31 64 624 19 10
info@joskranen.nl
www.joskranen.nl

L

L Design
5 bis, rue des Haudriettes
75003 Paris, France
ph. +33 1 44 78 61 61
contact@ldesign.fr
www.ldesign.fr

Yann Le Bouedec / Suck UK
31 Regent Studios, 8 Andrews Rd
E8 4QN London, United Kingdom
ph. +44 20 79 23 00 11
abi@suck.uk.com
www.suck.uk.com

Lievore, Altherr, Molina
Plaza Ramón Berenguer el Gran, ático
08002 Barcelona, Spain
ph. +34 93 310 32 92
estudio@lievorealthermolina.com
www.lievorealtherrmolina.com

Ligne Roset
Roset Möbel
Industriestrasse 51
79194 Gundelfingen, Germany
ph. +49 76 159 20 90
epost@ligne-roset.de
www.ligne-roset.com

M

Mass Studies
Fuji Bldg. 4F, 683-140 Hannam 2-dong Yongsan-gu
140-892 Seoul, Korea
ph. +82 2790 6528/9
office@massstudies.com
www.massstudies.com

J.P. Meulendijks / N-U
Twijnstraat 26A
3511ZL Utrecht, The Netherlands
ph. +31 30 231 30 22
j.p.meulendijks@n-u.nl
www.n-u.nl

Jasper Morrison
mail@jaspermorrison.com
www.jaspermorrison.com

Rainer Mutsch
Löwengasse 53/8
1030 Vienna, Austria
ph. + 43 66 44 53 55 25
studio@rainermutsch.net
www.rainermutsch.net

N

Torsten Neeland
61 Redchurch Street
E2 7DJ London, England
ph. +2121 02 07 729 65 47
tn@torsten-neeland.co.uk
www.torsten-neeland.co.uk

Normann Copenhagen
Østerbrogade 70
2100 Copenhagen, Denmark
ph. +45 35 55 44 59
normann@normann-copenhagen.com
www.normann-copenhagen.com

O

David Olschewski Produktdesign
Thürmchenswall 39
50668 Köln, Germany
ph. +49 176 24 51 01 06
info@david-olschewski.com
www.davidolschewski.de

P

Satyendra Pakhalé
Zeeburgerpad 50
1019 AB Amsterdam, The Netherlands
ph. +31 20 419 72 30
info@satyendra-pakhale.com
www.satyendra-pakhale.com

Phil Frank Design
939 SE Alder Street, Unit 9
Portland, OR, USA 97212
ph. +1 503 803 5536
phil@phil-frank.com
www.phil-frank.com

Pichiglás

Magallanes, 58, entresuelo
08004 Barcelona, Spain
ph. +34 607 826 507 or
+34 619 211 642
alfonso@pichiglas.net
www.pichiglas.net

Pollen Design

247 Centre Street, 4th Floor, Suite 15
New York, NY, USA 10013
ph. + 1 212 941 5535
marketing@pollendesign.com
www.pollendesign.com

R

Karim Rashid

357 West 17th Street
New York, NY, USA 10011
ph. +1 212 929 8657
office@karimrashid.com
www.karimrashid.com

S

Tatiana Sánchez

Loma Grande 2625, Loma Larga
Monterrey 64710, NL Mexico
ph. +52 81 1159 0037
info@jaleajalea.com
www.jaleajalea.com

SEED International

931st Massachusetts Avenue, Suite 604
Cambridge, MA, USA 02139
ph. +1 617 576 9668
info@seed-international.com
www.seed-international.com

Philippe Starck

18-20, rue du Faubourg du Temple
75011 Paris, France
ph. +33 1 48 07 54 54
projects@starcknetwork.com
www.philippe-starck.com

Studio Aisslinger

Oranien Platz 4
10999 Berlin, Germany
ph. +49 30 31 50 54 00
studio@aisslinger.de
www.aisslinger.de

Studio Archirivolto

info@archirivolto.it
www.archirivolto.it

Studio Bizq

Noordeinde 86 C
2514GL Den Haag, The Netherlands
ph. +31 70 346 72 32
mail@bizq.nl
www.bizq.nl

Studio I.T.O. Design

Via Brioschi, 54
20141 Milan, Italy
ph. +39 0 28 954 60 07
studioito@studioito.com
www.studioito.com

Studio Massaud

7, rue Tolain
75020 Paris, France
ph. +33 1 40 09 54 14
studio@massaud.com
www.massaud.com

Studio Mikko Laakkonen

Mechelinintaku 16
00100 Helsinki, Finland
ph. +35 84 00 41 58 62
info@mikkolaakkonen.com
www.mikkolaakkonen.com

Studio Wagner:Design

Mainzer Landstrasse 220
60327 Frankfurt, Germany
ph. +49 69 92 87 05 74
wagner@wagner-design.de
www.wolf-udo-wagner.com

T

Daniele Claudio Taddei

Feldeggstrasse 54
8008 Zurich, Switzerland
ph. +41 79 409 48 50
taddei@milnor.net

V

Vitra

29 Ninth Avenue
New York, NY, USA 10014
ph. +1 212 463 5700
home@vitra.com
www.vitra.com

W

Marcel Wanders

P.O. Box 11332
1001 GH Amsterdam, The Netherlands
ph. +31 20 422 13 39
joy@marcelwanders.com
www.marcelwanders.com

Gus Wüstemann

Albulastrasse 34
CH-8048 Zurich, Switzerland
ph. +41 44 400 20 15
architects@guswustemann.com
www.guswustemann.com

Z

Zanotta

Via Vittorio Venetto, 57
20054 Nova Milanese, Italy
ph. +39 0 362 49 81
zanottaspa@zanotta.it
www.zanotta.it